THE ANTHROPOLOGY OF CHRISTIANITY

Edited by Joel Robbins

Sensational Movies

Diabolo—"A New Sensation!" (December 1991). Photograph by author.

Sensational Movies

VIDEO, VISION, AND CHRISTIANITY IN GHANA

Birgit Meyer

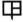

UNIVERSITY OF CALIFORNIA PRESS

University of California Press, one of the most distinguished university presses in the United States, enriches lives around the world by advancing scholarship in the humanities, social sciences, and natural sciences. Its activities are supported by the UC Press Foundation and by philanthropic contributions from individuals and institutions. For more information, visit www.ucpress.edu.

University of California Press
Oakland, California

Please see pages xvi–xvii for acknowledgments for parts of this book that were previously published.

Library of Congress Cataloging-in-Publication Data

Meyer, Birgit, 1960 – author.
 Sensational movies: video, vision, and Christianity in Ghana / Birgit Meyer.
 pages cm. — (Anthropology of Christianity ; 17)
 Video, vision, and Christianity in Ghana
 Includes bibliographical references and index.
 ISBN 978-0-520-28767-9 (cloth : alk. paper)
 ISBN 978-0-520-28768-6 (pbk. : alk. paper)
 ISBN 978-0-520-96265-1 (ebook)
 1. Motion pictures—Social aspects—Ghana. 2. Motion pictures—Religious aspects—Pentacostalism. 3. Motion picture industry—Ghana—20th century. 4. Video recordings—Social aspects—Ghana. 5. Video recordings—Religious aspects—Pentacostalism. 6. Video recordings industry—Ghana—20th century. I. Title. II. Title: Video, vision, and Christianity in Ghana. III. Series: Anthropology of Christianity ; 17.
 PN1993.5.G45M49 2015
 302.23′4309667—dc23

 2015026504

Manufactured in the United States of America

24 23 22 21 20 19 18 17 16 15
10 9 8 7 6 5 4 3 2 1

In keeping with a commitment to support environmentally responsible and sustainable printing practices, UC Press has printed this book on Natures Natural, a fiber that contains 30% post-consumer waste and meets the minimum requirements of ANSI/NISO Z39.48–1992 (R 1997) (*Permanence of Paper*).

To
Ashangbor (Michael) Akwetey-Kanyi,
Augustine Abbey (alias Idikoko), William Akuffo,
the late Seth Ashong-Katai, Hammond Mensah
(alias H. M.), and Socrate Safo

CONTENTS

ILLUSTRATIONS

PREFACE

As I passed through Sankara Circle, one of the main intersections in urban Accra, on my motorbike just before Christmas in 1991, my eyes were drawn to a huge hand-painted billboard (see frontispiece). Depicting a lady embracing a snake-man—a body of a python with a grinning male head—the board advertised a locally produced movie titled *Diabolo* (Worldwide Motion Pictures, 1991) as "a new sensation." Like many others, I went to watch this movie at the Rex Cinema in Central Accra. The screening was a tantalizing experience, not only because of the movie's plot but also because of the audience's boisterous participation in following the evil trajectories and sexual escapades of Diabolo—masterfully played by Bob Smith, who established himself with this role as "the Ghanaian Christopher Lee." Seeking to produce "quick" money with the help of supernatural evil forces, Diabolo lures unsuspecting, though morally dubious, women into his luxurious mansion, where he drugs them, transforms himself into a snake, and enters their vagina, making them vomit money. Playing on anxieties about the dangers of city life, fears of the hidden presence of evil spirits, a prurient fascination with transgressions into the realms of sex and the occult, the seduction of money and moral concerns about the dark side of "quick" riches, and the appeal of popular Christianity with its dualism of the struggle between the devil and God, the movie was a blockbuster (Meyer 1995; see also Wendl 2001).

I was in the midst of my dissertation research on grassroots appropriations of Christianity in the Volta Region (Meyer 1999a), and it struck me that the movie resonated with and offered an audiovisual extension of stories about "satanic riches" as they circulated as rumors, were published in popular papers and pamphlets, or were diagnosed in prayer sessions devoted to "deliverance from the powers of darkness" and recounted as testimonies in

churches. Conversely, the *Diabolo* story was embedded in a corpus of narratives about the dangers of occult money. Since this first encounter with a locally produced "Ghanaian film," I have been intrigued by the connection between such moving pictures and Christian preachings, especially as epitomized in the Pentecostal-charismatic churches that became very prominent in the mid-1980s. Until the end of my dissertation research in July 1992, I watched Ghanaian films whenever I had the chance on my occasional visits to Accra, noting that many of them attributed central importance to spirits and the spiritual dimension as it affects everyday life. Fascinated by the local use of the cheap and easily accessible technology of video in audiovisualizing popular imaginaries and the crossovers between the spheres of film and religion, I ventured into exploring the phenomenon of what was locally called Ghanaian films once my dissertation project was completed in 1995 (see Meyer 1999b).

This project has captured my attention over the past twenty years because the study of video movies not only revolves around captivating stories and their colorful audiovisualization; grappling with the wider cultural, social, political, and economic context of these productions allowed me to address broader themes and theoretical issues that lead beyond the movies themselves right into the transformation of everyday life in the aftermath of the neoliberal era of privatization and market deregulation. Taking colonial and state cinema as a backdrop, the starting point of this study is 1985, the year that saw the production of the first local video movie, *Zinabu* (Worldwide Motion Pictures), a blockbuster to which the *Diabolo* advertisement refers explicitly. Based on several periods of my fieldwork between 1996 and 2010, this book presents a historical-ethnographic study of the circuits of production, distribution (including exhibition in cinemas or on television and marketing as cassette tapes or VCDs), and consumption through which Ghanaian films were made and spread, becoming a popular and contested public phenomenon in Accra and beyond.

Throughout my research I have been involved in a long-term exchange with the film producers/directors Ashangbor (Michael) Akwetey-Kanyi, Augustine Abbey (alias Idikoko), William Akuffo, the late Seth Ashong-Katai, Hammond Mensah (alias H. M.), and Socrate Safo, who enabled me to follow the Ghanaian video film industry through its ups and downs. For me, as an anthropologist who uses writing as her main medium of expression, it was a tantalizing experience to be initiated into the world of filmmaking and to learn about the complexities of what I call "trans-figuring" narratives

into moving pictures. As a token of my deep gratitude for their long-term engagement, interest, and support, I dedicate this book to them.

In the spheres of film production, distribution, and consumption many people have generously put their time and energy into facilitating my research, answering my questions, allowing me to visit sets and screenings, explaining the intricacies of marketing, and so on. In particular I want to express my heartfelt thanks to film directors Lambert Hama, Nick Teye, and Ernest Abbeyquaye and to editors Marc Coleman and George Arcton Tettey at GFIC/GFC; Gado Mohammed (chairman of VIFPAG in the 1990s); Kofi Middleton-Mends at the National Film and Television Institute; the late Kwabena Sakyi at the censorship board; Benjamin Jeshie aka "JB" for taking me to screenings in small video centers across Accra; actors Emmanuel Armah, Fred Amugi, Edinam Atatsi, Lord Bentus, Eddie Cofie, David Dontor, the late Alexandra Duah, Linda Quashiga, Grace and Sheila Nortey, and Doris Sackitey; as well as filmmakers/producers/traders Alexiboat, Kojo Owusu Ansah, Veronica Codjoe, Steve Asare Hackman, Pius Famiyeh, Allen Gyimah, Hajia Hawa Meizongo and her brother Baba, Abdul Salam Mumuni, Ezekiel Dugbartey Nanor, Richard Quartey, Samuel Nyamekye, Veronica Quarshie and Moro Yaro. Many people shared with me their views on particular movies—or viewed them with me—and I am grateful for their willingness to participate in this project. I also thank Africanus Aveh (University of Ghana) for sharing his insights and critical thoughts about my take on the video phenomenon, John Collins (University of Ghana) for his open attitude about sharing his rich experiences in the field of popular music and culture, and Kwabena Asamoah-Gyadu (Trinity College) for his continued, productive engagement with my attempts to grasp the imprint of Christianity on Ghanaian movies and public culture at large.

With their unrelenting support and phenomenal hospitality over more than twenty years, Kodjo Senah and Adwoa Asiedu Senah were vital for the success of my research. They lodged me, assisted me with countless practical issues, helped me catch up with the talk of the town when I returned for a new fieldwork period, took me out to enjoy *kelewele* and drinks, and encouraged their younger family members (Ameko, Charles, Delali, Nabeka) to accompany me to cinemas or to watch and discuss movies together. I feel deeply moved by the way they opened their house and hearts to me; my husband, Jojada Verrips; and our son, Sybren.

My long-term engagement with the Ghanaian video film producers also entailed various attempts to profile their movies in the Netherlands. I would

like to thank Isabelle Vermeij for making possible a number of screenings in the—alas now defunct—Tropentheater (Royal Tropical Institute, Amsterdam); Jean Hellwig for finding funds and coproducing the first Ghanaian-Dutch movie *See You Amsterdam;* Mandy Elsas for introducing me to his amazing collection of hand-painted posters advertising Ghanaian and Nigerian films; and Eli Fiakpui and the late Efia Patience Asante, Pius Mensah, and Sam Kwesi Fletcher for their help in organizing all kinds of film-related events in the Ghanaian community in Amsterdam.

Research for this study was made possible thanks to a number of grants from the Netherlands Organization for Scientific Research (NWO). I would also like to acknowledge the support of the Department of Sociology and Anthropology at the University of Amsterdam, where I worked until 2006; of the Department of Social and Cultural Anthropology at VU University Amsterdam, where I worked between 2006 and 2011; and of my current Department of Philosophy and Religious Studies at Utrecht University. Facing the demands that come with a position of professor in the Netherlands and that require the conception and chairing of thematically driven collaborative research projects, I struggled for years to find the extended stretch of time needed to delve deeply into work on this book. Building on earlier articles and book chapters, taking up criticisms raised with regard to my previous work, and rethinking and substantiating my ideas, this volume has been conceptualized from scratch. Thanks to the stimulating intellectual environment at the Institute for Advanced Study in Berlin, where I stayed as a fellow from September 2010 until July 2011, I was prompted to place my inquiry into the interface of Christianity and Ghanaian video movies against a broader transdisciplinary horizon. Special thanks for raising questions and making suggestions that made me see my work in a new light go to Kamran Ali, Sandra Barnes, Nancy Hunt, Luca Giuliani, Elias Khoury, Albrecht Koschorke, Niklaus Largier, François Lissarrague, Reinhart Meyer-Kalkus, Joachim Nettelbeck, Tanja Petrović, and in particular to Christiane Kruse, who introduced me to the exciting field of German *Bildwissenschaft.* The full manuscript was completed during my stay at the *Zentrum Moderner Orient* (Berlin) in the second part of 2013, thanks to generous support from the Alexander von Humboldt Foundation. I am grateful to Ulrike Freitag for hosting me during the final writing phase and would like to thank Katrin Bromber, Bettina Gräf, Tilo Grätz, and Reza Masoudi Nejad for insightful comments.

I regard it as a privilege to be part of a thriving research environment that involves colleagues in the Netherlands and elsewhere. Our stimulating face-

to-face and written conversations have shaped the ideas about the nexus of religion, visual culture, and the public sphere that went into this book. In particular I want to mention Ze de Abreu, Freek Bakker, Markus Balkenhol, Karin Barber, Christoph Baumgartner, Heike Becker, Daan Beekers, Heike Behrend, Filip De Boeck, Annalisa Butticci, David Chidester, Marleen de Witte, Andre Droogers, Matthew Engelke, Johannes Fabian, Laura Fair, Jill Flanders-Crosby, Martha Frederiks, Faye Ginsburg, Francio Guadeloupe, Rosalind Hackett, Jonathan Haynes, Adrian Hermann, Lotte Hoek, Stewart Hoover, Peter Horsfield, Stephen Hughes, Gertrud Hüwelmeier, Duane Jethro, Frank Kessler, Pamela Klassen, Anne Marie Korte, Matthias Krings, Michael Lambek, Peter Lambertz, Stephan Lanz, Brian Larkin, Ruth Marshall, Daniela Merolla, David Morgan, Annelies Moors, Joseph Oduro-Frimpong, Martijn Oosterbaan, Crispin Paine, Peter Pels, Brent Plate, Katrien Pype, Bruno Reinhardt, Joel Robbins, Allen Roberts, Rafael Sánchez, Dorothea Schulz, Patricia Spyer, Irene Stengs, Jeremy Stolow, Maruška Svašek, Peter van der Veer, Bonno Thoden van Velzen, Tobias Wendl, Rhoda Woets, and Angela Zito. A number of these friends and colleagues read parts of the manuscript and offered valuable comments.

I thank Peter Geschiere for his fantastic support and warm friendship over the whole period of the research on which this book is based and for his inspiring, detailed comments on all chapters; his groundbreaking work on witchcraft and the occult significantly shaped my way of thinking and analysis. Besides helping me in so many ways to get around in Accra, Kodjo Senah also read most of the chapters, offered detailed comments, and helped me clarify many issues that called for his deep knowledge of southern Ghanaian society and life in Accra. To Terje Stordalen I am grateful for generously engaging with my work and for commenting on the manuscript from his perspective as a scholar of biblical literature; his persistent queries about issues I tended to take for granted or see as typical for the Ghanaian setting helped me to realize the shared human concerns that underpin the phenomenon explored in this book and in my own world. Over so many years I could discuss with Mattijs van de Port basic questions about what it means to do anthropology in our time, and without his intellectual support, mind-blowing ideas, probing questions, and detailed comments on parts of the manuscript, this book would not be the same. I thank Stijn van Rest and Erik van Ommering for transcribing many hours of recorded interviews, and Thomas van der Molen and Lotte Knote for assisting with compiling the bibliography. In finalizing the manuscript I could count on the remarkable language

editing capacity of Mitch Cohen and Joe Abbott, who helped me to make sure that my sentences say what I, as a native speaker of German living in the Netherlands for thirty years, have in mind. At the University of California Press I received exceptional support from Reed Malcolm, the best editor one can imagine. I would also like to thank Joel Robbins for his support and encouragement in his role as a series editor, and Stacy Eisenstark and Rachel Berchten for their engagement in making this study finally materialize as a book. Alexander Trotter prepared the index.

My gratefulness to Jojada Verrips is beyond expression. He has been my companion throughout the long trajectory from watching *Diabolo* at the Rex Cinema way back in 1991 to finishing this book. His wild thoughts (in the sense of Lévi-Strauss) about "the wild in the West" have been a constant source of inspiration and fruitful provocation. Without his practical support, his constructive intellectual engagement with my ideas, and his critical reading of numerous versions of chapters, this book would not exist. Our son, Sybren, grew up with my research on Ghanaian movies. At crucial moments he reminded me that it was my core concern as an anthropologist to finish this book. It is a fitting coincidence that this finally occurs at the same moment that he, too, is ready to leave our house.

· · ·

Some chapters include larger revised portions from previous publications. Chapter 1 builds on "Ghanaian Popular Video Movies between State Film Policies and Nollywood: Discourses and Tensions," in *Viewing African Cinema in the Twenty-First Century: Art Films and the Nollywood Video Revolution,* edited by Mahir Şaul and Ralph A. Austen (Athens: Ohio University Press, 2010), 42–62; chapter 2 incorporates parts of "Sensuous Mediations: The City in 'Ghanaian Films'—and Beyond," in *Wildness and Sensation: Anthropology of Sinister and Sensuous Realms,* edited by Rob van Ginkel and Alex Strating (Apeldoorn: Het Spinhuis, 2007), 254–74; and of "Self-Contained: Glamorous Houses and Modes of Personhood in Ghanaian Video-Movies," in *Bodies of Belonging: Inhabiting Worlds in Rural West Africa,* edited by Ann Cassiman (Antwerp: City Museum of Antwerp, 2011), 153–69; chapter 4 draws on parts of "Impossible Representations: Pentecostalism, Vision and Video Technology in Ghana," in *Religion, Media, and the Public Sphere,* edited by Birgit Meyer and Annelies Moors (Bloomington: Indiana University Press, 2006), 290–312; and chapter 7 inte-

grates substantial parts of "Mediating Tradition: Pentecostal Pastors, African Priests, and Chiefs in Ghanaian Popular Films," in *Christianity and Social Change in Africa: Essays in Honor of J. D. Y. Peel,* edited by Toyin Falola (Durham, NC: Carolina Academic Press, 2005), 275–306; and of "'Tradition and Colour at Its Best': 'Tradition' and 'Heritage' in Ghanaian Video-Movies," *Journal of African Cultural Studies* 22, no. 1 (2010): 7–23.

ABBREVIATIONS

CFU	Colonial Film Unit
ECOWAS	Economy Community of West African States
FESPACO	Festival panafricain du cinéma et de la télévision
FIPAG	Film Producers Association of Ghana
GAFTA	Ghana Academy of Film and Television Arts
GBC	Ghana Broadcasting Corporation
GFC	Gama Film Company
GFIC	Ghana Film Industry Corporation
GHC	Currency code for the new (or second) cedi, used in Ghana between 1967 and 2007
GHS	Currency code for the Ghana (or third) cedi, valid since 2007
NAFTI	National Film and Television Institute
NCC	National Commission on Culture
NDC	National Democratic Congress
PNDC	People's National Defense Council
SFC	State Film Industry Corporation
VIFPAG	Video and Film Producers Association of Ghana

Introduction

Ghanaian video movies are sensational in—and for—all senses. "From the producer of *Zinabu* comes a new sensation!" is how William Akuffo self-confidently introduced *Diabolo* on the billboard that caught my attention and drew me into the long-term study of the interface of video, vision, and Christianity in Ghana that forms the central theme of this book. I immediately understood that in Akuffo's use the term *sensation* was to express the prospect of a mind-boggling spectacle, intended to seduce potential spectators into a dazzling cinema experience that appealed to the whole sensorium and tied into popular Christian ways of making sense—morally and intellectually—in and of a world in turmoil. It took me more time to understand that video movies also were sensational in a deeper sense and, by the same token, to realize the conceptual potential of the notion of sensation as being key to gathering and forming people. As Jacques Rancière puts it aptly: "What is common is 'sensation.' Human beings are tied together by a certain sensory fabric, a certain distribution of the sensible, which defines their way of being together; and politics is about the transformation of the sensory fabric of 'being together'" (2009, 80). This book analyzes video movies as situated in the sensory fabric of southern Ghana in the period between 1985 and 2010, unraveling how they partook in, as well as capitalized on, the emergence of a new public (atmo)sphere and a particular "distribution of the sensible" indebted to Christian modes of looking.

Like many other African countries, since the mid-1980s Ghana has been a site of major transformations that brought about the state's gradual withdrawal from the economy and from control over the mass media, generating new forms of public entertainment and opportunities for private cultural entrepreneurs. This process was enhanced in the aftermath of the adoption

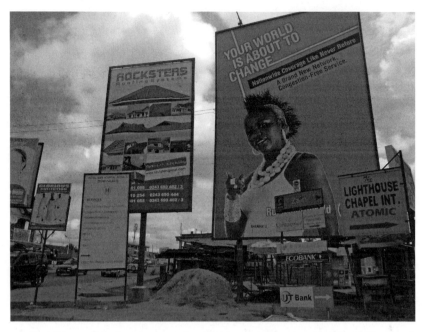

FIGURE 1. "Your world is about to change," mobile phone advertisement (April 2010). Photograph by author.

of a democratic constitution in 1992 after eleven years of military rule.[1] The Ghanaian economy was reconfigured to accommodate neoliberal capitalism, entailing more private enterprises, as well as the introduction of a broad range of fancy goods and new consumer possibilities. As elsewhere in Africa, economic liberalization and the rise of new possibilities for consumption accompanied the phenomenal rise and appeal of Pentecostal-charismatic churches (Asamoah-Gyadu 2005, 2007; de Witte 2008; Gifford 2004; Meyer 1998a, 2004, 2010a), many of which are run like transnational business corporations, and the rise of a new public culture strongly inflected with Pentecostalist notions and practices. Charles Piot's vivid characterization of neighboring Togo also applies to Ghana: "It is a time of extreme privation, of wild invention, of dramatic transformation" (2010, 5). This sense of change is poignantly expressed in the motto of a South African mobile phone company in its 2010 advertising campaign that was omnipresent in Accra: "Your world is about to change," which is befittingly accompanied by the call to "Rule your world" (fig. 1). Expressing a typical atmosphere of new beginnings, these statements resonate and link up seamlessly with Pentecostal mantras such as "Make a complete break with the past" (Meyer 1998a) and the emphasis

placed on remaking oneself and the world through conversion. This is the habitat in which Ghana's video movies thrive.

Although in the course of time a video industry in the Twi language emerged in Kumasi (Köhn 2008) and in the late 1990s a number of Hausa movies were produced in Nima (a predominantly Muslim neighborhood in Accra), my main focus has been on English-language video films made by self-trained producers located in Accra in the period between 1985 and 2010.[2] Nowadays, many of them are out of the business although their movies are still in circulation, thanks to the rise of numerous private television stations. Considering the sheer quantity of video films—until 2010, more than one thousand Ghanaian videos were registered with the censorship office, and the actual figure is even higher—many of which resemble each other because producers continue to recycle a limited set of themes, it is clear that they do not fit into the format of "auteur" films. Condensing entertainment and moral education, these films raise issues that matter to their audiences but in ways that challenge previous, state-driven cultural representations. In many movies indigenous religious and cultural traditions are represented as primitive or even demonic—much to the dismay of those championing these traditions as the nation's cultural heritage. By the same token, marked emphasis is placed on celebrating a modern, urban—and often Christian—way of life while probing its ambiguous moral implications.

Prone to repetition and following certain hyped themes (until the audiences get bored and crave a new sensation), video movies register vibes and moods. This process of registering and at times setting new trends has been the central focus of my research over the past twenty-plus years and also is at the center of this book. I take video movies as a kind of seismographic device that detects and represents directions and durations of movement "on the ground"—that is, in everyday lived experience. As a researcher I have tried to trace the vibrations of this movement. Being less interested in the story, plot, and message of individual films, per se, throughout my research I have found myself moving into and out of the movies, exploring how themes featured in plots resonate with each other and with broader concerns and, conversely, how such concerns find their way into films that sell. Exactly because they point beyond the screen onto which they are projected, these movies are a fascinating starting point to explore how the dynamic environment of the privatized and commercialized public sphere (Meyer 2001, 2006) brought about alternative cultural products that collide with state-driven policies on the representation of culture yet resonate deeply with the beat and rhythms

of everyday life and contribute to weaving a new sensory fabric with specific sensations, sensibilities, and ways of making sense (see also Ginsburg 2006).

"MAKING THINGS PUBLIC"

The adoption of a democratic constitution in 1992 and the start of a multi-party system in 1994 entailed the deregulation of the hitherto state-controlled media, giving rise to private initiatives in the realms of radio, newspapers, television, and film. Even the public Ghana Broadcasting Corporation (GBC), fully under state control until 1994, was pressed to sustain its radio and TV station by selling advertising to a large extent (Heath 2001), while the former state-film industry was sold to a Malaysian private television company in 1996. Thus, the withdrawal of state control over mass media—their "liberation"—occurred together with their liberalization, yielding a media environment that depends heavily on commerce. In fact, public presence via the mass media became possible for those who could afford it, and given the need to attract audiences, the spectacle became one of the preferred formats to raise people's attention.

Focusing on the social circuits of movie production, distribution, and consumption as they arose and operated between the mid-1980s and 2010, I employ the video film industry as a magnifying glass to explore in detail the economic, social, and political dynamics of cultural representation in southern Ghana's commercialized public sphere. Understanding how video movies are situated in this new setting requires a material, praxis-oriented (and even pragmatic) approach that moves beyond scholarly understandings of the public sphere as a disembodied zone of rational debate and communicative (inter)action (for an extensive critique in my earlier work see Meyer and Moors 2006; Meyer 2011a). Taking as a starting point the material dimension of the public sphere means focusing on bodies, objects, pictures, sounds, spaces, and practices, understood not in opposition to "abstract" ideas, norms, and values but as their indispensable carriers. In other words material forms are central to shaping the public sphere as a concrete and constructed space accessible and open in principle (*öffentlich,* or public, in the basic sense of the term). Publics and public issues are constituted and affirmed through the circulation of compelling, meaningful cultural forms (including movies) that "take place" in the public environment and address people (Barber 2007, 137–44; see also Warner 2002; Schulz 2012; Sumiala-Seppänen 2008). Bruno

Latour coined the German term *Dingpolitik* to indicate the centrality of objects and other cultural forms that are placed in public space and "bind all of us in ways that map out a public space profoundly different from what is usually recognized under the label of 'the political'"(Latour 2005a, 15). The point is a wider definition of the political that encompasses all processes of, as Latour aptly puts it, "making things public," of calling upon and assembling people, and, to invoke Rancière, of making and unmaking the "sensory fabric 'of being together.'"

Sharing such a broad view of the political, this book analyzes the public role of video movies from a material, praxis-oriented approach. Understood as *representations* of popular ideas and as material forms that are *present* in public space and address spectators through sensational registers, video movies not only provide us a glimpse into the ideas, moods, desires, and anxieties of the makers and their viewers but also help us grasp the very concrete practices through which "public" issues and "publics" emerge. Starting from the close connection between production and consumption that stems from the need to make films that appeal to audiences, I argue that video film producers working during the time of my research played a crucial role in "making things public." This was, literally, their core activity. They were producers in a more basic sense, as is suggested by the term *film producer,* which refers to a person who finances a movie. In Ghana those who called themselves producers not only surveyed the process of movie production but also played a vital role in shaping the content and plot. Many producers also wrote the script or at least came up with the initial idea for it, and some also directed and shot. Seizing the possibility to make films by employing the cheap and accessible technology of video since the mid to late 1980s, producers represent a new kind of cultural entrepreneur characteristic of the era of privatization (see also Grätz 2011, 2013). With no funding from the state or other players in the world of screen media, producers were "making public" those issues that necessarily remained close to audiences' views and concerns about the implications of the economic, political, social, and cultural transformations that affect everyday life.

Making video films requires producers to carefully analyze the field and take appropriate actions regarding the story, the plot and message, the use of actors and locations, marketing and advertisement, and state policies. As cultural mediators producers rework sayings, ideas, anxieties, and desires that float freely in other media, integrating them into moving pictures, hoping to make a blockbuster. In this sense the producers resemble the Yoruba popular

theater directors studied by Karin Barber (2000). As she points out, it is the local experience of grand-scale social transformations—with regard to urbanization, labor, the state, the extended family, personhood—that "set the terms in which images of other lives and other cultures were appropriated" and that remained the "mesmerizing focus of popular commentary" in various popular genres of the twentieth century, including the novel, drama, poetry, music, visual art, and film (2000, 5). The hotbed of the popular, so to speak, is the everyday life of common people (including all those involved in producing and distributing video movies). Thus, rather than denoting a fixed quality, the term *popular* invokes a creative energy at work that seeks to find cultural expressions for new experiences and ideas and that offers intriguing points of departure for imaginative scholarship (see Tonda 2011, 47).

Following the work of Johannes Fabian (1998) and Barber (1997b) on popular culture in Africa, I understand the adjective *popular* to circumscribe expressions of local cultural creativity that fall in between the categories of "traditional" and "modern." These categories have long guided Africanist research and still play a central role in the politics of cultural representation in Ghana and beyond. In the thinking of Fabian the notion of popular culture does not refer to a distinctive mode of cultural production but is, above all, a term that is mobilized as a critique of a fixed notion of culture: "When we add the qualifier 'popular' to culture, we do so because we believe it allows us to conceptualize certain kinds of human praxis that the concept of culture without the qualifier either ignores or makes disappear" (1998, 1). In other words, as Barber also stresses, the use of the qualifier *popular* refers as much to particular practices of cultural production as to a particular scholarly perspective—"an area of exploration, rather than an attempt to classify a discrete category of cultural products" (1997b, 7).

With the privatization of the media, matters whose appearance in the mass media was formerly restricted moved to the center of public broadcasting. Popular culture started to "go public" in a new manner, and this redefined the relation between cultural producers and their audiences. Just like local-language "concert parties" (Cole 2001; Gilbert 2000) and the Yoruba traveling theater, video movies dramatize people's struggle with social transformations. Theater, cinema, and television address and constitute audiences differently. While popular theater companies are in direct touch with their audiences during the play, video movies—as technologically reproducible cultural forms—are further removed (Haynes 2010a, 111). And yet, as this study shows, they were still made with a keen awareness of audience expecta-

tions in the local arena. Filmmakers, too, engage in what Barber calls the "generation of plays" (2000, 6–12). Coming up with a successful product involves constant feedback from actual audiences. Audience appreciation depends on a good mix that induces in them both recognition and amazement: movies that audiovisualize the ordinary with an extraordinary twist. There is no clear recipe for achieving this. For this reason, as I have already stated, in this book I analyze movies not as fixed, bounded products but as sounding boards in an ongoing conversation between producers and audiences that, if successful, generate additional conversations, additional movies, and so on. Movies mediate popular imaginaries—interweaving ideas, experiences, stories, and figures with regard to life in the city, personhood, love, the family, the morality of wealth, issues of trust, anxieties, and desire—that were in the air and, in turn, had an impact "on the ground." Precisely for this reason, they offer fertile resources to study the political dynamics of binding audiences to shared cultural forms and of inducing common sensations—hence the making and unmaking of the social—under the aegis of neoliberalization.[3]

In seeking to project stories that appeal, filmmakers negotiated and redefined the rules that govern practices of "making things public" in film. Not only were they new players in Ghana's transforming public environment, they also brought up new topics, formats, and styles of representation that challenged earlier regimes of visibility that governed state-driven representations of culture. Video movies differ from state films by transgressing limits to the representation of previously more or less hidden political matters (abuse of power and corruption), the occult, violence, and sexuality. I will show that these movies deviated from and, by the same token, were severely criticized in the name of long-standing formats of cultural representation in film. Depending on personal courage, taste, and moral conviction, producers were more or less inclined to bring issues, including from rumors and hearsay, right into the limelight of publicity. For instance, stories about "blood money," to which a film like *Diabolo* refers, had long been circulating. Likewise, depictions of nude women were available in porn movies made accessible in rather hidden circuits. But in the framework of state cinema, which was concerned with battling "superstitions," with "educating" the nation, and with enhancing "pride" in national culture, such stories would have been found entirely unsuitable to be brought to the screen. What was new about *Diabolo* was that it broke a taboo against projecting pictures of the occult and (some degree of) nudity onto a cinema screen.

So the initial "newness" of video movies did not stem so much from the content, per se, as, above all, from new modalities of "making things public" that transgressed previous restrictions, making public in a highly sensational mode what had been private and even secret before. This became their distinctive characteristic. Giving public visibility to matters that were barred from being screened in the context of state cinema, producers squeezed ever more issues into the category of the "public." I read the criticisms of these movies as important sources that shed light on the transforming dynamics of cultural representation in Ghana's post-1992 public environment. A new wind started to blow, as—thanks to the global circulation and easy availability of video technologies and the commercialization of film—access to screen media was no longer under state control. This implies a remarkable difference from the situation prior to the deregulation of the media, when the state engaged in a politics that sought to represent the culture of the nation and, by the same token, to "educate" the "people" to identify with these representations. With the diversification of access to media, this state-driven politics of representation for the sake of national unity and education has been cracked. This is the angle from which I analyze the appeal of the video phenomenon, as well as the debates and criticisms it evokes. How and why were video movies successful? What are the differences and similarities between the state discourse on film and video movies, on the one hand, and the affinity between the latter and Pentecostal vision, on the other? On what grounds were they criticized or appraised? How do Ghanaian films relate to the far more transgressive Nigerian films that started to flood the Ghanaian market in the late 1990s? By exploring these questions, what can we learn about the logic of mobilizing and gathering people in Ghana's post-1992 public environment?

VIDEO MOVIES AND PENTECOSTAL CHRISTIANITY

Pentecostal preachers skillfully and efficaciously seized the new opportunities for public exposure offered by the deregulation of the media. Popular since the 1980s, when the relationship between the state and the market was reconfigured along with the logic of neoliberal capitalism, Pentecostalism had a strong appeal for those disappointed by the perceived incapacity of the state to bring about "development." With its emphasis on the capacity of the Holy Spirit to induce personal change, enable ruptures and ever new begin-

nings, effect miracles, follow and protect born-again Christians wherever they went, and bring about health and wealth, Pentecostalism articulated a strand of Christianity that fit exceptionally well into the new climate of millennial capitalism (Comaroff and Comaroff 2000; Meyer 2007a). It had a strong impact on established churches that were pushed to adopt Pentecostal ideas and practices to prevent the exodus of their members into the new churches.[4] Also, Pentecostalism played a major role in shaping urban space, generating new forms of manifesting religion as a material presence (see also Lanz 2013; and Roberts et al. 2003 for the spread of Sufi imagery in Dakar). This happens through an impressive architecture (by the mid-1990s the major Pentecostal-charismatic churches had started huge construction sites on which impressive temples arose, mostly completed after 2000), the takeover of major cinemas, the organization of mass "crusades" devoted to deliverance from evil spirits to enable a "divine breakthrough," the use of massive sound-amplification systems, and a marked manifestation via the mass media and the advertisement of events on signboards, posters, banners, and stickers. Mottos placed on shop facades, stalls, and vehicles also take part in extending the spread of Christian-Pentecostal markers, expressing trust in Jesus, the need to fight Satan, expectations of miracles, and trust in the divine promise of prosperity and well-being.

Throughout my research I have followed two interwoven threads. Next to studying the articulation of the new experience-oriented born-again religiosity in Pentecostal-charismatic churches, I explored the spread of Pentecostal forms and formats into the public environment and into video movies. This book traces and unpacks this spread in detail. In so doing, I take a vantage point different from that taken by scholars in the framework of the "anthropology of Christianity," which privileges the study of Christian views and practices from within and, to invoke a standing expression, "in its own right." Work conducted in this framework tends to focus on committed Christians. This is a shortcoming certainly with regard to the study of Pentecostal-charismatic churches, whose intrinsic concern it is to "reach out" into the everyday lives of their followers, into the public domain, and into the sphere of politics and entertainment. To understand the significant public role of Pentecostal-charismatic churches, a study of the distribution of their ideas and practices into the wider world beyond the communities of faith and at least to some extent by independent actors is indispensable.[5] As Ato Quason also observes, in Accra Pentecostal megachurches "though not directly present in the street have had a significant impact on the overall

contemporary social imaginary of self-making at least since the 1980s" (2014, 153). Video movies offer privileged insight into the dynamics through which this "impact" on the social imaginary materializes. The basic idea of this book is that many video movies act as vehicles through which Pentecostalism goes public—albeit in a wild, rough, and sensational manner that eschews control by Pentecostal leaders—and contribute to effect new "pentecostalized" imaginaries.

This is a study of the transfer of Pentecostal ideas and imagery into popular entertainment and vice versa. As the example of *Diabolo* shows, this transfer piqued my interest in video movies in the first place. Pentecostal-charismatic churches articulate—indeed, amplify and project—broadly shared Christian understandings in a loud and plastic manner. And even though they tend to harshly criticize so-called traditional religion, they do not move beyond it entirely but instead reinvent it as the domain of the "powers of darkness" or the "occult." Able to absorb what is constructed as the "heathen past," Pentecostalism is at once a disrupting force that promises new beginnings *and* a mnemonic device that renders accessible ideas about the efficacy of traditional religion and African powers, albeit in a distorting and temporalizing manner. Pentecostalism resuscitates and amplifies widespread, popular Christian ideas and practices that make their way into movies. Crucial for the purposes of this study is the Pentecostal emphasis on the dualistic struggle between God and Satan, which, as I will show, lends itself to dramatic cinematic plots thriving on a specific logic of transgression that lays bare Pentecostalism's excessive potential.

The relation between Pentecostalism and video movies is not a straightforward one. In contrast to Nigeria and Congo, where certain Pentecostal-charismatic churches engage in producing Christian entertainment, be it in the form of Christian movies (Oha 2000; Okome 2007b) or televised soap series (Pype 2012), in Ghana there is no formal link between churches and movie production (Asare 2013, 98–99). The synergy between the two was brought about by independent filmmakers who, often reluctantly but for the sake of their business, sought to come up with movies that resonate with current trends. I take the fact that they did so—playfully and at times tongue-in-cheek—as an index of the popularity of the Pentecostal message and its suitability for audiovisual representation. However, the relation between movies and Pentecostalism was under constant negotiation on the part of filmmakers. In this process the ultimate factor was how paying audiences appreciated a movie. Precisely because filmmakers could not afford too

many flops, their products and the debates generated by them offer insight into broadly shared views and understandings, registering salient continuities as well as tacit new beginnings. Surveying the span of my research, the heyday of movies resonating with Christian-Pentecostal imagery was from the early 1990s to 2003, by which time the industry had almost collapsed. After its recovery there was more diversity, yielding, on the one hand, movies that criticize so-called fake pastors and, on the other hand, movies developing a new take on traditional culture. All the same, many movies made in the period between 2005 and 2010 (and later) still show a strong engagement with Pentecostal-Christian imagery, and the new directions taken have this imagery as a backdrop.

So in this book Pentecostalism is a shorthand for a complex of churches and organizations whose members and visitors share a particular vocabulary, imagery, and mode of operation through which the public sphere becomes "pentecostalized" (Meyer 2004). With this expression I do not wish to indicate a massive adoption of staunch born-again convictions—it remains to be seen how enduring and deep the impact of Pentecostalism will be in the long run, and there certainly are degrees of involvement. I think about pentecostalization in terms of the manifestation of Pentecostal forms—architecture, material culture, sounds, literature, pictures, and mottos—as dominant features in the public environment that are virtually impossible to eschew because they partake in a particular political aesthetic of the "distribution of the sensible" that has a strong impact on all spheres of life, from individual subjecthood to politics (see Marshall 2009). The project of Pentecostal outreach involves a complicated dialectic of spread that makes it increasingly difficult to state where religion stops and where it begins. From a Pentecostal perspective its very popularity, powered by the drive toward outreach, risks superficiality at the expense of depth; hence, many Pentecostals grapple with how to retain the thin line that divides being, as the often-used saying goes, *in* the world from being *of* the world (Meyer 2006a, 300). Moving beyond Pentecostal self-definitions that emphasize deep inner change on the level of the person, this book adopts an alternative vantage point. It takes Pentecostalism above all as a resource for imagery staging alternative cultural representations and as a mood-creating apparatus that informs the atmosphere in southern Ghana's public sphere.

As this book shows, many movies exude this—at times Pentecostal-*lite*—atmosphere (Agorde 2007; Diawara 2010). In so doing, the current business-driven video phenomenon collides with a long-standing state discourse about

the use of film for the enlightenment and education of the nation, as well as with the discourse of emancipatory African "Third" cinema (Diawara 1992; Ukadike 1994). In constant conversation with the expectations of the exponents of these discourses, video filmmakers operate in a field of tension between long-standing and current modes of cultural representation. Documenting the economic, political, social, and cultural dimensions of the transformation of the medium of film over a span of twenty-five years, this book does not assume a clear dichotomy between the old state-driven use of film and the new video phenomenon. Taking the transforming public environment as the ecological setting in which video movies are produced, distributed, and consumed, one of my key concerns is to spotlight how, in producing movies, video film producers negotiate the possibilities, constraints, and exigencies of business-oriented cultural production in Ghana's new public sphere, on the one hand, and the legacy of celluloid film production, exhibition, and consumption, on the other. Their movies encapsulate these negotiations, which, as this study illustrates, reflect and shape audiences' expectations and experiences.

To avoid misunderstandings, I would like to stress that this book is not intended as an overview that covers the full array of video film productions. Nor does it focus on movies as such. Here lies a significant difference between my project and Carmella Garritano's recent impressive study, in which she tells the history of the Ghanaian video film industry by analyzing selected movies as "visual texts" placed in a "historically contingent discursive field." Garritano identifies "variations in aesthetics, narrative form, and modes of spectator engagement and in the anxieties, desires, subjectivities and styles reiterated across multiple video texts" (2013, 20–21). Referring to my work, she states that its "limited scope created the false impression that Pentecostalism and its representation of occult practices figures prominently in all Ghanaian movies." Agreeing that "certainly, Pentecostalism animates many Ghanaian movies, and even when not championed or invoked explicitly, it remains a significant discursive strand in many more," she insists that "video movies are not monolithic, nor are they controlled by one dominant way of looking or mode of narration" (Garritano 2013, 19, 72). The scope of my previous work, as well as this book, is indeed "limited." Focusing on the nexus of film and religion, it offers a partial perspective. But as Garritano also concedes, the entanglement of video and Pentecostal-Christian imagery is a recurrent and dominant aspect of the video film industry in Ghana. Over and over again it has been profiled as the major point of criticism from, for instance, the state film

establishment. Religion in Ghana is not confined to a specific subsystem but happens all over the place, so to speak. It therefore leaves a strong imprint on cultural productions and the production of culture (see also Coe 2005). This historical-ethnographic study places movies within broader negotiations of culture in a public environment in which Pentecostalism is a prominent shaping force. It situates the production, circulation, and reception of movies against the horizon of broader issues, including the nexus of technology and state cinema (chapter 1), film and urban space (chapter 2), the constitution of audiences (chapter 3), the representation of the invisible (chapters 4, 5, and 6), and cultural heritage (chapter 7).

IMAGINATION—IMAGINARIES—IMAGES

I regard video films as relay points that feed and are fed by what and how people imagine. For this reason they are a rich and, indeed, energizing and sparking resource for anthropological research. In everyday parlance the imagination is often employed to refer to a chimerical representation of something that is not present and that may not even exist anywhere because it is "only" imagined, belonging to the domain of fantasy and illusion.[6] Leaving behind such a typically post-Enlightenment view of "imagined" and "real," "fantasy" and "rational thought," as mutually exclusive, I understand the "imagination" as a formative and creative faculty, located in the individual mind, to picture in front of the inner eye something that is not necessarily actually present outside of it. The imagination is not a faculty that represents the world "as it is" but is selective, partial, and subjective. It may allow an escape from the world with all its constraints, moving into realms of fantasy and ecstasy, but it is also harnessed to dominant shared imaginaries. Much could be said about the imagination, especially with regard to issues of visual perception and experience from a psychological, cognitive, and neurological angle (e.g., Strauss 2006). For the purposes of this book, however, my concern is the deployment of the imagination within a historically constituted phenomenological world of lived experience and its social categories and power structures.

As an individual faculty, the imagination can wander in many directions. It is neither locked up in the mind nor entirely free, because its deployment depends on "materials" that are situated in a shared lifeworld with its "languages of life" (Mbembe 2001, 15). In other words the imagination is

stimulated materially and sensorially and deployed in particular practices of imagining that depend on specific media (Traut and Wilke 2015, 17). People imagine along similar lines and together because this faculty is honed to operate within shared imaginaries (that are social *and* personal at the same time). I understand imaginaries as interlaced sets of collective representations around particular issues—such as the nation, ethnicity, the city, the family, sickness and well-being, the divine, the occult, and so on—that underpin the moral and intellectual schemes and sensory modes that govern people's ways of being in the world and that thereby "make" this world. Obviously, this view is inspired by the work of Castoriadis (1997), Anderson (1991), and Taylor (2004) on "social imaginaries"; each of these scholars stresses the formative, social nature of imaginaries to articulate a particular ethos and sense of reality. I agree with their basic idea that shared imaginaries underpin the organization of social life and even, in a deeper sense, call into being a world of lived experience that is taken as real by those participating in it. Indeed, as Castoriadis puts it, "it is the institution of society that determines what is 'real' and what is not, what is 'meaningful' and what is meaningless" (1997, 9). Imaginaries not only represent the world; they take part in making it.[7] The articulation of imaginaries, as Benedict Anderson taught us, depends on the availability of particular media; each media technology—be it clay tablets, print, cinema, television, or the Internet—entails its specific affordances and is tied to particular, historically situated power structures and modes of use and control. This implies that the imagination and imaginaries depend on and unfold with the use of particular media. They contribute to defining and constructing the world in specific ways and underpin what is imaginable in the context of certain authorized practices of imagining (Dünne 2011; Hermann 2015, 15).

My approach departs from the path cleared by Anderson, Castoriadis, and Taylor in three major respects. One, rather than using the notion of "social imaginary" in an overarching sense that pertains to a "society" or "nation" at a particular time and place, I think about *imaginaries* (in the plural) as tied to key semantic domains that echo the rich, differentiated, and unbounded nature of social worlds and how they are apprehended. This does more justice to the complexity of a "world"—especially in times of transitions against the horizon of the global—than a rather monolithic focus on one overarching imaginary that underpins a bounded social entity.

Second, I propose to take the *materiality* of imaginaries and the imagination more seriously than a focus merely on the social effects of shared imagi-

naries (as vehicles for social cohesion) would entail (see also Fuglerud and Wainwright 2015). Taking the social as an abstraction, and remaining stuck in a reductive mentalist understanding of the imagination, such a focus fails to acknowledge the centrality of the body and things in establishing lasting bonds among people via imaginaries that, though initially and ultimately arbitrary, are experienced as real and by the same token effect reality (see also Traut and Wilke 2015).[8] To transcend a view of the social as an abstraction that is signified through collective representations (see the pertinent critique by Latour 2005b),[9] I developed the notion of "aesthetic formation."[10] This notion is intended to help develop an approach for gaining knowledge about the actual modes through which relations between humans and the cultural forms they share are established in the midst of, and with the materials available in, everyday life and that are central to draw people into a particular sensory fabric. In this way it is possible to study how imaginaries are apprehended as being more than partial representations, how they are vested with truth and experienced as, so to speak, "the real thing" (Meyer 2009a).

Third, the notion of the *image* enshrined in imaginaries and the imagination requires more detailed attention. If shared imaginaries constitute—or effect—worlds and their social relations, the question is what role images play in this sharing. As noted, imaginaries are woven around diverse cultural forms such as objects, texts, pictures, words, songs, smells—in principle anything that exists in the world and is an object of perception and sensation. Put simply, the "stuff" to which imaginaries refer is not limited to pictures and other visual items. It is the imagination, as a visualizing faculty, that—not unlike a film—represents all this "stuff" as mental images. So an imaginary is an assemblage of mental images that is grounded in the material world and takes part in reproducing it as a phenomenological lifeworld that is experienced and vested with meaning. Therefore, an imaginary is not just a visual representation that stands apart from the world; it is a world-making device with its own reality effects. Imaginaries can only be powerful devices for world making (and hence be understood as real) under the condition that they are shared. An imaginary is shared—and thus made social—by gathering people who imagine in synchronization. This implies a process of tuning through which individuals incorporate exterior, material cultural forms as an assemblage of mental images (see also Wilkens 2015). Pictures, and visual culture at large, play a crucial role in the processes through which imaginaries are transmitted. Imaginaries are anchored in pictures. Prone to operate as autopoeitic devices that render *present* what they *represent,* pictures address their

beholders in a (seemingly) direct, immediate manner that sustains the evidence of the imaginaries they purport.

How does this sketch of the nexus of the imagination, imaginaries, and images relate to my approach to video movies? In Ghana the nation-state that long managed to control the politics of cultural representation via sets of shared imaginaries, so as to induce in "the people" a sense of the nation as a real and meaningful world, has come increasingly under siege. Specific to the post-1992 situation is that competing players vested in more or less stable alternative imaginaries—in particular Pentecostal-charismatic churches—came to populate the public environment, yielding an ecology of partly intersecting, overlapping, and conflicting imaginaries. Thanks to the easy access to mass media technologies, the common people face unprecedented possibilities to, as Arjun Appadurai famously put it, "deploy their imagination in the practice of their everyday lives" (1996, 5). Access to and use of video is one way of doing this (see also Okome 2010, 28), and this book unpacks the specific dynamics of this deployment within a transforming public environment. Using the metaphors of the seismograph, sounding board, and relay point, I wish to convey that movies are embedded in a larger fabric of cultural forms, including sermons, stories, plays, and songs that inform and express what and how people imagine.

Video movies recycle and remediate these cultural forms by audiovisualizing them. In so doing, they play a central role in honing the imagination in to old and new shared imaginaries that are key to how people define who they are, what they want, and where to move in a world "about to change." Video movies offer a privileged vantage point to register emergent, partly explicit, shared imaginaries that coexist with and are grafted onto long-standing imaginaries underpinned by the nation-state but that also collide with and transcend them. Many video movies, as this book will show, negotiate, challenge, confront, and partly incorporate the imaginaries deployed by state cinema and the nation state, on the one hand, and Pentecostal Christianity, which in turn cannibalized, through a logic of diabolization, long-standing indigenous ways of relating to the invisible, on the other. Offering insight into clashes and overlaps between these imaginaries and configuring a loosely knit, open, experimental—and in this sense popular—assemblage of imaginaries, these movies document the popular imagination at work.

Video movies represent shared imaginaries but also are present as moving pictures that are displayed in a cinema, on television, or on a computer screen. Debating the issue of the "power of images" (Freedberg 1989), a widely shared

consensus arose that "images . . . can be understood neither as mere carriers of meaning nor as representations or expressions of reality" (Flach, Margulies, and Söffner 2010, 14). The bodily and sensory—or aesthetic—effects of pictures on their beholders became a central research issue. To understand "what pictures want" from their beholders (Mitchell 2005)—which is to ask why they appear as autonomous actors with their own will rather than as human creations (even if we know better)—it is important to grasp how they are positioned in relation to imaginaries and the imagination.

One of the assets of the study of visual culture is that it addresses the human/image relation across various visual forms, such as paintings, sculptures, photographs, and films. In my native language, German, the term *Bild,* as Hans Belting explains in the *Anthropology of Images* (2011; in German *Bild-Anthropologie* [2001]), "is used for both 'image' and 'picture'" (2011, 9). As a term, *Bild* keeps together the mental, internal and the physical, external dimensions, distinguished in English by the words *image* and *picture.* Whether or not one wishes to maintain this distinction on the level of vocabulary,[11] the important issue is that the expression of mental images in a physical form—as pictures—requires the use of a medium. Media give a material body (Belting uses the term *Verkörperung*) to mental images that are, in turn, re-cognized by their beholders and incorporated into their imaginaries.[12] Media are the interface between the internalization of physical pictures and the externalization of mental images. This is not a question of a simple reversal, the point being that media do not simply transport a mental image but shape it in accordance with their technological properties and affordances. Media operate as mediators through which mental images and imaginaries are externalized and by the same token are transformed. This implies that in the process of incorporation, the mediality of a physical picture and the media technologies on which its expression depends may be internalized. This is seen, for instance, in the profuse metaphoric use of audiovisual technologies, such as the camera and the X-ray, to describe penetrating ways of seeing.

This distinction between image and picture, implicit in German and more explicit in English, is my starting point for exploring the interactive relation between the internalization and incorporation of physical pictures as mental images and the externalization of mental images as physical pictures (and other cultural forms). My concern is not a universal ontology of the image but the development of an approach that is helpful in investigating the role and power of pictorial media—including movies—in specific historical

settings to hone the imagination into shared imaginaries. Being indispensable for the material expression and figuration of mental images, media are at the center of the transfer between the ongoing incorporation of external pictures and the externalization of internal images. As Belting succinctly puts it: "Our internal images are not necessarily personal in nature, but even when they are collective in origin, we internalize them in such a way that we come to consider them as our own. We perceive the world as individuals, all the time making use of the collective conventions of the day" (2011, 11). In this way the social becomes personal.

Media are not simply material carriers that oscillate between the internal and external. Rather than acting as mere carriers, media shape the figuration of the images they convey and address beholders in a specific manner that triggers collective responses and tunes perception and sensation (e.g., McLuhan, Agel, and Fiore 1967). Film, as Walter Benjamin (1999) argued, transformed how modern people perceive the world.[13] Exposing a modern way of imagining in the era of technological reproducibility, a film may well be taken as a cinematic "actor" that turns the normally internal deployment of the imagination inside out: an externalization through which a film becomes like a brain (and vice versa) (as suggested by Deleuze 1991, 263–77). If media and techniques of mediation are incorporated into the sensorium, it also makes sense to regard film as an externalization of the inner imagination.

In this book I ask how video movies shape the way the imagination is deployed and operate as a synchronizing means that attunes personal and collective imaginaries. As I have noted, I am less interested in undertaking an analysis of movies as such. Of central importance are the ways people, oscillating between being taken by surprise and experiencing recognition, sense and make sense of the movies they watch and how movies—as imagining "actors"—convey particular modalities of vision, modes of looking, sensibilities, and sensations to their audiences (see also Hirschkind 2006). In this context issues of sensation need to be taken into account.

People do not perceive and sense the world in a raw manner but in the context of "aesthetic formations." I employ *aesthetics* here not in the commonplace, post-Kantian sense as limited to the disinterested experience of high art but in the broader Aristotelian sense of *aisthesis,* which refers to the sensory modes through which humans perceive, experience, and acknowledge the world.[14] As will be explained in chapter 3, I share the view of Merleau-Ponty (1968, 2005) and those inspired by him (e.g., Csordas 1990)

that perception, sensation, and knowledge about the world are grounded in the body. In my understanding, however, sensation and perception are mediated through and embedded in social (and thus political) categories rather than preceding them. Media and mediation are therefore the starting point of my analysis. From this viewpoint immediacy is a sensation that is produced through mediation rather than being its counterpoint.

The process of engaging with the world is structured—or better: filtered—through a "distribution of the sensible" (Rancière 2006, 2009). What is "sensible" is subject to authorized selection and distribution in a hierarchy of power. In other words power operates by orienting sensation toward certain matters at the expense of others. This involves a regime of sensation (or an "aesthetic regime") that underpins power structures but is also subject to contestations that render alternative, previously invisible and inaudible, matters sensible. This implies that art, which Rancière regards as potentially subversive precisely because it may render sensible new matters, is political (see also McLagan and McKee 2012). At stake is a political theory of sensation that vests insights from phenomenology with an awareness of the foundational operation of power on the level of the body.

Video movies mobilize sensation in ways that clash with state cinema. This is a clash between regimes of visibility that govern the representation of culture by stipulating what lends itself to display and what should remain concealed; what kinds of plots, images, and narrative styles to employ; how to address and teach audiences; and so on. Such regimes remain implicit to a large extent and become graspable primarily in situations of tension and conflict, in the face of alternative productions, as is the case with the rise of Ghanaian films. As I will show in detail, these films collide with the regime of visibility that underpinned the state film industry's representation of culture and are, in turn, indebted to religious notions of divination and revelation. I will explore the format of "film as revelation" to unpack the affinity between modes of looking and making visible in popular Christianity and video movies.

I understand sensation not as limited to perception and feeling but as encompassing the sensory, emotional, *and* semantic dimensions. That their entanglement is difficult to explicate may be due to a lopsidedness in our vocabularies toward theories of signification that evolve around texts and hermeneutics. As German philosopher Sybille Krämer (1998b) has pointed out, the distinction between the senses and sense has been mapped onto the distinction between *aisthesis* and *logos,* yielding the opposition between

sensuality and intellect, body and mind. Once bifurcated, the relation between senses and sense proves difficult to rethink in a way that escapes worn-out oppositions. Posing the question of the "sense of the senses," Krämer argues for an approach to sense as incarnated in the body and in hybrid objects. Sense is not abstract; it is mediated via bodies and things, which are the condition for its existence. Thus, "making sense" is not just an issue of thought but is grounded in the media that tune sensation in a historically specific setting.[15]

Asking how video films tune sensation is to ask about the effects of moving pictures on their beholders in the context of historically situated aesthetic practices of filmmaking and reception. Films combine visibility and audibility in ingenious ways that enhance the effects of pictures on beholders. As elsewhere, producers of Ghanaian films seek to captivate audiences with spectacular plots and imagery, including special effects intended to shock and trigger affect. But they also involve audiences in sharing the protagonists' feelings, offer moral messages, and explain what moves and shakes the world behind the surface of mere appearance. My central concern is to unpack the interlacing of these levels and, in so doing, show how sensing and making sense intersect in the making and consumption of movies. The sensation of visual items does not seem to be separate from signification (Singer 2009).[16] Throughout this book I am interested in the impressions pictures make on how people perceive, feel, *and* think. Film has the ability to generate more or less intense pleasures, desires, and anxieties, through which beholders get hooked to the screen.[17] Examining practices of filmmaking and film consumption, I seek to describe the conundrum of the affective, emotional, moral, and intellectual effects of moving pictures.

This book, then, explores video movies as a medium both of and for the imagination. Approaching movies as a medium *of* the imagination, I ask what they convey about what moves and matters to people on the ground, giving us a glimpse into the phenomenological world of everyday lived experience, with its anxieties, desires, opportunities, and insecurities. What does the imaginary world conjured by the movies show and tell us about how people imagine—perceive, sense, interpret—their world? What do the movies tell about life in the city, notions of personhood and belonging, fears of the occult, and attitudes toward "tradition"? Taking movies also as a medium *for* the imagination, I explore how—as didactic, albeit pleasurable, devices— they address audiences and partake in constituting their world of everyday lived experience. How does watching movies impinge on how the audiences

imagined the themes just mentioned, and how does this relate to their attitudes toward existing shared imaginaries? What do people expect to "get out of" movies? How do movies take part in "distributing the sensible" by tuning the senses of audiences, inducing certain experiences, and proposing certain interpretations? Which sense of reality do movies convey, and what do they show to be meaningful? Which modes of being in the world and which styles and designs are promoted, and how does Christianity come "into the picture"? How do video movies take part in effecting the transformation of a world "about to change"?

MEDIATING THE INVISIBLE

A salient elective affinity exists between Pentecostal attitudes of "vision" and the use of audiovisual devices such as video cameras, which are embedded in the framework of religious "revelation" (de Abreu 2009; de Witte 2008; Hackett 1998; Sánchez 2008). Notwithstanding the great diversity of Pentecostal churches in Ghana, certain core issues with regard to vision, and the visible and invisible, can be identified that are relevant to this study. Pentecostals deploy a large-scale social imaginary that involves the globe as a whole and that is geared toward mobility (in space and socially upward). Imagining the world as a stage for the "spiritual war" between God and the devil, a struggle held to be played out on other levels as well, including in the person, the point for Pentecostals is to be able to discern the operation of the "powers of darkness." This calls for the ability to "reveal" what happens in the spiritual realm or, in short, "the spiritual." The conviction that "the spiritual," though impossible to be perceived with the ordinary senses, interferes with the realm of "the physical" that is accessible to all is a key feature of a long-standing grassroots Christian imaginary that is fervently deployed by Pentecostals and, given the symbiotic entanglement between Christianity and so-called traditional religion, even shared to some extent by people who present themselves as "traditionalists."

Many video movies audiovisualize what audiences recognize as "the spiritual." My approach to such audiovisualizations is grounded in a conceptual framework that understands media as intrinsic to religion.[18] Imagining a "beyond" that requires a special mode of access, religion itself may well be characterized as a "medium of absence" (Weibel 2011, 33) that renders present what is not "there" in an ordinary manner (see also Traut and Wilke 2015, 18).

To grasp the process through which what is absent becomes present and real, I use the notion of "sensational form" (Meyer 2006b, 2010a, 2012). Rooted in the term *sense, sensational* encompasses the levels of perception (with the senses as organs for perception), feeling (having a sensation), and signification (making sense). Involving religious practitioners in particular practices of worship and patterns of feeling, these forms play a central role in modulating them as religious subjects. As authorized modes for invoking and organizing access to the level of the spiritual that shape both religious content (beliefs, doctrines, sets of symbols) and norms, sensational forms "are part of a specific religious aesthetics, which governs a sensory engagement of humans with the divine and each other and generates particular sensibilities" (Meyer 2010a, 751). Invoking a beyond that exceeds ordinary perception, sensational forms induce religious modes of sensing, feeling, and making sense that effect the very "beyond" that is posited and form the people addressed as believers. Elsewhere, I developed the notion of sensational form with regard to bounded religious settings (Meyer 2010a), especially in the Pentecostal spectrum. The point was to better grasp how particular authorized forms enable specific experiences that generate in religious practitioners a sense of divine presence and effect shared religious sensations. Here I extend the notion to the sphere of video movies. As this book will show, many movies feed on and reproduce Pentecostalist sensational forms—for instance with regard to prayer and deliverance—in their plots (see Asare 2013, 200–201, for an overview). But video movies are also sensational forms in their own right, located in the interface in which entertainment and Pentecostalism converge, feeding on and rubbing against each other. Rather than being more or less accepted a priori as constitutive for the genesis of divine presence, video movies need to establish themselves in such a way that their audiences authorize and authenticate them as truthful. The particular aesthetics of persuasion mobilized by video filmmakers to seduce spectators to take their movies as revelations that offer some kind of evidence of a "religious real" is one of the central themes of this book.[19]

I analyze video movies as sensational forms that picture things that are taken to be inaccessible to the naked eye, showing how spirits operate. To see, in this sense, is a participatory embodied act in which the beholder partakes in making something visible. As David Morgan pointed out in his trailblazing work, attitudes toward pictures are transmitted through authorized, learned, and embodied religious practices of looking and regimes of visibility through which human-made pictorial forms appear as harbingers of divine

presence (Morgan 1998, 2012). My concern is to explore how films audiovisualize the connection between the two sides—the "physical" and "the spiritual"—that together make up the world. Emphasis is placed on how many movies employ the dualistic scheme, which is grounded in grassroots Christian understandings and profiled to the extreme by Pentecostalism, which demonizes African gods. Skillful use of special effects gives witches, ghosts, forest spirits, ancestors, and occasional angels a spectacular appearance onscreen. The point I wish to make is that many movies render visible and audible what is imagined to exist yet resists being perceived by the ordinary senses. Offering some kind of extraordinary vision, movies revert to depicting horrible matters, including ritual murder. As I will argue, taking up popular Christianity's dualism of God and Satan as it is currently deployed by the Pentecostals makes it possible to adopt a logic of transgression that shows all the evil that is to be despised, leading down into the abyss of sheer horror. Presenting, as it were, a kind of pictorial evidence of the existence and operation of spirits outside of the bounds of the screen, video movies tend to affirm a broadly shared Christian imaginary of the world in all its complexity, and with its bright and dark sides. They tend to push the phenomenal possibilities offered by the dualism of God and Satan for audiovisual representation to the extreme—so much so, that staunch Christians may even feel uncomfortable vis-à-vis the spectacularization of evil—and thus pictures of the occult and sex—on the screen.

The deployment of this dualism and the urge to come up with ever "new sensations" has been one of the key attractions of video movies for audiences and, as noted, a target for constant criticism in the name of the state discourse on film or emancipatory African cinema. Instead of "educating" audiences, critics claim, movies reinforce silly "superstitions." This indicates a clash not only between different understandings of the purpose of film but also about the nature of reality and the value of African traditions and Christianity. I will argue that while "tradition" and "cultural heritage" tend to be matters of ultimate value in current debates in Ghana, as scholars we need to resist echoing such views and, instead, rethink tradition and cultural heritage as dynamically shaped through imaginaries. Studying the Ghanaian video film industry allows us to probe the emergence and appeal of alternative notions of personhood and identity that are grounded in entirely different imaginaries of past, present, and future. How do video movies sustain claims about an imagined reality in which spirits matter? Which reality effects in relation to the "spiritual" do they entail? How do Christians, in

particular, receive them—and where do contestations and cleavages emerge? How does the idea that the "spiritual" influences the course of things in the "physical," as depicted in movies, impinge on attitudes toward the city, models of personhood, and moral conduct? What do the quite negative representations of African indigenous religious traditions and matters such as witchcraft and blood money in video movies mean for current debates on "cultural heritage" and identity? What might be some new openings to reconfigure the representation of "tradition"?

VIDEO MOVIES AND AFRICAN CINEMA

During my first month of research, on Friday, 27 September 1996, I attended the Ghanaian premiere of *Deadly Voyage* (directed by John Mackenzie, Union Pictures and Viva Films 1996) at the International Conference Center in Accra. The movie was based on the "true story" of the Ghanaian Kingsley Ofosu, the sole survivor of a group of nine African stowaways discovered and drowned by the crew of the cargo ship *McRuby* in 1992. The premiere was preceded by a symposium on filmmaking, where I made my first acquaintance with representatives of the state perspective on film "as an instrument of national integration," as the minister of information put it in his speech. Partly filmed in Ghana (though without formal coproduction), *Deadly Voyage,* with its moving story of the terrible fate of the stowaways who left home for greener pastures, was presented as a good example to follow, especially by video filmmakers. Talking to a number of people from the national film scene during the reception after the screening, I realized what a bad reputation video movies had. Most of my interlocutors could hardly believe their ears when I told them about my research: "Really, Ghanaian movies?????? The quality is terrible!" "Typically elitist," I wrote in my diary. "I realize the enormous contrast and feel the wish to rehabilitate the movies. This is popular culture in the double sense that is despised by the elites. So attending the premiere has been an eye-opener for me."

This encounter, and my "gut" response to it, typifies the early phase in the rise of—and ethnographic research on—the video film industries in Ghana and Nigeria. Many early writings emphasize, with sympathy, the enormous effort made by self-trained filmmakers to launch a viable commercial video film industry (Haynes 2010a, 2010b; Okome 2007b). The idea was to make known to the outside world, and to the field of research on African cinema,

that something was happening in the shadow of African movies as we knew them. In the early days of the video film industry, the national film establishments in Ghana and Nigeria and the francophone celluloid African art film scene looked down on its products. Videos have been marginalized in major festivals such as the famous biannual Festival panafricain du cinéma et de la télévision (FESPACO). Concomitantly, scholarship was also divided, with film scholars working on African art films in the context of postcolonial studies, on the one hand (e.g., Diawara 1992; Gugler 2003; Harrow 2007; Thackway 2003; Ukadike 1994), and those working on videos from the perspective of popular culture, on the other. To a large extent, scholarship on video films appeared stuck in the very same straitjacket of defending these products against elitist notions that also shaped debates between video film producers and their critics.

In the meantime the Nigerian video film industry in particular and to a lesser extent the Ghanaian one have received a great deal of public attention via articles in magazines and a number of documentary films, as well as in avant-garde video circles. Broadcast by satellite channels throughout Africa, video movies have been upgraded as constant mass entertainment. Ghanaian and Nigerian video movies are available for sale or rent in all cities across Europe, the United States, and Asia that host African immigrants. Nigerian movies have become known by the fancy name *Nollywood* (a term that also extends to include Ghanaian movies—unduly, in my view).[20] Taking "Hollywood" and "Bollywood" as sources of inspiration, "Nollywood" has deployed a star system, with glamorous premieres, websites, and magazines (Okome 2007b). That in 2010 the association of Ghanaian producers followed suit and decided to adopt *Ghallywood* as a brand name displays their ambitions at the time.

The phenomenal rise and outreach of the Nigerian and Ghanaian video film industries contrast sharply with the comparatively small number of celluloid African art films, for which it is increasingly difficult to get funds (except in South Africa). And while the latter circulate via international art film circuits and barely reach African audiences, video movies offer televised mass entertainment to people in Africa day in and day out (McCall 2004, 98). Against this backdrop scholars, including me, felt increasingly uncomfortable with the "African cinema" versus "popular video" division that structured our field of inquiry in a particular manner.[21] Major figures in the field of African cinema have also begun to engage with Nollywood (Diawara 2010; Ukadike 2003), questioning claims made about African authenticity

that long underpinned the discourse on "African cinema" and investigating the work of filmmakers like Tunde Kelani that falls between video and art cinema (Perneczky 2013).

From my perspective the video phenomenon has outgrown this division, which has long instigated scholars (including me; see Meyer 1999b) to "talk back" in a manner that still takes African cinema as a point of reference and that easily gets sucked into quite predictable exchanges (like my initial "gut" response outlined above). Looked at from the thematic prism of African cinema, video movies are qualified as different and, depending on the stance of the beholders, as lacking sophistication or as offering enriching, new perspectives. This emphasis on difference barely notes the overlaps, and similarities, for instance in the representation of family relations and intergenerational conflicts, as well as of the unseen (Haynes 2011). One of the most problematic aspects of this division is that it makes it seem as if audiences had the choice to opt for one or the other. The point, however, is that "African cinema" and the state vision of film are usually invoked in a discourse that covers up an actual lack of available movies. Rather than inscribing my analysis into the framework of this division, I explore empirically the politics of the use of "African cinema" in mobilizing a particular cinematic vision geared to an "aestheticized and essentialized display of African difference" (Şaul 2010, 149) that dismisses and even excludes video movies from film festivals such as FESPACO.

Inspired by Brian Larkin's work on cinema and video in northern Nigeria, I approach video as a medium in the making, which cannot be abstracted from its technological affordances but needs to be embedded in a broader set of questions in order for us to grasp its "cultural work" (Larkin 2008, 2; see also chapter 1 herein). I take the video film industry as a living zone of cultural transfers in which all kinds of film traditions, including Hollywood, Bollywood, African art films, state cinema, televised stage dramas in local African languages, telenovelas, and popular theater are cannibalized. Characterizing Nollywood in a similar vein as "a copy of a copy that has become original through the embrace of its spectators," eminent African film scholar Manthia Diawara states, "Something is African when it is owned by Africans. Nollywood is Africa, and we cannot change it without changing the spectators. What is good about Nollywood is therefore that it has revealed to us where the collective desires of a large portion of the African population reside" (Diawara 2010, 185). Obviously these collective desires were constituted historically and shaped in long-standing colonial encoun-

ters, the imagery of which continues to haunt contemporary modes of self-representation. Exactly because of their rawness and, from a certain standpoint, unnerving political incorrectness, Ghanaian video movies form a rich resource to study the making and autopoeitic operation of a new popular imaginary that contains and reworks a broad array of elements, from colonial stereotypes about the primitive to current Pentecostal representations of wealth and the good life. As this book shows, what makes video movies "African" is the dialectical process of incorporating things from outside and, in so doing, transforming themselves over and over again in a process that Jean-Francois Bayart (2000) calls "extraversion." The refusal to represent Africa in line with closures imposed by dominant social imaginaries that also underpin the ideological invocation of "African cinema" is the central feature of video movies.[22] Instead of representing Africa in line with already fixed meanings, they explore—albeit in path-dependent trajectories—what it means for Africans to be part of a world that is not only expected to be "about to change" but that is also subject to massive ongoing transformations that affect all aspects of everyday life. This is one of the most exciting aspects of the industry.

Criticizing the tendency of research on video movies to stress their difference from African cinema, Jonathan Haynes has noted, "Film studies, as a discipline, has not yet been brought to bear with full force on the videos" (Haynes 2010b, 12). This reflects that "African cinema," to which videos are compared implicitly or explicitly, forms a quite specialized and bounded field that prominently features issues around Third Cinema (cf. Foerster et al. 2013). It stands more or less apart from the field of still strongly Western-oriented film and cinema studies. In addition, many of the scholars studying videos have a background in anthropology—like me—or work within the framework of popular culture studies. What intrigued me in my research on video movies was not the audiovisualization of imaginary worlds, per se, but how these worlds blurred into everyday lived experience. This is why I have not been inclined to venture into the study of film in a narrow sense (see also Ganti [2012, 21], who makes a similar point regarding her study of Bollywood). As I have explained, in line with my material approach to imaginaries and the imagination, in this book I analyze video movies as sensational forms that engage audiences not simply through the gaze—literally, as mere *spectators*—but in a far deeper way that calls on senses other than the eye and that solicits participation. Taking inspiration from work in cinema studies that takes audiences' visceral or haptic response to movies seriously (e.g., Barker

2009; Marks 2000; Sobchack 1992, 2004; see also MacDougal 2006), I examine the broader (political) phenomenology of the film experience—that is, the way the experience of watching that involves all the senses ties into the world of everyday lived experience.

THE RESEARCH

During my first period of fieldwork, between September and December 1996, my family and I rented an apartment in Teshie, a suburb of Accra that comprises a traditional Ga fishing village near the sea and a huge area consisting of a mix of compound houses, self-contained houses, and shacks. Our apartment was located on the second floor of a yellow-painted mansion owned by a book trader who used the ground floor as a storeroom. Another family occupied the floor above us. Arriving with our twenty-month-old son, Sybren, we were a kind of attraction in the area. We quickly got involved with the neighbors in the compound house next door, and we opened our house to visitors. Many conversations were about Ghanaian movies, which we also watched together in our living room or in cinemas and video parlors.

Throughout my research, along with maintaining contact with people in the industry, I watched movies together with audiences in public venues and in people's homes. Whenever possible, I tried to initiate conversations about movies, trying to figure out which ones were popular and which ones were not and for what reasons, as well as getting to know more about practices of watching and the repercussions this had on everyday life. In the course of time I conducted formal interviews with a number of spectators, including members of a local group of moviegoers who regularly visited the Roxy Cinema in Adabraka, the seamstress Floxy and her girls, and people whom I met through the snowball system. Of crucial importance were Kodjo Senah and his wife, Adwoa Asiedu-Senah, who greatly helped me to develop a sense of continuity. Watching movies together in their family home in Cantonments and on the campus of the University of Ghana, I also learned a lot about reception in everyday practice and about matters that were discussed in town and would eventually end up in movies.

Along with watching and talking about movies, especially in the evenings, right from the beginning I got in touch with the producers of films that were or had been popular. I chose to do so because I noted immediately that they were the crucial figures in film production in all its aspects, from coming up

with a story to marketing. Initially, there were no established female producers, but later I became acquainted with Hajia Hawa Meizongo (Silverline Productions). While I conducted a number of formal interviews (interviewing my key interlocutors several times between 1996 and 2010), I was mainly hanging out with them, often stuck in a traffic jam, in editing rooms, in their offices, or on set. Initially, the producers I interviewed gave me the impression that they saw me as a journalist to whom they could convey the information they chose. Gradually, it became clear to them that this was not exactly my role. I still remember well Socrate Safo's outcry after he realized that he had told me all kinds of things that he would not ordinarily confide to outsiders: "You are dangerous! Are you a witch?" At the same time, I realized that many of the producers enjoyed my detailed interest in their work. I have the impression that our talks were also useful for them, leading them to formulate conclusions and perspectives about their work.

Here I want to introduce five persons, in particular, who accompanied me throughout my research and who also feature quite prominently throughout the text. Others will be introduced in notes. *William Akuffo* (born in the Volta Region in, I guess, the late 1950s), the producer of *Diabolo* and a pioneer of the video film industry, had long been involved in the film industry by importing and distributing celluloid movies and working as an operator. His company has the promising and telling name World Wide Motion Pictures. The story of how he and Richard Quartey hit upon video as a substitute for celluloid, yielding *Zinabu,* is told in detail in chapter 1. He produced a range of movies with different themes, including occult matters, love stories, comedy, and action. Akuffo was immediately enthusiastic about my research, and I spent many hours talking to him and hanging out in his office and acting school near Kwame Nkrumah Circle. He is known for his sharp tongue and enterprising spirit; he often ridiculed the popularity of Christianity but opted nonetheless to include Pentecostal elements in many of his movies. Along with video filmmaking, he also made advertisements for toothpaste and other products. Several times he decided to stop shooting movies but occasionally ventured into new productions. He often complained about the state of the industry and the low quality of the movies. His high aspirations to create an African Hollywood also show in his founding of a big film village on the road from Tema to Sogakope, called Ghallywood.

Socrate Safo (born 1967) is a Kwahu who grew up in Bukom, a traditional Ga area that is part of Central Accra. He trained as a car mechanic but did not finish technical school. Instead, he put his time and energy into reading

about filmmaking and watching movies. Working in a video center owned by Sam Bea in Bukom, where foreign movies were screened in the mid-1980s, he developed a keen interest in making films. He thought of himself as a pioneer but then realized that Akuffo and Quartey were also in the business. His first film was *Unconditional Love* (Movie Africa Productions, 1988), a movie about a poor car mechanic whose girlfriend leaves him. Initially, Safo's family, in particular his brother who lived in the United States, supported him financially. In 1992 Safo joined forces with Steve Asare Hackman, with whom he produced eight movies. Open to experimentation, Safo made different types of movies. He is adamant about the importance of knowing what audiences want, and he gives it to them. In 2010, the last period of my research, this implied a lot of occult stuff and soft porn. In 2000 Safo received a grant to participate in a film seminar in Hilversum, the Netherlands. We met several times during his stay, and I advised him when he planned to shoot a movie titled *Back to Kotoka*. He occasionally came back to the Netherlands—which he called "the land of the robots." While he had little regard for my research at first, his attitude changed after he visited Berlin and fielded questions about one of his movies, titled *Women in Love,* from people in the audiences who had read my article (Meyer 2003a) about it. He is friends with Carmela Garritano and assisted her in making a movie (*The Video Revolution in Ghana,* 2000) about the scene. While he always belonged to the group of quite successful producers, he really hit the big time after he joined forces with Danfo B. A. in 2004, who ran a video store, and started to make movies on a grand scale. Throughout my research I admired his sharp tongue, his often provocative talk, and his capacity to realize projects with dazzling speed and energy.

Hammond Mensah, also known as "H. M." (born in the 1960s), is of Fante origin and belongs to the Ahmadiyya movement. Running the Princess Cinema at Takoradi (with fifteen hundred seats) for eighteen years, he knew all about audiences' preferences. His own background motivated him to start producing films. He already knew Akuffo when Akuffo was a distributor, and he wanted to take the same path. As co-owner of a big contracting firm, he had considerable capital to invest in film production. His first film was *Double Cross* (H. M. Films, 1992). To be distinctive, for his first productions he hired professional directors, including Seth Ashong-Katai, but with time he also directed. Being a Muslim was no obstacle for him to make thoroughly Christian movies because this was what appealed to audiences. When I started my research in 1996, H. M. Films was a household name. He was

hailed for producing one blockbuster after another, and he achieved a central position in the industry. Actors adored him because he paid more than other producers and lodged them in his private guesthouse. His own home in Takoradi was often used as a film set. He was one of the first, along with Akuffo, to have a big office, and he also ran his own shop. In this position he developed close contacts with representatives of the Nigerian video scene. Not surprisingly, I met the first Nigerians who came to sell movies in the Ghanaian market in his office in 1998. H. M. came to the Netherlands several times and coproduced *See You Amsterdam* (Vista and H. M. Films, 2000) with the Dutch Foundation VISTA. Between 1996 and 2003 we had regular contact; after that period he more or less withdrew from the field.

Augustine Abbey (born in 1963) began acting in his childhood. Touring the country with his Art Finders Theatre Group, he gained popularity and was invited to perform on GBC television. One of the most popular characters he played was Idikoko, a trickster. This is how he financed his study of administration and accounting at the University of Ghana, Legon. Ultimately, he opted for filmmaking, a passion he shares with his wife, the well-known actress Linda Quashigah, who acts in many of his movies but also in other productions. His face is well known throughout Ghana, and people still call him Idikoko. His first video movie, *Tricky Twist* (New Frontier, 1992), was based on the Idikoko character. Abbey produced movies of quite different types, including comedy, his preferred genre, love and romance, crime, and one very Christian movie, *Stolen Bible* (Great Idikoko Ventures, 2001). In 2010 he was swept up in the excitement generated by so-called sex movies, but his movie *Sex Machine* (I visited the set in May 2010) never came out because of government restrictions. During the period of my research we met on a regular basis. Moving about with him—he drove an old Mercedes—was always interesting because audiences recognized him as the Idikoko character. Helping him prepare to shoot a movie in Amsterdam (offering my house and acting as a set designer) also brought us into close contact, and we have remained so ever since. What struck me in our relations was the openness with which Augustine talked to me about problems in the industry.

Ashangbor "Michael" Akwetey-Kanyi (born in 1959) was trained as an electrician. He was born and still lives in "Russia," a popular neighborhood in Accra. His father runs a church, the Celestial Church of Christ, which is located on the family compound. Moving into the industry by helping his friend Augustine Abbey with lights, he developed a fascination with

filmmaking. His first movie, *Bitter Results* (Aak-Kan Films, 1995), came out not long before I started my research. Other producers long regarded him as a relative newcomer. Though in the period under study he often faced financial problems, he managed to stay in business. He rose to fame with movies about women with occult powers, and since the technology became available, he has excelled at stunning special effects. From the outset he took a strong interest in my research and took me along on his rounds through town. Through him I got to know all the facets of the industry, including production, distribution, and consumption. He introduced me to all kinds of key players in the industry and was prepared to talk to me virtually without end. In his office in Russia I spent hours watching his brother editing, talking, or just hanging out. He came to the Netherlands several times, staying in our house. In this way we, too, developed a close relation. His calm, patient, and respectful attitude to others—even in stressful periods—and his amazing sense of detail have always amazed me. I maintain regular contact with him by e-mail, checking up on things or asking for clarification about new matters that arise. I regard him as my mentor, without whom I would never have been able to collect the materials that have gone into this book.

Through these producers I became acquainted with others working in the industry, including actors, location managers, cameramen, editors, retail sellers, and exhibitors, and I was permitted to be present during editing and principal photography. I also got in touch with officers and jury members at the censorship office, through which each video movie had to pass before being screened or reproduced for sale. Thanks to the kind support of the censorship office and the perseverance of Akwetey-Kanyi, I received a complete updated list of all video movies (both Ghanaian and Nigerian) that have been submitted for censorship; this list formed the backbone of my historical analysis.

Also, I was privileged to meet with persons in the national film establishment, including Kofi Middleton-Mends at the National Film and Television Institute (NAFTI), film directors Seth Ashong-Katai, Nick Teye, and Lambert Hama at the GFIC, as well as scholars studying video in the school of performing arts. We had many debates (at times heated) about the value of video movies, and I tried to explain, as best I could, that I regard movies as mirrors of popular views that offer important insights for anthropological research. Especially with Seth Ashong-Katai, I had extensive discussions about these movies, and the appeal of Pentecostal Christianity in general, which he found deeply disturbing. Through these often controversial debates

I gained deeper insights into the stakes of the industry and the representation of culture. Ashong-Katai played a crucial role as a mediator between GFIC/GFC and private producers, for whom he directed many movies (at times under a pseudonym). Working as a director in numerous private video productions, he had an open attitude toward the new developments in the sphere of film, without, however, compromising his own standards very much. Together with H. M., he came to the Netherlands in early 2001 to write the script for *See You Amsterdam,* which he directed. Ashong-Katai introduced me to many people in the industry, including editors and actors. Along with directing films, he was also a poet. His untimely, sudden death in April 2009 was mourned by everyone in the industry and came as a big shock to me.

In the course of my research I became more and more deeply involved with the industry. Though I was able to spend only short periods of time in Ghana, coming back also had its own fruitful dynamic.[23] My relationship with the producers and others in the field got more relief, and my return always offered an excellent opportunity for a more or less systematic update. I tried to visit as many sets as possible, and occasionally I played small roles in video films. To better understand the antecedents of video, I consulted the files that dealt with colonial cinema in the National Archives and spoke to many people at the GFIC and NAFTI who knew the field inside out. Given the scale and complexity of the industry, it is, of course, impossible to know every significant person and all the movies. I often felt overwhelmed and wondered what to do next. Especially in the beginning, I found it difficult that my field of research was not bounded in space (as had been the case in my previous research in Peki). I was moving through relevant sites in Accra virtually all the time, from the premises of the GFIC to the major cinemas and video parlors, from NAFTI to the censorship office, from producers' offices to editing suites, from people's homes to pubs and shopping centers, from set to set. Always on the move, my anchor points in space and time were the producers, the pacemakers of the industry. They gave a kind of stability to my research, keeping me from feeling lost and losing track.

To my delight my interest in Ghanaian films met immediately with great enthusiasm from the people involved in the industry, certainly once they realized that I did not join the chorus dismissing these movies as trash but took them seriously. They appreciated that I was moving about in Accra, visiting venues that were considered "low class" until late in the evening, and they took this as a sign of commitment. Throughout my research I distributed articles and works in progress. My first published article on the industry

(Meyer 1999b) generated great interest because it paid serious attention to Ghanaian video movies as part of popular culture. While I am not sure that producers read my articles in detail, I know that the very fact that I wrote about their movies, which the local film establishment despised, meant much to them. That I came across self-descriptions on producers' websites that quoted my writings testifies to this.

Filmmakers quickly made me realize that they expected me not only to make their work respectable by writing about it in an academic style but also by creating alternative venues for international exposure. This prompted me to organize a Ghanaian video film festival in the theater of the Royal Tropical Institute (Amsterdam) in 2000, inviting William Akuffo, Seth Ashong-Katai, Ashangbor Akwetey-Kanyi, and Hammond Mensah to come to the Netherlands for about a week. After the first festival there were smaller events featuring Ghanaian video movies in the Royal Tropical Institute and the Africa in the Picture Film festival. Getting involved also entailed taking part in production. The Dutch Vista Foundation started to work with H. M. Films and received a grant to coproduce a movie in the Netherlands. Much of this film, titled *See You Amsterdam,* was shot in Amsterdam, and our house was used as one of the locations. Later on, our house was also used for a production by Augustine Abbey, *Amsterdam Diary* (Danfo B. A. Productions, 2005). Helping realize the film project was a wonderful occasion for participant observation, talks, and formal interviews. In the course of my research a number of my producer friends passed through Amsterdam and visited me, sometimes staying in our home. Spending time with these filmmakers allowed me to learn more and more about the vicissitudes of filmmaking and engendered between us a shared feeling of having accompanied each other for quite some time. This is one of the things I cherished most during this research: the capacity to remember things together.

The video film industry is driven by the urge to come up with new movies; it is all about the "latest film," and producers do not usually keep archives or records of their various productions. Old movies are often treated like trash, and tapes and VCDs are often left in a great mess. The emphasis is decidedly on the present, and the industry itself has no institutionalized memory. This is another reason the list from the censorship office is of great historical value. During my research I was often able to remind producers and others in the industry of past events or identify certain recurring themes and patterns. Extending over the period between 1985 and 2010, this book is intended as a memory aid for all those involved and interested in the industry; it aims to

generate further discussions about the past and future of video. In the meantime the industry has entered a new phase in which television and the Internet are important means in screening movies without necessarily generating income for the producers. My producer friends now belong to an older generation in the film business and have been forced to greatly reduce their production and look for alternative income-generating possibilities.

THIS BOOK

Emerging in a period of rapid transitions under the aegis of neoliberalization, video is an unstable medium. This book captures the dynamic process of the making of video as a new medium for the imagination by tracking the interlacing of its technological, economic, social, cultural, and religious aspects. Each chapter addresses broad, partly overlapping issues—technology, the city, morality, religious vision, iconographies of the occult, and cultural heritage—in the light of detailed historical-ethnographic materials. These are my starting point for a critical, reflexive search for and deployment of "grounded" theory.

Situating video in relation to celluloid cinema and the state-driven discourse about film as education, chapter 1 focuses on the economic, political, and social dimensions of video film production and circulation in Ghana's transforming mediascape. It presents a detailed analysis of the adoption and adaptation of video as a new technology that was initially taken as a substitute for celluloid and only gradually came to be used in ways that fully deployed the new affordances of video, including its portability and mass reproducibility. Video filmmaking is shown to be caught in the midst of tensions between the legacy of the state cinema discourse of film as education and a liberalized media environment in which commercial success depends on audience approval. The chapter unravels the ironies and paradoxes that characterize video as a new medium for making things public. It offers the material-technological horizon against which the possibility of video to effect Pentecostalist imaginaries arises.

Video movies, the rise of Pentecostalism, and the transformation of urban space—epitomized by the rise of Oxford Street and new residential areas—emerged at the same time, as symptoms of neoliberalization. Urban space is not only the setting in which the Ghanaian video film industry is situated; movies are also about the city, making a vision of the city materialize

onscreen. Chapter 2 argues that movies offer partial representations of urban space that audiovisualize an imaginary of Accra as a developed, modern city, expressing desires and anxieties of the inhabitants. This is why videos offer fascinating vistas into people's ambivalent experiences of city life. Far from being merely illusionary dream-works, movies also intervene in shaping the urban environment. They do so by offering urban styles, ranging from the body to architecture, which viewers eagerly seize and copy in fashioning a modern identity for themselves. Arguing that video movies showcase the symbiotic entanglement of urban imaginaries and film, the chapter demonstrates their role in imaging and deploying Pentecostal styles of urban personhood.

Audiences are constituted by being addressed by an appealing product. Chapter 3 shows how video filmmakers envision and address their spectators by mobilizing long-standing moral sensibilities and expectations regarding film that have governed film exhibition and censorship even prior to the rise of video. A film is expected to teach a moral lesson by inviting spectators to "get into" a movie experientially in order to "get something out of it." Focusing on how filmmakers negotiate the demands of the censorship board, on the one hand, and audience expectations, on the other, the chapter points out that successful movies straddle a thin line between the affirmation of a moral message and indulgence in the very transgressions that are necessary to emphasize what is good and yet question it from within.

Chapter 4 focuses on the interface of film and religion. Exploring the genesis of the video movie *Zinabu,* which is partly rooted in H. Rider Haggard's novel *She,* I identify a popular ontology according to which the "spiritual" is an invisible yet dominant aspect of the "physical." Claiming to "reveal" the "spiritual" and to grant audiences a "spiritual eye," many movies deploy the format of revelation. In so doing, movies claim to offer a much-desired mode of looking that is able to penetrate the surface of appearances. Revelation movies, this chapter argues, are instructive materials for ethnographic analysis because they audiovisualize Christian ideas and practices with regard to vision, offering insight into intricate interfaces of religious and cinematic regimes of visibility, unsettling cracks and contradictions, and the ultimate impossibility of full revelation.

The title of Chapter 5, "Picturing the Occult," names the paradox around which the revelation format evolves. If the "occult" is by definition hidden from view, how can it be depicted? Taking this question as a starting point, I explore the cinematic iconographies of three prominent occult figures:

ghosts, witches, and Mami Water. Their figuration springs from a creative synthesis of Western cinematic repertoires for conjuring the uncanny onscreen (as deployed in early ghost stories and horror movies) and popular Christian imaginaries around these figures, which, I argue, crystallize anxieties and desires that are difficult to express. Featuring such figures prominently, video movies take part in deploying an emergent generalizing vocabulary about the occult that contains specific indigenous notions and terms to refer to invisible forces and, by the same token, embeds them in a global frame.

Chapter 6 is devoted to the actual process of the "making of" movies that feature occult forces. Its basic idea is that film images are materially grounded in things, spaces, and flesh-and-blood people. The production of scary scenes begins on the set, requiring actors to simulate the operation of occult forces and even to lend their bodies to depict witches, ghosts, and other beings. The chapter follows the trajectory of filmmaking from the actual work on the set, involving struggles to ensure that the simulation of the occult generates persuasive pictures yet does not become the "real thing" for those engaged in simulating it, to the editing room and the manipulation of pictures via special effects, to advertisement and audience reception. The chapter thereby spotlights the intricacies of figuration and animation that come with the cinematic depiction of occult forces in a setting in which they are understood as real and in which belief and make-believe are easily blurred.

Harking back to the tensions between state cinema and video producers outlined in the first chapter, and building on the insights gained about the close link between videos and popular imaginaries in the subsequent chapters, chapter 7 positions video movies in relation to state policies on the representation of culture. How do video movies and their producers intervene in the wider discursive and political-aesthetic arena, with various players, in which the value, use, and representation of culture, tradition, and heritage are negotiated? The chapter examines how video filmmakers engage with state discourses about an adequate representation of traditional culture and heritage in their own ways. Aside from examining unfavorable depictions of chiefs that echo Christian-Pentecostal ideas about indigenous culture and religion as demonic, I also explore the rise of the "epic" genre, which depicts tradition and heritage in a more positive light, emphasizing aesthetic qualities and design.

The Video Film Industry

Having watched *Diabolo* in the Rex Cinema in December of 1991, I was eager to speak to William Akuffo, who had produced, directed, and edited the movie. Since I stayed mainly in the Volta region, it took some months before we met (in June 1992) in a small room, furnished with a TV and video deck, at the Ghana Film Industry Corporation (GFIC). Although Akuffo had no formal link with this institution, the GFIC premises were the obvious place to meet with anyone involved in movie production. Intending to further analyze the movie, I was eager to get a copy that I could take home to the Netherlands. Since the movie had been shot with a video camera, I expected that a request for a copy of the cassette would not be problematic. This was not the case. Akuffo had one "master" tape (the immediate product of editing) and a limited number of copies of the film that were used in exhibition. Precisely because the technological properties of video made it easy to copy and pirate cassettes—this happened on a large scale with foreign movies that were sent home by Ghanaians abroad—Akuffo made sure that he was in control of the way the copies were used. At that time video movies were screened only in cinema houses, and there was no possibility to buy copies anywhere in town. Akuffo or his assistants would take a copy to the venue where the movie was to be screened, count the number of viewers to make sure he would receive the producer's share of the admission fee, and then take the cassette home after the show. Having explained my motivation as a researcher and perhaps having impressed Akuffo a bit with my interpretation and the prospect of his being discussed in a scholarly article, I eventually gained his trust and received a copy of the cassette. When we met again in 1996 and my article featuring his movie had appeared (Meyer 1995; see also Wendl 1999), he told me that many of the other filmmakers had declared him

crazy for giving a copy of his cassette to an unknown lady, who could easily abuse his trust and pirate the film.

I mention this early encounter with Akuffo—long before I started my actual research on the video scene in 1996—to make clear that the technological characteristics of the medium of video, rather than determining a particular use, offer a range of possibilities that are subject to negotiation (see also Spielmann 2008). In other words the affordances of video technology entail certain constraining and yet not fixed possibilities for action that enable a particular use (Hutchby 2001). Initially, producers had no interest in selling home-video cassettes to the public. Instead, video was hailed as a technology that could be adopted in the realm of cinema and operate as a substitute for celluloid. While the easy accessibility, cheapness, and portability of video technology were welcomed, the intrinsic possibility for mass reproduction was a constant source of worry for producers who wanted to hold this reproduction in check. As Brian Larkin put it in his thought-provoking study of media technologies and urban imaginary in Nigeria, "What media are, needs to be interrogated, not presumed" (Larkin 2008, 3). The point, then, is to explore the nexus of technical affordances, the meanings attached to the technologies, their aesthetics, and their use in a particular social setting.

This chapter traces the rise of the video industry and follows its development until 2010. After setting the scene with a brief sketch of colonial and postindependence cinema, I distinguish three major shifts that transformed practices of movie production, distribution, and consumption: (1) the rise of video and the end of state film production, entailing the sale of the GFIC to a Malaysian private company in November 1996 (mid-1980s–1996); (2) the transition from reliance on hitherto state-run venues for movie (post)production and exhibition to the rise of a new commercial field, bringing about a shift from cinema screenings to the marketing of home videos (late 1996–2001); and (3) the phenomenal popularity of Nigerian movies, implying the transition from video to VCD (a cheap alternative to DVD) and from analog to digital (2002–10). Video technology, as this chapter will show, entailed new possibilities for shared popular imaginaries to evolve and become public in a way that was no longer fully controlled by the state yet all the same was shaped and constrained by older social-political uses of cinema, which placed strong emphasis on film as promoting the moral education of the nation. There was no clear and immediate break with state cinema after the adoption of video; rather, a set of gradual transitions emerged, yielding new contradic-

tions, constraints, and possibilities that have characterized the industry over the past thirty years.

CELLULOID CINEMA IN THE COLONIAL AND POSTCOLONIAL PERIODS

Cinema in Colonial Ghana: 1920s–1957

For informed discussion on the film industry in Ghana today, a detailed history of the industry still needs to be written.[1] Available historical documents indicate that the first cinema in the Gold Coast, the Cinematographic Palace, was opened in 1913 by the British company John Holt Bartholomew Ltd. in Accra (Pinther 2010, 94).[2] Then in 1922 the Palladium Cinema opened its doors to the viewing public. The fact that Palladium served as a dance hall for the local elite (Prais 2014) shows that, at the time, cinema was at the center of modern urban entertainment. Its owner, John Ocansey, a wealthy Ga who also founded the first Ghanaian bank, set up more theaters in other parts of the country (Mensah 1989, 9). In the course of the 1930s Ocansey, Bartholomew, and other entrepreneurs deployed cinema vans to tour the countryside (especially the cocoa-growing areas). Films were imported from India, America, and Britain. Usually, they were split into sections, so that screening a full movie took three or four nights (Mensah 1989, 9). In the 1930s, when synchronized dialogue was becoming the norm in new movie productions, most films shown in the Gold Coast were still "silent," because for technical reasons many cinemas could not play the sound that went with "talkies." Some people were employed to interpret film episodes into English and the local languages. Regarding the exhibition of movies as part of legitimate commercial activities, up to the 1940s the colonial administration interfered with the field of cinema solely through censorship and taxes (which were paid according to the length of a film).

In the initial period of the establishment of cinema, the Gold Coast colonial administration did not regard film as a vehicle for addressing the "natives." Tellingly, in a response to a report of the Colonial Films Committee dispatched via the Colonial Office in London in 1931, the acting governor expressed his doubts about the effectiveness of employing film in the service of education: "Local cinematograph proprietors maintain that educational or cultural films do not attract audiences and that they are compelled to depend more or less entirely on the more thrilling or amusing type of film to ensure

satisfactory attendance."[3] In response to a request to report on "the influence, good and bad, that cinema has on backward races in the countries directly and indirectly under your control," the secretary for native affairs and the director of education wrote a memorandum in 1933 that states that there were six cinema halls in the Gold Coast, showing about 180 films a month. Both authors stressed that there was "careful censorship" (as the archival files show, at times this evoked protests on the part of exhibitors) and that "there is no reason to think that the films exhibited locally have any moral effect demoralizing or otherwise." Only a small percentage of the population had access to movies, and films had "but little influence on the audiences."[4] In 1938 there were eleven cinematograph theaters listed (five of them located in Accra and the others in cocoa-growing and gold mining areas).

Only at the beginning of World War II did the colonial administration adopt the medium of film as a means of education and promotion of the colonial project.[5] Subsequently, the British Ministry for Information acquired the rights to show films, which were supplied "free of charge to Colonial Governments,"[6] and its Information Services Department produced and distributed films considered suitable to local colonial settings. Established in the Gold Coast in 1940, this department made use of cinema vans to organize film shows in the rural and urban areas, where it would assemble people in open-air spaces "to show documentary films and newsreels to explain the colonial government's policies to people in towns and villages free of charge" (Sakyi 1996, 9). An important feature of these open-air film screenings was propaganda films about the war produced by the Colonial Film Unit (CFU) in London (see also Diawara 1992, 3). Commercial cinema owners were required to screen CFU movies in addition to their own programming. Since watching movies was gradually becoming a popular leisure activity, in 1932, a Lebanese, Salim Captan, established Captan Cinema Company and ventured into the film industry by acquiring the Palladium Cinema; later it bought all the other cinema houses previously owned by Ocansey. In 1940 Salim Captan opened Opera Cinema and later a number of new cinema theaters in Accra (including Olympia, Orion, and Oxford), Kumasi, and some important towns in the cocoa-growing areas.[7] Another Lebanese company, West Africa Pictures Limited, ran cinema houses in Accra, including the Plaza, Rex, Royal, Regal, and Roxy. In 1950 the Indian Nankani family also opened a number of cinemas in Kumasi. These exhibition companies also engaged in film distribution and shared movies with each other.

After the war the CFU also started to produce educational films and a number of feature movies that were screened in Britain's African colonies. Contrasting the Western and African way of life, these movies presented the former as an embodiment of "civilization" and the latter as "backward" and "superstitious" customs to be abandoned (see Diawara 1992, 3; 1994, 44–48; see also Larkin 2008, 73–122, on colonial cinema in Nigeria). Film thus was closely related to governmental and imperial interests and employed to create loyal subjects. Placing film in the service of "civilization," the CFU was suspicious of Western movies—especially of American origin—that ridiculed or undermined the sense of Western superiority that the colonial power sought to convey to Africans (Diawara 1992, 1; Bloom 2008, 150). At the same time, as cinema operators continued to show foreign movies, film screening was never fully controlled by the colonial authorities; the latter were even obliged to at least partly give in to audiences' yearning for entertainment and show them their beloved Charlie Chaplin or cowboy movies after a number of educational films made by the CFU had been screened.[8] From the 1950s, cinema started booming, spreading into the popular neighborhoods and traditional Ga areas in Accra and exposing viewers to mainly foreign films (Pinther 2010, 101–2). Many of the cinema houses built at that time were open-air and stood for a modern form of commercialized leisure that addressed more or less anonymous strangers as a new urban public.

The Gold Coast Film Unit (founded in 1948 as part of the Information Services Department), which was to produce local educational films, took up themes perceived to be particularly relevant to the Gold Coast (Bloom and Skinner 2009–10; Mensah 1989, 11). These movies, too, were to serve colonial interests, and the focus was on promoting "purposes of better health, better crops, better living, better marketing and better human co-operation in the colonies" (Middleton-Mends 1995, 1; see also Diawara 1992, 5). As these objectives were thought to be best achieved "on the native soil with native characters" (Middleton-Mends 1995, 1), the unit trained African filmmakers. With the exception of one feature film, *The Boy Kumasenu* (Bloom and Skinner 2009–10; Garritano 2013, 33–46) all these films were newsreels and documentaries. As Mensah concludes: "So films mainly on subjects like the 'Police' and others bordering on law and order were produced to influence the people to respect the orders of the colonial government. Quite a few documentaries were however designed to educate on health, agriculture, civic responsibilities and current affairs" (Mensah 1989, 12; see also Morton-Williams 1953 for his study of audience receptions of these movies; and Meyer

2003a: 205–7). Also, as Kodjo Senah told me, there were quite a lot of advertisements—for instance for Barclays Bank or toothpaste from Lever Brothers—that promoted British products.

As the medium and mediator of colonialism, colonial films clearly were meant above all to "educate" the people. Film was to contribute to the colonial effort to produce a new kind of colonial subject who would acknowledge British superiority and agree to be "civilized" while resisting the dangers of modernity, especially the immorality of the city, the drive for selfish riches, and the discarding of family ties (Bloom and Skinner 2009–10). Nonetheless, colonial cinema cannot be reduced to these aims. Starting as a commercial enterprise, cinema generated a new audience with clear preferences for entertainment rather than "education" (as advocated by CFU films) and contributed to the rise of leisure and a new urban public culture (see Akyeampong and Ambler 2002; Barber 1997a; Martin 1995; Pinther 2010, 100). Thus, from the outset, cinema in Ghana was characterized by tensions between education, as propagated by the colonial authorities, and the realm of entertainment, as perceived by local populations. While colonial authorities did not oppose entertainment, per se, they were suspicious of certain aspects of commercial cinema. Offering, as Prais (2014, 202) puts it, "new vocabularies and images of modernity," as well as lessons to perform it, cinema emerged together with a deeply moral discourse about the virtues and dangers of film (see also Larkin 2008).

Cinema in Independent Ghana: 1957 to Mid-1980s

After independence in 1957, the Gold Coast Film Unit was transformed into the Ghana Film Unit and, in 1961, renamed the Ghana Film Production Corporation (Mensah 1989, 41).[9] The main purpose of cinema being educational, there was a clear continuity between colonial and postcolonial policies. Ghana's first president, Kwame Nkrumah (1957–66), attributed much importance to the medium of film in "educating," "uplifting," and "enlightening" the population and "explaining" state institutions, health interventions, and other policies to the young nation. Above all, film was to contribute to the emergence and consolidation of a national culture and identity. The ideal spectator addressed by state cinema discourse was a loyal subject, grounded in Nkrumah's vision of "African personality" (Nkrumah 1964; Hagan 1993; Schramm 2000, 340–41). This entailed pride in indigenous cultural roots and trust in the role of the government as the key instance for

safeguarding African culture and identity. Film was to operate in line with Nkrumah's cultural policy of *Sankofa*. Referring to the Akan image of a bird turning its head backward—meaning "go back and take"—Sankofa came to stand for a politics of culture that proudly incorporates certain traditional cultural forms and values as a means to move forward. Highlighting the importance of the past, Sankofa nonetheless stresses the importance of progress, the point being to bring together development and African cultural traditions (instead of opposing them, as had been the case in colonial times). In this regard film not only exemplified modern technology but also signified modernity itself and was found to be a particularly powerful means to conjoin African culture and modern "development."

Whereas in colonial times film exhibition had been in private hands and exhibitors were obliged to have their movies approved by the censorship board and (after 1940) to show a number of educational movies at the request of the colonial administration, Nkrumah sought to bring film exhibition fully under state control. In 1962 the state purchased the hitherto private West Africa Pictures Limited company and fused it with the Ghana Film Production Corporation, giving birth to the Ghana Film Industry Corporation, which combined film production, exhibition, and distribution. In 1965 the GFIC was renamed the State Film Industry Corporation (SFC) (Mensah 1989, 41). The industry was located in the modern neighborhood of Kanda, which also hosted the Ghana Broadcasting Corporation (GBC) and a number of government institutions, as well as modern private homes. In principle, as I will show in this chapter, Nkrumah's vision for film has continued to underpin the state discourse about and policies toward cinema. After he was overthrown in 1966, the cinema houses bought from West Africa Pictures remained state property, and the Cinematograph Act, passed in 1961 to regulate the exhibition and censorship of films, was retained until the emergence of video technology called for new policies.[10]

In the aftermath of the introduction of television in 1965, the government diverted the bulk of funds for filmmaking to the GBC, which was in charge of radio and television. Because of the deplorable state of the economy, the state invested little in filmmaking. In 1971 the SFC was again renamed the Ghana Film Industry Corporation (GFIC). Between 1948 and 1996, the year of the sale of the GFIC, the GFIC and its predecessors (the Gold Coast Film Unit and SFC) produced 385 newsreels and 200 documentaries but only 13 feature films on celluloid (Sakyi 1996, 13). Although the need for decent, locally made information and feature films was emphasized, alongside its

newsreels the GFIC actually screened American, European, Indian, and Chinese films. From the outset the realization of a fully state-run and state-controlled national cinema industry was hampered by lack of funds, which prevented a significant production of local movies. Even though the GFIC at least partly controlled exhibition and distribution, to make money it was necessary to cater to the expectations of the audiences in the GFIC theaters, many of whom loved foreign movies. As far as exhibition and distribution were concerned, the GFIC operated de facto in ways similar to commercial film exhibitors and distributors such as Nankani and Captan.[11]

The lack of locally produced feature movies was compensated for by a strong mobilization of the state discourse on cinema as education. Against this backdrop it is necessary to avoid confounding state discourse and policies with the actual world of film production, distribution, and exhibition. As sketched in the previous section, an urban audience attending commercial cinema had existed since the early twentieth century, and there were private and state cinemas all over Accra (as well as in other cities and cocoa-growing areas). In her evocative travelogue on her visit to Ghana, Jane Rouch (1964, 183–84), wife of anthropologist and filmmaker Jean Rouch, offers a short but vivid description of cinema. Reporting the tremendous appeal of movies involving love, action, and magic, which went "straight to the heart," she noted that the screen virtually dissolved, drawing the audiences into the cinematic world.

There was a hierarchy of cinemas, with Globe Cinema and Rex Cinema ranking on top. In these theaters visitors were supposed to follow a dress code and behave civilly—meaning that they would sit and watch quietly. In contrast, cinemas located in popular or traditional Ga areas did not maintain dress codes or enforce restrained behavior. The GFIC-affiliated filmmaker Ernest Abbeyquaye told me, "If you didn't want to behave, not be restricted, you went to the Opera, where you could scream as much as you liked."[12] This also held true for the Palladium, Regal, and Plaza. In these cinema houses people would shout, stand up, whistle, stand in front of the screen, or tell the projectionists to hold on for a while because they needed to have their laugh before the film continued. If not pleased, audiences would shout obscenities in Ga at the operator such as "onyaa ye . . ." (meaning "your mother's . . ."), throw tomatoes when something went wrong or they disliked the movie, or even (threaten to) destroy the furniture.[13] Movie watching was a highly interactive and lively affair. Many persons I interviewed stated that the different "classes" of cinemas attracted different "classes" of people, with different

tastes and viewing behaviors. In the popular venues people would bring drums, which were beaten when there was exciting action on the screen.

Telling is the account of Kofi Middleton-Mends, a well-known actor and teacher at the National Film and Television Institute (NAFTI). He told me that in the 1970s, when he once went to watch a movie in the Royal Cinema at Labadi, he recognized for the first time the differentiation of cinema venues according to social class:

> I had never entered that place; I had been to the Rex, Roxy, and Plaza, which is close to my house. But I had never been to the Royal. One evening, I drove there with my car and I went and parked there; I wanted to see the film there. The man at the gate said, "Oh, Master, what do you want here? Master, this place is not for you. The film will come to the Rex soon, so you watch it there." I did not fit in with the character of the people and left. So people are very class-conscious, they know that at the Rex Cinema another type of people comes, and the rates are higher there. Troublemakers and riffraff, if I may say so, were not there; they knew it was not a place for them.[14]

In vogue in these popular venues were Hollywood movies, especially cowboy movies and Indian films, as well as films on boxing, kung fu, and other martial arts. The state discourse on film as being in the service of education was far removed from actual practices of watching in the popular cinemas. Here, people came to have fun and entertainment and were eager to see (and shout along with) fighting scenes. For those adopting a view on film as education, these venues embodied the wild side of cinema, where people were exposed to the worst of foreign cultural influences. Criticism of cinema was not confined to state instances. Also within popular neighborhoods there was a discourse on the cinema as immoral and dubious (see also Larkin 2008). Church leaders frowned on attending these dark and rough venues, and many parents forbade their kids to go there. Ironically, in the course of the 1990s many of these cinema halls became places of worship for Pentecostal-charismatic churches.

Notwithstanding its actual participation in exhibiting foreign films and in catering to the needs of audiences in its popular cinema venues, the GFIC continued to produce an extensive discourse on the proper and morally sound use of cinema that condemned the bulk of foreign movies as having a bad influence that would induce local audiences to mimic the errant behavior they displayed. Summarizing the rationale behind the GFIC effort, Kwamina Sakyi mentions that it sought to "promote the ethical state, personality, and

culture of the African and to give them a wide international exposure," and to "help remedy the harm that Western media, particularly film, has done and continues to do to the African through the presentation of distorted pictures and information about him and manipulation of his mind" (Sakyi 1996, 2). This view about the need to produce alternative images of Africans for the world and to counter the negative influence of foreign films by promoting African culture and personality has been central to the state discourse on cinema up to the present. This discourse also underpinned the establishment in 1978, with the support of the German Friedrich-Ebert-Stiftung, of NAFTI, which offered professional training in all aspects of filmmaking and was legally bound to produce educational films. After 1978 many members of the technical staff of the GFIC were trained at NAFTI. In the state discourse on cinema, audiences were seen as copycats who were prone to reenact what they watched onscreen—hence the need, as also emphasized by the censorship board, to make sure that inappropriate behavior is punished right within the movie plot. Imported movies were accused not only of glorifying immorality but also of leading people astray from their cultural identity, both as Ghanaians and as Africans.

I will return to the vision of moral education adopted by the censorship board in chapter 3; for the moment, however, I want to stress that these ideas about desirable African movies existed in a void. Notwithstanding all the criticisms of the potentially alienating and dangerous effects of foreign movies, African art films, of the kind that thrived to some extent and have been celebrated in francophone settings, were virtually absent in Ghana. An important exception is Kwaw Ansah,[15] who produced and directed the internationally acclaimed film *Love Brewed in an African Pot* (1980), which won the Oumarou Grand Prize (FESPACO). The movie explores the clash between alienating colonial mind-sets and local culture, reflected in a difficult love relation between an ordinary fisherman and an educated girl whose father initially strongly opposes their marriage. In Ghana *Love Brewed* has been tremendously popular. During the 1980s, it was screened many times in high- and low-class cinemas (Mensah 1989, 67; Collatos 2010, 26), and a lot of people whom I interviewed during my research still spoke passionately about it.[16] In the wake of the emergence of video films, Kwaw Ansah became one of the most outspoken local critics. All the same, many of my interlocutors in the video industry referred to *Love Brewed* as a stimulating example that showed that local audiences were interested in movies made in and about Africa. Video filmmakers took the fact that this movie even contained a

quite spectacular witchcraft scene as a confirmation that depictions of spirits and the realm of the occult, which became one of the targets of criticism of video films, were generally acceptable. Until the emergence of video, no other African-made film had received similar attention. In cinemas and on television (which became more widely accessible in the 1980s), foreign films were dominant,[17] while the state cinema discourse kept on telling its own same story. The tension between this discourse and actual viewing practices was further exacerbated with the video boom that implied the influx of foreign movies on an unprecedented scale.

VIDEO IN THE VACUUM OF STATE CINEMA: MID-1980S TO 1996

In the first years of the military regime of J.J. Rawlings (1981–92) curfews and lack of resources affected public entertainment such as attending concert parties, musical performances, plays, and cinema and made people turn to television. Consequently, in this period hundreds of small video libraries and neighborhood video theaters sprang up in the suburbs of major urban centers. Quickly it was realized that video technology enabled more than easy access to foreign films. Various video enterprises were founded that recorded major family occasions, such as funerals and weddings, for a fee and thus facilitated communication between Ghanaians at home and abroad. Ghanaians in the diaspora used video recordings of funerals of dead relations at home to organize similar funerals in their countries of residence. More important, however, video was also appreciated as a useful means for making local movies.

Allen Gyimah, a trader in secondhand clothes, discovered the possibilities of video during a business trip to London in the early 1980s, when he visited a shop called Video City and bought some video equipment, including a camera, player, and telejector (using U-matic technology).[18] Back home he amused his guests in his nightclub, Copper Palace (Accra), by recording them on the spot and showing the clips onscreen. Greatly interested in cultural matters, he had close contacts with theater groups performing for GBC television and involved them in shooting a movie titled *Abyssinia* (see also Garritano 2008, 27; 2013, 68–69). Since at that time there were no editing facilities available in Ghana, the scenes had to be shot from the start in the order desired in the finished product. When *Abyssinia* was filmed, prior to

1985, no Ghanaian video feature movie had yet been publically screened. Released in 1987, however, it was not the first movie on display in cinema venues. Gyimah opened a number of small-scale cinema halls, all called Video City, which screened both foreign films and movies he and other Ghanaian producers made. His freelance filming activities incurred the wrath of state authorities, who then thwarted his efforts. Disappointed by low profits, Gyimah eventually withdrew from the world of film around 1990. It seems that in the early years of Rawlings's rule, when the government was bent on taking full control of the media, there was little room for allowing alternative private players to operate in Ghana's mediascape.[19]

A more successful attempt to go into private video film production was that of William Akuffo, who had been in the business of importing and screening foreign films for years. Offering his films to both private cinema owners and the GFIC, he had developed a keen sense for the type of movies that appealed to Ghanaian audiences. He told me how as an "operator" (shorthand for projectionist) he learned which films would do well in which area and how at times he would quickly switch to a movie that had less talking and more action. He disclosed that because of the difficult economic situation of the country in the 1980s, he worked with celluloid copies that were in such a deplorable state that viewers could barely discern the images on the screen. He observed that because the sprocket holes of films were constantly breaking and reels had to be pasted together, films became shorter and shorter. Video, even though far from perfect, offered footage of a higher quality, and for this reason Akuffo was much intrigued by the new technology:

> So in 1985, I went to visit a friend and I saw him showing a film, a very popular film I knew, *Snake in the Monkey's Shadow* [a martial arts film by Cheung Sum, Hong Kong, 1979], on his television and it was in color. I was wondering, "What is happening?" So he showed me the movie, and I was like, how come? And he said: "It is a new technology called video and it is just put in a cassette for the same play of time." So I said "wow" and sat down and watched it and found it very interesting. Then I asked him what he did with it and he said, "Oh, just show it to my friends," and I said, "This is money." He said, "How?" I said, "This is money, this is in color and everything." The TV stations were in black and white, you know. So I convinced him. And the house in which I was living in Chorkor [an area on the coast in Accra, inhabited mainly by Ga fishermen], I told him I could convert it into a theater and then we would start showing it. But I saw that taking the video from his room made him feel very uncomfortable, but I forced him and took it out and

placed it in front of my place and my place was by the road, so any person could see the video screen facing the road. (interview, 1 Oct. 2002)

Like Gyimah, Akuffo first encountered video as a possibility for screening foreign films, and likewise, the idea of using video cameras to shoot a movie followed suit. He much preferred to screen films in popular venues, where people would not be restrained in their mode of dressing and would feel free to make a lot of noise, commenting on the film, talking to and sometimes insulting the operator. This experience with audience reactions influenced his own filmmaking in that he sought to generate very lively responses. Long-winded films with much conversation "where nothing is happening" would not do well at all: "In my films I make sure that in the first five minutes at least something happens for them to sit on the edge of their seats and that they wait for more things to happen, you know" (interview, 1 Oct. 2002).

In 1985 Akuffo and Richard Quartey made their first movie, *Zinabu*, which was about a witch who converts to Christianity.[20] The script was written by Quartey, but Akuffo served as director, cameraman, and producer. They employed friends and acquaintances as actors and creatively experimented with the new technology. Editing was done by connecting two VCRs and copying scenes from one tape to another, in the right order of scenes. Displaying the realm of invisible powers, such as witchcraft, *Zinabu* epitomizes a key characteristic of Ghanaian (and for that matter Nigerian) video movies. Featuring the spiritual or occult, such movies became subject to heavy contestations, as well as popular appraisal. Unfortunately, once *Zinabu* was completed in 1985, the government imposed a ban on video films. In line with the state discourse on cinema, state authorities claimed that the American and Asian movies and "blue" (i.e., pornographic) movies that came into the country were having a bad effect on the public.[21] However, Akuffo pleaded successfully with the minister of communication to allow the production and screening of local movies, arguing that, in the long run, this would be the only adequate measurement to stop the influx of foreign ones.

The ban was lifted in 1987. Both local and foreign video movies were to be treated like celluloid films and thus would be subject to censorship by the government.[22] Though these films were usually pirated copies, the video centers screening them were to pay a fee to the Copyright Office, thereby somehow legalizing them. I say "somehow" because this was a partial legalization operating within global "infrastructures of piracy" that brought the movies and technology to Ghana and other countries (Larkin 2004).

Therefore, it would be a mistake to analyze the rise of video simply in terms of its technological characteristics (as often happens in mediacentric analyses of the "video boom"). The fact that video did not simply unfold as a new technology with its own logic, but was approached by the state *as if* it were cinema, cautions us against adopting a crude technological determinism. Video was the proverbial new wine poured into old skins, while, at the same time, its emergence was a symptom of the birth of a new public culture in the era of easy accessibility of electronic media. The rise and popularity of video exposed the tension between the state's wish to control movie exhibition and consumption, on the one hand, and the actual impossibility of this project, on the other. The negative discourse and written policies intended to control video's dangers could ultimately not be matched by efficient measures. Nonetheless, it is important to emphasize that, in the early days, video filmmakers themselves actively partook in framing their video movies as cinema for the nation, thereby gaining some degree of acceptance, while at the same time running into problems and contradictions.

In screening for paying audiences, video was literally made to mimic celluloid. When Akuffo showed *Zinabu* in the Globe Cinema, he camouflaged the video deck and made sure that he himself appeared in the projection room, as if he was operating the show from there. The spectators readily accepted the video movie as cinema, as Akuffo told me with satisfaction: "I talked to people and asked them, 'Was that video?' and they said 'No, no, it was shown on the wall, so it was cinema.'" The movie was phenomenally successful, and Globe Cinema screened it three times a day for weeks (Garritano 2008, 27). Video was celebrated as a new, easily accessible medium that would make it possible to revive a local film industry with limited means. In this context it is telling that Akuffo and his peers preferred to describe themselves as *film*makers rather than as *video film*makers, advertising their products as "Ghanaian films." The ambition was big, as the names of Akuffo's company—World Wide Motion Pictures—and that of Socrate Safo—Movie Africa Productions—show.

When video movies started to thrive and to bring fresh films into the system, the GFIC was not only unable to produce feature movies but also lost control over distribution and exhibition. Until 1984 the GFIC had organized the import and distribution of movies by itself, but after 1984, 85 percent of all movies screened were hired from private distributors, who received 40 to 50 percent of the admission fee (Mensah 1989, 48). The GFIC was caught in a vicious circle. Supposed to import movies that would be attractive to audi-

ences, the GFIC exhibition branch was to be self-supporting. Because of a lack of funds, however, it could not import a large number of new movies, and this implied that the same old ones were shown over and over again, resulting in a decrease in attendance and exacerbating its financial difficulties. By hiring films from local distributors, the GFIC started to make some profit again (Mensah 1989, 51–53), and this led it to open its cinema houses for the screening of local productions.

After the success of *Love Brewed,* Kwaw Ansah came out with *Heritage Africa* (Film Africa Limited, 1989), the first Anglophone film to win the Etalon de Yennenga Prize (FESPACO) and the Organization of African Unity (OAU) award for the film "that best addresses the cultural problems of Africa."[23] *Heritage Africa* is about the inner conflict of a black colonial official who eventually reclaims his own culture, from which he has been alienated through colonialism (and thus fully resonating with the Sankofa discourse on culture). After launching *Heritage Africa,* Kwaw Ansah encountered severe financial problems that prevented him from making another film on celluloid. Although he made some video movies, for him video was not a viable alternative to celluloid,[24] and in 2003 he eventually opened his own television station, TV Africa (de Witte 2012). The commercial failure of *Heritage Africa* and the GFIC's difficulty in offering its audiences movies in line with the state discourse on film both indicate the deep crisis of celluloid and of the educational and Sankofaist vision associated with it.

From the early 1990s on, Ghanaian video movies started to boom. Markedly distinct from African art films, these movies should be understood as a hybrid outcome of a complicated process of incorporation, in which initially foreign imagery and global technology are articulated toward the local setting. Many videos can be characterized as *bricolage,* containing elements from Hindi films, kung fu films, horror movies, and Latin American soap operas—all available on television and as videos—as well as Christian popular imagery and, last but certainly not least, Pentecostal sermons. The rising popularity of these movies generated a full-fledged industry that evolved at the interface of established, though partly defunct, cinema structures for production and exhibition and the new possibilities offered by video. Although the first set of movies had been made by groups of amateurs "from the street," some degree of professionalization gradually emerged. The new video industry included new actors and established ones, whose faces were known from local drama plays screened on television, as well as directors, scriptwriters, cameramen, location managers, sound and light controllers,

and editors. Often one person combined several of these tasks. Most producers, many of whom also served as directors and at times also handled the camera, were men, but a number of women (for instance, Veronica Codjoe, Hajia Meizongo, and Nana Akua Frempoma) also went into production. There was a mix of people who had received training within NAFTI and the GFIC and those learning on the spot. In the absence of reliable formal structures and the impossibility of receiving loans from official sources, video film production thrived to a large extent on personal informal networks, with part of the payment for services often taking place only after a film had been screened and had generated money. In the early days the budget for producing one movie was around US$2,000. If about five thousand copies were sold, the producer could break even; from ten thousand sold copies on, a movie was regarded as a big success. Producers usually sought to maintain personal relations with important persons involved in the production, distribution, and exhibition of their movies, and this included a social commitment to people's well-being. If a member of the crew fell sick or had to cope with the death of a family member, producers were expected to give support, as was also the case in other professional cultures.[25] Video film production depended to a large extent on relations involving mutual financial and moral obligations. Only in this way could the industry evolve, while, at the same time, the heavy dependence on personal relations was a constant source of conflicts and disappointments (see also Adejunmobi 2007, 9, who describes a similar setting of film production and marketing outside of the formal economy for Nigeria).

Ghanaian film producers formed the Video and Film Distributors Association of Ghana, which organized the sequence in which movies were to be screened in the cinema houses,[26] with the Ghana Films Theatre, the air-conditioned cinema located on the GFIC premises,[27] ranking on top, followed by the Rex Cinema and the other GFIC cinemas. Actual film distribution was organized via "boys" who worked with a particular producer, advertising and screening the movie throughout the country. In the early days distributors employed colorful hand-painted posters on canvas or flower sacks, which were painted by popular sign writers and roadside artists who were already involved in making posters for foreign movies (Wolfe 2000; see also Woets 2011).[28] The portability of the posters and videotapes made it easy to offer programs—sometimes requiring only a TV and video deck, sometimes a telejector and screen—throughout the urban areas and eventually all over the country. The posters, which were later replaced by more fashionable

promotion materials (such as a number of still photographs of the video's scenes pasted on paper or, again later, a computer-designed poster), were spectacular eye-catchers for Ghana's and—later on—Nigeria's evolving movie culture.

The success of initially untrained movie entrepreneurs prompted the filmmakers at the GFIC to consider video a viable alternative to celluloid. Although a number of established filmmakers, such as the eminent cameraman and GFIC director Rev. Dr. Chris Hesse, who had worked for Nkrumah, were reluctant to do so, the fact that the black-and-white laboratory had broken down and there were no facilities or funds for color made video acceptable as a technology for film production.[29] Gado Mohammed, who had been a member of the GFIC board of directors in the early 1990s and who acted as the chairman of the Video and Film Producers Association of Ghana (VIFPAG) at the time of our interview, told me about the transition within the GFIC:

> So it was obvious in those days that celluloid had no future in Ghana, given first that we had no color laboratories for us to process films; you had to go to London, together with an editor, and you still had to pay for an editor in London to process for you. These are some of the difficulties by which you could see that the future lay in video. So the emphasis in those days was to encourage GFIC to move into video. . . . So reluctantly they started to do it. . . . You know Akuffo and others had low budgets, but the GFIC budgets were very high, so they realized that if they continued like that, they couldn't survive, because they could not recoup their money. (interview, 16 Nov. 2002)

For many of the professional filmmakers who were affiliated with the GFIC as civil servants but had never made a feature film because of the lack of funds, the acceptance of video technology offered a long-awaited opportunity to finally produce *movies*. This turn opened new possibilities for reconfiguring the GFIC in line with the Structural Adjustment measures implemented by the Rawlings Regime at the instigation of the IMF. Thus, in 1993 the GFIC was transformed into a limited liability company (in which the government retained 49 percent of the shares) that had to go commercial and be self-sustaining. Until it was sold to a private Malaysian television company in November 1996, the GFIC registered twelve video movies with the censorship board. After taking up video, the GFIC premises became the central node of Ghana's evolving industry. Not only were actors and other technicians on hand to sell their services to the private producers, the latter also

FIGURE 2. Filmmakers at Gama (from left to right: Moro Yaro, Seth Ashong-Katai, Kofi Owusu, Ashangbor Akwetey-Kanyi, Hammond Mensah, Billy Anyomi Agbotse, Stanley Sackey; August 1998). Photograph by author.

came to rent cameras and lights and to use the services of the GFIC's experienced editors, who had switched quite easily from celluloid to VHS. The bulk of these costs would usually be settled once a film generated box-office income. The fact that movies were screened mainly in the GFIC cinemas brought many producers to the GFIC premises to negotiate a place in line and a running time (preferably more than just a weeklong screening per venue). Notwithstanding the animosities between private self-trained and established filmmakers, the GFIC premises were the central space where their encounters took place and the industry evolved (fig. 2).

Facing the popularity of video movies launched by self-trained producer/directors such as William Akuffo, Sam Bea, Socrate Safo, Steve Asare Hackman, and Augustine Abbey, the GFIC had to find a way to make films that would "educate," as well as appeal to the audiences. While some of the GFIC movies were celebrated as very successful—*Baby Thief* (GFIC, 1992), directed by Seth Ashong-Katai, was especially well-liked by audiences—other films were dismissed as "artificial" or "book-long." From the early days of video there was a clear tension between GFIC productions, with their focus on morals and family life and embedded in the film-as-education framework of state cinema, and films by private producers, who spiced their

melodramatic and moralizing plots with special effects that visualized spiritual forces, such as ghosts, witches, ancestor spirits, and mermaids. Many video filmmakers also framed their stories in dualistic terms of struggles between divine and satanic powers that resonated with the messages of the phenomenally popular Pentecostal-charismatic churches, which, as I outlined in my introduction, had become an increasingly public factor since the mid-1980s. Indeed, the distinction between films that affirm the reality of spiritual or occult powers, on the one hand, and those that neglect them or even dismiss beliefs in their existence as "superstition," on the other, is a thread that has run through the Ghanaian video film scene ever since its inception.[30] This distinction can be mapped onto the one between higher- and lower-class cinemas. While GFIC productions targeted mainly the former, private producers sought to make movies that would appeal to, as they put it, "all classes of people," not just "elites."[31]

Adopting video as a substitute for celluloid implied that private video entrepreneurs, many of whom had previously been involved in the now defunct sphere of celluloid film screening as operators, distributors, or electricians, had to position themselves in relation to the educational project of the state-run film industry. Occupying a long-standing void in the national cinema tradition, they had to face both censorship and the established discourse on what cinema was supposed to be. As I will explain in more detail in chapter 3, though the censorship board was often critical of the content and technical standards of video movies, it rejected very few films submitted. From the outset video films have been subjected to criticisms from the Ghanaian film establishment—for example, formally trained filmmakers at NAFTI and the GFIC, policy makers, film critics, and intellectuals whose vision is to link national culture, heritage, and film in Ghana. Kwaw Ansah complained: "I have seen films by Ghanaians created through the video medium where you find Africans eating human flesh with European angels descending from heaven to exercise justice or whatever on them. This is one of the dangers that people should be cautioned against in film production" (1995, 29). In an interview with Steve Ayorinde and Olivier Barlet, Ansah pointed out that "Hollywood has made so much against the black race and when we have the opportunity to tell our own stories, we are confirming the same thing! Even we are doing worse than Hollywood!" (quoted in Ayorinde and Barlet 2005).[32] Such criticisms have been expressed over and over again, lamenting the overdose of men's sexual escapades with young schoolgirls, the strong inclination to visualize such matters as ghosts, witches, and *juju,* the

staging of spiritual fights in which the Christian God eventually overpowers indigenous deities, and of course the overall low technological standards for plots, acting, editing, and sound. Video movies elicited the constant criticism that they affirm "superstitions," thereby failing to "educate" and instead keeping people "ignorant," and that they "misrepresent" Ghana to outsiders (see Asare 2013, 72–73; Okome 2010).

Right from the beginning private video filmmakers were torn between accommodating the established state discourse on film as education—or at least avoiding being reprimanded in public for failing to "educate" the people by displaying bad behavior and affirming "superstitions"—and the need to sell their films to paying audiences, which placed quite different expectations on a "good" movie. Many (targeted) viewers were more or less committed to the new Pentecostal-charismatic churches, which started to thrive in the mid-1980s in conjunction with the rise of video films and the opening of the public sphere to alternative voices. Increasingly, producers realized that to stay in the business they could not afford to live up to the expectations of the establishment by shifting into the production of enlightening and educational movies. The following statement by Ashangbor Akwetey-Kanyi, which he made when I asked him in 2002 to reflect on his vision of the video film industry, brings out private producers' views:

> You see, when celluloid died out in Ghana it was the ordinary man in the street who picked up the video camera and started to make movies, just to fill in the gap. Whether you like it or not, the self-trained filmmakers have sustained the industry up till now, do you understand? And these guys call themselves professionals? All these years they have done nothing, there is not a single one of them that can say he has made about ten movies all over the years or that kind of stuff. All these years they have been sitting down in their offices and they have done nothing to help the industry, but always they get up to say this and say that. No, they should just go ahead and make movies, just like the self-trained professionals are making, they should make movies and then we can start to compare notes, because if the self-trained films are not good, then their films will knock them off the street. It's on record that all the self-trained filmmakers have made the most successful films in Ghana, so what are they talking about? (interview, 12 Nov. 2002)

This statement not only addresses the constant assaults and humiliations from the establishment but also asserts that without the initiatives and risks taken by self-trained producers, Ghanaian cinema would in all likelihood have ceased to exist. The next section explores the growing antagonism

between the world of self-trained video filmmakers and the national estab-
lishment during a new era when, somewhat ironically, film production no
longer was a task of the state.

FROM CINEMA TO VIDEO FOR
HOME CONSUMPTION: LATE 1996 TO 2001

Video movies started to flourish in the very same period when the state with-
drew from wielding immediate control over mass media in the aftermath of
liberalizing the economy and adopting a democratic constitution. Opening
up the public sphere to alternative voices after 1992, a new public culture was
in the making that allowed the expression of divergent views, creating new
tensions and confrontations. This development not only implied political
debate and criticism of government policies but also facilitated public articu-
lation of popular imaginaries that had hitherto circulated through alterna-
tive circuits, including cheap tabloids, church sermons, or rumors, yet had
been barred from "big" state-controlled media (Sreberny-Mohammadi and
Mohammadi 1994). Opening up such respected and official media as radio,
television, and film for these circuits triggered heated discussions about what
had value in Ghana's new "representational economy" (Keane 1997). Given
the close link between state cinema and national culture, the question was
how the arrival of the highly fluid and poorly controlled medium of video
would influence the public representation of culture. In hindsight it is clear
that for the video film industry, 1996 was an important point in time that
opened up possibilities for renegotiating the relation between video film and
the state.

When I started my research in September of 1996, the GFIC was still in
place, in the midst of a changing media environment and public sphere. Once
a modern state institution with good equipment, now the premises appeared
somewhat run-down. All the same, thanks to adopting video, the GFIC staff
was very busy making films and screening local movies in its cinemas. Despite
many objections from the national film establishment, in November of 1996
the state sold 70 percent of the shares of the GFIC to the private Malaysian
television company Sistem Televisyen Malaysia Berhard of Kuala Lumpur.
The new company was called Gama Media Systems Ltd. and had two
sections: Gama Film Company (GFC) was devoted to film production and
TV3 to television. Just a short while before this, the upgrading of the premises

had been started. The takeover of the GFIC did not bring a revival of film-making on the basis of celluloid, as many had hoped; instead, it affirmed the use of video as a cheap and accessible technology. The Malaysians—as they were popularly referred to—brought in new video equipment for use within Gama and for rent to ensure that movies had the quality required for television. This implied that VHS, still in use at that time (certainly by private producers), was replaced by Betacam (or at least S-VHS).[33] Gama showed little interest in attending festivals for African cinema, such as FESPACO. Instead, the company tried to establish itself as a springboard to market Ghanaian films in the television format throughout Africa.

Seeking to transform the old GFIC into a private company producing popular films for television, the Malaysian directors of Gama faced the stubborn resilience of the view of cinema as a nationalizing and educational project. Former civil servants who were now employees of Gama (placed in the GFC section) were still dedicated to the state vision of cinema. Even though some of them had directed movies for private producers, they were quite critical of the new type of movies, which they found went too far in depicting juju (occult practices or magic), witches, and ghosts. I had extensive discussions about the implications of video for the development of the Ghanaian movie scene with directors Nick Teye and Seth Ashong-Katai, who had long worked for the GFIC before it was taken over by Gama. While they very much welcomed the use of video as a medium, they were suspicious of my (in their view all-too-positive) analysis of private producers' movies as instances of a popular culture going public in new ways and insisted on the importance of cinema for educating people. At the very least, they found that video entertainment should not mislead people into a negative view about their own cultural heritage, as was the case in many video movies.

In contrast, the chief executive officer of Gama, Khairuddin Othman, complained that many of his employees still regarded the GFC as "Nkrumah's baby" and were reluctant to make films that appealed to popular taste (interview, 30 June 2000). Othman pointed out to me that he saw nothing wrong with making movies that visualized occult forces, as such depictions were standard in Hollywood horror movies, as well as in Indian cinema. The Malaysians sought to push filmmakers working at Gama to adapt to the new situation, to realize that cinema was now a matter of business, and hence was to appeal through entertainment. The use of cinema to educate the nation was outdated, and the main aim of Gama was to open up the African market.[34]

Gama sought to launch a new kind of movie that differed significantly from the type of films made by the GFIC and that was not based on the view of cinema as education but was profit-driven (see Garritano 2013, 210). Between the takeover in November 1996 and the end of 2004 the company registered twenty-six films, the peak being in the years 1997, 1998, and 1999. Although a number of movies were still indebted to the GFIC approach, others offered new perspectives. A much-celebrated movie, appearing in 1999, was *Dark Sands* (dir. Lambert Hama), about a corrupt police officer who is involved in the drug trade (Meyer 2001). Many viewers were enthusiastic about this film, both because of the topic (police corruption was a matter of concern that had been kept out of the public realm prior to the liberalization of the media) and the technically sophisticated action scenes. Tellingly, Gama ran into problems with the censorship board when it presented *Set on Edge* (dir. Tom Ribeiro, 1999), another movie about a corrupt police officer. In this case members of the board, including the representative of the police, objected to showing the officer receiving a bribe and visiting (and suggesting he had sex with) his girlfriend while on duty and while a criminal en route to prison sat waiting in the car. It was feared this scenario would damage the reputation of the police. The fact that this movie was rejected twice before it was passed in August 1999 shows the degree of separation that existed between the sphere of state cinema, represented by the censorship board, and commercial film entertainment as represented by Gama.

Reducing its investment in video film production, Gama ceased to be a major player in the video scene. Taking up the possibilities arising from the liberalization and commercialization of formerly state-controlled media, the company promoted its television station, TV3, as an alternative to GBC-TV. Focusing on television, its involvement in film production became more and more indirect, in that it rented out equipment for filmmaking and editing and offered video producers the possibility of screen advertisements of upcoming movies on TV, sometimes for cash, sometimes in exchange for the right to screen a producer's old Ghanaian films, provided they were judged to be on a satisfactory technological level. Although Gama was officially responsible for the GFIC's equipment and film stock, to workers within the company it soon became clear that there was little commitment to earlier achievements. Figure 3, depicting part of a garbage heap of reels and films that was left for months (in 2002) in the vicinity of the Gama parking lot, testifies to the effects of the sale: the end of celluloid and of the institutionalizing of state cinema (fig. 3).[35]

FIGURE 3. The end of celluloid, Gama parking lot (October 2002). Photograph by author.

Ironically, in the face of media liberalization that culminated in the sale of the GFIC and that reconfigured the production, distribution, and consumption of films, the film censorship board and the interventions of politicians and policy makers in the field of video kept on mobilizing the state discourse on cinema. A "Draft of the National Film and Video Policy," written in September 1995, stipulated that video and film are "image-building tools and need to be positively directed for public good" as "strategic tools for national integration and national development." Stating that the video boom "needs to be encouraged and assisted in the national interest," the policy sought to intervene in video production. The point was to ensure that movies "promote positive and desirable aspects of Ghanaian culture," offer images of indigenous and African hero(in)es "as role models for our people in all areas of human endeavor," and contribute to "establish the common identity and interest of all African and Black people and cultures everywhere." The use of "indecent, inhuman and dehumanizing images" was to be avoided, while the "extensive and authentic use of local and African costumes, music, dance and other national symbols" was encouraged (Ghana Ministry of Information 1995, 3).

Even though the policy was not implemented, it has continued to express and shape the attitude of state institutions toward video movies up until the

present. NAFTI also reiterated this perspective and conveyed it to its students; the few graduates who worked for private producers and went so far as to make films featuring witchcraft and juju were subject to heavy criticism. Since the mid-1990s there have been numerous seminars, sometimes also organized in conjunction with European institutions such as Germany's Goethe Institute, intended to educate self-trained filmmakers and raise their awareness about the medium of film. The organization of national film (award) festivals also reiterated this point.

In 1999 the National Media Commission, which had been set up by the Ghanaian Parliament in 1993 as an oversight body for the media, drew up its *National Media Policy*. Addressing the new role of media in the age of democracy and commercialization, the policy moved beyond a view of media as promoting "positive national identity and confidence" (National Media Commission 1999, 22) and was mainly concerned with the balance between the positive and negative effects of the globalization of information and communication on local culture (especially regarding the gap between the information-rich and the information-poor). Nevertheless, reminiscent of the earlier "Draft of the National Film and Video Policy," it still was critical of the "poor technical, artistic and ethical standards with most of the current generation of films made in Ghana" (National Media Commission 1999, 12). With regard to video, the *National Media Policy* echoed the earlier draft policy, demanding that steps be taken to ensure that films are "in keeping with Ghanaian traditions and mores and promote desirable aspects of Ghanaian culture," entail "the extensive use of authentic national cultural forms and symbols" and "establish the common identity and shared interests of all African and black peoples and cultures everywhere" (National Media Commission 1999, 50). From this perspective video movies were still criticized for affirming obsolete "superstitions" and fears and for offering disturbing misrepresentations of Ghanaians.

Around 2000 it was clear that filmmaking had become a matter of small-scale private business. Complaining bitterly about the commercial takeover of the GFIC and the new style of operation and communication, several filmmakers left Gama voluntarily or were fired. Realizing that filmmaking was no longer funded by the state, they were obliged to offer their services on the private market with its own dynamics and dependency on the approval of audiences. Even in the realm of business, most of them, as well as many filmmakers then graduating from NAFTI, still embodied the spirit of national cinema and reproduced what Gado Mohammed called "the mentality of celluloid." The cooperation between directors hitherto affiliated with

GFIC/Gama and NAFTI, on the one hand, and private producers, on the other, proved to be quite tense, as there was little agreement between the two parties about what constituted a good film. The depiction of juju was an especially contentious issue. While these directors did not want to lose their reputations (one reason why some even worked anonymously), private producers did not believe in the success of GFIC-type, "book-long" educational films and found it impossible to synthesize the tenets of the "Draft of the National Film and Video Policy" and the *National Media Policy* with their business.

To keep going in a heavily commercialized industry without state funding, without a major private investor, and with no possibility to receive bank loans, self-trained private video producers struggled to secure the approval of their audiences at home and to find new publics in other African countries and the diaspora. They experienced—even felt in their pockets—that films that did well in the local market might fail to appeal to the national film establishment, as well as to the world of African cinema, and vice versa. Conversely, they knew perfectly well how to distinguish "FESPACO films" from their own most successful productions.

For instance, Socrate Safo has been experimenting with different types of films for years. He told me that he once made *Chronicles of Africa* (Movie African Productions, n.d. [between 1997 and 2000]), a film that was critical of evangelism and that valorized indigenous culture. The film not only flopped in the Ghanaian market, because people did not like this kind of "colo" (old-fashioned and directed toward the past) and anti-Christian movie; it also received little recognition from the establishment. Safo even recounted with some bitterness that Ghanaian professionals associated with the GFIC and NAFTI actively contributed to marginalizing Ghanaian videos made by self-trained people at FESPACO. Therefore, he could not help but turn to making movies that resonated with people's imagination and lifeworlds. Safo's example reveals that video filmmakers were conscious of different movie genres and styles of filmmaking, with distinct aims—ranging between national identity and development, safeguarding cultural heritage, and appealing to popular culture. They certainly longed for some recognition and were frustrated that their attempts to create a viable Ghanaian video film industry met with such harsh criticism.

While it thus became increasingly clear that video movies were unlikely to live up to the expectations of the national film establishment, independent producers moved away from their own understanding of video as a substitute

for national cinema. The understanding and use of video as an easily market-able, mobile medium implied a shift in Ghanaian video filmmakers' orientation. Gradually, they lost their ambition to receive awards at established film festivals. After all, the point was to make ends meet. Increasingly, producers made use of the easy reproducibility and transportability intrinsic to video, thereby realizing yet another feature of this technology's potential.[36] This trend transformed film exhibition and distribution. As sketched earlier, video movies were initially screened only in cinemas and neighborhood video centers, with the producer or his assistants sitting at the entrance and counting the number of patrons, so as to be able to claim the producer's part of the entrance fee (typically about 50 percent). In the mid-1990s, video shops began to sell videos for home consumption, after they had been screened in the state-owned and some of the private cinemas, and well before they would be shown on television. Ghanaian videos were less and less often shown in cinemas, which were increasingly taken over by Pentecostal churches, but were advertised on television and in the streets as videos to take home. Toward the end of the 1990s the main income was generated through the sale of tapes rather than the box office. Also, because of the great number of movies being released, the waiting line of films to be screened in the cinemas became very long. Often producers sought to come out at strategic moments, for instance releasing the second part of a film just after the first part had been on TV. At this time the video shops—the most prominent among them being Hacky Films, Miracle Films, H. M. Films, and Alexiboat, located near Opera Square in central Accra—had become the central nodes of the industry (fig. 4). Located in a buzzing area in central Accra, Opera Square derived its name from the Opera Cinema. The square is a node in the public transport system and a hotspot for foreign exchange, shops selling electric articles, sewing materials, and videos. The shift from the GFIC/Gama premises to Opera Square as the vibrant epicenter of the industry mirrors the severance of the link between the video industry and (the idea of) state cinema.

The video marketers would not only sell movies but also import tape cassettes (from China and Korea) and magnetic tape (from the Netherlands) so that they could copy a movie using only the required tape length and organize cassette duplication on a large scale. Producers had various options to sell a movie via a shop owner. Either the latter would invest in the production and deduct the investment from the sales, or the producer would hand over to the shop owner a fixed number of so-called sleeves, featuring the movie title and attractive pictures, that would be placed inside the plastic tape

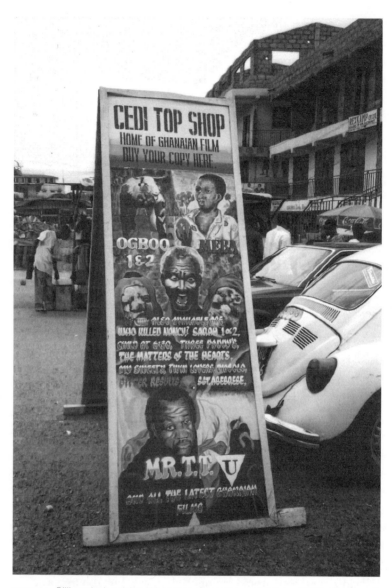

FIGURE 4. Billboard advertising videotapes, Opera Square (October 1996). Photograph by author.

casket. The producer would then be paid on the basis of sleeves sold.[37] Given the interest in selling a large number of copies, shop owners started to develop new forms of promotion. A particularly spectacular one was the so-called float (started around 2000), which implied hiring a brass band that would travel on an open truck throughout Greater Accra, accompanied by swarms of "boys" who sold tapes to passers-by and motorists in the omnipresent traffic jams. The idea was to make a lot of noise, literally, to attract the attention of potential buyers. Not surprisingly, producers who also ran their own shops did well, since they could profit not only from the sale of their own movies but also from those of their rivals. Around 2000 the most popular and flourishing shops were owned by H. M. Films, Miracle Films, and Princess Films, who were all known for their "high-class" movies.

The move away from the GFIC/Gama premises, which had played a vital role especially for editing, was also facilitated by the shift from Betacam and VHS to digital video, as a result of which producers could make use of digital editing programs, such as Adobe Premiere.[38] From 2000 on new enterprises came up that offered digital editing services, including a vast array of special effects. Next to Gama, other institutions also offered editing services. These included the Indian Nankani company, which had a long history in importing movies and exhibition equipment; the Church of Pentecost, which had discovered the importance of media in spreading the Gospel and now was prepared to rent out its editing bench; the Ministry of Agriculture, which offered its editing facilities for commercial use; and individual entrepreneurs like Big Star Studio Bin Yahya (Big Daddy), which was run by a young man called Afra in Nima, who had mastered Adobe Premiere and specialized in special effects. The rise of expertise in creating special effects within Ghana was regarded as a major achievement. It relieved producers from traveling to MadHouse studio and similar sites in Lagos, which first dominated the creation of effects by using the digital format.

Whereas in the beginning producers' prime worry had been to deal with the criticism made in the light of the state discourse on cinema, which they simultaneously internalized and/or resisted, after 1996 their key concern gradually shifted toward appealing to commercial audiences interested in videos for home consumption. From the end of the century on Ghanaian producers faced the problem of surviving the onslaught of highly popular Nigerian movies on the Ghanaian market. This trend reconfigured the market and required that Ghanaian producers once again reposition themselves.

Although the challenging presence of Nigerian video movies had been debated since the late 1990s, their impact has become considerable since the beginning of the twenty-first century. During my stay in Ghana in the fall of 2002, I noted that Ghanaian video filmmakers complained more bitterly than ever about the influx of these imported African movies. Now they not only faced criticism in the name of the state discourse on cinema, but they also felt the danger of losing their audiences—and thus their market—to the Nigerians. They found themselves in a deeply ambivalent position, for it was clear that what fascinated the Ghanaian audiences about Nigerian films— their lavish display of riches, occult powers, and violence—was the very focus of criticism from the establishment. Most obviously, Nigerian producers were less restricted in visualizing occult matters, violence, sex, and dualistic fights between God and Satan than were Ghanaian producers, who still felt constrained by the standards of the national film establishment. Ironically, through pressure from the establishment, Ghanaian video producers had moved away from making films about witchcraft and toward new, somewhat artificial, plots that involved cocaine and policemen, while Ghanaian audiences still enjoyed the former kind of movies. Nigerian videos filled the gap (Haynes 2007; Krings and Okome 2013).

Many spectators with whom I discussed their preference for Nigerian movies told me that they were impressed by the superb display of wealth and costumes, the spectacular special effects, the visualization of magic, the stardom of the Nigerian actors, and the emotionally moving plots.[39] I remember that one of my friends, who had been a staunch fan of Ghanaian movies, told me enthusiastically that she had wept when watching a Nigerian movie, which she took as a sign of the superior emotional appeal of these productions.

The entry of Nigerian movies into the system made Ghanaian video filmmakers realize that in order for them to stay in the business they had to offer something unique to their audiences. While some producers engaged in coproductions with Nigerians, resulting in movies with spectacular special effects and big Nigerian stars[40] who acted alongside Ghanaian actors, others shot movies featuring well-known concert party comedians, including Santo and Judas, who spoke in Twi. The latter trend gave rise to the Kumasi video film industry, in which Miracle Films, whose owner, Samuel Nyamekye, was based in Kumasi, played a central role (Köhn 2008). Others again made good

use of their international network and shot movies that were partly situated in Ghana and partly abroad.[41]

The popularity of Nigerian movies among the audiences reconfigured the market. While initially video shops were run by Ghanaians who sold mainly Ghanaian films, after 2000 about half of the twenty video shops I counted around Opera Square were operated by Nigerians and sold mainly Nigerian films. This change derived partly from increased contacts between Ghanaian and Nigerian video producers, which yielded a number of coproductions and opened up the Ghanaian market for Nigerians. A number of Ghanaian shop owners, some of whom also operated as producers—including Hammond Mensah (H.M. Films), Samuel Nyamekye (Miracle Films), and Abdul Salam Mumuni (Venus Films)—shifted to marketing Nigerian movies. Since the rights for selling Nigerian films could be purchased at a comparatively cheap price, while at the same time experiencing high demand, a lot of money could be earned without going through the trouble of film production. The major shop owners thus brought out a host of Nigerian films, thereby playing an active part in the downfall of Ghanaian movies (see Garritano 2013, 158). This made it increasingly difficult to draw the attention of the public to a single Ghanaian film, while the sale of a substantial number of copies was necessary to recoup one's investment and generate capital for another production. This flooding of the market with Nigerian products almost killed the Ghanaian industry.

In response to these developments, the Film Producers Association of Ghana (FIPAG, as VIFPAG was renamed in 2002) sought the help of the state to protect the market against the "dumping" of Nigerian movies. Remarkably, in a document called "Influx of Foreign Films" (Film Producers Association of Ghana 2002) presented to the government, FIPAG adopted the state discourse on cinema in criticizing Nigerian films. FIPAG acknowledged that Ghanaian producers had made mistakes in the past and conceded that "our films must ultimately aim at liberating the minds of our people from superstition, devisive [sic] tendencies, ethnic and religious wars, ignorance, squalor and diseases such as the HIV/AIDS pandermic [sic] which is currently engulfing the entire African continent" (Film Producers Association of Ghana 2002, 2). Next to the bad cultural and social effects of the "influx" of Nigerian movies—which were criticized for displaying excessive violence and sex-related activities and for enhancing superstition—the producers also pointed to the disastrous economic effects. Nigerian movies usually were smuggled into Ghana.[42] Thus, importers circumvented the payment of the required import duties and did not submit the movies to

censorship authorities. In FIPAG's view this was against ECOWAS (Economy Community of West African States) trading protocol, stating that it was "shameful that dumping in combination with the practice of exclusion [of Ghanaian movies from the Nigerian market] is being perpetrated by one set of traders against their counterparts in a friendly neighbouring ECOWAS country" (Film Producers Association of Ghana 2002, 5).[43]

FIPAG demanded that the government take measures against smuggling Nigerian movies into Ghana and make sure that all movies were approved by the censorship board. To protect the market, it called for a release system that would lower the number of Nigerian movies launched per week. The producers also formed an antipiracy committee that mobilized customs officers to prevent the import of Nigerian movies and pleaded with the government to place a ban on Nigerian movies in 2003. Video film marketing even became the topic of a meeting between a high-powered Nigerian delegation and Ghanaian government officials, but no regulatory measures against the influx of Nigerian movies were ever undertaken. This outcome shows even more clearly that private video producers could not expect much from the state, as film production and consumption now were entirely controlled by the free market.

The overwhelming success of Nigerian movies among Ghanaian audiences generated a severe crisis in the Ghanaian video film industry. In 2003 its future looked grim. Movie production was down. Many producers shifted to other activities, at times related to film production (e.g., making product advertisement spots for television), at times unrelated (e.g., selling ice water). The records of the censorship office show that after 2004 there were hardly any new Ghanaian films registered, and the industry almost died. In this period the bulk of films presented to the censorship board were Nigerian (even though most Nigerian movies were not taken there at all). As I have mentioned, I had originally contemplated framing the book I intended to write in terms of the rise and fall of the Ghanaian video industry. Yet, against all odds, the industry has been able to regain strength.

The only way to survive was to try to win back the hearts of Ghanaian audiences by direct competition with Nollywood. This implied, first of all, that it was necessary to shift to the VCD format in which Nigerian movies had been sold since 2003. For some time VHS and VCD technology coexisted, yet within a span of a few years the latter replaced the former. Established video sellers who had invested in technology for VHS reproduction experienced big losses when they launched Nigerian movies in the VHS format, while informal traders already illegally imported VCDs of the same

films. Ghanaian audiences adjusted rapidly to the change, because cheap VCD players from Asia were available. Offered at a cost of around GHC 25,000 (GHS 2.5), a VCD player was within relatively easy reach and became present in many urban homes.[44] In a setting such as Ghana, where the "latest" fashion is much valued, Nigerian movies had the aura of being technologically more advanced, whereas Ghanaian videos looked comparatively old-fashioned. In retrospect Safo analyzed the situation as follows: "We were overtaken by technology. We released films on VHS, they already used VCD. We used an outdated technology" (interview, 10 Jan. 2008).

In 2004, together with video shop owner Danfo B. A., Safo successfully relaunched a number of his old VHS movies in VCD format.[45] VCD reproduction, which was carried out in specific plants (since 2005 there have been two in Ghana), was much cheaper than copying VHS tapes. The relaunch generated substantial capital, which Safo and Danfo B. A. invested to come back into the business. They rented a huge space in an office building in Newtown, bought their own equipment, including digital cameras and editing facilities, and employed several crews, each of which would work on a movie. The movies were mainly in Twi (with English subtitles), and many of them were shot in Danfo B. A.'s home village Sapeiman, where they set up a film village. Also, following the example of Nigerian producers, Safo founded his own acting club in which he trained young people not only to act but also to perform other aspects of film production. He proudly likened the enterprise to "a well-oiled machine, like a German car" (interview, 10 Nov. 2007).[46]

Safo and Danfo B. A. made a lot of money through a series of witchcraft movies, called *Kyeiwaa*. Completely ignoring the constant and typical criticisms from the film establishment, Safo made the kind of movies popular audiences were craving: witchcraft, comedy, "rituals" or occultism, and last but not least sex. Provoking scandals by transgressing boundaries became his new trademark, and he actively called on the media, which he himself called "hyping," to make his movies become the talk of the town.

Other film producers also returned to the business in 2005. Following Safo's example, they placed importance on having one's own office, equipment, and personnel (usually employed on a freelance basis).[47] Thanks to the total shift from analog to digital electronic technology, producers got control over the whole production process up to the final version of the movie and ordered its reproduction at the VCD plant. Simply by owning a number of computers—often ingeniously adapted to the tropical environment (fig. 5)—and having the know-how to use editing programs, producers no longer

FIGURE 5. Editing at Aak-Kan Films (April 2010). Photograph by author.

needed to depend on editing facilities and the services of editors. Many producers started to run their own acting clubs or acting schools, from which they recruited most of their casts. The improved quality of the movies' camera work, plot, and sound was appreciated by audiences, who were even prepared to pay more for a Ghanaian VCD (GHS 2.5) than for a Nigerian one (GHS 2.00). Filmmaking paid again and was a lot of fun.

The shift from VHS to VCD reconfigured the field. Those who had been major players before and had big stakes in VHS technology were surpassed by people like Safo and Danfo B. A., who first adopted the new technology and were able not only to produce a number of blockbusters but also to sell them in Danfo B. A.'s shop (fig. 6). Other big producers taking up VCD emerged. Along with Miracle Films, which was never out of the business

thanks to its key role in the Kumasi Twi language film scene and a capacity to quickly adjust to the new technology, Venus Films, owned by Abdul Salam Mumuni, emerged as a producer of "high-class" glamour films. There is a huge contrast between Safo's movies, which bring a lot of juju and other occult matters to the screen, on the one hand, and Abdul Salam Mumuni's films, which visualize the life of the wealthy and beautiful, on the other. Whereas the former worked extremely quickly and made concessions on quality, the latter established his company as technologically sophisticated. Having operated as a video shop owner since 1999, Salam made a name as a first-class film producer with *Beyonce: The President's Daughter* (Venus Films, 2007), a blockbuster movie featuring spectacular cars, houses, and costumes—and for this reason mistaken by many viewers for a Nigerian production. With this kind of movie Salam consciously and successfully competed with Nollywood. Much of his inspiration for the type of films he produced came from Indian movies; when I last spoke to him (23 April 2010), he was actually developing his network into the circles of Bollywood. Having traveled to India, he realized the importance of the cinema for generating good publicity, so he launched his movies in the only posh cinema in Accra, the Silverbird, in the Accra Shopping Mall (established in 2007). Salam was able to "create" some new stars, including Jackie Appiah, Nadia Buari, John Dumelo, Majid Michel, and Yvonne Nelson, and as all producers readily admitted, these set new and high standards for Ghanaian movies. It is remarkable that many of these stars have light skin, suggesting that Salam's movies profile a particular (and problematic) ideal of beauty (as a well-known actress with a darker skin who was sidelined by him complained to me). Some of these stars, who were also featured in joint Ghanaian-Nigerian productions, contributed to the rise of the Ghanaian industry. Many viewers believed that by taking part in such coproductions, Ghanaian actors polished their acting skills considerably. So whenever these star actors appeared in Ghanaian movies, people were easily drawn.

Safo and Salam Mumuni represent the two sides—juju and glamour—that demarcated the field of Ghanaian movies and acted as trendsetters for other producers over the past few years. Driven by the urge to keep audiences attracted, Safo and Salam Mumuni released extremely controversial movies with, for Ghanaian standards, highly revealing sexual scenes and suggestive titles like *Hot Fork, Sexy Angel, Love and Sex* (all produced by Safo in 2010), and *Guilty Pleasures, Heart of Man,* and *Dirty Secret* (Venus Films, 2009, 2010, 2011), with many other producers following their example.[48]

FIGURE 6. Danfo B.A.'s shop at Opera Square (January 2008). Photograph by author.

The rebirth of the Ghanaian video film industry in VCD format again faced criticisms from the perspective of the state discourse on cinema for failing to educate and affirm African culture and values. During my visit in 2010 movies containing sex scenes were heavily criticized, both from the film establishment and in public debates.[49] All in all, the shift to VCD implied further severance from the realm of state cinema and its emphasis on education and a move toward a kind of cinema thriving on attraction and excitement, just like Nigerian movies.

The phenomenal attention paid to Nigerian movies throughout Africa (via the sale of VCDs and the TV satellite channel Africa Magic) and the coinage of the term *Nollywood*[50] generated a debate among Ghanaian producers about their position in the field of moviemaking in Africa. They believed that, even though the use of video for film production had started in Ghana some years before Nigerians also ventured into video production, the Nigerians had been able not only to win over Ghanaian audiences but also to gain some international recognition and esteem. Clearly, the point was no longer to make it at FESPACO but to be as successful as Nollywood. In 2005 William Akuffo founded a movie studio, located on the road between Tema and Sogakope,

which he called Ghallywood. He registered the label under his name. The huge terrain contains not only a number of private houses for actors, a canteen, and Akuffo's personal office but also a boarding school that offers three-month courses in film production for youngsters from Accra and the neighboring countryside. During my visit in 2010 Akuffo expressed his high ambitions and his dream about Ghallywood becoming the center of "high-class" movies made in Africa, operating on the same plane as Hollywood and Bollywood. His initiative met with some reservations from his fellow video film producers, partly because they were suspicious about Akuffo's ownership of the label *Ghallywood* and therefore preferred to use the label *Ghallygold*.[51] Nonetheless, all agreed that Ghanaian producers needed to unite to be able to compete with Nollywood and gain global recognition.

During my last field trip I noted that ultimately the reshuffling of the video film industry had yielded a new self-confidence among Ghanaian producers. Many of the old producers were back in the business, and new ones were entering the field. Now the more established ones looked critically at the technologically mediocre productions of the newcomers. While the former acknowledged that they had also made a lot of mistakes in the early days, they insisted that the improvements made over the past years set a new standard that needed to be met. Along with films being launched as VCDs, the satellite channel Africa Magic Plus broadcasted nonstop films made by Ghanaian producers and from some other African countries (while Africa Magic is restricted to Nigerian movies). African movies were shown on TV all the time, and Opera Square was the place for new movies to be launched, with huge and spectacular computer-printed posters screaming for attention (fig. 7). With many new productions coming out, all competing for audiences, FIPAG took on the task of organizing producers and sellers in order to control the release of new movies. Obviously, this was a feeble enterprise, as the imposition of release schemes depended on the acceptance of successful producers with their own shops, who needed huge sales to keep their companies going.

Since 2011, however, the industry has started to face an even larger challenge: the rise of private television channels that broadcast Ghanaian and Nigerian films day in and day out. These channels had bought rights for screening old movies as often as they liked from producers for the relatively low sum of GHS 200. In early 2015, as I finished the last revisions of this book, the video film industry as I got to know it has almost broken down, and it remains to be seen whether and how it will rise again. With so many movies on display via television and the Internet, audiences feel less inclined

FIGURE 7. Opera Square (April 2010). Photograph by author.

to buy new films than they were before; this makes it difficult for producers to generate the capital necessary to make new films and requires them to develop new procedures to generate attention (Socrate Safo, phone interview, 13 Dec. 2014; Akwetey-Kanyi, phone interview, 16 Jan. 2015; and Augustine Abbey, e-mail, 17 Jan. 2015).

CONCLUSION

This chapter has shown that Ghana's evolving video industry was framed in the context of existing practices of mediating culture and the discourses around it. There is a clear line from the concerns about the potentially immoral or misguiding effects of commercial entertainment in colonial times, to the rejection of foreign movies as detrimental to the "African personality" in the postindependence state discourse on cinema, to the film establishment's fierce criticism of Ghanaian video movies as alienating audiences from African culture, and even to Ghanaian video film producers' worry about the influx of Nollywood films. Clearly, the discourse about

video incorporated earlier discourses about colonial and postindependence cinema, involving the ideal spectator, the threat from outside, and the (im) morality of moving images. Even though video technology ultimately came to replace celluloid, it would be a mistake to conceptualize the relation between cinema and video as a linear move from one medium to the other. Put differently, video was mediated through cinema (see Larkin 2008, 6).

The fact that, for a considerable time span, video producers deliberately presented video as a mere substitute for celluloid, and hence as operating within the well-established sphere of cinema, shows what is at stake. Producers, audiences, and the national film establishment did not use video as an entirely new technology with its own unique features but as one that encompasses and makes up for the shortcomings of good old celluloid. While it was certainly acknowledged that video differed from celluloid in terms of production—cost, handling, development, and capacity for color—the meaning attached to video as a technology and its use in social settings was grafted onto the long-standing meanings and uses of cinema.

This placed video in a minefield of contradictions. I have pointed out that a gap exists between the state discourse on the educational purpose of cinema and its actual social uses. The ideal spectator addressed by this discourse and actual audiences did not converge. The tension between education and entertainment that has existed since the British colonial administration recognized cinema as a useful medium and mediator of colonialism has been exacerbated over the years. After independence this tension was mapped onto a sharp opposition drawn between African culture and national identity, on the one hand, and the "influx" of dangerous materials from outside, on the other. This opposition underpins a scenario in which the ideal spectator of educational cinema was under siege, threatened by immoral and alienating moving images from outside. The task of the state was to protect and guide this endangered subject, who was prone to imitate the pictures he or she saw. As we have seen, however, there was a gap between the strong articulation of a view of cinema as harbinger of national education and cultural identity, on the one hand, and the actual capacity of the state to make this view materialize, on the other. Cinema appeared difficult for the state to master, technologically as well politically.

This chapter has traced the actual demise of celluloid, which started with the lack of funds to produce feature movies and ended up in the sale of the GFIC to a private television company, opening the doors wide to the rise of a commercial film culture. Notwithstanding the fact that the GFIC shifted

to video and that censorship was imposed on all locally produced and pub-
licly screened video movies, it is clear that the arrival of video did not restore
the capacity of the state to control film production and exhibition. The rise
of video entailed a phenomenal boost for the sphere of commercial film that
was closely tied to the expectations and desires of local audiences and was
dominant in the "low-class" cinema venues. Like Akuffo, many of the self-
trained video filmmakers had a background in commercial cinema (as man-
agers, operators, or just as fans of movies) and made use of their expertise to
design movies that would be a hit among the audiences. Operating as a sub-
stitute for celluloid, video increased the presence and appeal of commercial
cinema, thereby invoking harsh and often repeated criticisms from the film
establishment and worries about the kind of spectator addressed in popular
video movies. The post-1992 liberalization and commercialization of the
media, including film, further exacerbated the rise of commercial cinema and
entailed a decline of state control over the means and modes of cultural
representation.

The trajectory of the Ghanaian video film industry over the past twenty-
five years, as examined in this chapter, can be situated at the interface of the
state cinema discourse and the privatization of filmmaking, along with the
public sphere at large. This official discourse persisted in the face of a chang-
ing political economy of culture that allots the state a less and less effective
say over film production and consumption. Instead, the success of movies
and the profitability of the Ghanaian film industry depended ever more on
meeting the taste of its audiences. This situation was intensified by the phe-
nomenal popularity of Nigerian movies, in response to which Ghanaian
video film producers' resistance to the discourse of the establishment
strengthened. Along with wielding control over video's capacity for repro-
duction, it became crucial to please audiences, even if, as was the case for
many Ghanaian producers, this implied deliberately moving beyond the state
discourse on film (which was still maintained against all odds and ever more
severed from actual control over film, as I have shown). It is ironic that
Ghanaian private, self-trained producers, who initially were able to satisfy the
wishes of audiences by making films that diverged from the usual movies in
the framework of cinema as education (which still largely underpinned GFIC
productions), had by the turn of the century almost lost their audiences, who
turned en masse to Nollywood productions. From then on Ghanaian pro-
ducers struggled to retrieve their viewing public by intensely mobilizing an
aesthetic of attraction and transgression similar to that in Nigerian movies.

Having stressed that video was welcomed into the void left by the downfall of celluloid, it is nonetheless important to emphasize that the two technologies differ considerably. Though framed as a substitute for celluloid, and hence fit to slip into the sphere of cinema, this chapter has shown that video is a far more accessible and cheaper technology. This particular affordance allowed new players, who had hitherto not had the opportunity (or the skills) to handle a camera and shoot a movie, to enter the circles of movie production, exhibition, and distribution, giving rise to a thriving popular video film industry with numerous types of jobs and new audiences. Like the big transition from celluloid to video, which brought new actors into the circles of moviemaking, the smaller transitions from cinema screenings to the sale of videos for home viewing and the shift from VHS to VCD reshuffled yet again the field of movie production. The quick appropriation of the technological aspects of these transitions made it possible for some producers, such as Safo and Danfo B. A., to assume a more central role in the aftermath of their shift to VCD.

The easy accessibility, reproducibility, and portability of video entailed their own contradictions for private video filmmakers. Video is a democratic medium that is easy to handle but difficult to control. In contrast to celluloid, virtually everyone can shoot video movies, get access to pirated copies, and exhibit or sell them. When video filmmakers were still satisfied with screening their movies in the cinemas, piracy was not yet a big problem. Drawing video into the ambit of cinema worked as a mechanism of control, through which the potential for mass reproduction was blocked. This changed with the transition to selling movies as videos for the home, itself a consequence of the increasing quantities of movies awaiting screening. Video producers, as this chapter has shown, were haunted by the reproductive potential of video. Not only did they face the threat that their own movies could be pirated by others, especially outside of Ghana in the diaspora, but they also worried about the incessant presence of huge numbers of movies from other Ghanaian producers and above all from Nigeria, which decreases the chance for a single video to receive much audience attention. With the rise of Nollywood—described in terms of "influx" reminiscent of the earlier state criticism of the rise of video in the 1980s—producers attempted to control the situation by claiming and regulating the Ghanaian market, a project for which they even appropriated the state discourse on cinema and sought the support of the state. Clearly, an ultimately irresolvable tension existed between the easy accessibility and the control of video. Video's technological

properties made it both a blessing and a curse for producers. Next to this, the propensity of audiences to watch movies at home and the increasing availability of old video movies on private television channels also affected the industry. It seems that, ironically, producers suffer from the ongoing demand for screening their old productions on television, with heavy financial consequences that preempt the making of new movies.

To conclude: in this chapter I have sought to offer insight into the contradictions, paradoxes, and ironies of filmmaking in contemporary Ghana. State discourses about the virtues of film (and African culture at large) and the need to "educate the people" coexisted alongside thoroughly liberalized and commercialized infrastructures for the production and consumption of movies. The reproductive potential of video called for modes of controlling what ultimately was uncontrollable. At stake is the opening up of the public sphere as a stage for displaying, on a massive scale, hitherto silenced popular imaginaries that addressed not the ideal spectator of the state discourse on cinema but an alternative one that had so far thrived outside of the spotlight of state cultural politics. The visualization of these imaginaries onscreen, as undertaken by the video film industry, reflected as well as contributed to a fundamental reconfiguration of the public sphere. The particular aesthetic of these movies will be explored further throughout this book.

TWO

Accra, Visions of the City

During my research on the video scene I was on the road—first in a white Toyota station wagon (Verrips und Meyer 2001), then in a blue Opel Astra station wagon, and finally in a green Nissan Almera—virtually all the time, from about 10:00 a.m. (when the heavy traffic from Legon to Accra had eased considerably) until late in the evening. Having my own car was very convenient, as the locations that I had to visit—including the premises of the GFIC at Kanda and NAFTI at Cantonments, the video shops and stalls at Opera Square, the censorship board office at the North Industrial Area, numerous cinemas and video parlors in popular neighborhoods, Pentecostal churches, editing facilities, design shops and printing presses (for posters), video producers' offices, film sets, and more or less fancy spots to conduct interviews with people in the film scene—were scattered all over Accra. On my rounds I could at times take along producers, actors, or video exhibitors and use the time spent in the car for discussions. The unavoidable traffic jams and long distances to cover often provided much time to talk. Traffic jams were markets by themselves, with sellers offering a stunning range of things, including newspapers, magazines, drinks, ice cream, toilet paper, fans, plastic toys, small electronic gadgets, fanciful lights, dog leashes, Jesus posters and other religious articles, calendars, and, of course, the latest Ghanaian and Nigerian video movies. For me, driving was not just instrumental, getting me from one point to another, but a mode of participation in urban mobility. Roaming through the city was an exciting experience, through which I got a good sense of the outlook and gradual transformation of the infrastructures relevant for the video industry and the city at large over a period of fifteen years. The first thing I did any time I came back to Ghana for a new period of fieldwork was to find out about new road constructions and flyovers, fanciful spots, and

"places to be." As this chapter will show, given the symbiotic relationship between the video industry and the modern city, these sites would sooner or later feature in movies.

In the beginning I did not frame my research as urban anthropology but took the city as a mere context. During my fieldwork, however, I gradually realized that I was not only conducting research *in* the city, exploring Accra as an urban space hosting the video industry with its shifting nodes and relevant sites, but also *on* the city, studying the way Accra was represented in video movies and how this related to audiences' views and experiences of urban life. The image of Accra depicted in movies was quite different from the impressions I gained by driving through the city. I noticed a gap between the city of everyday urban life and the beautified city that appeared in most of the movies. Although video movies are part of the lifeworlds of their viewers in complicated ways, they offer only a partial view of the dreamed, utopian city. With the exception of so-called epic films, films that foreground the settings of the urban poor or exotic "traditional" sites did not do well commercially.

The movie *Reward* (dir. William Akuffo, World Wide Motion Pictures, 2000) offers a case in point. It focuses on the wretched existence of a poor car mechanic who lives in a kiosk—a temporary wooden structure that is even too small to contain his bed, so that we see his and his wife's feet extending out of the door at night. In a popular neighborhood this movie depicts the difficulties people face in everyday life—poverty, marital infidelity, the death of children, and witchcraft. I liked this movie very much because of its almost documentary character; it was indeed advertised as a "true life story." But in conversations with audiences I learned that the film was not "nice," not worth the price of admission. Who wanted to see this kind of low-class neighborhood? Didn't the filmmaker have the money to rent good locations, posh cars, and beautiful costumes? Another movie that various audiences described as "not nice" is *Subcity* (dir. Socrate Safo, Movie Africa Productions, 2006). This film tells the heartbreaking story of a young girl in Bukom, a traditional Ga area in Jamestown (Accra), who, as a result of maltreatment and poverty, goes into prostitution and ultimately contracts HIV. The film was shot in the neighborhood where Safo had grown up. For him the motivation to make this movie was his wish to educate people about the dangers of AIDS. But from the outset, when he was still planning the film, it was clear to him—and this proved to be right—that such a movie would not make

money because the audiences expected another, more elevated, urban environment.[1]

Rather than situating plots in the messy popular quarters of Accra, successful video movies focused on more exquisite vistas, zooming in on what were considered beautiful spots. In the beginning of my research I often questioned filmmakers about their choice to more or less block out colorful markets, popular neighborhoods such as those where most of the audiences lived, simple roadside drinking spots, street restaurants—in short, sites familiar to the audience. They made it clear that this was not the Accra they wanted to depict; and somewhat irritated, they wondered why Westerners were so fascinated by the mess and were not interested in the beautiful, clean, and modern sides of the city? Why always go for an exotic, and ultimately dirty and backward, Africa? they wondered.[2]

Blocking out popular areas and, as I will explain in more detail below, representing the contemporary village as backward, the modern city was the prime setting in which plots evolved. The term *modern* is grounded in a vocabulary that came into being in colonial times and refers to a mode of life that seeks to "break with the past" and to take part in the wider contemporary world (Geschiere, Meyer, and Pels 2008). Framing the "past"—as well as "tradition"—as modernity's "Other," the terms *modern* and *modernity* refer to an (if only partially) accomplished trajectory of "civilization," "progress," and "development." My use of quotation marks indicates that these terms belong to particular ideological discourses of colonial and postcolonial governance, are mobilized in scholarly analysis, and feature in popular parlance. This being so, the point is not to give an objective definition of these terms, as it were, but to explore the politics of their use, especially with regard to the expectations and anxieties enshrined in these terms in popular thought and speech (Ferguson 1999) and, of course, in the urban imaginary conveyed by video movies.

The fact that Ghanaian video movies went for the "modern" does not imply that they were confined to merely displaying urban beauty. Quite a number of them addressed the dangerous dimensions of urban life. Rich city people were shown to go astray morally, squandering money in fanciful consumerist settings, often at the expense of taking care of a loving wife and children at home. Modernity was shown to entail its own moral problems and dilemmas. A number of movies, including Nigerian ones, even explicitly featured the city's new occult societies that engaged in "rituals." These

societies were held to be formed by "big" people who appeared as beautiful and nice, owning fanciful mansions and flashy cars, going to work in multi-story office buildings, but owing their wealth and status to ritual murder. Here the modern city was made to appear as a facade behind which evil things happened that movies set out to render visible. Much to the dismay of local film critics and intellectuals, this kind of movie not only confirmed "superstitions" instead of educating and uplifting the audiences but also created a deeply problematic image of Ghana and Africa at large for outsiders.

Not unlike the industry of telenovelas, the video film industry was a dream fabric that displayed the much-desired, glamorous—though morally problematic—life of the happy few in clean urban environments, while the daily mess that was so familiar to the audiences was usually bracketed out. Ghanaian video filmmakers did not simply use film to "document" urban space in all its facets but conjured a partial vision of Accra as beautiful, neat, and developed, albeit with its own spiritual and moral dangers. It was a Janus-faced vision—both utopian dream and specter—that many people found fascinating because it resonated with their aspirations, desires, and anxieties. Ghanaian video films—and even more so their Nigerian counterparts—produced a particular vision and valuation of urban space and its proper representation that was deeply indebted to popular Christian views of the city. I argue that these movies may therefore best be regarded as both mirrors of and windows onto a popular imaginary of urban modernity, with its particular material culture, lifestyle, and notions of personhood and belonging. Exploring the depiction of Accra—and to some extent Lagos—as a modern city onscreen, this chapter focuses on the beautiful *and* spectral dimensions of streets and buildings, on so-called self-contained houses in new middle- and upper-class neighborhoods, including the associated consumption and fashion, as well as on urban models of personhood. The point is to grasp how the mediation of Accra in video films both reflects and feeds into specific forms of urban life, with its infrastructures, work and entertainment sites, modes of dwelling, lifestyles, and notions of personhood and the groundedness of these elements in popular Christian attitudes. In other words this chapter shows how the urban imaginary invoked by video movies both mirrors a particular vision of the city and feeds back into actual urban life. With the notion of an "urban imaginary" I do not wish to invoke a contrast between an actual physical world and a level of mere imagination but instead insist that, as Rolf Lindner put it poignantly, "the imaginary, far from constituting a flight from reality, is another way of connecting to it" (2006, 36).[3]

Like most contemporary cities in Africa, Accra is characterized by an interference of topographies, with their particular spatial arrangements and architectonic structures, which originated at different times, crystallizing old and new political-aesthetic visions of the city (see also De Boeck and Plissart 2004; Quason 2014; Pinther 2010; Pinther, Förster, and Hanussek 2012). In other words Accra is not simply a physical environment that consists of historical, intersecting layers—an urban texture—but also a heterotopic space that generates (partly competing, partly overlapping) urban imaginaries that offer "interpretive grids" through which urban life is experienced and given form (Soja 2000; see also Lindner 2006a). In Accra the intersection of these layers is rife with contradictions rather than being contained in a more or less peaceful chronology (see also Larkin 2008, 6). As I have stated already, in audiovisualizing a broadly shared popular imaginary, video filmmakers made conscious choices in blocking out certain locations that they found unsuitable for representation onscreen and foregrounded others. To understand what underpinned the choices they made in mediating the city in their movies, it is necessary to briefly trace the layers, and the associated political-aesthetic visions, that make up Accra today.

Prior to becoming the capital of the crown colony of the Gold Coast in 1877, Accra was the political, economic, and spiritual center of the Ga state. Formed in the seventeenth century at the crossroads of trade between the transatlantic economy and the African interior, Accra was never inhabited by the indigenous Ga population alone. European trading forts, powerful African immigrant merchants, and Ga leaders competed for a share of the wealth generated through trade in gold and slaves (Kilson 1974, 6). The Ga, as Parker (2000) showed, were engaged in a long-term process of "making the town," by seizing opportunities for trade and bridging political and cultural frontiers. Since its inception, Accra has hosted diverse population groups—a fascinating instance of African urban cosmopolitanism (Kilson 1974, 6). Far from being a mere colonial creation, Accra is part of a long Ga history of urbanism and was already well-developed before it became the colonial capital. After 1877 the city was "at once the headquarters of the new colonial order and the epicenter of an older Ga world" (Parker 2000, xix; see also Quason 2014, 37–63), rife with tensions and conflicts.

Along with being part of the traditional Ga area, contemporary Accra also bears traces of the architectural development realized under the colonial

administration. Its concern with sanitation and hygiene implied a policy of racial segregation (maintained until 1923), leading to the establishment of a European Quarter at Victoriaborg (later called Ridge). The administration also established a town council that wielded authority over the setup of the city, bypassing traditional Ga bodies. While Accra never was a city strictly separated along racial lines, segregation patterns nonetheless persisted into the twentieth century (Hess 2000, 40). Also the designation of commercial areas, for instance High Street in Central Accra and new model settlements such as Adabraka, as well as the resettlement of parts of Jamestown to Korle Gonno (where Palladium Cinema was located), shaped the city structure. The main concern of the colonial administration was to establish Accra as a commercial and administrative center. Since the British did not intend to host a substantial number of white settlers, they invested little money in general urban development. They rarely interfered in the traditional Ga areas and other settlements inhabited by Africans that became increasingly crowded with migrants. Under Governor Sir Gordon S. F. Guggisberg (1919–27) deliberate measurements were taken to turn Accra into a modern colonial city, with an infrastructure of broad roads and a bridge across the Korle Lagoon that allowed the city to expand westward, as well as the construction of schools, hospitals (including the well-known Korle Bu Teaching Hospital), and leisure spots (such as the polo field on the coast, located between High Street and the coast in central Accra). Nonetheless, also under Guggisberg, access to "development" was partial, with popular settlements remaining marginalized. Since the 1940s, in the aftermath of the 1939 earthquake that destroyed parts of Accra, the city witnessed deep structural transformations. The growth of the population entailed not only an increasing differentiation along ethnic and class lines but also a diversification of living areas (Pinther 2010, 46). During World War II the British architect Maxwell Fry drew up a master plan for Accra that was indebted to the modernist architecture associated with Le Corbusier, Walter Gropius, and Mies van der Rohe; after the war the plan was further developed by B. D. W. Treavallion and Allen Flood. It was driven by a vision of the new modern city, constructed from scratch, on a blank sheet of paper. The central idea was a spacious layout with dual roadways connecting the different functional zones, such as the commercial and administration districts, with residential areas. The plan reveals a concern with order and hierarchy (Pinther 2010, 45–50). While it shaped the infrastructural layout that still typifies Accra today—designing important through roads and new residential areas—the plan never materialized in full.

Paradoxically, in master plans of the time, popular neighborhoods were left blank, making it seem as if they were empty and thus open for further planning, whereas in truth they contained most of the inhabitants. This blanking out is typical for the colonial vision of the city as a space that was to bear the imprint of colonial modernity. As I have stated already, these neighborhoods were marginal to colonial city planning and policies, while commercial aims and the infrastructure required by them were the focus. The movie *Jaguar,* directed by Jean Rouch (1957), which was shot shortly before independence, fleshes out these blank spots. The film gives a wonderful impression of the attraction that Accra, as a modern and developed city, had for people in other parts of West Africa. Following the journey of three friends from Niger to the Gold Coast, the film offers stunning views of the bustling central business district and gives a glimpse into popular urban culture with its own modes of consumption. Tellingly, one of the three friends associates himself with the Jaguars, who adopted the name of the car brand to underscore their newly acquired flamboyant lifestyle (not unlike that of the Sapeurs in Brazzaville [Gandoulou 2008]). *Jaguar* (pronounced Jagwah) was a term popular in the 1950s and represented "the quintessence of modern life" (Collins 1976, 54). There also was a famous concert party company called the *Jaguar Jokers* (Collins 1976, 54–57). The film *Jaguar* itself was screened in the local cinemas (Jane Rouch 1964, 183), where new urban forms of leisure and consumption developed (Pinther 2010, 93–104).[4]

Under Kwame Nkrumah the colonial master plan was reconfigured, the major differences being the emphasis placed on the improvement of hitherto marginal and overcrowded areas (this, however, had little practical effect) and the construction of new markers of Ghana's independence. The Nkrumah administration embraced modernity and sought to shape Accra accordingly, adopting what was known as the "International Style," a style that transcended the local in favor of new forms conducive to signifying the modern nation. As Janet Hess argued, the reconfiguration of the urban context under Nkrumah occurred within a broader project of shaping Ghana not only as "imagined" (Anderson 1983) but—literally—as a "constructed community" (Hess 2000, 42; see also Pinther 2010, 48). Sites such as Black Star Square, Independence Arch and the associated assembly ground, State House, the Ambassador Hotel, the National Museum, and the Organization of African Unity building (popularly called Job 600) were icons of Nkrumah's vision, in which architectural modernism was merged with "an imagining which allied the heroicized image of Nkrumah with a culturally homogenous

notion of the 'nation'" (Hess 2000, 53). Interestingly, African traditions—reframed as Sankofaism—were part of this modern vision.

With the overthrow of Nkrumah in 1966, large architectural projects under construction in Accra came to a standstill. A number of the buildings constructed under Nkrumah—such as the Ambassador and Star hotels—were abandoned and left to deteriorate under the military government that came into power.[5] When I visited Accra for the first time, in 1988, I was struck by the level of deterioration of buildings and streets, the lack of color, the absence of big building projects, the shortage of basic goods in the open market and in once upmarket stores with promising names such as Glamour or Kingsway, and the virtual absence of entertainment venues.[6] Shortly after, with the liberalization of the economy, the look of the city started to change. Throughout the extensive period of my research, though I did not conduct any specific research on city construction and urban problems, I witnessed a boom in the building of hotels, enterprises, (mega)churches, streets, and new commercial and entertainment spots, such as the street connecting traditional Osu with J. B. Danquah Circle, popularly known as "Oxford Street" (Quason 2014), and the Accra Shopping Mall located at Tetteh Quashie Circle (which started operating in late 2007). Along with this, Accra expanded on all sides by new middle- and upper-class neighborhoods such as East and West Legon, Adenta, Oyibi Ashongman, Taifa, and Kasua, consisting of sheer endless areas of plots with self-contained homes, many of which were still under construction as of this writing. These areas also contain niches occupied by the poor, who render services to the rich, while the traditional Ga areas and older popular neighborhoods are also bursting at the seams. Along with spectacular private initiatives since the early 1990s, the state has also undertaken a number of construction projects. Most notable are the National Theatre, the National Conference Centre, and the Nkrumah Mausoleum, the final resting place for Nkrumah and his wife, Fathia, which is located on the former colonial polo ground on High Street, where Nkrumah proclaimed the independence of Ghana. These developments are in line with a broader reappreciation of Nkrumah's vision and achievements in contemporary Ghana.

Thus, today, Accra includes a heterogeneous set of areas that originated at different times: quarters such as Chorkor, Korle Gonno, Jamestown, Osu, Labadi, and Teshie, which fall under various Ga traditional authorities; the central business district, which includes the post office, Opera Square, High Street, Makola Market, and central lorry stations; an area for ministries and

state administrations; and vast spaces ceded to the army (Ghana Air Force at Burma Camp, the Military Academy at Teshie). There are also upmarket residential areas such as Ridge and Cantonments that host a mix of mansions (often for expatriates), office spaces, embassies, and cultural centers; upper-middle-class residential areas (Labone, Dansoman); long-standing and new popular neighborhoods with multiethnic inhabitants (Kaneshie, Russia, Odokor, Pig Farm, Abeka, Lapaz), some of them initially planned for Muslims (Adabraka, Nima, Newtown), as well as the aforementioned middle- and upper-class residential areas, which are still under construction. Between 1960 and 2000 the population of Greater Accra (the whole traditional Ga area, including the city of Accra and the adjacent harbor town of Tema) grew from about five hundred thousand to almost three million (Twum-Baah 2002, 3). This growth is primarily due to migration; in 2000 Greater Accra, which occupies only 1.36 percent of the total land area of Ghana, housed almost 16 percent of the country's population (Twum-Baah 2002, 2).[7]

In Accra the envisioned modern beautiful city materialized only partially, yet as a partly utopian vision it is nonetheless omnipresent as a project to strive for. The dream of "development" and "progress," materializing in new four-lane to six-lane highways and flyovers, neat housing complexes, hospitals, electricity, and happy citizens, is still evoked in state propaganda, as well as in commercial advertisements. However, the capacity of the state to convert this vision into reality was put into question by the presence of buildings that were under construction for years without showing much progress, bad roads with more potholes than asphalt, decrepit vehicles kept on the road only by the constant work of handy roadside mechanics, illicit dwellings and overcrowded areas, foul-smelling open drains failing to match even the lowest standards of hygiene, and many disabled persons, beggars, and traders plying their wares in traffic jams and on pedestrian pavements. This situation persisted long after the implementation of the Economic Recovery and Structural Adjustment programs. Indeed, as Michael Herzfeld aptly put it, "Cities, often created in part to monumentalize the permanence of the nation-state, can easily become the seat of challenges to its vision" (2001, 146).

Yet the shortcomings of the state in narrowing the gap between the vision of progress and its actual, tangible realization does not make people discard this vision as such. As in other parts of Africa, in Ghana people affirm certain "expectations of modernity" (Ferguson 1999), insisting on the wish to realize the dream of the good life, which they associate with the modern, beautiful city. These at least partly unfulfilled expectations and experiences of being

excluded and marginalized form a resource for new public players, especially Pentecostal-charismatic preachers, who promise alternative routes to "progress." As I explained in my introduction, Pentecostal views and practices have also spilled over into popular entertainment. The video film industry, in particular, itself an outcome of the liberalization of the media, has tended to more or less cruise along with Pentecostalism's popularity. As will become clear later in this chapter, salient elective affinities exist between video movies and Pentecostalism with regard to the city, understood as the epitome of modern life.

MEDIATING THE CITY

The city has been a prime source of inspiration and an object of representation right from the beginning of film (Kracauer 1947). To be reassembled into a whole on the level of the imagination, the fragmented and vast space of the modern city itself seems to require the medium of film to counter experiences of increasing fragmentation and distraction. As Walter Benjamin (1999) argued in his essay on the work of art in the era of technological reproducibility, cinema offers a new mode of looking at the city, through which the city becomes involved in a new imaginary.

Many postcolonial states that held or still hold a monopoly on film have strategically used film to construct a national identity (Hjort and MacKenzie 2000), with the capital being the ultimate symbol of the nation. Films sustain the myth of the nation through a specific imaginary, with the city as the key symbol. Able to convey an imaginary of the city as a coherent whole by zooming in and editing out, film can be harnessed to make up for the difficulty of matching the actual, constructed city with the vision of the ideal city. As I suggested in the previous section, visions of a "city yet to come" (Simone 2004) feed into actual architectural works, which in turn figure as indexes of the vision out of which they were conceived. There is a circular relation between the levels of the envisioned and the constructed city, between the urban imaginary and the actual physical environment, and film plays a central role in conjoining these levels. Nkrumah's bold vision of Accra as a modern city materialized through a number of constructions, such as Black Star Square and other icons of modernity and progress but did not shape the city as a whole, which retained crowded settlements and messy areas. Nonetheless, the key icons that referred to Nkrumah's vision, as well as his effigy, were

reproduced and spread via stamps, postcards, and film, offering an aesthetic of make-believe that makes it difficult to maintain a neat distinction between actual urban space and the envisioned city. This use of media in conveying ideal images of the city fits in well with Nkrumah's ideas about film. Even though the GFIC archive no longer exists (at least according to my inquiries), we can assume that the newsreels shot by the GFIC also conveyed Nkrumah's view of modernity as "a sign of national and political achievement" (Hess 2000, 45). Here lie the roots of the preference I encountered among video filmmakers for depicting signs that stand for "development" and "progress" and for the association of this kind of forward movement with "beauty."

As we saw in chapter 1, with the breakdown of the state film industry and the rise of video, control over the politics of representation changed. Thanks to the cheapness and easy accessibility of video, an alternative urban imaginary could be projected onto the screen. Under conditions of media liberalization, the use of audiovisual media for offering alternative visions of the nation and other (for instance religious or ethnic) forms of community was seized by people who hitherto had been forced into the role of mere spectators and targets of the state vision of cinema as education. Under these conditions popular ideas and imaginaries that had so far been more or less barred from exposure in official channels could "go public." Nonetheless, it is important to realize that these alternative imaginaries did not bring a complete rupture with earlier state visions of the city.

Video movies were usually replete with long scenes—in fact, a bit too long for Western spectators used to African art films—in which cars took the audiences on a ride, passing by established key icons of modernity. Instructively, these scenes were usually accompanied by Western-style music. Instead of offering the usual perspective that was familiar to ordinary people who traveled in cramped minibuses, called *trotros,* or on foot, these movies transposed spectators to the back of a smoothly running limousine, making them feel like motorized flaneurs (see Green-Simms 2010). The city thus emerging through the gaze of the camera located at the back of the car—many filmmakers kept audiovisual libraries with clips of day and night travels through Accra—crystallized a dream image, rather than mirroring an actual, lived-in space. This image mobilized the—to some extent outdated yet partially still appealing—imagery of modernity, with its International Style architecture, large squares, and clear street design. The recently completed state-driven initiatives in road construction and new buildings, such as the Nkrumah Mausoleum, were smoothly incorporated into this image. Despite the

privatization of the video film industry and its gradual decoupling from the state discourse on "film as education," filmmakers still tended to use the visual language of icons of "progress" that hark back to the Nkrumah era.

Of course, this visual language existed alongside representations of new fancy sites for conspicuous consumption generated as a consequence of the liberalization of the economy. The video movies launched over the past fifteen years may well be regarded as a veritable audiovisual archive that documents the gradual metamorphosis of, for instance, Oxford Street, displaying the latest additions to hip venues selling fast food, drinks, and ice cream. Clearly, the point here is not the depiction of national icons that refer to the state as the guardian of "development" but of global consumer items being conspicuously present, as people put it with a flash of national pride, "in our Ghana here." As Ato Quason argues (2010, 2014), Oxford Street, with its countless shops and advertisements, presents itself as an interface of the national and the transnational, promising Ghanaians that just by stepping in they can take part in emergent global patterns of consumption. Analyzing advertisements of mobile phone companies, Quason shows that this advertising imagery offers a vision of black youth, which is not marked as Ghanaian but encompasses Africa and the Caribbean, as taking part fully in a global consumerism (2010, 85–88; 2014, 145–50). In Oxford Street Ghana is part of the world. The local encoding of this street became clear to me when I visited places on it with my interlocutors. After a lunch at Frankie's, a pizza parlor and ice cream bar, one woman who worked at the censorship office thanked me for taking her there, saying, "You make me feel big." The representation of Oxford Street in video movies was to evoke among audiences a similar feeling of proud incorporation in the realm of a beautiful modern world—an intriguing instance of "Afropolitanism" (Selasi 2005; Tuakli-Wosornu 2007) at home in Africa.[8] Movies offered the possibility for a mimetic participation in global consumption, as a means to connect with and claim full membership in the contemporary world, albeit on the level of the imagination (see Ferguson 2006, 161).

The combination featured in video movies of icons of state-driven modernity and new images of consumerism spotlights a reconfiguration of the promise of "development" and "progress," which was no longer the sole province of the state but involved multinational private enterprises, as well. The city of Accra, as it appeared in video movies, was no longer a bounded space controlled by the nation-state's politics of representation, which sought to match the imagination and construction of the nation through iconic sites.

This mix of well-known icons belonging to an earlier visual "language of stateness" (Hansen and Stepputat 2001) and items associated with global capitalism depicted Accra as part and parcel of the global infrastructures of transport, communication, and technology through which capitalism operates (see also Larkin 2008; Sassen 2002; Simone 2001). Video filmmakers were not only urban entrepreneurs who emerged as a consequence of the rise of the infrastructures that made video technology and technologies for cassette and disc reproduction available; they also acted as visionaries who conjured up a view of Accra in which global infrastructures were shown to have touched ground, moving the city into the range of fancy and developed sites and inviting audiences to step in.

In contrast, the village was usually represented as a backward space, stuck in poverty and ignorance. Many movies poked fun at village girls arriving in the city. They were shown giving themselves to immoral men who took them out to fancy boutiques, restaurants, and hotels. These girls were depicted as having no idea of how to dress; they could not walk in high-heeled shoes and had no clue how to eat with a knife and fork. Villagers were depicted as amazed by the iconic sites and consumer items available in Accra. For instance, in *Kiss Your Wife* (Video Africanus, 1995), a villager is fascinated by an electronically driven advertisement, placed at Kwame Nkrumah Circle, that displays three subsequent images. When a man passes by, telling the villager (who is of course recognizable by his outfit and habitus) to pay GHC 1,000 for each image he watches, the poor chap readily does so and even thinks that he duped the city-dweller because he admired the changing images not just once but several times. This scene captures the extent to which the village was regarded as opposed to the city, with its entirely different values and lifestyles. Mistaking an advertisement for a genuine consumer item, people from the village did not yet understand the language of modern consumption, let alone master urban modes of fashioning the self. On the whole, far from cherishing village life and propagating a "return to tradition," as was often the case with African art films, many video movies depicted the village in a rather negative manner. As Tobias Wendl puts it aptly: "In a temporal dimension the 'village' marks the past, whereas the city marks the present. In Freudian terms, the village forms part of the 'uncanny,' of what the city has repressed, and what now returns from time to time into the consciousness of the city-dwellers as 'the horror of tradition'" (2007, 5). This resonated with many urban inhabitants' ambivalent stance toward the village. It was a place where they still belonged (and ultimately would be buried)

because of the extended family but was also deeply problematic and opposed to their vision of modern life (see Pinther 2010, 202–11).[9]

Thus, video films transformed Accra into a modern urban space similar to depictions of cities in foreign movies by zooming in on what fit this view and deliberately excluding certain sites: a way of "editing" the city by means of deliberate cuts that extended into the editing room, where the pictures were further fashioned and underlain with appropriate sound. The transformation of Accra from a very messy space into a simulacrum of the modern, orderly designed city onscreen had a remarkable impact on audiences. Again and again I heard from viewers that it was wonderful to see—and show to foreigners—the beauty and "development of Ghana" (by which they actually meant the capital, the symbol of the nation) onscreen. This was also asserted by many Ghanaians in the Netherlands, who used movies as windows to see how Accra "developed" in their absence. Even though the dream of progress and development failed to materialize in the lives of many, they still aspired to it. Filmmakers used video to conjure up a vision of this desirable city. In so doing, they produced a modern vision of the city that was necessarily partial, selective, and at a distance from the everyday urban life of the majority of their audiences. Even though it was a dream image, however, the beautiful city depicted in movies had real effects in that it shaped audiences' ideas about the good life, development, and urban behavior.

BEHIND THE FACADE OF BEAUTY AND PROGRESS

As we have seen, video films also derived appeal by visualizing the city as an immoral and even uncanny sociocultural space. Many films addressed the theme of the old and fat, yet wealthy, "sugar daddy" who ultimately lost everything and ended up disgraced because of his inability to control his libido and stick to his faithful wife. Conversely, young women typically were shown as easily seduced by fancy goods, nice cars, and hip entertainment; ultimately, they ended up in the gutter. Along with the city's seductive consumerist possibilities, its anonymity was also depicted as potentially problematic. Unlike in the village, in the city people did not know each other's background and family, and this could cause disaster, as in the movie *Our Father* (Movie Africa Productions, 1997). In this film an old man finds out that he has impregnated his own daughter, whom he took as his girlfriend. Many video movies picture the modern city as a potential realm of immorality, fueled by

the quest for sexual pleasures and luxury goods. This moralizing critique resonated well with ongoing discussions—held on radio, on TV, in churches, and among groups—about the moral decline that was perceived as haunting Ghanaians in general and urban residents in particular. This critique focused sharply on the young (because "they don't respect" and because they adopt "indecent" dress styles) and on married men, who were easily seduced by good-looking yet all the more financially demanding girls.

The theme of the scary city, in which beautiful appearances conceal underlying ugly and dangerous things, can be traced right back to the first video movies. The aforementioned *Diabolo* figure could operate only in the anonymity of the city at night, where he spotted his prey in fancy bars. The character was inspired by *An American Werewolf in London* (dir. John Landis, 1981) and adapted to the local situation, which entailed refashioning the monster as a snake-man. Akuffo told me that he even knew a village woman who had watched the movie and then set off to Accra immediately to warn her daughter about this kind of man (interview, 4 Oct. 2002). In his view *Diabolo* was a moral film that would alert the young to the dangers of city life and admonish them not to sell their bodies or trust wealthy strangers. In the city it was especially difficult to look behind the surface of appearances, where nothing is what it seems. This was one of the lessons video movies taught.

Partly in response to the great popularity of Nigerian movies, with their emphasis on occult forces in the city (since about 2000), in Ghanaian video films the theme of a rich, city-based person's involvement with occult forces became increasingly important. This kind of film echoed an understanding of the city as being haunted by "a seemingly arbitrary circulation of the unknown" that AbdouMaliq Simone found to be characteristic of many African cities (Simone 2001, 17; see also De Boeck and Plissart 2004). In 1999 a number of women were found dead around Accra, sometimes with missing sexual organs. This became a matter of great public concern; people were afraid to go out at night and reproached the police for not finding the killer(s). How was it possible, it was asked, that the state could not protect its citizens?—thereby suggesting links between the spheres of the police, politics, and the criminal rich. Two films—*Accra Killings* (Kama Films Production, 2000) and *Mataheko: The Danger Zone* (Corporate Films, 2000)—were made about these events. Likewise, both the popular and the "serious" press fueled such moral panics, with accounts stressing the dangers of city life, the impossibility of trusting people, and the need to always be

alert ("Be vigilant!"). All these things affirmed people's conviction that in the city they were in dire need of spiritual protection, as it was impossible to know what kind of invisible spiritual forces governed the visible world. The fears about Accra as an unsafe place not only offered material for films but also affected the video film scene in a practical way. One of the reasons why, after 2000, producers gradually started to release their films immediately as videos for home consumption was that people did not feel safe going out to the movies at night. At that time many people complained to me that Accra was becoming increasingly like Lagos, which especially at night was allegedly a hunting ground for serial killers who sold human body parts to become rich. One was no longer able to trust anybody. My friends often warned me not to stop at traffic lights at night or, better, not to go out at all—an impossible option, of course, given the nature of my research.

There is an intriguing relation between the vision of Accra, as depicted in Ghanaian movies, and that of Lagos, as shown in their Nigerian counterparts. Arguably, Nigerian video films played a primary role in disseminating a view of Lagos as increasingly out of control—a kind of Sodom and Gomorrah on African soil—which seemed to resonate with Ghanaian migrants' experiences in urban Nigeria. In Lagos people supposedly employed immoral and even occult means to progress in life, and this turned that city into an apocalyptic hunting ground. If Lagos—both the way it was pictured in movies and according to people's own experiences—was deeply admired for its high level of consumption and overall wealth, Accra was regarded as having yet to reach that stage. This was a somewhat mixed blessing, since—as Nigerian movies showed—the achievement of wealth in Lagos had its own price. The new models of success were people with a dubious morality; preeminent symbols of the modern city, such as office buildings that could be the meeting places of secret societies; the trunk of a Mercedes Benz, symbol of success, might contain a dead body; a plastic bag from a posh store might contain a human head; a brand-new, clean banknote might have been vomited by a zombie locked up in a casket; an Internet café, icon of technological development, might be unveiled as a node in a network of fraud that was underpinned by dangerous spiritual forces (e.g., the blockbuster *Blood Money: The Vulture Men,* OJ Production, 1997). All these were shown to happen in Accra as well, but people were still convinced that Lagos was ahead with regard to wealth and glamour, as well as occult involvement. In the vision that the movies conveyed of the city—Lagos, as well as Accra—audiences were urged to look beyond the surface to find out the true nature and

origin of things, especially when fabulous riches were displayed. That the cherished icons of state-driven development and consumerist venues were shown to be especially suspect revealed ambivalences about progress and development in the "city's confused modernity" (Okome 2002, 324).

Revealing in this context is the remarkable absence of scenes, both in Ghanaian and Nigerian movies, depicting people at work. While one recurrent location was the office, it was above all a backdrop to invoke the flashy world of business. The focus was usually on the boss—well-dressed, rich, and immoral—and his secretary—good-looking, sexy, and serviceable. She picked up the phone, acting as a gatekeeper for the flow of unwelcome visitors, especially extended family members who imposed moral and financial obligations on the boss; and, of course, she was the target of the boss's sexual advances. The office did not appear as a space in which real work was done—often, it was by no means clear what the business was about—and this affirmed the vision of a modern, consumerist lifestyle that came, to invoke a Pentecostal phrase, as a "divine blessing" or, conversely, was based on "blood money." In many films the real way of making money—even on the part of Pentecostal pastors who were increasingly shown to be "fakes," since they reputedly obtained their spiritual powers by paying secret visits to traditional priests—was shown to occur through occult means, involving contracts with spiritual forces, zombies, and the use of magic for persuasive fraud.

So far, I have concentrated on visions of the city as a public space shaped by iconic images and consumer items that index a particular understanding of "development" and "progress." For the rest of this chapter my focus will shift from the vision of urban space at large to the way residential areas, fancy homes, and the material culture of their inhabitants are pictured in movies. In taking this trajectory, we will move closer to the urban lifestyles that were depicted—or, better, scrutinized and questioned—in video movies, as well as to the model of personhood that underpinned the vision of the self-contained house.

NEW RESIDENTIAL AREAS

As I have mentioned, the past twenty-five years have witnessed a remarkable extension of the city, with ever more plots demarcated on the outskirts on which self-contained houses—usually built with money earned by Ghanaian migrants in Europe and the United States—are located: an index of the

owner's financial success. East Legon, built in the 1990s, was one of the posh-est new construction areas of Accra, a place to be for celebrities from sports and business (see Pinther 2010, 107–30). Huge constructions combining, for instance, Roman-style pillars and exuberant roofs, with glittering tiles and walls painted in bright colors—a postmodern pastiche—caught my eye. One house looked more impressive than the other and might serve as a model for other evolving areas. As the construction of a house depended on one's avail-able funds—there was practically no possibility of getting mortgages—the process from start to completion might take up to fifteen years. Indeed, the houses under construction, and the emergent neighborhoods in which they were located, testified to a vision of city life that was still in the making.

Like the emergence of Oxford Street, the residential building boom would have been impossible without the adoption of Structural Adjustment pro-grams and the adoption of democracy and a civil government.[10] In the period between 1984 and 2000 the housing stock increased by 108 percent, with the main building activities taking place after 1990 (Grant 2009, 67). A great deal of the building boom depended on Ghanaians abroad,[11] who started to mas-sively invest in "long-distance house building," spending between US$25,000 and US$400,000 of their remittances for their dream house in Accra (Grant 2009, 67; see also Yeboah 2000). The phenomenon of the building boom signaled the confluence of transnational migration, on the one hand, and the liberalization and commercialization of the economy, transforming land hith-erto associated with Ga chiefs into a commodity, on the other. The new neigh-borhoods were sites where "transmigrants" made a new lifestyle that was at loggerheads with earlier, "traditional" modes of life and indebted to global culture.

During my last stay in Ghana, in April and May of 2010, many people whom I asked about the building boom expressed their surprise that the people building new houses were usually quite young. Kodjo Senah explained to me that, until recently, building a house was a matter of concern for mature people only. Having a house would not only reflect a "big man" status in the family but also implies taking on extensive moral and social responsibilities for the family at large (see also Kilson 1974, 30–31, 37–47). A family house would be open to all (needy) family members. A sharp contrast existed between the modes of dwelling of the older (socially senior, yet financially poorer) generation and the younger (socially junior, but rich) generation that sought to set itself apart,[12] creating intergenerational tension and instability in kinship relationships. Building became a largely individual project, turn-

ing the house into a statement about one's personal achievement and identity.

This resonates with Grant's finding (2009, 88–89) that the recent building boom implies a break with traditional conceptions of land, kinship and dwelling, and community life. Marketing land and building fenced houses— or even gated communities—stands in marked contrast to the mutual obligations and mode of attachment that underpin the family home. Generally speaking, members of a family have an inalienable right to the family house, which is usually organized as a compound, with an open space for cooking and washing and separate rooms all around. Even if a person decides not to live there, he or she has the right to access it for particular ritual social events, such as funerals or "outdoorings" (an important family ritual to celebrate the birth of a child). With the building boom, however, family members with financial means invested less and less in the upkeep of family houses, which appeared more and more wretched, often housing a large number of poor family members. The rise of the mansion and the deterioration of the family house were two sides of the same coin. Grant notes that since about 1990 a stigma has been attached to the family home; living there, certainly at a mature age, came to be regarded as a sign of failure, while, conversely, moving out into a "self-contained" house was taken as a sign of success. While he certainly has a point that, with the recent building boom, staying in the family home was coded as a sign of personal failure, it is important to realize that the idea of moving out of the extended family into a nuclear family home is not recent; it was already propagated by nineteenth-century missions (Meyer 1999b). The stigmatization of the family home, coupled with the building boom, was part of a broader transition, in which new models of success emerged that bypassed older appreciations of seniority, education, and, to some degree, soberness. Flamboyant dress, a flashy car, and a fancy mansion inhabited by the nuclear family became the visual markers of the new spirit, which was supported by the rise of Pentecostal-charismatic churches. As I will argue below, the modern self-contained house, and especially the high-class mansion, featured as the natural accompaniment for this model of personhood and its vision of the good life. Obviously, the connection between Pentecostalism, wealth, and a flamboyant lifestyle raises major questions about this particular kind of Christian religiosity, which is difficult to place within a Weberian framework of the Protestant Ethic, with its emphasis on "innerworldly asceticism." With respect to both its outlook and its mode of worship, this kind of Pentecostalism is firmly grounded in the here

and now and operates as a gatekeeper to a successful, morally sound, modern way of life that may, however, easily be corrupted and derailed (Marshall 2009; Meyer 2007a, 2010a).

Of course, as I have stressed already, ideals should not be taken at face value. The flip side of the remarkable building boom was a great shortage of decent housing for inhabitants of the cities (Buckley and Mathema 2007; Yeboah 2000). Official statistics indicated that around 2011 Ghana still lacked housing for about one million people (Kodjo Senah, personal communication). Following the economic liberalization policies of the early 1990s, private participation in the building industry was phenomenal. This brought about a new politics of inclusion and exclusion, which privileged those with money and transnational networks to seize the new opportunities. Those who did not have financial or sociocultural capital were left alone, with nothing to expect from the state any longer. Nonetheless, the new neighborhoods, consisting of an ever-expanding patchwork of plots, each of which was used by just a small number of people, spoke to the imagination. The capricious mansions represented in movies became models of and for a new glamorous way of life, from which most viewers, however, were excluded in their everyday lives. Actually, many of the viewers themselves lived in crowded popular areas, in family houses or small rented rooms in compound houses. This often involved troubles, as I also witnessed during my first period of fieldwork in 1996, when I stayed in the popular neighborhood of Teshie, in the midst of compound houses inhabited by families from different ethnic groups, temporary shacks hosting mainly people from the North, and, of course, plenty of churches. Watching movies with people in the neighborhood, I realized that the gap between their type of houses, which was barely represented in movies (and if so, usually negatively, as an untenable situation), and the high-class, self-contained mansion visualized in movies was the space for the fabrication of dreams of a modern and presumably better life. The high-class mansion located in Accra's new posh residential areas was taken as a tangible sign of the new times to which many people aspired and which they enjoyed seeing in movies.

THE SELF-CONTAINED HOUSE ON THE SCREEN

A self-contained house was distinguished from other types of houses by having its own bathroom(s) and kitchen and a fence around it, permitting access

to be controlled. It was inhabited by a nuclear family and some servants (maid, houseboy, watchman, gardener). The ideal of a marriage in which husband and wife lived together with their children, undisturbed by other family members and strangers, was much emphasized in movies. For example, one quite early Ghanaian movie, *Dangerous Game* (Aak-Kan Films, 1996), problematized the shortage of houses for young couples. A man in desperate search for a place to stay with his wife rents a room from a landlady who lives in a high-class mansion and lies to her that his wife is his sister. A series of misunderstandings ensue, in the course of which the husband is torn between the flirtations of and increasing financial dependency on the landlady, on the one hand, and the increasing anger and jealousy of his wife, on the other. The movie shows how the husband's initial lie about his actual marital relations yields fatal misunderstandings that not only disrupt the marriage but also turn the man into a killer. The central message of the movie, reiterated by many other films, is that for married couples it is better to have a house of their own, undisturbed by perpetrators who interfere with the couple's life. Also, taking a second wife is shown to be a recipe for trouble (as in the paradigmatic and much-discussed movie *Fatal Decision* [H. M. Films, 1993]). Another key theme in movies is the interference of in-laws in the life of recently married couples, with a mother-in-law often playing a destructive role because she cannot stand a situation in which her son gives his wife more (financial) attention than her, or the older generation pressing the couple to quickly give birth to a grandchild (*Twisted Fate* [Piro Films, 1993]; *Not Without* [Hacky Films, 1996]). Movies celebrating the self-contained house as the natural habitat of the married couple resonate with the high valuation of this urban way of life and the importance of not only a material but also a mental fence shielding off the nuclear family, especially young and middle-aged persons. As will become clear below, this also resonates with the Christian, and especially Pentecostal, views of personhood and belonging in southern Ghana that I encountered during my research.

While, generally speaking, Ghanaian films from the outset leaned toward visualizing a modern urban lifestyle and (as much as possible) posh locations, it became the particular trademark of the "high-class" film production house Venus Films to spot new stunning, glamorous sites. Its director Abdul Salam Mumuni told me enthusiastically that recently homeowners had even started approaching him to offer their houses as locations (interview, 24 April 2010). Salam's movies revolve around (often fair-colored) stars and huge houses, with a garden, a swimming pool, and an impressive lane in which to park cars

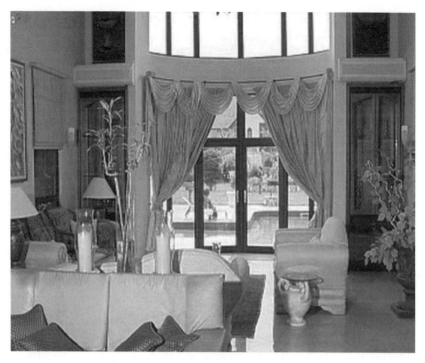

FIGURE 8. Living room, screenshot from *Princess Tyra*.

(fig. 8), as in *Beyonce: The President's Daughter* (Venus Films, 2007), *Princess Tyra* (Venus Films, 2008), and *Who Loves Me?* (Venus Films, 2010). His locations and movie stars set the standard for other producers, and his movies were the talk of the town. Many movies invite viewers on a tour through all the rooms of the house, including the kitchen and bathroom, putting the house on display for audiences' scrutiny (for earlier examples see *Matters of the Heart* [Great Idikoko Ventures, 1993] and *Jennifer* [Gama, 1999]). The living room is where visitors are received and the family gathers to watch television and to have dinner. As in real life the living room is representative of the house owner's status and achievements (see Pinther 2010, 53). In high-class houses there usually is a flat-screen television, a dinner table (often made of glass), a set of leather sofas and easy chairs, a big cupboard containing glasses and chinaware, and—if space permits—a bar or a billiard table. Decorations on the wall include large-format photographs of events in the life of the family—for instance, marriage photographs—as well as stylish pictures and fancy lights. Some interiors feature items marked as African alongside modern, global designs and often also some kitsch (for instance, a

glittering plastic Christmas tree, present all year round, as in *Who Loves Me?*). In short, the interiors testify to the transnational setting in which homeowners operate (see also Grant 2009). Displayed on the screen, these houses were to generate a mixture of amazement and pride that such glamorous homes, previously associated with telenovelas and Nigerian movies, now also existed in "our Ghana here," affirming once again, like Oxford Street, that Ghana was part of a cosmopolitan world.

Lifestyle

The conspicuous display of beauty and wealth ensured that audiences regarded films as trendsetting with regard to the latest fashion and lifestyle. As the opposite of what was celebrated as *the latest*—a label typically used to advertise video movies—stood things dismissed as *colo,* a term used to refer to old-fashioned things. From the beginning of cinema in Africa, film has played a central role in developing and spreading new urban styles, for example via the figure of the gangster, the cowboy, or Superman (e.g., Burns 2002; Powdermaker 1962, 261–64), as well as local appropriations, such as the aforementioned Jaguar people featured in Rouch's film. From the perspective of the discourse on film as education, audiences fascinated by these figures were regarded as copycats, unable to resist the outward appeal of these role models and hence alienated from their own African identity, culture, and values. The fear associated with so-called copying was based in a paternalistic and moralizing discourse that presupposed a proper African identity and was suspicious of creative experimentation in the sphere of popular culture. Instead of regarding spectators as potential victims falling prey to Western influences, I approach spectators as agents who struggle to design their lives on the level of the everyday (de Certeau 1984) and in so doing take up—or "copy," provided this is not understood as a mechanical process but as creative appropriation—things they liked. Therefore, I advocate employing the notion of style to analyze the impact of the display of urban settings and role models in movies. Style here is understood as a shared practice of signification that is based on creative recycling and repetition. Style is central to performing (rather than merely expressing) identity, and adopting it successfully radiates a certain mood that conveys a sense of well-being (Ferguson 1999, 96; Meyer 2004, 95). Shaping appearance, style is a social practice for designing personal and collective identities. *Lifestyle,* understood in this sense, implies concrete and shared practices of signification, through which persons form

themselves, navigating among limited possibilities and high aspirations (Meyer 2009a). As observed by Christiane Brosius in her work on the Indian middle classes, "new identities in the process of being imagined and shared require new spaces (and stages) on which they can be manifested, converted from imagination into actuality and vice versa" (Brosius 2010, 342). Style is one of the central practices through which this conversion occurs, bringing into being a desired urban imaginary.

The high-class mansion was appreciated as a prime location for video movies because it was regarded as the most complete materialization of modern life. Here urban lifestyle was displayed in full. Even though having such a mansion for oneself was an unattainable dream for most viewers, some part of the material culture of its inhabitants could be appropriated more easily. Ever since I started watching movies with Ghanaian audiences in 1996, I have been intrigued by the fact that female spectators, especially, would scrutinize the consumer items that were displayed conspicuously in full detail and at some length in a lot of movies. When there were eating scenes, viewers would draw close to the roasted chicken or whatever was displayed, trying not only to see but also to virtually taste what the people in the movie were consuming. Likewise, they scrutinized and discussed at great length the specific looks of characters, evaluating dresses and hairstyles. In the beginning of my research I often found myself surprised that people would dwell so much on these matters and were not really willing to engage in deep discussions about how to interpret a movie.

Despite these experiences, I only realized in full that this attitude was grounded in a widely shared mode of watching movies (which may be traced back to the beginning of cinema as urban entertainment) through the seamstress Floxy, a woman in her early forties who ran a flourishing sewing atelier with many apprentices in La.[13] At the time we met in 2002, Ghanaian films were comparatively unpopular and losing audiences to Nigerian ones. Floxy, who owned a video player that was on almost all the time, explained to me how irritated she and her apprentice girls were about the bad choice of costumes in Ghanaian films. Could I imagine that a woman would wear the same dress and have the same haircut over the whole period of time covered by a movie?! This was not realistic—urban women strived to visit the hairdresser and beauty salon at least once a week (Kaupinnen 2010)—and was really unappealing. At one time she had lent some of her own clothes to a producer, only to find out that they were not handled well; dresses were destroyed or missing. This showed that Ghanaian filmmakers failed to pay

attention to something as essential as dress and appearance. In contrast she praised Nigerian movies for offering exciting fashion styles that she could copy. She explained to me that she always watched Nigerian movies with the eyes of the seamstress and got inspiration from what she saw. The following interview fragment conveys not only her mode of watching but also my ignorance and surprise:

B[IRGIT]. *So you also look at the cars and the houses? You also look at the styles? And at the furniture?*

F[LOXY]. How they furnish their rooms, yes! And how they have their curtains. Because sometimes, their curtains, they are done with the chairs matching.

B. *Okay . . . I never pay attention to it.*

F. Yeah, I look at it.

B. *And then you learn something from it?*

F. Yeah, I learn a lot. And then sometimes, too, where they lodge [sleep] . . . those who are rich, when they change the bed [sheets], they also change the curtains. So all the time in their bedrooms, the curtains match the bedsheets. (interview, 29 Oct. 2002)

Paying attention to furniture and discerning the match between curtains and bedsheets reveals a detailed, appearance-centered mode of watching that initially was foreign to me. Eager as I was to get at the meaning of movies, I tended to concentrate on the characters onscreen. Thanks to my conversations with Floxy and her girls, I came to understand how important an appealing display of urban style was for audiences watching movies. Many of Floxy's customers used to phone her when a particular movie was shown on television, asking her to make the same dress for them or inquiring about the possibility of getting a certain pretty fabric they had seen (and that probably originated in Nigeria). This particular use of movies as sources of inspiration was not new, per se, nor limited to Ghanaian and Nigerian movies. Since the 1990s the screening of various series of South American telenovelas has led to the emergence of new clothing styles for women. The wildly popular soap opera series *Acapulco Bay,* shown on TV3 in 1998, lay at the base of a phenomenally hip and at the same time contested dress style, called *Apuskeleke,* which consisted of a miniskirt and a tiny top, displaying legs and belly (Sackey 2003). Earlier, the figure of the cowboy or gangster had appealed to

the imagination and generated urban dress styles. Recognizing the impor-
tance of movies for urban fashion resonates with a perceptive body of works
on dress and identity in Africa (Allman 2004; Hansen 2000, 2005;
Plankensteiner and Adediran 2010) that foreground the importance of con-
sumption for expressing a sense of self and belonging. A person's carefully
chosen appearance and outfit, involving beautiful dresses and hairdo, as well
as his or her ability to adopt the latest style, is a performative act through
which a particular aesthetic of the urban, cosmopolitan person is displayed
(Küchler and Miller 2005; Hahn 2008). Georg Simmel's statement about
jewelry also pertains to the items in question here: "Style is always something
general. It brings the contents of personal life and activity into a form shared
by many and accessible to many" (Simmel 1964, 341).

Floxy advised me to urge my Ghanaian filmmaker friends to improve the
outfits of their characters and to upgrade the locations because otherwise
audiences would not be interested in their movies. I did so, but the matter
turned out to be more complicated than I had thought it would be. Many of
my interlocutors tended to dismiss those Ghanaian movies that displayed a
posh material culture as "too artificial"; they knew that urban lifestyle in
Ghana was not as sophisticated as in Nigeria. Even though movies were
appreciated for beautifying urban space, audiences required the representa-
tion of the house and its inhabitants to show some degree of realism. If a plot
was situated in Ghana, and inside the house people dressed elegantly—as
Nigerians were held to do—there was something wrong. The discerned arti-
ficiality unmasked the movie as a pure fiction, too far removed from local
circumstances and exactly for that reason failing to show "our Ghana here"
as being part of the wider world of successful consumerism. For a long time
Nigerian movies were better suited to satisfy audiences' expectations. I never
heard these movies being charged with artificiality, as even the most fancy
expression of wealth (and any other excess of violence, sex, or the occult) was
deemed possible in Nigeria.

Ultimately, the successful use of wealthy locations and well-dressed inhab-
itants in Ghanaian movies was only possible once the building boom had
taken off in Accra. This was the moment when Salam, and others engaged in
more recent glamorous productions, stepped in. These more recent Ghanaian
movies, made from around 2006 on, spoke to the imagination of their audi-
ences in a very concrete manner. Along with dress and hairstyle, the interior
design of houses displayed also prompted audiences to adopt new styles. For
instance, one of my friends, involved in a building project herself, told me

that she and her daughter watched both Nigerian and Ghanaian movies as sources of inspiration. When she saw nice things, she would call her husband to come and see them, and they might then ask their carpenter to copy a piece of furniture that was featured in a particular movie or to go after a particular kind of curtain. The wooden floor in the hall of her new house was inspired by a Nigerian movie. Thus, films were not merely interesting because of the dramatic plot but also—and perhaps above all—because they conveyed a sense of a modern, high-class lifestyle.

In sum, movies offered style items that could be adopted on several levels, ranging from hairstyle to dress, from a piece of furniture to a floor, from a garden design to the look of a house. Important here is that, while the mansion constituted a high-class style as a package, audiences were able to copy and adopt those pieces that were within their financial reach. There were, in other words, different levels on which it was possible to partake in, and seize, at least some part of the world of the happy few. Offering possibilities for a symbolic—or, one could better say, metonymic—seizure of that world, video movies addressed and stimulated new communities of style and taste. Films not only mirrored a world that was aspired to but also offered materials to viewers to become mirrors themselves through the adoption of a modern style. Through style people participated, albeit partly and symbolically, in the glitzy urban world to which they aspired, while conversely, screened images materialized in real life through the adoption of style.

The Bedroom

While movies displayed the outer look of a house and the living room and its inhabitants in a manner that can best be described as conspicuous consumption, they also revealed private and secret matters that were normally secluded from the public eye. As I have argued elsewhere (Meyer 2003b), one of the points of attraction of Ghanaian video movies was that they address audiences as voyeurs, allowing them to peep into what normally remains hidden.

In movies featuring high-class houses the bedroom is elaborate and usually has at its center a huge bed with blankets and fine bedsheets (suggesting the presence of air conditioning). This is the space of intimacy, where delicate matters such as problems of infertility and marital conflicts are discussed between husband and wife. The camera usually fades out when a couple starts getting close to each other and kiss. The suggestion in movies of the

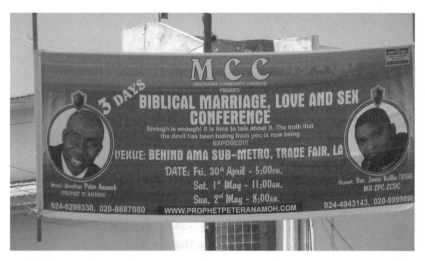

FIGURE 9. Advertising banner for "Biblical Marriage, Love and Sex Conference" (April 2010). Photograph by author.

importance of a satisfactory sex life for the endurance of marriage resonates with the teachings of Pentecostal-charismatic churches. Emphasizing the need for a sound spiritual bond between husband and wife that should be emotionally stronger than the blood ties with one's own extended family, Christian publications propagate a Western-oriented, bourgeois model of the nuclear family reminiscent of the 1960s. However, while these publications and discussion meetings are surprisingly open with regard to sexual matters (fig. 9),[14] movies usually have been more restrained and more or less refrain from exposing parts of the naked body and open erotic scenes involving a married couple.

This changed by late 2009, when a number of filmmakers began to venture into displaying sex more explicitly (although still refraining, as far as I can tell, from exposing private parts apart from female breasts and male buttocks), triggering a public debate about film and morality, with many viewers feeling uncomfortable about the idea of watching such movies with their children or maid being present. These bedroom scenes always depict couples that are engaged in illicit sex, involving prostitution or infidelity. In contrast, married and decent couples are not shown having sex. The depiction of sex is thus always associated with "bad" people. Stripping them naked in front of the camera and showing their private parts is, as it were, a way of exposing their low moral standards. Nonetheless, in movies the bedroom of

the married couple is shown to be at the heart of the modern house, the key symbol of the marital union. This stands in marked contrast to traditional marriage, which would not entail that a couple share one bedroom all the time (see Cassiman 2008; Kilson 1974, 45). Even films not explicitly addressing Christian marriage represent the bedroom as the key symbol of a marital union that is thriving thanks to this shared intimate space.

The bedroom, as an intimate space, is profiled as an appropriate and efficient site for personal prayer. Often persons are shown praying in despair or deep contemplation in front of a picture of Jesus, but at times the Jesus depicted in the picture is shown to act and offer divine protection to the beholder, for instance by instigating a revelatory dream (as in *Women in Love* [Movie Africa Productions, 1996]). As an intimate site suited to open up to the spiritual dimension, a bedroom can also be shown to contain some secrets to be hidden from the public eye, for instance one's involvement with occult forces. Not only do movies display the use of love magic, as phenomenally shown in the movie *Mariska* (Aak-Kan Films, 1999), in which a woman keeps a "spiritual" miniature double of her lover in a pot hidden in a cupboard in her room. There are also quite a number of movies involving a secret cupboard in the bedroom or even a separate secret room devoted to occult forces. Locked with a key, such spaces are shown to contain a pot with a bloodthirsty snake, a coffin, or even a zombie, as in the movie *Time,* a Ghanaian-Nigerian coproduction (Miracle Films, 2000) in which a man kills his wife "spiritually"—that is, by a contract with evil occult forces—and keeps her dead body in a closet in his bedroom, where she vomits money.

House and Personhood

The self-contained home, bounded by a fence and housing a nuclear family, not only offers a model for an ideal modern way of life but also expresses an ideal of seclusion that exists on the level of the person. This parallel between house and person is central. A statement made by one of Kerstin Pinther's interlocutors, a resident in East Legon, illustrates the point well: "The house I own should have its own personality, its individualized appearance" (Pinther 2010, 118). The house constitutes part of the self-definition of the owner. The appeal of a self-contained house goes along with the appeal of modern notions of personhood and visions of the good life, as launched through Christian conversion. As I have argued extensively elsewhere (Meyer 1999b), from the outset the Christian person has been imagined to be less permeable to

influences from outside, in particular from the extended family. The Basler Mission and the Norddeutsche Mission, both active in southern Ghana since the mid-nineteenth century, instigated the building of separate Christian villages or communities and cemeteries within villages that were christened "Salem," with houses for nuclear families, at a distance from what they called the "heathen" settlements. Staying in a traditional home (often also the seat of ancestral spirits) after conversion was regarded as a constant assault on the new Christian's integrity, as living *in* the house meant living *with* the family and ancestral spirits. The new Christian homes, as well as the lifestyle and material culture of their inhabitants, featured as signs of a modern and Christian way of life. Here, new patterns of distribution and consumption developed, and a gap opened up between Christian and non-Christian family members. The former refused to take part (at least openly) in family rituals that involved pouring libations and slaughtering sacrificial animals for the ancestors and saw new opportunities for at least partly renouncing existing moral obligations and rights associated with kinship in favor of closer ties with their spouses and children. Converting to Christianity, dismissing family gods and ancestor spirits, living in a house in the Christian part of the village, and adopting new patterns of distribution and consumption occurred in tandem with a major social transformation in which personal independence became more and more attractive—as it still is today.

This, however, was not a straightforward success story. The popularity of Pentecostalism tied into a longer genealogy of negotiating new models of personhood understood to be severed from family-based social bonds yet proving difficult to attain in full. Instructively, for the Ewe, among whom I conducted long-term fieldwork in 1989 and 1991–92, a person's spirit (*gbɔgbɔ*) was imagined as a virtual space that could be inhabited by different kinds of forces occupying it like a "rented room." The actual occupation of this "room" could easily develop into a battlefield, as is the case in so-called prayer and deliverance services, when evil spirits are cast out of that inner space, making room for the Holy Spirit to enter. In the experience of many Christians the Holy Spirit itself operates as a kind of knife, able to "cut" blood ties that link a person to the extended family and to the village (Meyer 1999b, 179–87).[15] Especially within Pentecostal-charismatic Christianity, the desire to "make a complete break with the past" has been tied to a vision of personal well-being and wealth (indeed, once traditional moral obligations and financial responsibilities to share resources have been discarded, it is easier to accumulate wealth).

This desire is epitomized in the iconic image of the self-contained house that stands by itself. Concomitantly, the Christian person has a metaphorical "hedge" around himself or herself, just like the fence around the self-contained house.[16] The analogy of the hedge and the fence suggests the existence of a mental wall that separates, protects, and shields the person from the outside world. While the hedge is to set off the individual person, the fence sets off the nuclear family. Indeed, the nuclear family house is understood to be the most adequate setting for the new type of (born-again) person who strives to keep the extended family at some distance in favor of other social ties (especially to one's spouse but also to colleagues, friends, and members of one's church). Conversely, from a Pentecostal perspective family homes are often regarded as abodes of the devil, because many of these houses have buried in their compounds ancestral magico-ritual objects that believers regard as retrogressive.[17]

In video movies this dualism has been fleshed out over and over again against the backdrop of the moral geography of city and village, with the latter being the realm of the extended family living in a family house, occult spiritual powers and a form of personhood based on blood ties, and the former standing for the negation of all the village stands for. The conflicting relation between urbanites and villagers is poignantly expressed in the relationship between rich house owners and the maid, who often is a distant family member from the village. Denied access to the table of the rich family, maltreated and sexually abused, the maid is shown to be the victim of the selfish pursuits of her urban relatives, who refuse responsibility and exploit her. Once she has been made pregnant by her master or the son, she is kicked out and abandoned (see *Ghost Tears* [Hacky Films, 1992]; *Naomi* [Harry Laud, 1995]; *No One Knows* [Hacky Films, 1996]).

And yet the project of seclusion on the level of both the house and the person is never accomplished entirely, as a host of narratives, church testimonies, and, of course, movies shows. Oftentimes, people still feel troubled by spirits associated with their home village or their extended family—indeed, with "their father's (or uncle's) house." I take this as an indication of the acknowledgment of being tied into a more encompassing social fabric than the ideal of a secluded personhood might suggest. The same goes for the self-contained house (including the mansion), as it featured in movies.[18] The gate to the yard is a case in point. Especially in the somewhat older Ghanaian movies, it is guarded by a houseboy who hails from the North, still remaining a villager in his attitudes and comportment even though he now lives in the city. The houseboy, often

masterfully played by Price Yawson, alias "Waakye," or by Augustine Abbey, alias "Idikoko," literally acts as a gatekeeper, opening the door for the house owners to leave and enter with their cars and controlling access by visitors (often by telling lies to those who are not welcome to come in, for instance poor family members). He is a liminal figure with janitorial authority, serving to accentuate the difference between undeveloped people outside and the inhabitants of the house, with their wealth and refined manners (although they might hide evil actions, as mentioned above). The houseboy sometimes even acts as a trickster who follows his own plans (even going as far as sleeping with the landlady, just as the landlord or his son might sleep with the maid). By virtue of his humorous naiveté and trickster attitude, the houseboy ridicules or expropriates aspects of the nouveau riche lifestyle that he helps to demarcate. As is typical for the figure of the trickster, the houseboy embodies the ambiguity of the modern urban way of life to which many aspire.

In my view this shows that in many respects the modern way of life represented by the self-contained mansion is not (yet?) entirely taken for granted. The fact that the houseboy is a less prominent figure in later movies revolving around glamorous mansions may suggest a gradual change toward a new standard. While the extended family is still seen as a potential threat to the urban, secluded lifestyle, new and more anonymous threats have emerged. Now concerns about security loom large, and protecting oneself by using the latest means, including electrical fences, has become a central issue. The point is no longer merely to prevent uninvited intruders who might lay claim on the inhabitants by virtue of family ties but above all to keep out thieves and armed robbers (see also Pinther 2010, 123–24). Nigerian movies, in particular, picture the security threats faced by the rich and, as critics have said, teach audiences how to commit armed robbery. Just as the ideal of the modern secluded person is difficult to realize against the backdrop of a social fabric that still partly relies on kinship ties and the concomitant moral obligations and that still places big men under the obligation to share their riches, the self-contained house is still a site that is literally and symbolically "under construction."

CONCLUSION

In the beginning of this chapter I invoked the gap between the city of everyday urban life that I witnessed on my daily rounds and the beautified city

that appeared in the movies. Clearly, it would be a mistake to state that this gap marks an opposition between "real" and "imagined" or "made-up." When video filmmakers questioned me about Western people's preference for a colorful, yet messy and—in their view—ultimately dirty, Africa, they referred to a particular imagination of Africa as it lives in the minds of Westerners. Indeed, we are all familiar with documentaries showing the deplorable marginality of Africa, marked by civil war, corrupt elites, violence, hunger, and the horror of HIV, among other things. African art films tend to offer alternative imagery, pointing to the beauty of village settings and traditional repertoires, or spotlighting the ways people manage their lives against all odds in popular neighborhoods in urban areas. While this imagery is not wrong, per se, it is partial. Given that representation depends on some sort of selection, partiality is unavoidable. A problem arises when partial and selective pictures are invoked as if they show how Africa "really" is. Interpreting pictures in this manner is rooted in a long-standing representation of Africa that ultimately refers back to the old colonial script of the "dark continent"—marginal and different, outside of the "civilized," modern world (Ferguson 2006, 6–7). Viewers easily incorporate pictures of Africa into this script and take them as insightful of Africa "as it is."

The video movies take another standpoint and offer an alternative perspective that challenges the script and representations of Africa that have become familiar to Westerners and that resonate all the more with Africans' anxieties, hopes, and visions. Above all, these movies challenge Western teleological ideas of progress and the good life in terms of increasing modernization and development at the expense of religion. As I have argued, the way Accra has been constructed, and the icons and consumer items it contains, was born out of visions and master plans that were only partially realized yet that fed into the urban imaginary through which the city has been perceived and experienced. Filip De Boeck's view of Kinshasa as a vast hall of mirrors, reflecting different visions of the city, fracturing "Kinshasa's urban world into a series of kaleidoscopic, multiple, but simultaneously existing worlds" (De Boeck 2002, 243; see also De Boeck and Plissart 2004), applies equally to Accra.[19] Video movies relate to these worlds in a specific way. The fact that these films resonate with people's lifeworld, that is, the world of their lived experience, does not imply that they mirror that world in full. On the contrary, tying into desires of moving out of the mess, the point of the movies is to give a glimpse of the "city yet to come" (Simone 2004) by skillfully zooming in on particular parts of Accra (and Lagos) while neglecting others.

Movies mirror people's lived dreams, as well as their lived experience. The envisioned city is invoked through an audiovisual strategy of make-believe that selects and privileges certain key icons.

Even though Ghanaian and Nigerian video movies offer partial views, placing a disproportionate emphasis on certain elements, it would be wrong to dismiss these films as mere fanciful chimeras. The beautiful *and* spectral images of the city—with the former masking the latter—do not belong to a separate realm of fantasy. Instead, these images come out of and feed back into the world of people's lived experience in complex ways. An interplay exists between the "imagined" and the "real," so much so that movies destabilize and render untenable the distinction between these levels. Indeed, what Achille Mbembe said about the mixing of these levels in writing about Africa also applies to the way the city and urban lifestyle and personhood feature in video movies: "The oscillation between the real and the imaginary, the imaginary realized and the real imagined, does not take place solely in writing. This interweaving also takes place in life" (2001, 242). It is exactly in this sense that films both mirror and shape a popular urban imaginary that is part of and yet not congruent with the fabric of everyday life. Or, to quote Lindner once again: "The imaginary city . . . is the reverie of the real. Therefore it cannot be invented arbitrarily. Like a dream the imaginary is latent and deeply rooted" (Lindner 2006, 36). Being rendered "real" by virtue of being grafted onto constructed space, the urban imaginary is not a mere matter of the mind but also exists through pictures and is, indeed, "deeply rooted" in sites, things, and desiring bodies (see also Meyer 2008).

Audiovisualizing a widely shared urban imaginary, the key concern of the movies was to offer a perspective from which Accra appeared to be part of the contemporary world, located within global infrastructures through which people, goods, technologies, and ideas circulate. Not only did the video film industry itself stand for this global interconnection; it also engaged, in the registers of the imagination, in picturing a mode of life in which African urbanites were part of and seized the contemporary world (see Brosius 2010; see also Desai forthcoming for a similar argument with regard to Indian middle classes). This picturing was not confined to the mind but entailed a performative model for action. Invoking Simone (2001; see also Ong 2011), who coined the term *worlding* to describe urban Africans' attempts to relate to the larger world effectively, video films and their producers can be seen as vital instances active in the "worlding of African cities." Adopting urban styles was a key mode through which this worlding occurred. This seizure of

fashion and the desires for a secluded house and personhood are not a matter of simply "mimicking" Western styles but, as Ferguson also argues (2006), should be understood as making claims to membership and participation in a shared, contemporary global world (see Cooper 2005). This is also the motif that underpins the appeal of Pentecostal-charismatic churches and their global version of Christianity (Robbins and Engelke 2010). Even though it may be easy to critically dismiss the consumerism that is hailed in many movies (and via the "Prosperity Gospel"), it is of key importance to also read this deliberate wish to connect with the wider world as a critical political statement that puts commonplace visions of Africa into question and raises major questions about what is African in African culture, religion, and identity. The video film industry offers a fascinating yet edgy case to think through these questions.

THREE

Moving Pictures and
Lived Experience

When I started my research on Ghana's video film industry in September 1996, the number of movies that had appeared so far was around 220.[1] Along with watching movies screened in cinemas and video centers, I wanted to catch up with the stock of older Ghanaian movies that had been produced since the making of *Zinabu* in 1985. Especially in the first month of my research, I asked a number of persons—taxi drivers, shopkeepers, merchants, and neighbors—about movies. I quickly noted that there was a set of very popular films that were associated with particular producers who had achieved the status of household names and who pretty much guaranteed quality. Many people were able to immediately mention a number of titles— *Zinabu, Diabolo, Ghost Tears, Fatal Decision, Whose Fault?*—and enthusiastically told me the story line of their favorite movie. In this way I became acquainted with the field. I visited the few video shops that existed at the time—Sidiku Buari and Hacky Films at Opera Square and the store on the GFIC premises—and talked to the sellers about popular movies. Based on their advice and on the titles that were frequently mentioned in my random talks with people, I purchased a large number of cassette tapes (around fifty). Thanks to my contacts with producers, I was also able to get a number of tapes that were not yet or no longer available as videos for home viewing.

Because I was interested in audience reactions as much as in the movies themselves, I did not watch alone. I rented a video player and television set, and our living room turned into a mini–video center with at times up to forty people present on several evenings in the week. These were women and men, and many young girls and boys, aged between five and fifty years. Even though the sound and image quality of the video player and the tapes was

quite bad, most of our visitors were prepared to neglect these shortcomings, eager as they were to get involved in the movies. For quite some time I tried to initiate discussion after a movie had been shown. Over and over again, however, I was confronted with people's lack of interest in this kind of endeavor. A few polite sentences were uttered to answer my questions, and then there was an uneasy silence to be broken by a demand for another movie. Gradually, I realized that my own, at the time ill-conceptualized, idea of doing audience research by discussing a movie afterward echoed my personal and quite intellectualist approach to movies as bounded cultural products demanding interpretation. Such a stance presumes a distance between the movie and its viewers, with the latter having to figure out the meaning of the former.[2]

This was not how the audiences assembled in our living room looked at movies. Constantly commenting on the pictures, cracking jokes, shouting when there was a struggle, and at times directly addressing the protagonists onscreen, these viewers made watching a film a rather noisy social event. It was an interactive performance. The audiences in our living room—and in Accra's video centers and cinemas at large—acted as sentient and sensual beings, pulling the movie and its characters right into their everyday lives. A good movie, I began to realize, was one that affected people emotionally and made them recognize something about themselves. While special effects were welcomed with intense pleasure, and sometimes anxiety, the basic appeal of movies lay in the fact that they successfully zoomed in on familiar—and family—matters, making people say, "This happened in my house."

Pondering the difficult question of how to do "audience research" in this setting, my understanding of spectators' attitudes toward video movies was sharpened by a remark made by our neighbor and frequent visitor Kwaku after we had watched *Not Without* (Hacky Films, 1996). This movie was about a marital conflict instigated by a mischievous mother-in-law who treats her son's God-fearing wife badly. At that time Kwaku himself was having a conflict with his wife, who had temporarily left him, having taken their little daughter and gone to stay with her parents. Right after having watched the film, Kwaku stated that it made him realize that he had made a big mistake in his marriage and that he felt very sorry about it. Even though the family in the movie was better off than he was—they lived in a mansion, whereas he lived in a compound house, and they had a good car, whereas he had only a run-down taxi (Verrips and Meyer 2001)—he believed immediately that the

film related to his own life. This spontaneous remark opened up my understanding that audiences, in watching Ghanaian movies, expected to recognize themselves and to extract from the movies moral messages for their everyday lives.

Even though the state discourse on film as education and its vision of the ideal spectator collided with actual viewing practices, it is still true that "education"—albeit of a special kind—was a matter of big concern to audiences. Over and over again I heard that they wanted not only to be entertained by a film but also "to get something out of it." The point is that they referred to a moral education that taught how to go about relational matters, especially with regard to marriage, family life, and the extended family. Basing my audience research on an experiential approach to film in which audiences are understood to participate, in this chapter I argue that Ghanaian movies were anchored in and shaped audiences' world of lived experience. Thriving on familiarity and recognition, movies owed their appeal to their capacity for offering moral direction and advice to those living in a modern urban setting. Filmmakers, spectators, and the censorship board all partook in shaping the movies as cultural products expected to do moral work. Exploring the ways in which watching movies was embedded in the world of everyday lived experience, this chapter argues that the movies addressed and constituted audiences as a moral public with a particular ethics of watching.

FILM AND EXPERIENCE

As I explained in my introduction, a great deal of work on African art cinema disengages from actual audiences and imagines the "ideal spectator" as a silent, gazing eye. Focusing on movies as mere objects for viewing, the question of what and how they represent looms large. With regard to the Ghanaian (and for that matter Nigerian) video phenomenon, such approaches have serious shortcomings because they do not get to the heart of the specific relation that exists between state institutions, filmmakers, movies, and audiences in specific historically situated contexts. In the Ghanaian setting in which I lived, filmmakers were closely related to actual audiences, whose world of lived experience they shared, whose stories inspired their scripts, and with whom they sat in order to learn about their watching behavior. Movies were designed in such a way that watching was a communicative and sensory

experience that was linked with issues that mattered in everyday life. Indeed, filmmakers knew very well that "getting something out of a movie" depended on audiences being able to *get into it* and *take it in*. In this understanding a film, as such, would be inadequate as a unit of analysis, the point being that what matters is the overall performance in which audiences engage with a movie in the cinema, in a video center, or in front of a TV.

The basic characteristic of Ghanaian video movies being that they nourish themselves from and feed back into everyday life, a phenomenology of film experience offers fruitful incentives to deepen our understanding. Identifying film as a communicative system that involves relations linking filmmaker, film, and spectators, Vivian Sobchack played a pioneering role in formulating an approach to film theory that examined the act of viewing itself and the communicative competence of viewers to make sense of a movie. Famously, she advocated an understanding of film as "the expression of experience by experience" (Sobchack 1992, 3). Film, in other words, creates a space in which the screening of the *experience of the film characters* simultaneously becomes an *experience for the audiences*.

For Sobchack film is the medium of communication that condenses the exchange between embodied perception and "enworlded" expression: "A film is an act of seeing that makes itself seen, an act of hearing that makes itself heard, an act of physical and reflective movement that makes itself reflexively felt and understood" (Sobchack 1992, 3). Or, in the words of Jennifer Barker: "What we do see is *the film seeing*: we see its own (if humanly enabled) process of perception and expression unfolding in space and time" (Barker 2009, 9). This exchange is also at the core of Merleau-Ponty's phenomenology.[3] From this perspective film is not simply an object for viewing but is best understood as a particular kind of audiovisual language that addresses audiences through the registers of the flesh and via the senses. In other words film is not a mere audiovisual representation but a presence of animated, moving pictures that have the capacity to touch and affect spectators (see also Marks 2000; Sobchack 2004). Intriguing here is Sobchack's view of film as a kind of sensing actor that invites—or seduces—spectators to sense along and thereby participate actively. Though vision is obviously central to film, seeing is not confined to the gaze but is understood to work synesthetically with other senses, especially hearing and touch. What is invoked here is the "corporeal eye," circumscribed as "the embodied view or tactility in our meeting with 'screenic' persons, things, and events" (Verrips 2002, 38; see also Barker 2013; and Morgan 2012). This embodied, sensory kind of viewing resonates

strongly with Ghanaian audiences' visceral, interactive engagement with video movies and underpins an understanding of film as offering a superior "spiritual eye."

Of course, for a film to operate as the "expression of experience through experience," shared structures of experience must link the filmmaker, the film, and the spectators in one communicative fabric: "In so far as the embodied structure and modes of being of a film are like those of filmmaker and spectator, the film has the capacity and competency to signify, to not only have sense but also to make sense through a unique and systematic form of communication" (Sobchack 1992, 5–6). This is a very important general point, helpful for understanding the interactive dynamics that account for the success of a movie with a particular audience. In relation to the Ghanaian video film industry, it resonates strongly with what I referred to in my introduction as the *circularity* between filmmakers and audiences. As I pointed out, for a filmmaker the survival of the business depends on his or her capacity to come up with *moving* pictures that captivate audiences sensorially, emotionally, morally, and intellectually and that leave ample space for interaction among themselves and with the film. *Moving,* here, is invoked in the double sense of cinematic motion pictures and their potential to *touch* the spectators (see also Barker 2013, 13–20; Spyer and Steedly 2013). Filmmakers seek to grip audiences with pictures that resonate, albeit in complicated ways, with their shared world of lived experience. I say "complicated" because this shared world is not congruent with an empirical reality that is simply observable out there but is constituted phenomenologically (see also Jackson 1996, 15). As I have intimated already, this is a world driven by imagined visions and possibilities for the future, haunted by specters of failure and despair, and full of hidden dangers that call for vigilance. It is a world in which a spiritual realm intersects with the physical one, even though the former is not apprehended by ordinary perception—and this is why specialists for spiritual vision, such as traditional priests and Pentecostal pastors, are in high demand. Importantly, as will become clear in this chapter and the next, this demand for some kind of extraordinary vision also includes film. It is for this very reason that a study of film is such a suitable entry point into the urban lifeworld of southern Ghana.

The success or failure of a movie for spectators depends on the capacity of filmmakers to mediate everyday experiences in such a way that the movie incites recognition by and participation of the audiences. *Mediation* is a key term here, as Sobchack also acknowledges in her characterization of film

watching as "both a direct and mediated experience of direct experience as mediation" (Sobchack 1992, 10). By this, she seeks to further refine the statement that film is an "expression of experience through experience." Her point is to emphasize that even though filmic expression both *mediates* (namely, the experience enacted by the film characters) and *is mediated* (i.e., through the cinematic apparatus), it is still "directly" perceived by audiences. Film, as she also puts it, offers "mediating acts of perception-cum-expression that we take up and invisibly perform by appropriating and incorporating them into our own existential performance" (10). Even though she recognizes that film mediates *and* conveys experience, Sobchack's line of reasoning about mediation appears to lack clarity because it retains existential phenomenology's tendency to privilege "direct" perception and experience above mediation.

Here we touch on a more fundamental problem in Merleau-Ponty's phenomenology. I am sympathetic to existential phenomenology's grounding of language and culture in the materiality of the body and its insistence on the interdependency of sensing and making sense. Rather than reducing language to a system of arbitrary signifiers that stand in a referential, and hence distancing, relation to the world, the interdependency of perception and expression allows for an understanding of language—or, more broadly, semiotic systems—as fundamental to processes of both world making *and* signification. Language is rooted in the sensing body and is therefore part of the world, while it also offers the possibility to communicate about the world.

Thus, the centrality that Merleau-Ponty assigned to the body, implying a grounded and embodied understanding of language and communication, is key to get at the constitution of the world of people's lived, "thick" experience that, in my view, is anthropology's domain (see also Csordas 1990; Geertz 1973; Jackson 1996, 2005; Stoller 1997). Nonetheless, one weakness noted by many critics is that phenomenology tends to brush over the fact that perception itself is shaped by sociocultural expressions. Obviously, Merleau-Ponty's version of phenomenology, by understanding perception and expression as "reversible," acknowledges some degree of feedback of sociocultural expressions into perception and experience. This is also highlighted in Sobchack's phrase "mediating acts of perception-cum-expression." The importance, however, of mediation in generating and sustaining *particular possibilities for perception,* while excluding others, is elaborated insufficiently because of the emphasis placed on the primacy of "direct" perception.

We perceive a world that is already shaped by sociocultural expressions that render perceptible particular matters rather than others and that we

engage and possibly make our own through perception. Perceptions, in this understanding, are mediated by expressions that tune the senses of the perceivers, involving them in a socially constituted world that foregrounds certain sensibilities and sense impressions and discards others. "Direct" or "immediate" perception, then, does not precede mediation but is born of it (Meyer 2011b; see also Eisenlohr 2009; Mazzarella 2004). Experience, too, depends on shared modes of perception that allow for a particular experientiality and is thus always mediated. In short, I propose to place center stage the fact that sensations and sensibilities do not emerge from an unmediated, direct encounter with the "world" but arise and are sustained as part of particular sociocultural and sensorial regimes that underpin a particular "distribution of the sensible," to invoke Jacques Rancière. I call these regimes "aesthetic formations" (Meyer 2009a; see also introduction).

Therefore, I propose to advance the understanding of film as mediation by taking into account that, by implying selection, mediation is a project with social and political implications. Instead of remaining within the warm language of phenomenology's existential framework, in which perception and experience are immediate and primary over expression and which entails some degree of blindness to power (see also Knibbe and Versteeg 2008), it is important to acknowledge that film ingeniously converts the mediated experience of others into audiences' own experience. Audiences—provided they do indeed get "into" a film—inhabit and by the same token animate the mediated experiences of the film characters. Nothing can express this process of inhabitation better than the praiseful statement "this happened in my house." Based on this experiential recognition, spectators were prepared to rework, more or less consciously and explicitly, their personal experiences in the light of the movie.

Thus, while for me the phenomenology of film proposed by Sobchack is indispensable for analyzing the impact and effects of video movies, it is imperative to broaden—and, indeed, politicize—this phenomenology by recognizing the ideological operation of movies from *within* the realm of experience.[4] If, in watching a movie, mediated expressions are being incorporated into spectators' bodies and enlivened, we can pose the question of how video movies, as sensational forms, take part in a broader process of aesthetic formation of moral personhood. This is the key question that underpins this chapter. Before getting into the morality purported by movies, it is necessary to explore how Ghanaian audiences were addressed, and hence constituted, as resonating bodies by filmmakers and the censorship board.

ADDRESSING THE AUDIENCES

As I explained in chapter 1, from the outset Ghanaian video filmmakers found themselves in a crossfire of criticisms launched by the film establishment. Video filmmakers' increasingly self-conscious insistence that their movies were woven from the stuff of everyday life—and thus were "true stories"—spotlights a new direction in filmmaking in Ghana that accompanied the deregulation and commercialization of film. Their attitude toward their critics is well captured in the statement Akwetey-Kanyi made about a debate at NAFTI: "They are in the office. We are in the street to hear what people are talking about, and this is what we make our films from" (interview, 7 Sept. 1999). Audiences were not just out there but were constituted by being addressed in a manner that appealed to them. Certainly with the rise of Nollywood, this required that filmmakers constantly struggle not to lose or to recapture their spectators. As film was primarily a matter of business, filmmakers sought to live up to the expectations of the audiences by anticipating what they might like, observing their reactions, and listening to their criticisms. This was more or less successful, and certainly with the increasing availability of Nigerian movies and the overall large number of movies launched per week, it became difficult for Ghanaian filmmakers to keep their audiences tuned in order to at least recoup what had been invested in the production. Importantly, these constraints made for a highly interactive attitude on the part of filmmakers, who, rather than opting for a movie that would express their own idiosyncratic vision, went for audiovisualizing what lived in popular imaginaries and sought to entice audiences to recognize and get into the film plot. In so doing, they had to walk the fine line that separated joyful recognition of what is familiar—"This is (about) us!"—from boredom—"It's always the same old story." Profit came from getting audiences to visit the cinema or video theater (the prime source of income until around 2000), or to buy a cassette in order to watch the "latest" film, and to a lesser extent from selling exhibition rights to national and all-African TV stations.[5]

The necessity to capture and bind paying audiences implied that filmmakers themselves were constantly engaged in an "audience research" of sorts, making themselves receptive to pervasive moods and seeking to harmonize with popular sentiments. In the period when movies were still shown primarily in cinemas and video theaters, filmmakers would regularly sit with the audiences (this was convenient because they had to be present to get their

share of the box office anyway). As Safo explained, "It's a whole culture, you get into the cinema hall and you dissolve into that culture, you will have to flow with the flow, and sometimes when people cry you have to cry along, and when the poor girl is being poorly treated, then people will also cry along. You must study the audience" (interview, 18 Nov. 2002). There was general agreement that studying the audience was necessary for success and could even give inspiration for a new movie.[6] This stance brought about a kind of cinema that, like early Euro-American (Elsaesser 1990; Hansen 1991) and early Indian cinema, "imagined its audience to be present, and was therefore alert to its cultural expectations" (Vasudevan 2000, 11). Movies thereby engaged viewers in an experiential, sensational dynamic that involved, as Safo put it, "a whole culture."

A successful movie, as filmmakers would phrase it, was a film "that is talked about in town." Indeed, movies were not only born out of, but, if successful, also fed back into, stories that circulated in public space. Video filmmakers explicitly aimed to achieve this, for instance by designing short slogans that lent themselves to become part of popular discourse and that were repeated over and over again in the movie's advertising clips on television and via "floats" (when the release of the latest movie was advertised by a loud procession through the city). This could be a phrase like, "There is something in the soup" (*The Other Side of the Rich* [GFIC, 1992]); "Mabodam" (Twi, "I am sick"), which became the name of a popular hairstyle (*Step Dad* [Movie Africa Productions and Hacky Films, 1993]); or "Eshe wobu, Eshe wosisi, eshewo tiatia" (Twi, "Your guilt is in your chest, your guilt is in your waist, and therefore you are growing thin," *Dangerous Game* [Aak-Kan Films, 1996]). The point here is that video filmmakers not only designed films that resonated with their audiences but also sought to make audiences resonate with the films by adopting their vocabulary, as also happened with rap and "hiplife" music (see Shipley 2009a, 637; 2013; see also McCall 2002, 85, for a similar account regarding Nollywood as "a forum for public discourse").[7]

So who were the audiences addressed by filmmakers? From the outset video movies have been a popular phenomenon that speaks mainly, though not exclusively, to urban audiences in the lower and middle classes. Persons with a high level of education and access to satellite television showed little interest in buying Ghanaian films (though they might appreciate Nigerian ones). As William Akuffo put it: "You have to look at what type of audience we are dealing with. The elite people don't attend films. They criticise films. They like

the society films. They have M-net. When they come out to see your film, they will like to compare it with what they see. A lot of them cannot see through. It is not the type of film they are used to" (interview, 12 Dec. 1996). Although the situation changed with the rise of glamour movies such as those brought out by Salam Mumuni, the majority of spectators were what was seen as common people. By and large, the video phenomenon was situated mainly in urban areas in southern Ghana, appealing to people in professional groups like small-scale traders, seamstresses, hairdressers, office workers, car mechanics, and workers in all kinds of more or less informal jobs. While the number of people who actually bought a movie tape was limited, movie audiences were much larger than the sale of cassettes suggested because viewing usually occurred in a social setting. Also, cassettes circulated in social networks and were bartered. Especially with the increased screening of video movies on television, which was further enhanced by the introduction of the Africa Magic and Africa Magic Plus satellite channels, movies came to be screened in workplaces, such as Floxy's (see chapter 2), offices, roadside stalls, restaurants, and other public venues. With this massive expansion it became more difficult for filmmakers, as well as for researchers like myself, to pin down the audiences in distinct categories. Like Pentecostalism, Ghanaian and Nigerian movies achieved a public omnipresence, and virtually everyone had an idea about these products, in a range covering enthusiastic appreciation, sympathetic support, relative indifference, and fierce rejection.

When asked about their audiences, filmmakers often differentiated among kinds of movie theaters and, by implication, the neighborhoods in which they were located. As I have pointed out, they had little illusion that they could attract the elites. They had in mind different sets or "classes" of people, ranging from educated middle-class viewers who would visit the Ghana Films Theatre (where it was not permitted to enter with slippers), to quite respectable venues such as the Rex and the Roxy (fig. 10), to "rough" theaters, such as the Dunia in Nima or the Royal in Labadi, where audiences were notorious for their preference for fighting scenes and special effects, and further down to the video centers (fig. 11). The higher a movie theater's class, the quieter and more educated the audience. Still, private filmmakers usually sought to make movies that would "crosscut" and reach all these audiences by catering a bit to each of their tastes. This resulted in the production of movies that could not easily be assigned to one particular genre. Local distinctions mobilized in advertisement campaigns were romance, action, comedy, "spirit" or "rituals," horror, history or old times, love and sex, glamour,

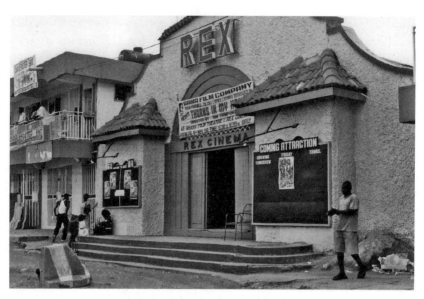

FIGURE 10. Rex Cinema (November 2002). Photograph by author.

Kumasi films (i.e., films in Twi), and Nigerian films (and, as old film posters show, Ghanaian films were quite often advertised as Nigerian to draw a larger crowd). I would be wary about taking these distinctions as indicative of fixed genres, however. The labels themselves were fluid, and many movies combined elements from, for example, comedy, action, "spirit," and horror.[8] Melodrama was the overarching framework for most movies. Interestingly, the classification of the audiences' classes based on types of cinemas did not cease with the decline of the cinema as the prime setting for watching movies. Up until I concluded my fieldwork in 2010, filmmakers would still refer to types of audiences by invoking types of cinemas (e.g., "this is something for Dunia people"). Again, this testifies to the fact that, as a medium, film is fully realized only by including the space in which it is screened.

Striving to articulate a common denominator, many filmmakers told me that they were aware that most viewers more or less strongly endorsed Christianity, in particular its Pentecostal version, which was grafted onto popular grassroots Christianity. As I noted in chapter 1, this preference on the part of the addressed audiences impeded the possibility of making movies that were explicitly anti-Christian. Filmmakers were also very much aware that most spectators were women (70 percent according to Akwetey-Kanyi). This was also confirmed by managers of cinemas and video theaters. While

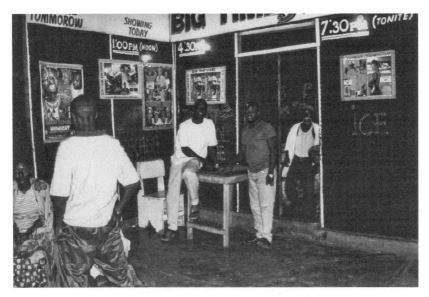

Video center (October 2002). Photograph by author.

youngsters patronized American action movies, and fishermen were much into kung fu and various other martial arts, Ghanaian videos were taken as a family entertainment, typically on the instigation of women. As the manager of the Rex explained, "It is the ladies who want to go to the movies, because the films portray something about them, the story line tells them something about themselves, about marriage, about how men behave" (interview, 9 Sept. 1999). Video film sellers, too, told me that most of their customers were women, or at least men who were sent by their wives or girlfriends to buy a particular film. Women found Ghanaian (and Nigerian) movies suitable devices to warn their men against all kinds of trespasses, including affairs with immoral, loose young girls.

Eager to make popular movies that became the talk of the town and sold like hotcakes, for a long time many filmmakers took as the imagined ideal spectator the faithful and Christian yet desperate woman who experienced domestic problems and yearned for a better life. She embodied the moral values of the nuclear family that were constantly under siege. With this ideal spectator in mind, filmmakers were inclined to design movies that resonated especially with their female viewers' experiences, consoling them and giving them moral support, while teaching a lesson to the wicked. Of course, there were always attempts to digress so as to privilege other subject positions, for

instance that of the good man suffering from a bitchy woman, or to depict an intriguing transgression, like that of the woman who engages in a lesbian relationship with a mermaid. But on the whole, filmmakers believed that it was difficult to successfully launch a film that was critical of the ideal Christian woman or failed to represent that character and that rejected Christianity outright. Somehow the strong presence of Pentecostalism in the ecology of Ghana's public sphere had to be taken into account.

This dawned on me for the first time when I watched *The Beast Within* (Astron Productions, 1993) with a group of youngsters in our living room in Teshie in the fall of 1996. This film chronicles the mishaps befalling the managing director of a big company and his family, who struggle to get things right again. While the husband loses himself in agony and despair, his wife continuously prays in front of a picture of the Sacred Heart of Jesus—but to no avail. On the contrary, things get worse and worse. While the setting of the movie—a typical self-contained house inhabited by a nuclear family with a modern middle-class lifestyle—was all right, my young friends greatly disliked the end. In the last scene a "fetish priest" from the village appears. Dressed in a loincloth and holding a horsetail in his hand, he reveals the spiritual source of all the troubles that have befallen the family. What was found most scandalous was that the "fetish priest" detects a juju that was hidden behind the picture of the Sacred Heart of Jesus, in front of which the family had so often prayed in despair, hereby calling a troublesome spirit into the house (see also Meyer 2010b). In the youngsters' view it should have fallen to a man of God to put things right again rather than to a native priest who, as these viewers asserted, was himself in league with "the powers of darkness." The youngsters told me that for that reason the film, produced with much care and presumably a substantial outlay of money, had flopped in the cinemas. Other examples of failure, for instance movies about lesbian sexuality, such as *Supi Supi* (Cobvision Productions, 1996) and *Women in Love* (Movie Africa Productions, 1996), also confirmed audiences' preference for a Christian heroine. The point is not that there was no room for the character of the bad woman—the loose girl was the natural foil for the pious wife—but that the central figure should be an object for positive identification. While, certainly after the renaissance of the Ghanaian video scene in the digital format after 2005, the imagined audiences became more diverse, there still was a preference for the morally sound heroine and an overall modern and Christian ethos.

Of course, with ever more movies being put into the system and the tremendous public appeal of Nigerian films, filmmakers struggled more and

more to retain and, if necessary, recapture their audiences. While the latter greatly appreciated seeing their own surroundings and stories projected onto the screen, they were nonetheless critical spectators whose taste and judgment grew more refined with the rise of the industry. Over and over again I met people who were generally positive about Ghanaian movies but criticized Ghanaian filmmakers for failing to portray a local lifeworld realistically. For instance, a young student who loved to watch movies in the cinema, at school, and at home told me that she was irritated by the fact that in some movies persons who, given their dress and material culture, obviously had a certain social standing, went into emotional outbursts of anger that were absolutely unconvincing for people of this kind. How could a well-educated father run into a school and beat up the headmaster, as happened in *Killing Me Softly* (Astral Pictures, 1997)? Also, the tendency, especially in GFIC/Gama productions, to offer much talking in so-called Big English was regarded as problematic, both by audiences who did not understand English very well and yearned for "telling pictures" and by those who had mastered English and easily identified the movie discourse as artificial.

Another problem concerned the portrayal of emotions. Emotional movies, and in particular those that made viewers weep, were held in high esteem. Whereas Nigerians were credited with a natural talent for invoking emotions of despair, Ghanaian filmmakers were criticized as having difficulties getting their actors to express emotions in a realistic and compelling manner. When people found out that I knew many filmmakers, they told me to let them know that especially the portrayals of emotions should be improved. In fact, based on deep appreciation and high expectations of video movies, such criticisms differed from those invoked by the perspective of film as education. The latter raised fundamental issues about video movies' politics of representation; the former just asked for "improvement" to make the movies easier to identify with. While filmmakers shrugged their shoulders when faced with objections that mobilized the state film discourse, they took the statements made by their targeted audience very seriously. After all, the spectators' irritation about artificiality was the flip side of their desire for realistic film characters grounded in the world of their own lived experience. Such realism was a condition for audiences to recognize themselves in, get into, and hence endorse and coauthor a movie.

Another criticism, made from the same sympathetic perspective, concerned problems of continuity. Many viewers found it difficult to follow movies that did not show clearly how a person got from point A to point B.

There was a popular demand to avoid leaving too much to the audience's imagination and to visualize all occurrences within the movie, just as in the genre of the telenovela that became increasingly popular in the 1990s with the deregulation and commercialization of television. This was of particular concern for people who could not follow the dialogue because of their lack of proficiency in English and who therefore could not be taken over the thresholds between different scenes and editorial cuts. People also disliked what was called a "bad" (in the sense of morally unsatisfactory) ending. They also complained that many movies were serialized, each part of which ended with a cliffhanger so that they had to wait far too long to "get something out of it." Many also disliked endings that left audiences wondering how the story would go on or failed to satisfactorily restore the proverbial "triumph of good over evil." The demand for a proper end and a moral lesson echoed the rather explicit regulations formulated by the film censorship board that will be central in the next section.

CENSORSHIP AND THE MORAL OF THE STORY

Even though video filmmakers transcended the old, paternalistic state discourse on film and its vision of the ideal spectator as needing protection against dangerous influences from outside and requiring a solid grounding in the Nkrumahist African personality, the role of the state in controlling films has not ended. Filmmakers have become increasingly laconic about criticisms raised from the perspective of the film-as-education discourse, but they still have to make sure their films will pass inspection by the censors. As I pointed out in chapter 1, the attempted market regulation launched by FIPAG in 2009 required that a film receive approval by the censorship board in order to be eligible for sale and public viewing. The censorship board bases its decision on whether a movie should be passed and what its classification should be (U for "universal," X for "adults only," or A for "children in the company of adults") on the verdict of previewers. These previewers consist of representatives of different societal groups (including the Muslim Council, various churches, and the Ga Traditional Council), commissions (such as the National Commission on Culture, the National Commission on Children, and the Trade Union), and representatives of state institutions (such as the military, the police, and the education system).[9] Not surprisingly, the board's regulations implicitly construed the audiences as vulnerable to

the impact of violent, vulgar, sexual, or otherwise offensive images, against which they need to be protected by censorship. In other words, film being regarded as extremely powerful in impressing pictures upon the audiences, the imagined spectator was held to easily succumb to the power of pictures and to lapse into copycat behavior and therefore needed an explicit moral framework.

In a small folder distributed by Ghana's Information Services Department, titled "Guide to Film Censorship" (which I received in 1996 and which was still in place in 2010), the terms of reference are explained in detail. After the preview session, in which the filmmaker presented his or her film, the board could reject a movie in full if it was found to offend "religious feelings" or "good taste" by inappropriate behavior or vulgarity, to cause racial hostility, or to depict cruelty. The board could also recommend cutting certain scenes, particularly those involving fighting, killing, punishment, torture, violence against women, the inferiority of Africans, or the undermining of law and order. While the guide recognizes that certain scenes need to be included for the sake of the story, it is against excessive or prolonged portrayals of problematic, transgressing acts. Interestingly, it explicitly discards a particular use of sound and camera angles, such as the close-up, to amplify undesirable behavior, especially violence. Championing the female cause, the regulations also authorized the board to object "to scenes in which women are subjected to voilence [sic] and they should be avoided, wherever possible. The board can only allow where they are absolutely essential to the story and when they are introduced with the minimum of emphasis. *Shots of men striking women* in the face are included under this head" ("Guide to Film Censorship," emphasis in the original). The basic idea, stated as the document's conclusion, was "that it is not the type of film that matters but the treatment and the moral tone. Adventure films such as gangster and cowboy films may do little harm to children as long as they are not brutal and sadistic, and as long as the moral, that is, *the triumph of right over wrong,* is abundantly made clear" ("Guide to Film Censorship," my emphasis). By and large, the movies presented for preview remained more or less within the limits set by the board surprisingly well. My file of movies presented for preview at the censorship office indicates that between 1993 and 1996 the board rejected just twenty movies (out of 220). No later rejection is mentioned, and I take this as an indication that all movies in this period eventually passed. Rejection only happened when a movie was considered beyond repair because it lacked scenes in which evildoers were punished, as stipulated by the regulations, or

because it was not clear what kind of moral lesson the movie was attempting to convey. More often, the board requested that certain scenes be taken out or that the title be changed. At the beginning of my research filmmakers, seeking to push the limits of the permissible, especially with regard to violence and sex scenes, complained that the board gave them a difficult time, especially because they needed to win back the audiences who were turning en masse to the far less restricted Nigerian video movies. Later, complaints about censorship greatly diminished, and in 2010 I was surprised to note that many of the established filmmakers who were back in the business expected the board to restrict the release of technically and otherwise mediocre movies made by newcomers to the business and to have a critical eye on Nigerian movies. In fact, FIPAG developed smoother relations with the board and effected a shift in the preview procedure from the threat of rejection toward classification into different categories. Even the boom of movies with quite explicit "love and sex" scenes, fashionable since 2008, passed through censorship, the only stipulation being their classification as for adults only.[10] However, the launch of this type of movie triggered a lot of critical response from audiences who complained about the low moral standards of these products. Even people who were not opposed to watching porn, per se, stated that they felt uncomfortable about the idea of watching such films in other than private settings (see Asare 2013, 71–73, on the debates triggered by these movies).

In 1996 the actual terms set for the censorship of videos were still being negotiated. Here it is important to recall that, given the small number of local movies made under the auspices of the GFIC, the board did not have much to worry about until it was confronted with the huge number of privately produced video movies in the late 1980s. In other words an institution established in the context of the state film industry that mainly previewed foreign movies now became a key player in a deregulated media environment. In contrast to the discourse on film as education, which was still mobilized by people affiliated with NAFTI and GFIC/Gama to critique video movies, the censorship board showed a far more pragmatic attitude. Although the regulations suggest a rather strict procedure, the preview sessions that I attended took place in a down-to-earth spirit, at times with few previewers attending. With the rise of local productions there were logistical problems related to paying an allowance to the previewers and arranging for their transport. Attending a number of sessions, I quickly realized that board members generally had little appreciation for Ghanaian videos, per se, even

though they made them pass through the preview. While panel members had problems with the general orientation of the movies, echoing the state discourse on film as education, in the preview sessions they were mainly concerned with details.

For instance, during the preview of *The Intruder* (Jubal Productions, 1996), a movie about an evil man who uses juju to intrude on the romance between a young man and woman yet is ultimately overpowered thanks to Christian preaching,[11] I was surprised at the attention previewers gave to particular scenes that had not struck me as problematic. A board member requested that one scene featuring a pickpocket who was never caught or punished during the movie be removed. The Muslim representative complained about the representation of the "fetish priest" who sells juju as a Mallam, which was contrasted with the positive representation of a Christian pastor—to no avail, as other members did not regard this as reason to reject the movie. Questions were raised about the last scene, in which the evildoer received a wound that immediately attracted flies. This was regarded as "culturally inappropriate," and the board recommended that it be shortened. On the whole the majority of the previewers appreciated the message—criticizing the destructive use of juju to achieve material benefits for oneself—and passed the movie.

Adopting a pragmatic stance toward local productions, members of the censorship board in principle appreciated the existence of video movies because they catered to the demands of local audiences. Although these movies were found to be not yet up to standard and to be dabbling in "superstitions," they were considered less harmful than many foreign movies. I was able to get some information from members of the board via a questionnaire that Sakyi, who held a degree in mass communication, designed on my behalf and to which nine persons responded.[12] As one previewer (from the Church of Pentecost) put it, "in terms of technical quality, they are far behind the foreign films, but in the main, the audience may be more comfortable with the Ghanaian films because of the cultural background of the messages they portray." Along with frequent criticisms about the lack of technical mastery of video and story lines, there were also complaints about the strong emphasis on "superstitions." One previewer noted drily that "most of the films are on fetish and the usual belief that every mishap by man is influenced by Satan."

Notwithstanding its fundamental criticism of the failure of video movies to live up to the state discourse of film as education, the board only

occasionally requested that films be revised and resubmitted and even more rarely rejected a movie (except in the early days). This not only testifies to a high level of pragmatism on the part of the board but also indicates that video filmmakers, even though challenging state cinema, internalized the regulations stipulated in the "Guide to Film Censorship" to such an extent that their products would be difficult to reject. The reason for the relative convergence between the regulations and the design of the film plots stems from the fact that these regulations themselves crystallize a long-standing regime of addressing—and hence constituting—film audiences that harks back to the colonial and early postcolonial era. As I pointed out in chapter 1, colonial film censorship was set up to protect audiences from foreign influences that were regarded as potentially disruptive for the maintenance of colonial rule. The postcolonial state's concern to shield moviegoers from foreign movies, which were perceived as alienating and thus a threat to African personality, persisted. Clearly, the individual imagination had to be harmonized with a desired national imaginary, thereby constituting film viewing as a space for negotiating habitus. Along with the censorship board's paternalistic project of protecting audiences, the need to teach moral virtues also became an explicit concern. This is not simply a top-down approach but part and parcel of an interactive process in which the expectations of the audiences played a key role in the specific way cinematic culture and the discourse related to it took shape. The strong emphasis on morality echoed a broader, commonsense view of the educative purpose of cultural forms. Popular stories about the trickster Ananse, proverbs, "concert parties," TV drama, and Christian sermons were all premised on the expectation that they must teach virtues by telling stories.[13] The censorship board's insistence on ensuring that films show "the triumph of right over wrong" and audiences' wish "to get something out of a movie" both echo this long-standing expectation, which filmmakers struggle to fulfill. Local movies operate within a heavily moral framework that is deeply engrained in common sense.

"GETTING SOMETHING OUT OF IT"

Even when a movie passed inspection by the censorship board, spectators could be critical of its moral teachings. A film could be found to be quite entertaining, but spectators might still dismiss it, saying, "There is nothing in it." Frequent statements like "I want to get something out of it" or "I want

to advise—or educate—myself" point to a popular pedagogy, claimed by audiences, that appreciates film as conveying important lessons for the future.[14] Since it was expected that these lessons be clearly discernible, much depended on how the movie ended. William Akuffo told me that he quickly had to change the end of *Diabolo* after the first showing, in December of 1991. In that version the Diabolo character, who had committed several murders, was shown sneaking away: "In *Diabolo 1* the snake escaped and people thought what sort of stupid film is this? I always watch the audience reaction. So I asked, 'Why do you think it is a stupid film?' They said: 'How can they allow the snake to go just like that?' They want punishment immediately. So I changed the end. We reshot the portion where the boys attack the snake and hit it and finally burn it. They wanted to see it burned. Then they were happy" (interview, 12 Dec. 1996). Given the close face-to-face contacts between filmmakers and audiences, Akuffo quickly heard the latter's criticisms and adjusted his movie. This example spotlights the dynamic relation that exists between filmmakers and audiences in Ghana. Even though I classify Ghanaian movies as part of "popular culture," it would be a mistake to presume that this entails a self-evident match between a movie and the expectations of the spectators. On the contrary, I discovered that filmmakers needed to work hard to achieve a product that was "popular" in the double sense of the term: a recognized part of the popular imagination and popular in the sense of having mass appeal. Making a popular movie depended on a process of negotiation between audiences and filmmakers, through which the latter anticipated and responded to criticisms and complaints from the former.

Having been prompted to design the new ending in which the snake got burned, Akuffo had to worry about how to produce a follow-up. The solution he found was to have *Diabolo 2* start with a severely injured Diabolo (in the shape of a person), suggesting that somehow the snake had escaped the fire, leaving Diabolo almost dead. People's moral concerns persisted about the proper punishment of this character who, like a trickster, was able to survive all kinds of assaults. For instance, Kofi Middleton-Mends told me that he was once approached by a taxi driver who recognized him as having played a role in *Diabolo 3* (World Wide Motion Pictures, 1994). The taxi driver was furious about this movie because it failed to fulfill his moral expectations. Regarding the Diabolo character as evil, he was annoyed that at the end of the movie the character still lived on. He found that the value of film should be that "good must always triumph over evil." That was also his hope for his

own life. So he told Middleton-Mends: "This film must be finished for me, this bad character must be destroyed, no matter if the filmmaker wants to give it a follow-up" (Middleton-Mends interview, 12 June 1998). Interestingly, even if a movie was found to be unsatisfactory in not offering a sound moral, spectators would still reinstate their own morality through film criticism. Again this shows that what should matter to scholarly analysis is not just a film as such but also the space in which it is produced and consumed.

The emphasis both the censorship board and the audiences placed on a crisp, clear moral and the need to show *within the film* that evil deeds are punished affirmed the heavily moral undertone that movies were expected to convey. As producer (and actor) Augustine Abbey also explained:

> At the end there is always a message, because people go to watch these films not because they just want to go out, but because they want to learn at the same time. Take "Osɔfo" [i.e., Osɔfo Dadze], for instance, a program that has been on TV for thirteen years. Osɔfo means pastor. At the end of the show the pastor comes and faces the audience, the viewers, and addresses them: "You have seen the program, so when you commit a crime, this is what will happen to you." It was a very interesting show. Instead of allowing the people to pick whatever message there is in the program, he will come at the end of the show to tell them. People believed then that every film must have a message at the end. So if you do a film that is very artistic, but has no lesson, people will ask you, "Why? What are you telling us?" At the end of every production, the good person is vindicated and the bad person is punished. We do dramatic justice at the end of any literary work, every film, every drama, any piece of art. (interview, 10 Dec. 1996)

Still, movies were not flat morality tales that showed only what is good. Here it is important to recall that the censorship board was prepared to legitimize the depiction of morally problematic behavior if it was required by the story line. This worked in favor of a narrative structure in which the "triumph of right over wrong"—or, as many spectators would phrase it more existentially, of "good over evil"—allowed for an obsessive focus on what was wrong or evil. Inciting a prurient encounter with the evil that one despised yet nonetheless found (all the more?) intriguing, this narrative structure translated easily into Christianity's dramatic logic of the spiritual fight between God and Satan. Although from the perspective of born-again faith Satan was to be fought, it is also clear that Satan's very existence was necessary for the Holy Spirit to be recognized as a superior force. Just as video movies had to depict evil in order to teach a lesson, Pentecostalism "needed" the devil—and all he

was made to stand for—as much as it fought him. The paradoxical logic of morality requiring and even producing transgression is what the two share.

Pondering all the movies I saw (including the more recent glamour movies that came up around 2007), I cannot think of a single movie that does not thrive on the dramatic structure of a moral combat of some sort. While, as I have pointed out, filmmakers distinguished among "classes" of audiences that were related to certain "classes" of cinemas, the notion of a moral fight in which what is right and good is ultimately shown to be victorious appealed to all spectators. The domestic domain, which was central in most of the movies, was the prime theater in which stupid husbands stood against their faithful wives, mothers maltreated their daughters-in-law, madams or masters made their maids suffer, lovers were broken apart by greedy parents or other mischievous characters, and so on. Ultimately it was always about right and wrong, good and evil, angels and demons, God and Satan. One of the key attractions of movies, as I realized by visiting cinemas and video theaters, was the pleasure that spectators experienced when, finally, evil was shown to be punished and order restored, conveying a deep satisfaction at witnessing the correct operation of shared moral principles in action (Meyer 2003b).

Importantly, movies were not expected to teach morals in an abstract manner but through the narrative in which they were embedded. While, as I have pointed out, movies were designed in such a way that they resonated with audiences' worlds of lived experience, there still was a remarkable difference between the two. Film crystallized shared imaginaries that, by being offered as an "experience of experience," became imaginable for the viewers and that they could carry into their own lives. In their everyday settings people found it difficult to understand their own predicament from their positions in the midst of things. In contrast, films, as I was often told, "expose and reveal many things people do not see so clearly in their daily lives." The gift of seeing clearly—also invoked in Kwaku's statement that thanks to *Not Without* he realized what he had done wrong in his marriage—was one of the major ways through which films were thought to educate spectators. This possibility to make people see things that they found difficult to discern clearly in their daily lives stemmed from the technical properties of film as a particular representational device that works through compelling, "motional" pictures, rather than mere texts or words.[15] Conducive to a still largely oral culture, film was at the same time understood as a quintessential modern audiovisual medium that allowed even people with a low education to engage with the wider world.

It is important here to highlight three properties of film and their specific use. One, as film compresses time (for instance through flashbacks), it is able to show the consequences of certain bad or immoral acts that unfold over a long period in real life. Many movies depict how certain sins committed in the past shape the predicament of the film characters with whom spectators engage. While in daily life it is difficult to know how past acts have affected one's present, films "reveal" this. Showing the disastrous consequences of particular acts—for instance squandering money, sacking a loving wife, or neglecting one's children—and the positive outcome of good behavior, especially staying upright and God-fearing, movies were found to give valuable directions for the future. Displaying how a certain character went astray and regretted it when everything was too late, movies instilled in audiences an urge to avoid similar faults or to correct them before it was too late. The lessons learned from movies, as I was told over and over again, were important for planning one's future.[16] Films could even convey a sense of hope and direction. As one woman put it: "Film teaches that you can rise up."

Second, film transcends social and spatial boundaries. While the protagonists in a movie, just like people in real life, may wonder what is in another person's mind or what goes on in inaccessible spaces, audiences get the whole picture, certainly in social viewing settings in which reactions from others can be taken into account; they are therefore positioned to have a good overview of a situation. In this way movies speak to an overall sense of insecurity about what motivates other people, suggesting that it is important to be alert and "vigilant" so as to get a clearer picture of a whole setting or situation.

Third, as I will point out in more detail in chapter 4, spectators perceived movies as able to conjure the spiritual realm that was considered inaccessible with the ordinary senses. The use of special effects revealed to viewers the machinations of evil spirits and the hand of God. Many viewers felt deep satisfaction about such scenes. Convinced of the reality of spirits, they were pleased that movies made these forces visible. Movies were found to be superior to the naked eye because they could audiovisualize such forces, generating a public whose members helped each other believe in the existence of these forces.

Thus, film was particularly appreciated for teaching moral lessons because of its special capacity to encompass extended periods, peep into what remains inaccessible and secret, and conjure up the spiritual realm. It was a device able to show what was conceived as "real" (understood in the phenomenological sense) in its totality. In distinction to the moral teachings conveyed through

other cultural forms, film offered a special kind of superior vision that uplifted spectators from their position in the midst of things, in which many important matters remained opaque. The moral teachings offered by movies were accompanied by a particular possibility to witness what is impossible to see with the "naked eye." Ultimately, the morality of a movie was to be delivered in the cinematic experience. People were invited to "get into" the movie yet at the same time were offered a superior perspective that allowed them to know more than the protagonists themselves. This is how lessons were learned, lessons that were found useful in everyday life. Although vision is obviously central to film, it is important to stress the synesthetic involvement of other senses in the process of what is—problematically—called "watching." Both still and moving pictures appeal to the eye, but they also touch beholders on a deeper level.

WATCHING MOVIES: A "LIVE" PERFORMANCE

Pictures and Sounds

I have to confess that I often found watching a Ghanaian or Nigerian movie on my own quite boring. In such a situation certain scenes, such as the lengthy car rides mentioned in chapter 2, appeared a bit long to me. This sense of being somewhat bored was intensified by the fact that often the dialogue was difficult to understand and the sound editing lacking. And while I usually find it difficult to watch scary movies alone, I find it telling that I had no problem with horrific scenes in Ghanaian ones. This, in my view, is because in the latter little attention was paid to bringing in sound effects that vested moving pictures with horror and anxiety in a way that would work effectively for a spectator, like myself, who was socialized in the cinema in a different manner from Ghanaian audiences.

Whenever I watched movies in the company of Ghanaians, however, things were different, provided the movie was good—appealing as far as content and presentation were concerned and not dismissed as "artificial." I was fascinated by the audiences' willingness to ignore technological shortcomings, including the periodic overall breakdown of the system, tracking problems, or inaudible sound, and to work their way into the movie (fig. 12). The scenes I would otherwise experience as lengthy were just right to allow for extensive commentary, scary pictures were greeted with shrieks of horror, and at all times—though to a lesser degree at Ghana Films—audiences

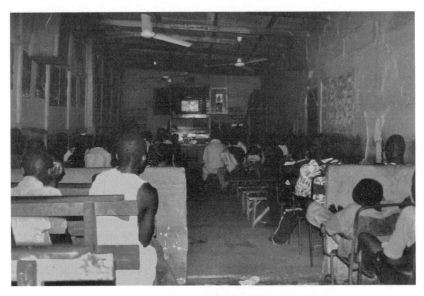

Inside Drisdale video center (November 2002). Photograph by author.

engaged with the movie by talking and shouting. Pondering the difference between my personal experience of watching alone and watching with others, I realized that Ghanaian (and Nigerian) movies were not closed cultural products that stood by themselves but were open and incomplete, in need, as it were, of audience attendance. A movie, one could say, is fully realized only in the performance of watching, with the audiences making "noise." Indeed, audiences participate above all via sound, that is, by commenting, chatting along, shouting, laughing, or singing.

I have noted that in the production of movies, getting good pictures got far more attention than the quality of the soundtrack. Of course, filmmakers underscored scenes with appropriate music, either from Western classical music files or with songs composed for the movie,[17] and made sure that there were a number of catchy sentences and slogans that appealed to the audiences. Many movies, certainly those designed to cut across "classes" of people, including spectators with little education or mastery of English, used minimal dialogue. What was actually said was often left to the actors, many of whom did not learn the—often incomplete—script by heart and who improvised. This testifies again to the prevalence of orality in the setting of filmmaking, in which actors were the ones expected to speak with an appropriate voice, thereby bringing to life the often somewhat artificial written text.

Especially in older productions, there is quite a lot of "Big English" with significant mistakes,[18] followed by tirades of insults and curses in Twi (in the early days often performed by the actress Grace Omaboe, who has great experience in television drama). With time correct use of English and more elaborate dialogue became a mark of distinction; however, such movies were often considered "book-long" by audiences in popular venues. When Ghanaian movies had their comeback in 2005, many had dialogue in Twi (sometimes with English subtitles), which is used along with English as a lingua franca in southern Ghana, while glamour movies were shot in English. Still, good sound was difficult to produce. Since movies were not shot in studios but on location, it was difficult to exclude ambient noise. And so, for instance, the sound of a little horn blown by ice cream sellers—Fan Milk—made its way into a movie and rendered understanding difficult in a scene in *Tasheena* (Aak-Kan Films, 2008).

Imperfect sound, however, should not simply be taken as a symptom of technological failure but also as offering a possibility for audience involvement. Ever since the introduction of the cinema in colonial times, sound was the domain that primarily belonged to film audiences. As we saw in chapter 1, even after the production and global circulation of "talkies," many movie theaters in Accra did not have the equipment necessary to play the soundtrack. This did not mean that watching a movie was a silent enterprise, though, because there was a storyteller who would comment on the pictures. Also, people brought in drums that were beaten during fighting scenes and loudly engaged both with the operator, if something went wrong or they disliked the movie, and with the pictures on the screen.[19] Thus, from the outset oral audience participation accompanied watching a movie.

The long-standing tradition of audience participation by contributing its own sound remained very much alive, especially in the cinemas and video centers in popular neighborhoods. Significantly, it was regarded as a mark of distinction of "high-class" cinemas such as Ghana Films that people were expected to watch quietly. In such a venue occasional outbursts by individuals who stood up and shouted were regarded as inappropriate and were, at a minimum, ridiculed. In contrast, "lower-class" venues were associated with a noisy process of watching in which people enjoyed what others said as much as the movie itself. This was the setting in which most of the current filmmakers, many of whom were involved with the cinema professionally or were at least fervent cinemagoers, had familiarized themselves with the medium of film. From the outset video filmmakers sought to make movies that could

be understood without necessarily following the dialogue (either because of potential technical problems or because audiences do not understand English). Films were deliberately designed to entice audiences to engage orally with what they encountered on the screen. Indian movies, which have long been popular in Ghana and which were found to be understandable even though the dialogue was not dubbed, were often invoked as an example of movies that involve audiences successfully. The point is that even though filmmakers struggled to improve the sound quality, movies have long been organized in such a way that they leave room for audiences to involve themselves by making their own sound. This began to change gradually after 2005, with the transition to digital technology and its faster editing and quicker cuts. Ultimately, the more perfect and tautly cut a movie, the less possibility for interactive audience involvement.

Watching Together

Gradually the higher classes, who had access to color television and satellite channels, abandoned the cinema. The transition from attending the cinema to watching movies in the more secluded, domestic setting, taking place in the mid-to-late 1990s, implied that much of the fun of watching as a public performance was being lost. But watching movies at home was still a social affair and, moreover, did not fully replace public viewing, especially in popular neighborhoods in which many people lived in cramped circumstances. For instance, one of the frequent spectators at the Roxy (interview, 29 Sept. 1999) told me that he did not like watching movies on television at home, because with his father, mother, and wife present he could not let himself go as he could when he was in the cinema with his friends. Many other people, too, appreciated the experience of watching together. Even in the living room at home, as I experienced in our house in Teshie in 1996 and later in the homes of friends, animated and noisy ways of watching together still occurred, though with the decline of cinema this mode of active audience participation may ultimately be coming to an end. In 2010, however, there were still many video theaters in popular areas, making the public viewing experience possible, while in homes, as well, viewing was still a social activity that involved plenty of commentary and debates. As Kodjo Senah put it in a comment on an earlier version of this chapter, "Watching film is supposed to be a communal or at least a group affair. The lone viewer is often pitied as someone who has a domestic problem and simply wants to avoid a conflict

situation." Films were to make people talk, and only in that way was their participatory potential realized.

Let me evoke the atmosphere of watching together by describing a visit Charles Asiedu and I paid to the Kwa Ofori video center in Jamestown on the evening of 10 July 1998.[20] At the time, power cuts left parts of the city in the dark on fixed evenings. The venue, located in a popular, severely impoverished, neighborhood populated mainly by Ga fishermen and their families, consisted of rows of wooden benches and a big television set placed in front. The operator was in a small room at the back, lit by a blue bulb. When we arrived, an Asian action film was in progress. Except for one woman, all of the approximately twenty-five spectators were men. Throughout the screening audience members commented on what they saw and accompanied fighting scenes by shouting, "Paa, paaa!" When the good guy, who had the sympathy of the audience, had a sexual dream, people appreciated this, saying that this was a nice thing. Everyone clapped when the bad guy drowned in the end.

At around nine o'clock the screening was over, and we went outside, where we talked to Nana, a young man who came to Kwa Ofori to screen the Ghanaian movie *The Suspect* (Aak-Kan Films, 1998) on behalf of its producer, Akwetey-Kanyi. Spotting me outside in this rather wretched environment, many people expressed surprise—a mismatch between the "class" of the video center and their perception of me as an educated person who would rather be in a place befitting her station at Ghana Films. Charles and I were hanging out at the entrance of the venue near a poster that consisted of a set of still photographs advertising the movie (fig. 13). One woman who had seen the movie already told the bystanders what it was about. This was good word-of-mouth publicity, as she said that the film was "very nice." When we entered the hall again because another screening was about to start, music clips were shown, much to the joy of the audience. This stopped quite abruptly when about seventy people, most of them women, were present. All of a sudden the light and the television went off, making people become impatient and shout. But then the film could be shown smoothly, though the sound quality was so bad that the dialogue could barely be heard. After a period of initial complaints about the sound, the commotion calmed down, and the spectators got into the story. As usual, and in a manner reminiscent of concert party performances (Barber 2000, 204–39; Cole 2001, 135), the audience commented on the moving pictures and explained the story to each other. In the following, the reactions of members of the audience will be rendered in italics to show graphically what they brought into and got out of the movie scenes.

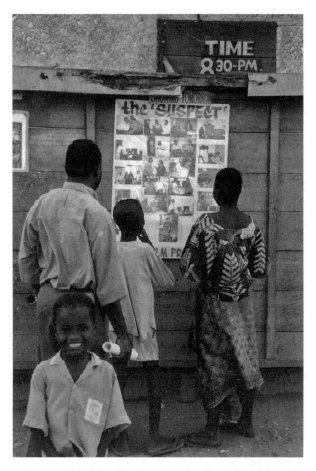

FIGURE 13. Advertising *The Suspect,* Video Center Kwa Ofori (July 1998). Photograph by author.

The Suspect is a movie about two childhood friends, one of whom is rich and successful, one of whom is poor. *People in the audience commented on the fate of the latter with sympathy: "Oh, he cannot go to places in town, he is poor, he has to stay at home."* But then he gets involved in the business of his rich and God-fearing friend. As soon as the hitherto poor fellow gets some money, he starts to enjoy life ostentatiously and is unfaithful to his wife and takes a girlfriend. *The audience criticized him sharply, shouting, "Chameleon!!! Foolish man!!!" They disapproved of him eating chips and chicken in a restaurant together with his new love, saying that he now eats "rich men's food," while he fails to give even chop money to his wife.* One evening his wife waits for him in the living room, blocking the door to the bedroom so that she can ques-

tion him. *People burst out in laughter when he tries to crawl underneath her legs and she suddenly lets her legs fall on him so as to trap him.* In one scene the guy arrives at home and refuses to eat the kinkey and fish (a typical Ga dish) that his wife kept for him. *The audience got angry about this behavior (not eating what your wife prepared is a big insult). "Ah, now he is eating chips only." The engagement of the spectators was like an informal trial in the street or on the market in which they insulted and judged the bad protagonist, whose behavior certainly resonated with actual everyday life experiences. When he has his girlfriend sit on his lap, they called for him to take her from behind, thereby underlining his immoral behavior.* The man gets deeper and deeper into immoral behavior and starts cheating. He embezzles money and, as the audience is led to understand, he has a hand in getting his friend and boss arrested for possession of cocaine. All the good characters in the movie pray that the truth will soon come out. *On the occasion of each prayer spectators expressed their sympathy for those who believe in God, especially the poor wife who suffers and the friend who is in jail.*

One time the desperate wife of the bad man wants to send a cassette letter to his brother abroad to complain about his behavior. But when she has just started speaking into the microphone, a woman comes to fetch her for Bible classes. She leaves, leaving the recorder on. Then the husband comes home with his girlfriend, taking her to the marital bed—*an act that completely appalled the audience*—and sleeping with her (this is not shown in full but suggested by zooming in on a lot of tissue paper put on the ground). The girlfriend, who claims that she is pregnant, wants to know why he is so rich, and then and there he admits that he put cocaine in his friend's house and alerted the police so that the friend was arrested. On her return the wife is shocked to see the traces of the sexual encounter. She realizes that she left the recorder on and starts listening to the tape, sighing, "Oh God, Oh God." Through this involuntarily recorded confession the bad man is ultimately exposed. His friend is set free. *The spectators loudly expressed their happiness and applauded.* The movie ends with the rich friend feeling flabbergasted; he weeps, saying: "I took him as my brother." *People in the audience echoed that, indeed, as the film shows, "some friends are very bad." The moral of the movie, according to a number of people we asked outside, was that "greed is very bad." The movie was found to be very good because it showed this.*

The Suspect had everything audiences expected of a good movie: a clear dualistic structure in which God-fearing people ultimately expose and overcome the selfish and immoral evildoer, much attention to transgressive acts

(especially sex and crime), a good wife and a trustworthy friend with whom to sympathize, an evocation of the modern setting of the city and the mansion of a nuclear Christian family, some degree of suspense, a recognizable moral message, and lots of room for involvement through sound. It is no surprise that the movie was a blockbuster at the time.

Ethics of Watching: Opening and Closing Off the Self

The ease with which audiences involved themselves emotionally in *The Suspect* and were prepared to sense and feel alongside the characters should not be taken for granted. The flip side of the appreciation of moving pictures as a way to appeal to and educate audiences was a concern with the potentially destructive impact of such pictures. In other words, in a manner reminiscent of the ideas behind the censorship guide, exactly because movies were found to be powerful, they could be enlightening but also dangerous. This became very clear to me during my conversations with several teenage girls— Beatrice, Faustina, Lisbeth, Mefia, Mabel, and Nancy, all around fifteen to seventeen years old—in the fall of 1996. These girls had taken a keen interest in our family—especially in our then almost two-year-old son, Sybren alias Kofi (he was born on a Friday). They attended most of the film showings in our living room but also accompanied me at times to watch Ghanaian movies in the Lascala Cinema nearby.[21]

Living in the same compound house next door, the girls, all of whom still went to school, knew each other very well. They attended the Church of Pentecost that was located in the neighborhood and had big dreams about their future, which they hoped would lead them out of the noise and crowdedness of a compound house. I noticed a very strong concern to avoid mixing with the wrong people and to stay "pure"—not an easy project in a world in which people lived so close to each other and in which poverty easily drove young women into offering sexual services to well-to-do men to enable them, ironically, to pay their school fees. They wanted to keep their virginity until they got married and to have a church wedding in which to wear a white bridal gown. They struck me as deeply moralistic and fearful that they would open themselves up to Satan. As I noted in my diary: "They want to stay pure by all means" (20 Oct. 1996).

While, obviously, Ghanaian movies were conducive to the morality to which the girls aspired—like Kwaku, they often praised movies for teaching good lessons—they still had second thoughts about certain scenes and about

cinema as a whole. Even though they would watch quite a lot of Ghanaian and Nigerian movies in church, their pastor disapproved of church members going to the cinema. This was a morally dangerous space, and, as they put it, "When you are there, Satan may get hold of you easier." Fond of Ghanaian movies, yet afraid of the immorality of the cinema and the spiritual dangers inherent in a great number of films with powerful pictures that did not endorse a Christian perspective (especially fantasy, horror, and porn; see Pype 2012, 152), these girls had internalized a particular, and as I found out later, more broadly shared, though often implicit, "ethics of watching." Resonating with the Islamic "ethics of listening" that developed with regard to cassette sermons in Cairo (Hirschkind 2006, 67–104), with this phrase I wish to emphasize that watching is an active, moral practice—an act of gazing—through which spectators engage with movies in a way that is conducive to their own vision of the moral self. This ethics of watching is not only deployed to *open* one's mind and watch attentively but is also mobilized in acts of sensorial *closure* in order to avoid being polluted by the intrusion of evil pictures and sounds (see Bakker 2007).

On 19 October 1996 we visited the Lascala to watch *Supi Supi: The Real Woman to Woman,* a movie about lesbian sexuality. While the clips shown prior to the start of the movie—Michael Jackson dancing, including at times sexually explicit gestures—were on, the girls next to me closed their eyes and covered their ears. They asked me to let them know when *Supi Supi* started. The movie itself was quite moralistic, showing how a young woman is lured into a sexual relationship with a rich female trader. Ultimately, through this relationship she loses not only her boyfriend but also her fertility—the suggestion is made that the women use a tightly rolled piece of paper in their intercourse, injuring the young woman's uterus. Of course, a moral framework is a prerogative, not to say excuse, for screening transgressive acts. And obviously a movie on the immorality of sexual relations between women must include bedroom scenes. As soon as such scenes were shown, the girls would again close their eyes and put their fingers in their ears to close themselves off. One girl even used her cloth to cover her head. The point for them was to block immoral pictures and sounds from entering their bodies. This ethics of watching was also mobilized at times when we watched movies in our living room, prompting spectators to, for instance, hide behind a chair. Of course, to get back into the movie when a scene with powerful, morally problematic (often sexual) pictures was over, it was necessary to allow some bad pictures and sounds to come through every now and then so as to know

when matters were clean again. As it was thus impossible to fully shield oneself from dangerous pictures, cinema and movies were said to have a polluting potential. Precisely for this reason, as the girls told me, it was important to perform a cleansing prayer after having watched a movie, most certainly after having been to the Lascala to see a movie with filthy scenes such as *Supi Supi*.

I understand these attempts to shield oneself by not letting in certain sounds and pictures as acts of anesthesia (Verrips 2006; see also Buck-Morss 1992) through which the vast possibilities for perception are limited by practices of numbing. Grounded in a vision of what constitutes a moral subject, self-anesthetization is part of a particular, strongly Christian ethics of watching deployed by spectators such as my young friends to stay pure and sane. While the girls were particularly explicit about their attempts to close themselves off from potentially harmful pictures and sounds, their concern with being accessible via such sense impressions was broadly shared. As I explained in chapter 2, the person is understood to be porous and open to outside influences that must always be blocked out so that some degree of "buffering" is reached, while at the same time good influences are allowed to come in. The acts of anesthetization while watching movies I am describing here were countered by moments of utmost attention and receptivity. Audiences at times joined in aloud with prayers uttered by characters onscreen, shouted "Hallelujah!" at the defeat of an evildoer, or sang along with a hymn. So in addition to closing themselves off from pictures and sounds that were considered inappropriate and polluting, viewers sought to open themselves up to virtuous sensory impressions, especially those related to divine power. Watching a movie was a kind of moral exercise that had much in common with attending a sermon. My point here is that, precisely because movies were attributed the capacity to leave deep, long-lasting sensory impressions, spectators negotiated—more or less consciously—the modality of their own receptivity and moral personhood.

This bodily and sensory engagement with movies—and the appreciation of the haptic potential of pictures that goes along with it—was part and parcel of a broader sensitive subjectivity mobilized most explicitly in Pentecostal churches and conducive for navigating the space of the modern city, with its dangers lurking behind the surface of shiny appearances. The city was a "sensuous geography" (Rodaway 1994) that was never merely subject to the gaze and contemplation but also engaged people in myriad sensory and bodily ways that required an attitude of constant "vigilance." The dream of the self-contained mansion and the secluded self that went along with it involved a

sense of an urgent necessity for closure and, indeed, of a certain kind of anesthesia that made people immune to particular sensory experiences of the world. A sticker, "I am an untouchable Christian. Pure Fire Miracles Ministries," which I saw on the dashboard of a taxi in January 2008, perfectly expresses this attitude. The act of closing off was not only required when visiting the cinema but also stood for a broader set of "techniques of the self" that involved a particular sensory self-discipline. Because the city had many spaces that were hot and visceral, and because family and marriage relations had their own dark side, as well, it was through one's own moral behavior and acts of anesthetization and opening up that one had to shield oneself from potentially destructive, evil influences and let in the good.

The popularity of Pentecostal-charismatic Christianity, as I have argued elsewhere (Meyer 1998b), may be seen to reside at least in part in its capacity to offer people certain guidelines on how to open and close themselves to impressions from outside and a number of practices, such as a quick internal prayer, to ward off the potentially dangerous and intrusive influences that they are exposed to in everyday life in the city. Since what meets the eye and the ear could be ultimately deceptive, it is important to alert oneself to matters that are difficult to perceive in an ordinary way because they are linked to the realm of the "spiritual." This extraordinary perception demanded particular techniques of closing off and opening up that were offered by religious practitioners and mimicked in movies. Film taught not only the need to deploy sensory techniques such as vigilance, receptivity, and closing oneself off. By virtue of bringing onto the screen transgressive acts—especially regarding the occult and sex, pointing to acts that are morally untenable—film also requires that such techniques be mobilized in an ethics of watching. Indeed, these movies not only took part in articulating a morality that shaped, affected, and confronted audiences but also demanded a careful screening and sensory management of the self that echoed Christian, and particularly Pentecostal, teachings. In this sense Ghanaian and Nigerian movies had the potential to both purvey and assault morality.

CONCLUSION

Numerous video movies digressed from the state discourse on film as education in various respects. Most saliently, in line with popular Christian understandings, these movies framed African spiritual forces as demons, thereby

confirming the existence of a spiritual realm invisible to "the naked eye." The state discourse on cinema branded the picturing of this realm as an unfortunate and deeply problematic confirmation of "superstitions." Still, as this chapter has shown, these movies and the state discourse on cinema saliently converged in their understanding of film as a moral medium. Video movies, like African art films and state cinema, were expected to express a "cautionary pedagogy" (Sereda 2010), warning viewers against going astray in one way or another. Indeed, the idea that movies have to convey moral lessons was held in common by the audiences, the filmmakers, and the censorship board, and it lay at the base of a strongly moralistic video film aesthetic. But whereas the ideal spectator imagined by the state discourse on cinema was to be educated about his or her African personality that needed to be (re)captured through Sankofaism, many video movies (except, to some extent, epic films) addressed viewers who were in search of security and orientation in a quickly transforming, insecure world, without taking recourse to cultural heritage as a positive resource. Although movies confirmed the existence of an invisible spiritual realm, they opted against a positive valuation of spirits in terms of heritage, as advocated by Sankofaism. The moral public that was addressed and constituted by Ghanaian video movies was regarded as needing ethical guidelines for personal behavior to ensure protection and progress in everyday urban life.

Grounded in audiences' world of lived experience, movies appealed to them, to invoke Vivian Sobchack once again, by "expressing experience through experience." Stressing that filmic mediation implies making certain choices about the representation and expression of audiences' phenomenological lifeworld, I have argued that video movies were part of a broadly shared sensory regime that framed perception, induced and affirmed certain sensibilities, and propounded a particular notion of the sentient subject that was indebted to Christianity and its idea of modern subjecthood. Therefore, rather than understanding perception as a primary process through which people engage with the world, as phenomenology would have it, I understand video movies as sensory devices that do not simply reflect, but also intervene in, everyday lived experience by addressing spectators and inviting them to perceive in a particular manner.

Taking this understanding as a starting point, in this chapter I have argued that movies raised Ghanaian viewers' sensitivity to matters that remained hidden behind the surface of appearance yet were nonetheless believed to exist. Exposing hidden or secret acts and the machinations of

spirits in the framework of the realism that was characteristic of video movies' popular aesthetic, films took part in rendering people alert to matters that could not be sensed ordinarily. As successful films resonated seemingly naturally with spectators' world of lived experience *and* deployed a particular vision of how to be a modern person, they can be understood as powerful devices that partake in anchoring new modes of subjecthood in the bodies of the viewers. The need to be vigilant and alert to what is hidden was one of the prime sensorial attitudes conveyed by movies. Movies mediated and by the same token naturalized these specific modes of perceiving and relating to the world. Being both the ground of being and the prime site of sociopolitical (or ideological) inscription, the body was placed at the center of converting mediations into personal experiences, thereby vesting the former with sensory and experiential immediacy. This is why this book is not merely a study of a particular popular film culture. I take popular film as a prism through which to gain insight into the constitution of subjecthood in contemporary Ghana. From this perspective audiences are not merely spectators of movies but, more broadly, are understood as people of flesh and blood grappling to develop and internalize particular techniques of the self. These techniques of the self, I suggest, fit easily into the sphere of film in that they emphasize the importance of "seeing clearly" and of opening oneself up to and closing oneself off from outside impressions. Conversely, the ethics of watching deployed with regard to movies flowed into a broader ethical mode of conduct. In this sense film was involved in shaping a modern habitus.

The moral teachings conveyed by movies are immediately related to the constitution of a "cinesthetic" subject (Sobchack 2004) that is enabled to see a bit more clearly than when left in the midst of things. The possibility to extract a moral vision from a movie follows from being shown, by various audiovisual techniques, the hidden precursors and consequences of certain acts. In this sense a particular sensorial engagement of the spectators is the sine qua non for conveying an ethics suitable to help one get along in everyday life. The possibility to learn, as we have seen, went along with a high degree of audience involvement. While bad movies might be branded as "too artificial" or as unsuitable "to get something out of it," a positive engagement is expressed via statements that stress recognition ("this happened in my house"). Audience participation is also secured by tailoring movies to accommodate long-standing social viewing practices in which audiences, as it were, "complete" the movie by bringing in their own sound. The basic assurance that movies offer is the proverbial victory of "good over evil." One of the

attractions of movies is that they make audiences experience pleasure at this victory and, hence, at the well-functioning of the moral fabric at large. In other words movies not only offer teachings about morality but also convey these teachings in an entertaining manner. Getting something out of a movie and having fun in watching it belong together. The moral lessons through which people "advise themselves" are always embedded in specific narratives that are recognizable and also offer the possibility for a good laugh.

Even though movies are approached as teaching moral lessons, they are not on the safe side of morality. Movies involve spectators in an "aesthetics of outrage" that, "aimed at bodily stimulation, represents an experience of film integral to film itself" (Larkin 2008, 187). Precisely because moving pictures are attributed the power to impress themselves on people, while, in turn, people are held to be permeable to the materiality and visceral nature of pictures and words that reach them from outside, movies are found to have both virtues and vices. Given the Manichaean dualism and the logic of transgression on which Ghanaian video movies thrive, even the most pious movie implies this danger of unleashing the very forces that are to be defeated and that are branded as evil. Here we touch on the ultimate ambivalence of the popular video aesthetic: the greater the importance of a moral message that shows the triumph of good over evil, the greater the need to depict transgressions, to bring to life what is despised and feared.

Film as Revelation

Deliverance from the Powers of Darkness 1 was the second Ghanaian movie I watched, around Easter in 1992 in a small video center in Teshie. This was shortly after its producer and director Samuel Ankrah (alias Sam Bea) had released it. The movie is about a poor young woman who comes from the village to Accra, where she is lured into a satanic cult to become a witch (see Wendl 2007, 7–8). As the evocative poster that was used to advertise the movie (fig. 14) spotlights, she is placed at the center of a struggle between evil spirits, represented by a primitive-looking traditional priest, and God, represented by a pastor dressed in a Western suit. The latter is a powerful and captivating preacher, who delivers the woman from demons—depicted by a snake coming out from between her legs—and she becomes a born-again Christian.

What struck me immediately about this movie was that it resonated even more explicitly than *Diabolo* with stories about demonic possession and divine victory as they circulated in Christian circles, especially among Pentecostals. This made me realize all the more that video movies and similar stories, conveyed through rumors, songs, posters, sermons, testimonies, and popular books (including the best seller *Delivered from the Powers of Darkness,* by the Nigerian Emmanuel Eni, which was widely read in southern Ghana and beyond; see Ellis and Ter Haar 2004; Marshall 2009; Meyer 1995) occupied the same terrain. The imaginary of popular Christianity, strongly deployed especially in Pentecostal-charismatic churches, converged considerably with that conjured up in video movies (see also Pype 2012, 107), sustaining a thick, mutually affirming intermedial texture. Not only did *Deliverance* screen a typical Christian-Pentecostal narrative about the realm of the "powers of darkness," but Sam Bea presented his conception of this

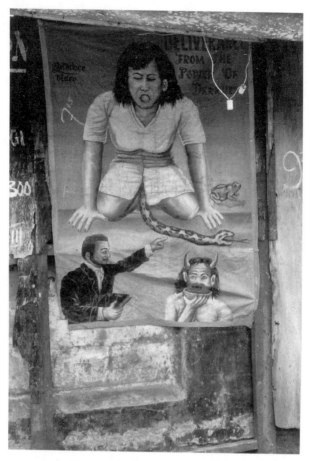

FIGURE 14. *Deliverance* film poster at Sam Bea's video center (June 1998). Photograph by author.

movie itself in analogy to having a Christian vision.[1] When I interviewed him in his video center in Jamestown (26 June 1998), where the movie was shown occasionally on popular demand, he told me that one evening he was lying down, but not asleep, when he saw a vision emerge on the wall of his room. The story came in subsequent pictures, each of which appeared on the wall, just like a film. He immediately called his wife, who was then selling tickets in their video center, and told her what he had seen and heard. He decided to turn this experience into a movie, and this became *Deliverance from the Powers of Darkness 1*. Even though he was not a regular churchgoer and did not quite understand how or why the vision appeared on his wall, it

prompted him to make a Christian film that was even shown in many churches and was much appreciated by audiences. Pastors also congratulated him for projecting this vision onto the screen. According to Sam Bea the movie's appeal lay in the fact that it showed in pictures what people had only heard about and had to imagine before their inner eye. Clearly, the audiovisualization of his filmlike vision—a movie made possible thanks to the availability of cheap video technology—spoke to a general audience interest to access the realm of the unseen that was found to cause a great deal of "spiritual insecurity" (Ashforth 2005) and, indeed, is a symptom of an "insecure modernity" (Laurent 2008; see also Bonhomme 2012, 226).

In the course of my research such a transfer of inner images, which usually were evoked through narratives about the operation of spirits in sermons, rumors, and testimonies, into vivid film pictures turned out to be a basic and recurring feature of many video movies. I describe this transfer as *trans-figuration*. Invoking the Latin terms *trans* (across) and *figurare* (to give a gestalt, to "form," or to "shape"), *trans-figuration* in my use places center stage the practices through which an imaginary expressed through sermons and other narratives, including dreams and visions, is pictorialized in movies and feeds back into narratives and the inner imagination. I use *trans-* in a double sense, involving a vertical and a horizontal axis. To begin with the former, my concern is to explore the figuration of what is claimed to go beyond the ordinary, the "physical," and thus to elude straightforward depiction. My—playful—point of reference here is of course the "Transfiguration of Christ," the metamorphosis of the human Jesus into the divine Son of God, that has been a subject of deliberation both in theology and (Christian) art.[2] In this sense *trans-figuration* refers to a process of transformation through which the ordinary—the mundane, human, or "physical"—is revealed to involve a higher—"spiritual"—dimension existing in excess of, but also within, the ordinary. Obviously, by figuring the operation of divine—as well as allegedly demonic—power in the spiritual realm, the format of revelation also entails such practices of—even literal—metamorphosis. Second, and here we come to the horizontal axis, I use *trans-* in the sense of transmittance across media. This usage resonates with the notion of "transcoding," developed by Christoph Uehlinger (2005), which calls for a detailed study of the transfer of symbolizations across media, for example from texts to pictures or music, and vice versa. As Terje Stordalen puts it succinctly, "Tracing religious symbolizations through their media opens roads of interconnection and

inter-media transcoding" (2013, 31). I prefer *trans-figuration* to *transcoding* because the emphasis in my analysis lies on the figurative dimension of the imagination.

Figuration involves the shaping and designing of figures that are perceived to materialize via various materials and, by the same token, also assume a vivid presence in the imagination as plastic—in the sense of sculptured—inner images. In a recent essay on figuration, Niklaus Largier (2012) discusses Erich Auerbach's (1938) notion of *figura*. Developed through a detailed analysis of the etymology and use of the notion in classical biblical literature, Auerbach introduced *figura* as an expressive form. As a sensory gestalt it shapes the imagination in such a way that the historical event to which the text refers is experienced realistically. Auerbach moved beyond a metaphorical or allegorical reading of figurative speech that seeks to trace its referent, insisting instead, as Largier points out brilliantly, on its pictorial dimension and its reality effects. Texts are grounded in inner *images* that constitute a "linguistic reality" that conjoins plastic-sensory, pictorial, and rhetorical dimensions (Largier 2012, 5). Emphasizing the figurative dimension of texts, Largier's reading of Auerbach offers an encompassing take on figuration and imagination that includes, but is not confined to, typical pictorial media. *Trans-figuration,* then, refers to the transmission of particular figures *across* various media, including written text, sermon, rumors, depictions, and movies.

The process of trans-figuration, based on the partial convergence of popular Christianity and video movies, is the central theme of this chapter. Dominant until the temporary breakdown of the industry in 2003, this feature still informed movie production between 2005 and 2010, albeit to a lesser extent. The focus in this chapter is on movies that set out to render spirits visible through what I call a logic of revelation. "Revelation" was not a locally recognized video film genre (comparable to, for instance, the Indian genre of the mythological within which gods emerge onscreen [Dwyer 2006])[3] but rather a largely taken-for-granted, widely shared, and usually implicit notion that informs both the production and reception of movies up to this day. Well-grounded in the Bible, the notion of "revelation" was understood by audiences as a reference to the Revelation of John (the last book in the New Testament) and comparable biblical texts. A typical expression of Jewish and Hellenistic apocalypticism, the Revelation of John was, throughout the twentieth century, for Christians in Ghana a constant resource for the articulation of apocalyptic visions and, more important, for the deploy-

ment of particular revelatory "looking acts" (Morgan 1998, 8) that offer insight into the realm of the unseen. Rooted in the popular imaginary on which the video scene feeds and that it sets out to audiovisualize, the notion of film as revelation affects both the production and consumption of movies as products that offer some kind of extraordinary insight. Moving beyond a dualistic understanding of "film" and "religion" as separate spheres, this chapter focuses on the technoreligious practices that underpin the production of movies that are (designed to be) recognized by spectators as successful harbingers of truthful insights into a dimension that is considered inaccessible via ordinary perception.

FILM AND RELIGION

Incorporating religious forms and elements into movies is not specific to Ghanaian (or Nigerian) video films. Nor is it a new phenomenon. Since the beginning of cinema, more than a hundred years ago, the silver screen offered a formidable projection space for the appearance of both human and "spiritual" figures from canonical religious texts, such as the Bible or the Mahabharata, and a diffuse realm of spirits. While the "magic of cinema" is a standing expression that invokes movies' capacity to enchant audiences in a largely disenchanted society (During 2004; Moore 2000; see also Meyer 2003a), film theory has barely raised the question of cinema's relation to religion.[4] This question received far more attention in theology and religious studies, yielding analyses of how movies treat biblical themes, above all films involving Jesus, in the light of established conventions of (textual) representation (Reinhartz 2006; see also Bakker 2011). Along with such investigations, scholars in this field also raise more fundamental questions about the relation between religion (de facto Christianity) and popular culture, of which film (de facto Hollywood movies) is seen as a prime exponent (Forbes and Mahan 2000; Clark 2003). In a book titled *Film as Religion* religious studies scholar John Lyden (2003) argues that in modern (American) society cinema assumes certain functions that previously belonged to the domain of religion. Taking his inspiration from Clifford Geertz's (1973) definition of *religion*, Lyden regards films as "religious" because they represent particular worldviews that endorse morals and values.

From this perspective film is understood to operate as a functional substitute for the church service in the wake of modernization and secularization.

Grounded in a secularist narrative, this conceptualization of the relation between religion and film is not false, per se (although, in my view, the characterization of film as "religious" would demand a deeper reflection on the secular production of the religious; see Asad 2003). However, it is hardly applicable to settings like Ghana, where processes of democratization and media liberalization coexist with the strong public presence of religious organizations, especially Pentecostalism. The fact that many video movies draw on the imagery deployed by popular Christianity and even adopt the format of revelation, suggests that the relation between film and religion is more complex than a view of the former as a substitute for the latter would suggest. As I will show in this chapter, the two are deeply entangled.

Instead of invoking a functionalist argument through which film can be approached as standing in for religion, I suggest taking as a starting point film's basic characteristic of offering a virtual window or door that leads spectators into another world—the diegetic universe of the cinema—calling on the "human capacity for transcendence" (Sobchack 2008, 197). As Vivian Sobchack has argued, this capacity is mobilized not only in the sphere of religion but also through the cinema (and, I would add, the sphere of literature and the imagination at large), in its call "for a unique exteriority of being—an ex-tasis—that locates us 'elsewhere' and 'otherwise' even as it is grounded in and tethered to our lived body's 'here' and 'now'" (Sobchack 2008, 197). In other words "ex-tasis" offers a kind of enchanted experience of standing outside of, and yet being grounded in, the here and now. As our bodies provide the "material and sensual ground—the phenomenological premises" (Sobchack 2008, 197) for sensing and experiencing some kind of "beyond," analyzing movies that feature as revelations of the spiritual realm more or less persuasively requires a material approach that places the senses center stage. The point here is to grasp the specific way in which moving pictures, the senses to which they appeal, and the sensations they yield are intertwined.

What film shares with religion, understood as a practice of mediation, is that both conjure imaginary realms and beings that appear real within certain bounds, that is, within the frame offered by a film or by a religious tradition. From the outset film theory has generated debates between advocates of phenomenological realism (e.g., André Bazin, Edgar Morin, and Siegfried Kracauer) that view film as a window on the real world, on the one hand, and formalist approaches (e.g., Béla Balázs, Sergei Eisenstein) that view film as a frame that constructs an imaginary universe, on the other (Elsaesser and

Hagener 2010, 13–34; Sobchack 1992, 14–16; see also Jay 1994, 459–84). The question of whether film should be understood as *showing* a reality out there or as *making* a virtual one was transcended with the rise of poststructuralist Deleuzean film theory, according to which film pictures are a material reality of their own and film is a world-making medium that restores the bond between humans and the world that the rise of modernity tore apart (Deleuze 1991, 223–26). I am sympathetic to approaches to film that acknowledge the materiality and figural reality of moving pictures that appeal to and are incorporated in the sensoria of the audiences. Assessing the potential of film as a world-making medium calls for an ethnographic approach that explores the aesthetic practices and regimes of visibility through which these cinematic pictures are actually vested with a sense of being "real"—even more "real" than the things that meet the proverbial "naked eye."

Understanding the process of investing film pictures with reality—both on the level of production and reception—demands moving out of the narrow confines of film analysis and focusing on the broader setting in which movies are produced, circulated, and received, and the regimes of visibility on which working with pictures relies. Video, I argue throughout this book, is not a medium that can be taken for granted. Video movies are embedded in a world of everyday experience, mobilizing practices of revelation that need to be explored ethnographically. Leaning heavily on popular Christianity, which in turn builds on a widely shared popular ontology, Ghanaian video movies are made to take part in imagining—and indeed "imaging"—a spiritual realm that is featured and taken as "real" by many spectators. *Showing,* and by the same token *fabricating,* an invisible dimension as being part of the lifeworld is what these video movies do, as this chapter will show.

Focusing on the convergence of religion and film, I do not intend to completely blur the two. Watching a movie and attending a church service are different activities, and audiences are, of course, aware of this. My point is that being alert to the interface of religion and film allows us to explore how movies, in the framework of entertainment, offer a perspective on the spiritual that accommodates audiences' quest to "see clearly." How, then, did cinematic and religious practices of making visible and guiding spectators' gaze come together and achieve "reality effects" by which moving pictures became plastic figures vested with an aura of presence? How did cinematic and religious aesthetics converge in appealing to and shaping the senses, thereby partaking in a particular "distribution of the sensible" that is

sensitive to particular phenomena that elude ordinary perception? Pursuing these questions, my key point in this chapter is that films framed as revelations playfully simulate a Christian perspective to persuasively give spectators a sense of grasping how the "spiritual" is entangled with the "physical."

AUDIOVISION IN ACTION: *ZINABU*

The movie *Zinabu,* by William Akuffo and Richard Quartey, is a fascinating starting point for exploring the nexus of movies and Pentecostalism. Like *Deliverance from the Powers of Darkness,* it exemplifies "film as revelation." The story for *Zinabu,* the first Ghanaian video movie exhibited in a cinema, was written by Richard Quartey. A native Ga and born in Accra, Quartey was trained in the fine arts at the Kwame Nkrumah University of Science and Technology, Kumasi, and in mass communication at the University of Ghana, Legon. After *Zinabu* he continued making movies.[5] I met Quartey for the first time in September 1996, after I had watched his movie *Abaddon* (Paragon Pictures, 1996), a story about a child fathered by the devil who eventually is exorcized. This was in the early days of my research, and at the time I was struck by its profusely Christian underpinnings. During my conversation with him at the bar on the GFIC premises, he explained that concern with the demonic was typical for his movies. His motivation, he told me, was to render visible the spiritual clash between evil forces and God. The Hollywood horror genre, including *Rosemary's Baby,* and Christian popular literature, especially John Bunyan's *Pilgrim's Progress* (see Hofmeyr 2003; Meyer 1999b), were exciting sources of inspiration for Quartey, who, like Akuffo, sought to develop a kind of horror packaged in a Christian framework (Wendl 1999, 2001). He regarded it as his task as a filmmaker to "reveal what happens in the spiritual realm," even though the censorship board and the GFIC officials who had to decide whether or not to screen his movies were in favor of movies promoting African cultural values and disliked the Christian-oriented imagery and message.

Throughout my fieldwork I met him occasionally, but it was only much later that we talked about his work and ideas at greater length in his home in Mamprobi (on the evening of 24 April 2010 and the following morning). Quartey, being in his mid-fifties, was a quite successful man. Along with making movies he also worked as a fashion designer. As a university graduate he had a high standing, which was also reflected in his election as the vice

president of FIPAG. We sat on the verandah of his flamboyantly designed home, which was painted green. The beautifully arranged plastic flowers and the lights made me feel as if we were on a film set. He wanted me to get the "correct" information about *Zinabu* because of its importance for the history of the video phenomenon in Ghana. While Akuffo, whom he had known since childhood (they are related), had directed and produced the film, Quartey had developed the script. To his dismay his role had been down-played, making it seem as if Akuffo had conceived the film all by himself. Taking out many boxes that contained his impressive archive of scripts, news-paper clippings, photographs, and film costumes, Quartey brought the early days of filmmaking alive for me.[6] I realized that from the outset Quartey, in distinction from many of his colleagues, had been adamant about the impor-tance of appropriate costumes, which he designed himself. He also appreci-ated having a script, which, certainly in the early days, was not standard. And he sought to make his actors speak correct English, though he realized that the way of speaking he liked and that matched his own education was far removed from the speech of the people. Music, too, was dear to him, and he composed (and often sang) his own film music. In the production of *Zinabu,* as he told me, many mistakes were made—they had to reshoot the whole film because of a problem with the sound—but they succeeded, and the movie was a blockbuster for weeks at the Globe Cinema.

She

Quartey explained to me that the story of *Zinabu*—a female witch who seduces men with money and ultimately converts to Christianity (fig. 15)—was inspired by both H. Rider Haggard's novel *She* (1887) and his own con-version experience. He had read *She* when he was still a student in St. Thomas Aquinas Secondary School at Cantonments (Accra) and "fell in love with the story," which "had an effect on [him]."

A classic of the genre of Imperial Gothic (Brantlinger 1988) and one of the best-selling books of all time—according to Wikipedia, eighty-three million copies have been sold in forty-four different languages—the novel is based on the British imperialist literature of the late nineteenth century. As such, it echoes the familiar trope of Africa as the "dark continent." Intrigued by telepathy, spiritualism, and reincarnation, many of the writers in this genre, including Rudyard Kipling, Bram Stoker, and Robert Louis Stevenson, mobilized romance and occultism against "scientific materialism" and its

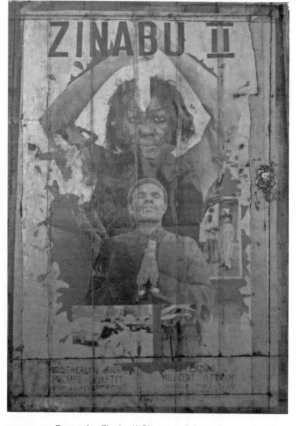

FIGURE 15. Poster for *Zinabu II*. Photograph by author.

naturalistic narratives (Brantlinger 1988, 227–53). Asserting the colonial claim of superior Western rationality, yet at the same time venturing anxieties about it, the Imperial Gothic genre was symptomatic of the contradictions that underpinned the heyday of the British Empire (Brantlinger 1988, 227). In many of his novels Haggard (1856–1925) invoked an imaginary African landscape in which matters that run counter to the idea of civilization—the occult, the all-powerful woman—are brought to life yet kept at bay at a safe distance from Europe (Stiebel 2001).

"She," or Ayesha, is a virtually immortal woman, a remnant of a long-lost ancient Arabic civilization who lives in the swampy and isolated interior of Africa.[7] Here she awaits the return of her reincarnated lover, whom she killed out of jealousy more than two thousand years ago. She is the white queen of a primitive tribe, the Amahaggar, whose members are under her spell, as the

name with which they refer to her—She-who-must-be obeyed—also suggests. She reigns not by force but by the terror instilled in those who fear her: "My empire is of the imagination" (Haggard 1887, 175). Three white adventurers— an ugly, middle-aged university professor from Cambridge named Horace Holly; his stunningly beautiful ward, Leo Vincey, who looks "like a Greek god"; and their servant, Job—set out to resolve a mysterious family secret transmitted to them by Leo's late father, which leads them to She.[8] They start as skeptics, but once in her awe-inspiring presence, they can't help but acknowledge that She is real. While Job is filled with fear, Holly and Leo desire her for her beauty. The scholar Holly, who knows everything about classical civilizations, encounters in She the limits of his rational outlook and self-chosen sexual abstinence. Even he, symbol of the best of British scholarship, succumbs to her empire of the imagination. Haggard leads the protagonists, and along with them his readers, to contemplate that "there are more things in Heaven and earth than are dreamt of in your philosophy, Horatio" (1887, 41).[9]

While interpretations of this novel usually explore its relation to the British or Western imagination of Africa, it is often ignored that Haggard modeled the figure of She on his own experiences among the Lovedu and Zulu in South Africa. Residing in South Africa between 1875 and 1882, Haggard worked as an assistant to the British colonial official Theophilus Shepstone (1817–93), who was fascinated by the Zulu and maintained a personal friendship with the Zulu King Cetshwayo. Fritz Kramer (2005, 44–50) reads the novel as a fictitious distortion—an "ethnofiction"—of Haggard's experiences in South Africa. Kramer traces the imaginary figure of She to both the queen of the Lovedu, Modjadji, who ruled her people without appearing in public and who was held to be immortal, and the beautiful Zulu goddess Nomkubulwana, who ensured the growth of her followers' crops. In contrast to these African women with whom She shares the features of power and autonomy, however, She is a lonely, Puritan, sexually abstinent woman of Arab descent who rules primitive blacks. Haggard's actual encounters with narratives about powerful African queens, Kramer argues, were transformed into a non-African, more civilized figure.

While Kramer points out how "ethnofiction" exoticizes Africans and establishes white superiority, Caroline Hamilton analyzes *She* and other novels by Haggard as popular reflections of Shepstone's political vision and its repercussions on Zulu historiography. Long before the term *indirect rule* was established as the typical British mode of colonial governance, Shepstone

advocated governing by relying on local political structures,[10] a theme that also occupied Haggard, as *She* clearly shows. Hamilton (1998, 117–23) argues that Haggard translated Shepstone's vision for Zulu sovereignty under the auspices of the British Empire into a popular format. Oscillating between fiction and reality, his novels were read by many as true accounts. Tellingly, Haggard noted with regard to his most famous book, *King Solomon's Mines* (1885): "It would be impossible for me to define where fact ends and fiction begins in the work, as the two are very much mixed up together" (quoted in Haggard 1885, 123). This also applies to *She,* which was published about two years later.

Hamilton's point that *She* and other writings shaped both public opinion and visions of colonial policy in Imperial Britain as well as Zulu historiography is important because it places the novel in actual contact between Westerners and Africans; however, its impact is not limited to the Zulu and South Africa. Though I do not know of any research on the circulation and reception of the novel (and the various movies made about it) in Africa,[11] I assume that for many African pupils, reading the book was part of the curriculum, as it was for Quartey. This makes his fascination with *She* all the more intriguing. Approached in this way, *Zinabu* is not just a Ghanaian movie but part of a broader imaginary evolving in the "imperial encounters" (van der Veer 2001) that affected Africans and Westerners and that still shapes current popular imaginaries.

Zinabu

Quartey explained to me that before becoming a born-again Christian, he was "someone who doubts," a person very skeptical about the existence of things he could not see with his eyes. Through his conversion experience he came to accept that "there is more to this world than the physical," that "there are things that are beyond you." And so, "right now it will be difficult for someone to convince me that there is no heaven, there is no hell. Because I once went there and I descended into it and I saw what was happening there." While the She in H. Rider Haggard's novel is both a strong ruler *and* a captivating woman to whom every man who sees her would succumb forever, Quartey was fascinated above all by her female charms, through which she "could control men and that kind of thing." That he referred to her as "She-*the woman*-who-must-be-obeyed" (thus inserting "the woman" into her awesome name) emphasizes his concern with her seductive female qualities.

Interestingly, his wife also was popularly known as She, a name she also used for her cosmetics store in Mamprobi.

Being overwhelmingly beautiful and sexually abstinent and having spiritual powers to bind any man, Zinabu operates like She. By enticing men, yet not acquiescing to their desire to have sex with her, she steps out of prevailing gender patterns, being independent and in control. The first part of the synopsis, written by Quartey and shown to me at the time of our interview,[12] titled "Zinabu (Not All That Glitters Is Gold)," coincides with part 1 of the *Zinabu* series.[13] This synopsis was the basis for the plot. As I have pointed out, video movies were produced under the conditions of a culture that is largely oral, so actors were given considerable freedom to choose the phrasing for their dialogue:

> The scene opens with Mr Mark Korley, a factory hand, spotting an attractive beautiful and loving lady behind the wheels of a posh car. His appreciation dwindles after he notices a gentleman, into whom he had bumped, enter the marked car. He curses his stars for not getting a clear look and more so a chat with the lady.
>
> The next day, Joe, a friend of Mark also a co-worker, presents his friends (i.e., Mark, Kweku and Bob—all workers in the factory) with the day's newspaper. There is a catastrophe in the form of an accident on the front page. Mark identifies the car and the victim to be Mr Vicsons, the man he bumped into and saw enter the car. No mention was, however, made of the lady.
>
> Puzzled, he takes a stroll along that same street after work and bumps into the same lady behind the wheel of a more flashy car. He attempts an interrogation, but is lured into the car and unfortunately falls for the beautiful driver—Madam Zinabu Sam.
>
> Zinabu, it must be emphasized, possesses some unique natural and supernatural qualities which enable her to captivate, seduce, hypnotise, and make a victim capitulate.
>
> In their newly found romance, certain delicate proposals, treats, and warnings are given. The sudden vicissitude in Mark's life makes him readily accept Zinabu's delicate conditions without analysing its long-term effects. This, however, culminates in his untimely death because, as Zinabu later puts it:
>
> "He disobeyed and paid dearly."
>
> What she meant by this statement was Mark's falling for another attractive girl—Helen—who he spotted at the swimming pool and met later at a disco.

Reverberating with Quartey's vivid way of speaking, this synopsis dwells rather lengthily on the first scene, which establishes Mark's desire for Zinabu,

who still is with another man (who presumably met the same fate that Mark will later meet). Since Mark is poor, he cannot afford to have a girlfriend or wife, and he looks wretched and silly in his clothes. Zinabu's look and her flashy car strike him like lightning. When Zinabu invites him into her car and into her fenced mansion with its fancy interior—for instance a nice bathtub with a showerhead that Mark initially mistakes for a phone—he immediately falls for her. All he wants is to leave behind poverty and enjoy the better side of life. He accepts her "delicate conditions" without further thought. While he is thrilled about her beauty, he nonetheless has to accept that he cannot have sex with her or with any other woman. This is a clear instance of an exchange, not unlike the deals made with "Mami Water" (see chapter 5),[14] in which wealth is received for sexual abstinence, and hence the loss of sexual pleasure and the possibility of procreation. This is one of the recurring themes taken up in Ghanaian movies. If Mark fails to comply, he will die. Of course, once he has become a rich man with a car, his sexual appetite awakens but to no avail. Any time he tries to get close to Zinabu, she reminds him of his pledge. And even when he is about to fall for another woman, Zinabu's spirit appears to him, warning him about the consequences.

But as the synopsis also states, eventually he sleeps with the beautiful Helen. Totally drunk, he follows his instinct, disobeying Zinabu's warning. The next morning he wakes up satisfied and happy. Fearing that Zinabu might have bewitched his car to destroy him, he takes Helen's car. In the last scene we see Mark humming that he "did it" and that he will now retrieve money from the bank and go to America. Of course, Zinabu takes revenge. By way of montage, the movie switches from showing poor Mark locked up in a car that can no longer be steered to Zinabu doing the sympathetic magic with which she effects a spiritual bond that affects Mark. With marks around her mouth, and in front of a pot and a voodoo doll on which she spills the blood of a chicken, the depiction resonates more with Hollywood fictions of voodoo than with actual ritual practices in traditional cults. Switching from one location to the other—from the car to the voodoo shrine and back—the camera offers spectators a kind of extra vision. It reveals how a process visible to everyone in the street—Mark struggling in the car—is directed from a spiritual realm that is normally hidden from view. The deeper Zinabu gets into the ritual, the less controllable the vehicle becomes. There is smoke in the car, and Mark is suffocating. Dramatic Western-style classical piano music underlines the death struggle. Once Zinabu has put the chicken into the pot and its legs stop moving, Mark is dead.

This juxtaposition and blending of the "physical" and the "spiritual" side of things is typical for the way the camera offers a particular kind of super-vision to the spectators in film-as-revelation movies. This is where cinematic modes of showing and religious acts of looking intersect: the camera reveals what the naked eye cannot see, thereby being coded as a device that makes spirits visible and audible and, in so doing, offers vision to the spectators. If *Zinabu* shares with *She* the concern to display the power of a beautiful woman to rule "through the imagination," the movie also digresses from the novel in a significant way. While in Haggard's novel She perishes in the Fire of Life, leaving the two Western protagonists in the void of an eternal desire for She that can never be satisfied, Quartey's Zinabu is not made to die but to be exorcized.

This scenario echoes Quartey's own commitment to Christianity. Baptized as an Anglican, he always "troubled pastors with questions about God." He was a "skeptic" but also a "seeker." When he was in his mid-twenties, he had a conversion experience that occurred after he had fasted for five days, without drinking even water, in his family house. He had written a letter to God, which he read every hour, asking Him to manifest himself. On the last day of fasting he thought he was going to die, and therefore he drank some milk. After that he started speaking in tongues. The people in the house did not know what to think of his behavior, except one woman who said that he was possessed by the Holy Spirit. This proved to be correct, he asserted to me. After this time he had visions, which he received in a trancelike state. One time, he reportedly ascended to heaven, with his body hanging upside down, and he saw God. Through this experience, which made him see things more beautiful than what he could ever design as an artist, he was finally persuaded that God is real. And so is Satan, who once tried to grab him with a hairy hand. Quartey gave artistic expression to many of these visions in moving pictures.

The story of *Zinabu* echoes his own experience of being born again, as the second part of the synopsis, which summarizes poignantly how the story unfolds in part 2 of the *Zinabu* series, shows:

> Mr Bob Mensah—Mark's beloved [i.e., friend] in the group—received this unbelieving news with shock, and taking nothing for granted, suspecting foul play, decides to probe into and investigate the mystery, using himself as bait.
>
> Tried as he did, he unfortunately fell in love with Zinabu. He detected that the mystery had to do more with the spiritual realm than the physical. He also realized that Zinabu was possessed and belonged to a witch cult where sorcery and occultism was practiced.

Being a Christian, Bob starts exploring the spiritual realm, battling the forces of darkness with the name of JESUS. He had it tough, though, but finally succeeds in casting out the demons from Zinabu, whom he had promised to marry.

Once Bob has realized that "the mystery had to do more with the spiritual than the physical," he ventures into the spiritual struggle against the "powers of darkness" that stand at the center of popular and also Pentecostal religiosity. Uttering the name *Jesus,* Bob invokes a powerful Pentecostal speech act believed to have devastating effects on evil spirits. The movie shows that Zinabu eventually loses her spiritual power and becomes a docile, married woman. For some time she is still haunted by the powers that previously underpinned her magic. This is a continuous source of trouble—for instance, when the evil powers spiritually tie her womb and prevent her from giving birth, making her go through painful and prolonged labor until the spiritual struggle is resolved.[15] But ultimately, after a drawn-out spiritual war, she is delivered to be a loving wife and mother—a resolution entirely in line with the emphasis on the value of the modern nuclear family celebrated by Christians in contemporary Ghana (and quite typical of the 1960s Western family ideal).

She and *Zinabu* converge in showing that a powerful woman with supernatural powers able to put a spell on any man is unacceptable. While She loses her life in the flame of eternal life (because she entered it for a second time), Zinabu is reborn as a Christian, cleansed through fervent prayers. Stripping a woman of her supernatural powers through deliverance and conversion, as is the case with Zinabu, parallels the process of early Christian evangelism in Ghana. Missionaries were horrified by female priestesses, who obviously challenged Western Christian notions of decency, chastity, and submissiveness, and saw their conversion as a victory over the devil (Meyer 1999b, 62); such priestesses functioned as a trope for the sexualization of the black body as visceral and inferior (Tonda 2011, 48). Female converts lost the possibility to gain a powerful position via access to spiritual entities and were instead embedded in the male-centered, paternalistic version of Christianity advocated by the missionaries, which had little room for spiritually powerful women. Video filmmakers had to take into account the expectations of their predominantly female audiences, but this did not imply that they had to celebrate a woman like Zinabu (and many similar characters, with often illustrious names such as Demona, Namisha, Mariska, or Babina). The true heroine was the Christian mother and spouse, who was in control of herself

and, in contrast to her morally weak husband, did not succumb to seduction. In line with the Christian perspective that women and men involved with spiritual powers are evil and demonic, such characters were usually made to either perish or convert.

"PHYSICAL" AND "SPIRITUAL"

The reference made in the synopsis to the terms *physical* and *spiritual* is crucial to what the framing of a film as revelation implies. The pairing of these terms is the central characteristic of a broadly shared popular ontology, according to which *spiritual* refers to an invisible, yet nonetheless present, dimension of the "physical."[16] The "spiritual" is the domain of various powerful forces that effect certain actions in the "physical" but are difficult to see because they operate in secret. The spiritual is not simply an inert domain but is understood in terms of a moving principle, just like breath or wind (which is at the basis of the term for spirit in Ewe *(gbɔgbɔ)*, Akan *(sunsum)*, and Ga *(mumɔn)*. Seeing the "spiritual" in action requires special techniques for divination or revelation that operate within a specific regime of visibility. This implies that a full grasp of the world cannot be gained by relying on the mere observation of appearances but requires deeper insights as a basis for full knowledge and control. In this sense the distinction between the physical and the spiritual entails a political theory of knowledge according to which superior visionary capacities to uncover, and conversely to conceal, the spiritual are a source for power to achieve—and possibly convey to others—deep knowledge about the world (for a similar point regarding the Lunda see Palmeirim 2010).

This theory of knowledge underpinned the indigenous worldviews onto which Christianity was grafted. From the outset of evangelization it was incorporated into Christian superiority claims that Christianity threw light into the darkness of "heathendom." At the same time, Christian missions introduced an alternative attitude toward the spiritual as anchored in the notion of belief in the existence of an invisible monotheistic High God, who cannot be seen or represented as such because He is a transcendent entity who appears in the world indirectly. As outlined in my earlier research on local appropriations of missionary Pietist Christianity (Meyer 1999b, 2010c), it was difficult for the indigenous people to accept the stress on belief as an inward disposition at the expense of appreciating ritual and the use of

powerful objects.[17] The rise of African Independent and, later, Pentecostal churches is at least partly rooted in misgivings about this prerogative, yielding what I called an Africanization from below that negotiated Christian ideas and practices in the light of indigenous worldviews (Meyer 1992). The idea has been retained that the spiritual works through the physical and that special techniques of divination or revelation are required to "see" how this occurs. Distinct is the Christian invocation of a dramatic structure of a harsh opposition between good and evil spirits that plays out in the physical but has to be confronted in the spiritual. Hovering around the notion of the devil, the central feature of this popular Christian religiosity is the strong concern to reveal the "powers of darkness" that are held to operate behind the surface of appearances. Resonating with traditional practices of divination, revelation is to achieve some degree of insight into and control over these powers, be it by having "visions" (like the one Sam Bea experienced) and dreams or by relying on the Spirit of Discernment. Making these powers visible through revelation is understood as the first step in defeating them.

When I asked Quartey, whom I knew as an eloquent speaker, how he understood the relation between the spiritual and the physical, he ventured the following explanation:

> Most people will like to believe what they see, what they can touch, what they can feel. But with the spiritual, it's like ... there is another bigger power somewhere. Because once [in] a while, we will all be sitting in a car. And there is a little scary something, like an accident, and all say: "Hey, Jesus, God!" Why? If all is about the physical, why don't you say "Richard"? Or call a name: "Birgit"? But it is spontaneously that everyone is praying either "God" or something... "Jesus." And when you lie down somewhere, you feel you are sleepy, and then you realize that you have dreams that you even can't comprehend. Which means that there is more to this world than the physical. ... So when we talk about the physical, we are talking about a thing that any other person can comprehend. But when we are talking about the spiritual, you talk about things that your physical, mental, carnal mind cannot comprehend. Things that are beyond you. Why do people die, and when they die, what happens?

Quartey's assertion that human beings have a basic sense of the reality of the spiritual, which comes out in moments of danger or in dreams, is widely shared in southern Ghana. Dreams are not understood as effected by a subconscious processing or digesting of personal everyday experiences but as openings to the spiritual realm that may yield important messages, if only interpreted adequately. The understanding that there is more to reality than

what meets the eye informs people's ideas about themselves, their relations, and their environment. The notion of the existence of some other dimension lurking behind the surface of appearances and, though invisible to the "naked eye," still determining the course of things conveys a sense of being spiritually vulnerable and insecure. To understand the true nature of the physical and to be able to navigate appropriately, people look for deeper insights. Importantly, here the spiritual is not understood to be ephemeral and elusive and thus as opposed to matter, as a commonsense Western understanding of he spirit-matter relation would have it. Instead, the spiritual is characterized by what I would like to call an *invisible materiality* that, to be grasped fully, must be expressed and externalized via words and pictures.[18] Revelation is thought to achieve this externalization, which is understood not as an act of mere representation for the sake of display but also as achieving some degree of control over what is represented through the very act of representing it.

Quartey himself wanted to alert people to the fact that, in his view, "there is a spirit behind" many events and even ordinary things that could easily confuse and mess up people's lives. Hence people had to be vigilant and alert. This is what he emphasized—and indeed, preached—via the medium of film. In this way *Zinabu* is paradigmatic of a whole set of movies that, by fighting evil spirits, partake in (trans-)figuring the spiritual, thereby affirming the reality of and danger imbued in the spiritual forces represented, as well as celebrating the superior vision on which their figuration relies. The struggle against demonic forces never leaves these forces behind once and for all, because they form an indispensable target on which both the movie plot and the popular Christian vision of the world as a site of "spiritual war" depends. Indeed, invoking this war and asserting the superiority of the Holy Spirit is Pentecostalism's raison d'être and has been one of the main selling points of movies like *Zinabu*.

VIDEO FILMS AND CHRISTIANITY

While Richard Quartey was exceptional as a filmmaker because of his full commitment to the Christian cause, his movies were not. Many filmmakers—at least for some time, in response to audience demand—made movies framed as revelations, exposing and hunting down demonic powers in the name of God. Unlike in Nigeria, in Ghana there is no separate category of "Hallelujah movies" produced by Pentecostal churches. Christian imagery and recourse to revelation as an audiovisual strategy characterizes a great

number of movies. Hammond Mensah (alias H. M.), an Ahmadiyya Muslim, rose to fame with his heavily Christian movies in the 1990s and early 2000s but lost out after the transition to VCD. Take, for instance, his very popular blockbuster *Fatal Decision* (H. M. Films, 1993), a film about a man who, because of the supposed infertility of his wife, marries a second wife, named Mona. There are spectacular scenes in which Mona's spirit leaves her body, as witches supposedly do, transforms into a vulture, and starts to trouble her rival "in spirit." Ultimately, the first wife is expelled from the house; she gives birth and dies in misery. Her son, however, is saved by divine intervention and cared for by a pastor. In the end the son turns out to be the hero of the story, making his old father feel ashamed but, all the same, forgiving him his past mistakes. H. M. explained to me that in a country like Ghana, where the majority of filmgoing audiences are Christian, "if you show anything that goes against Christianity, you are doomed, people say nasty things about your film" (interview, 7 Sept. 1999). He did not find it at all problematic to use Christian imagery, as long as the movie itself would convey a message that he stood for. In his view, as for Ahmadiyya, there was a strong convergence between Muslim and Christian morals and ideas about evil.

However, filmmakers with no strong religious affiliation or moral convictions also accommodated the demand for movies of the film-as-revelation kind. Even those who were tired of "all this Pentecostal crap," as Akuffo put it,[19] were prepared to adopt "revelation" as a format, framing movies with phrases such as "Thank you Jesus," "This is a true story," "Thanks to God Almighty," "Be vigilant," and the like. Thus, irrespective of the degree of personal belief and sincerity, filmmakers still operated in a field in which born-again Christianity was very popular and with which they had to somehow resonate in order to make profitable films. In addition the format of revelation offered excellent possibilities for the use of spectacular imagery, especially of demons, violence, and sex, that had a strong appeal for the audiences but was acceptable only if placed within a moral frame.

How would Christians value the rapprochement between video movies and popular Christianity, as epitomized by revelation movies? Even though, as I explained in my introduction, I did not conduct research in a specific Pentecostal-charismatic church, I talked to born-again believers and pastors about the relation between media and religion, video movies and church, whenever I had the chance. The issue was especially intriguing, because in the course of the 1990s most cinemas were transformed into churches or at least were occupied by them most of the time (Meyer 2006a). This takeover sug-

gests a significant shift from more or less secular urban entertainment, as represented by the cinema, to Pentecostal Christianity as a key instance for organizing a mass public. Offering some kind of Christian entertainment, a great many video movies navigate in between the cinema of the past and what I call Pentecostal-lite entertainment, that is, entertainment making use of a Pentecostal style of representation (Meyer 2004).

Although there is an obvious similarity between the spatial structure of a cinema and that of a Pentecostal church—both have the shape of the auditorium that involves the emblematic order of the mass ornament (Kracauer 1995)—many Pentecostals were nonetheless concerned about the temporary use of the cinema as a space for worship. They considered the cinema, at least the popular, noisy locations, immoral (see also Larkin 2008, 149). For that reason, prior to using the space for a church service, the cinema would be ritually cleansed through prayers, as was common practice for the House of Faith Ministries, which hired the Opera Cinema from the Captan family for its Sunday and some occasional weekday services. The Reverend Samuel Amoako Boafa told me about the problems of using the cinema hall for church purposes. In his view the people who went to watch movies at the Opera would vomit and spit on the ground, and many of them were ganja (i.e., hashish) smokers. All in all they belonged to a different "class" of people who did not attend his church or probably any other one. On Saturdays the church's "prayer force" and also the senior pastor would come together to sanctify the venue through prayer. On Sundays they decorated the hall nicely, put a screen in front of the toilet doors, and sprayed the toilets (though, unfortunately, the smell of urine was still there). As the benches were always dirty, people did not like to come in white clothes (interview, 30 Oct. 2002). For all these reasons the church leaders regarded the use of the cinema as temporary and longed to get their own building.[20]

Many people agreed that, if watched in a proper environment—at home or in a decent place—they could get much out of movies of the kind discussed here. One female pastor, Akua Adarquah-Yiadam from House of Faith Ministries, however, told me that she disagreed with my proposition that Pentecostal pastors liked video movies (interview, 20 Nov. 2002). For pastors and "serious Christians" video and television were an "unnecessary distraction, which is more harmful than good." She herself disliked Ghanaian films, because of the strong emphasis on occult forces (something I found remarkable, considering that in her church pastors preached quite a lot about the invisible operations of demons and the devil). In her view one had to be careful

with the medium because it could encourage people to copy the evil that they saw onscreen. All the same she certainly appreciated film as a medium for preaching. She had shown a film to the congregation depicting how a dead man—who had been a pastor—was raised from his coffin. His widow had taken him to a "crusade" by the famous Nigerian preacher T. B. Joshua, and the movie was circulated to testify to his capacity to perform miracles. The people in her church had been impressed, and she found that this was a good film. Drawing a contrast between video movies and a movie about a "crusade," she seemed to suggest that the latter was "good" because it documented the power of God. The use of films to support one's faith in divine miracles, effected by a charismatic preacher and with audiovisual evidence, was typical for a Pentecostal use of film as a medium for spreading the Gospel.[21]

The performance of miracles and the celebration of vision—consonant with the adage that seeing is believing—drew contemporary Pentecostalism close to the realm of entertainment and audiovisual media such as video, TV, and radio, which became widely accessible in the aftermath of many African countries' (re)turn to democracy. While some pastors and born-again Christians were critical of video movies and the (in their view) immoral space of the cinema, others embraced the movies for offering powerful moral messages and revelations (see Asare 2013, 230–35; Asare explores how pastors and members of Action Chapel International and World Miracle Church International in Ghana and Great Britain responded to video movies). Irrespective of whether Pentecostals endorse, reject, or criticize these movies, it makes sense to regard both the video film phenomenon and Pentecostal-charismatic churches as part and parcel of a broader process in which belief and spectatorship, religion and mass entertainment, became ever more entangled, sedimenting in a particular embodied habitus and urban habitat. Again, video films of the revelation kind do not stand by themselves but are a genuine part of a broader world of lived experience. Nothing can better illustrate the entanglement of film and religion than two intriguing cases of crossover: an actor becoming a pastor and pastors becoming actors.

An Actor as Pastor

Eddie Cofie already had a background in stage acting when he ventured into the video scene in the early 1990s. Playing the role of a pastor in numerous movies, including *Deliverance from the Powers of Darkness, Fatal Decision,* and *Diabolo IV,* he became the prototype of the film pastor.[22] In this role he

garnered a lot of respect and was held in high esteem by audiences. One day a man stopped him in the street, saying, "You have brought peace to my home." The man had not been on speaking terms with his wife when they watched *Fatal Decision* on television with the whole family. While watching, the man told Cofie, he and his wife had recognized themselves in the movie, and now they regretted their past and started talking to each other again. The man congratulated Cofie, saying, "Give us more films, so that you heal our homes." This event made Cofie realize that "people see their own story in the film. But it is untold and they couldn't say it. But then film speaks to what is in them, and the bitterness comes out." So watching the movie made the man look at himself in a new way and repent. Cofie also once met a woman who told him, "Because of your film, my husband has changed."

Pleased by the therapeutic effect that his performance as a pastor had on his audiences, Cofie came to regard himself as a "self-called" minister. In his view this was the reason why he could act well in this role: "If you believe in what you do, it becomes very good." He told me that he liked to make films that were popular. He found that people trained at NAFTI and the film establishment at large failed to understand that people were socialized through folktales that involved matters such as snakes, witchcraft, and the like. Since people were talking a lot about these things already, the attraction of video movies was to "offer them a new version of what they already know; that is why they like film so much. Now they are seeing what they have been hearing." When I asked him whether there was a similarity between the vision offered by movies and in church, he answered, "Yes, pastors may say, 'I am seeing a vision,' but film brings this vision onto the screen, it becomes a reality, people understand it better, and they follow what they have been hearing at church. So film supports sermon." Interestingly, people in his church, the Apostolic Foundation Ministries, asked him to take part in a course on pastoral work, and when I met him again some years later, he was a pastor in real life.

Pastors as Actors

If Cofie exemplifies a smooth transition from actor to pastor, the Reverend Edmund Osei Akoto of the Fifth Community Baptist Chapel (Madina, a suburb of Accra) stands for the reverse move, albeit temporarily (for more examples see Asare 2013, 230).[23] He explained to me that the rise of Pentecostal-charismatic churches initiated a new "mass movement," in which the key word was *mass participation*. This was significantly different from

presenting Christianity to the congregation as a mere "program," as was the case with the "orthodox" (e.g., the historical mission) churches. Since Pentecostals sought to extend their influence beyond the mere confines of the church service and were eager to turn their members into "full-time" Christians, he saw a need to reach out into the sphere of popular culture and the arts. Mass Pentecostalism required all-round participation and, thus, mass culture and mass entertainment.

Before he was appointed a pastor, Akoto and his wife would visit the Ghana Films Cinema at the GFIC. Even though this was a respectable, "high-class" venue, once ordained, he could not go out to entertainment venues in the same way as before, so he watched a lot of Ghanaian and Nigerian films on television. Resonating with statements by Cofie and Quartey, he said that films "reveal the operation of the powers of darkness. They give ideas about how demonic forces operate, how to counteract evil forces with the blood of Christ, how to apply faith to counteract." In contrast to the position taken by the Reverend Akua Adarquah-Yiadam, he had no problem with excessive depictions of occult forces, provided it was made clear that they were evil. These forces should not only be portrayed; it should also be asserted that God overcomes them. Therefore, like many spectators, he insisted, "To me, the ending [of a film] is the message. From here I make my own assessment and judgment." When I asked him how he knew that the moving pictures of the demonic presented in films indeed revealed what happened in the invisible world, he emphasized that in his view about 80 percent of these visualizations were correct. He knew this, since he himself was much engaged in deliverance; he saw how demons manifested themselves through people and also heard people confess, and "what they say matches with what the films show."

When his old schoolmate, the producer, director, and actor Augustine Abbey, asked him to play the role of a pastor in the films *Stolen Bible (Secret Society) I* and *II* (Idikoko Ventures 2001/2002), he accepted the role. The story is about a group of selfish, wealthy men worshipping an indigenous spirit who offers money in exchange for a beloved person (in particular a wife) yet is finally destroyed by divine power. The theme of the sacrifice of the beloved wife has been endlessly recycled in paintings, written narratives, rumors, and a host of Ghanaian and Nigerian films.[24] Building on these already circulating materials, *Stolen Bible* does not claim to tell a completely new story but rather to give visual expression to an existing one in such a way that it appears ultimately realistic. *Stolen Bible* is about Ken, a jobless man (played by Augustine Abbey), and his loving and beautiful wife, Nora. Just

when Ken is desperate about his situation, he meets his old friend Ato, who is fabulously rich and takes him to a secret society, Jaguda Buja, whose members have acquired their riches by sacrificing the person they love most in life. Terrified, Ken tries to sacrifice another woman, Dora, who went into prostitution out of poverty, instead of Nora, but his plan fails because Dora calls out the name of Jesus in time. When he has been forced to sacrifice Nora in a spectacular scene that involves special effects such as a snake coming out of her mouth, he starts to get rich. His gaining a high position in his church echoes rumors at the time about churches, particularly those that emphasize the Prosperity Gospel, offering a perfect hiding place for occultists, witches, and immoral persons. Behind the mask of a Christian appearance these persons are believed to do evil or to cover up past evil deeds, as in the case of Ken. Yet when the pastor is about to honor him in public, Nora's spirit arrives and drives Ken mad—"you cannot go to heaven with a stolen Bible"—and makes him lose his wealth. One day Dora, who now works for the Lord, finds him in the street and takes him to a deliverance session, where a pastor (Rev. Akoto) prays over him until the evil spirit has left him and all the other members of the secret cult, and the spirit perishes.

Abbey explained to me that he opted for the Reverend Akoto to play this role because many actors, even though they might be staunch Pentecostal believers, were not able to embody the role of a pastor in a truly convincing manner. Audiences might find certain scenes "too artificial" and thus be unable to suspend the idea that they are just watching a movie. Shot in a real church with a real pastor, *Stolen Bible* sought to convey authenticity by bringing in line what people believed about the realm of the spiritual and its filmic representation. This required compelling pictures that would be recognized and experienced as truthful revelations. And *Stolen Bible* succeeded in this; as Abbey assured me, tapes of the film sold like "hotcakes" in the streets, and some churches even organized screenings for members. The last scene in this movie shows how Ken is exorcized. This scene is intense, powerful, and highly realistic, and the pastor playing himself as a pastor was at his best. As in everyday life, the pastor in the movie leads the congregation in praying, and we see and hear them speak in tongues. For Pentecostals this mode of speaking is induced by the Holy Spirit. In the movie this prayer—which is just like actual Pentecostal prayer sessions—is shown to bring about the appearance of the spirits against which the Christians fight and even brings them to the church for everyone to see. Speaking powerfully—with authority—is thus taken as necessary to make what is normally hidden appear. The

praying voice is shown to be able to tear open the smoke screen that occludes the spiritual underpinning of appearances. In short, the Pentecostal ability to look beyond the physical involves not only the gaze as such but also words and appropriate gestures—in the movie the pastor typically stretches out his arm in a commanding manner—that summon a force to manifest itself. By the same token, revealing how the spiritual affects the physical is not limited to seeing alone but involves other senses as well, especially touch (see also Palmeirim 2010).

Akoto told me that he let himself go, just as he usually did when he was in church. Knowing that many people would watch the movie, he wanted to really preach a message. Yet this time it went even better than otherwise, because normally when he did deliverance, he was tense, fearful, and very cautious. In this situation, however, there was no fear, so he could perform very well. For him it was "great fun to cast out devils!" Akoto's statement captures nicely the predicament of video film production. While movies of the kind presented in this chapter were framed as revelations of the struggle between divine and demonic forces, obviously they had to figure the invisible, spiritual realm in a convincing manner, that is, by persuading audiences that the filmic imaginary resonates with their own (culturally formed) imaginations. In the moral scheme of revelation movies fearful-looking indigenous priests or Mallams are the typical counterparts of prayer-ful pastors like Akoto. Stuffed with various articles—masks, pots, herbs, beads, sculptures, coffins, and voodoo dolls—their shrines are shown to be located in liminal settings, such as the night, the bush, the seashore, or secret rooms.

The urge to persuade audiences of the reality of the spiritual and its dangers also motivates *Pastors Club* (released in four parts in Twi, with English subtitles, by Miracle Films, 2009), in which a number of real-life pastors play prominent roles (fig. 16). The central figure of the movie is Pastor Matthew (in real life the Apostle John Prah), a powerful Pentecostal preacher who, as the movie shows, is able to heal even apparently hopeless cases—a blind man, a leprous woman—by mobilizing the power of the Holy Spirit. After criticizing his head pastor for withdrawing funds from the church, Pastor Matthew is expelled. He starts his own church, initially without any success. He has a dream in which he sees a number of angels in heaven, who, one after the other, place their hand in a fire and, on withdrawing it, receive a ring. Recognizing one of these angels as the well-known Prophet Sam, Matthew pays a visit to him in the "physical"—that is, in his posh mansion—asking

him about the meaning of the dream, which he takes as a sign from God. Encouraged by Prophet Sam, Matthew is lured to submitting himself to the regime of Mami Water, a close ally of Satan and empress of the world. She dominates others with her sharp turquoise eyes that may turn green or even red when she gets angry. Matthew gets deeply involved with her, and, given that she is a jealous spirit, he is not able to maintain any sexual relationship with a real woman (as in *Zinabu*). His church flourishes thanks to this occult pact; he uses a handkerchief vested with occult power, represented in the movie as fire. Like churches run by other "fake" pastors and prophets, his church attracts a huge audience, including a great number of loosely dressed young women, who are shown to read the Bible seemingly seriously (mimicking the close-ups used to depict the ideal sermon listeners in televangelist programs; see de Witte 2003), while displaying parts of their breasts and their sexy long legs. When they walk up and down in church in their miniskirts, they shake their buttocks. Words like *Greed, Lust, Heresies,* and *Anger,* inserted as special effects in big red letters that slowly evaporate, show that in truth these women are demons sent by Mami Water to create confusion. Taking up long-standing themes, such as a pact between the mermaid and the fake pastor who owes his power to evil spirits, the movie is not special as such. Amazing, however, is the very end, when the four pastors who acted in the movie address the viewers and, in a manner reminiscent of the Osɔfo Dadze format (see chapter 3), explicate the message. The Prophet Appiah Kubi (United Bethel Prayer Ministries International) begins, saying (as subtitled in English), "Don't be surprised to see me assume such a character in a movie. I'm a servant of God, anointed by Him, and accepted by people. I was trained by the Academy of Missions and Theology and ordained by Bishop Akwaboah. The film is meant to serve as a lesson to members of congregations, pastors, and the general public for them to discern true prophets from false prophets these last days." The pastor Obeng Kwarteng (Bethel Prayer Ministries International) also urges viewers not to "see this just as a movie and wonder why pastors are acting in it." And the Apostle Adams Amaniapong explains, "It's pastors who can communicate the message properly, and that's why we've gotten involved. We're putting up this performance to alert all pastors. Beloved, have you seen what God is using the medium of video to teach you? I'm a true pastor trained in a Bible school. This is my calling." Clearly, these pastors seized the occasion to assert their sincerity, making reference to their professional training. Knowing the Bible, these men of God agreed that the medium of film was useful to "teach a lesson" by

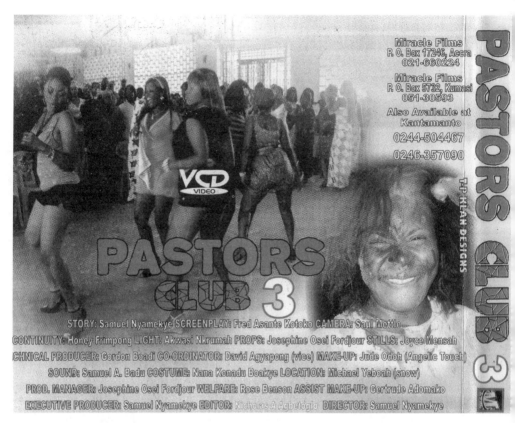

FIGURE 16. VCD Cover of *Pastors Club*. Photograph by author.

showing how even pastors could fall for the temptations of power, money, and sex. Even though at the very beginning of the movie it is stated that "all characters, incidents and places in the film are fictitious and bear no resemblance to any person, living or dead," the pastors' appearance at the very end leaves no doubt that the movie was not just fictional. The pastors responded to heated discussions in Ghanaian society in the aftermath of disclosures about the involvement of Pentecostal pastors and prophets with occult forces. The rising popularity of Pentecostal-charismatic churches has been accompanied by a steady stream of rumors about fake pastors—also reflected in a number of movies (e.g., *Born Against* [Kapital Screen Pictures, 1995]; *Candidates for Hell* [Extra 'O' Film Producers, 1995]; *Karishika* [Tony Jickson, 1996]; see also Asare 2013, 67). In May 2008 these rumors reached a new stage in the aftermath of the publication of news reports in the serious press about the traditionalist Kwaku Bonsam, who stormed into a Pentecostal

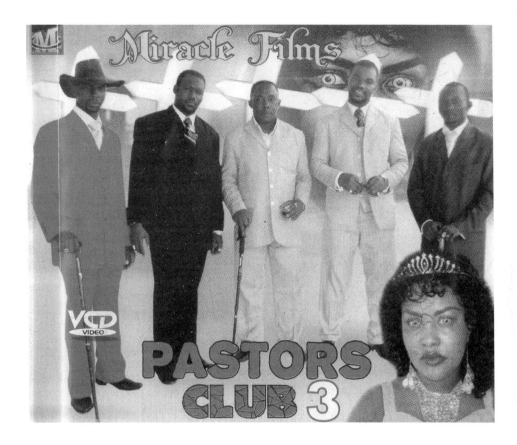

church in the Brong Ahafo region and publicly challenged its pastor to pay for the juju he had done for him or return it. Kwaku Bonsam—a telling name, as *bonsam* means "devil" in Twi—claimed that there were more than one thousand pastors who had secretly called on his service and threatened to reveal their names (Lamote 2012; see also Shipley 2009b). *Pastors Club,* made soon after these allegations, takes these challenges at face value yet, in line with the logic of "fakery," insists that nonetheless good pastors do exist. Along with addressing the general churchgoing public, the pastors had a particular message for colleagues: "If you find yourself in this situation, come to us and we will pray with you in confidence and not make it public." They thereby asserted their capacity to reconvert fakery into truth.

Taking actual pastors who played fake pastors so as to assert themselves as true pastors, *Pastors Club* pushed the strategy of revelation to the limit. For the sake of revelation real pastors had to copy precisely the bad behavior

that, if disclosed, marked pastors as fakes. Indeed, here "public obsession with the fake becomes a form of moral discipline that produces what it claims to mitigate against" (Shipley 2009b, 547). As the pastors seemed to realize, there was a potential for backlash in this extreme revelatory work that required evil and immorality to be staged in order to be shown as bad. One of the pastors commented explicitly on a scene showing the men of God deeply involved in immoral acts with sexy girls in the "Prophets nite club," explaining that they needed to act in this compromising way to produce the pictures needed to teach a moral lesson. While the Reverend Akoto could simply play himself and hope that his performance would draw new people into his church, the pastors acting in *Pastors Club* faced a more complicated situation. Their scandalous acts displayed in the movie had a subversive potential, signaling the ultimate impossibility to distinguish "fake" from "genuine."

Exposing alleged men of God as employing a Christian appearance as a screen behind which occult powers found their perfect hiding place echoed the broadly held idea that nothing is what it seems. This awareness further enhanced the importance of revealing, layer by layer, what lies underneath appearances, but it also spotlights the impossibility of full revelation. Revealing what is underneath an appearance necessarily entails figuration, and the production of new appearances that call for further revelation, so there is no way to escape the ambivalent characteristic of figuration to both expose and conceal. In this sense revelation is similar to a screen that, literally, displays and shields off at the same time.

THE SPIRITUAL EYE

The central argument of this chapter is that the use of the revelation format in a great number of movies testifies to their groundedness in spectators' world of lived experience, in which popular Christianity holds a central place. In this section I will examine the overlap between Christian acts of looking and the perspective offered by revelation movies. The movies' credibility derives from the extent to which spectators can recognize them as truthful documentations of the spiritual. This can easily fail, of course, making people disqualify a movie as boring or artificial. A good movie not only has to make viewers forget that they are merely watching a film but also must persuasively offer a superior kind of vision that allows them to see more clearly. Through techniques of montage that suggest a bridge between the

physical and the spiritual, audiences are invited to look beneath the surface, deep into people's minds and into their hidden operations and secret interactions with spirits. Tying into Pentecostal and, more broadly, popular Christian understandings of vision, in revelation movies, at crucial moments the camera invites audiences to mimetically partake in the all-seeing "eye of God," for whom nothing is hidden from view.[25] Partaking in this divine vision involves both seeing and being seen. The eye of God is understood as a penetrating gaze—imagined as similar to a camera that records people's lives like a film—through which human beings both become the object of divine supervision and control and receive the gift of the "spiritual eye."

The point here is to intimate a match between Christian acts of looking and the "eye" of the camera. As I have suggested, the propensity to take seriously the penetrating gaze of the movie camera as offering some kind of revelation ties into a popular Christian understanding of faith as yielding a superior kind of "spiritual" vision. This understanding resonates with the centrality attributed to the perspective of the omniscient narrator in many biblical passages, as well as in popular Christian literature. The following quote from a Pentecostal tract summarizes the close link that a theological perspective posits between faith and seeing: "Even though God has given you everything that you need for life, your physical eyes cannot see them because they are in the spirit realm waiting for your taking. *Your* faith however, can see them and be sure of them. *Your* faith can be certain of them. *Your* faith is both your spiritual eye and your spiritual hand. *Your* faith can see hope in the darkest circumstances of life. *Your* faith can defy the odds and press on to hope against hope" (Gbordzoe 2000, 27 [emphasis in original]).

This understanding of the "spiritual eye" as a divine gift that gives direction under unusual circumstances is nicely expressed in an essay written by a student about his favorite Ghanaian movie: "We have to be good Christians for God *to appear to us* and give us direction in all circumstances in order to save our life and other's lives" (essay written on 22 Nov. 1996 [my emphasis]). The student praised *The Witches of Africa* (Ebkans Enterprise, 1992), a film that reveals the hidden machinations of a witch who confuses a man's mind and fixes the spirit of his wife so that she seems to be dead, not only for exposing witchcraft to the spectators but also for asserting that God appears to "good" Christians. In this movie faith is shown to be the vital condition for mobilizing God—who is represented in the movie by a picture of the Sacred Heart of Jesus—to manifest himself and look after the faithful. The felt presence of God is also the prerogative for being able to probe beneath the deceptive

surface of appearances and look into the spiritual. The movie he referred to, like others discussed in this chapter, was appreciated by spectators for affirming that they could access and incorporate the kind of vision represented in films for their own benefit, seeing more clearly and deeper in their own lives. The demand for this kind of vision is expressed poignantly by the following statement by a woman whom I interviewed casually on 4 October 2002 while she was watching a movie in her cosmetics shop: "Films teach us about the evil forces that try to bring us down. In this country, when you want to progress and grow, some people will not like it, so they will do something against you. Films show how all this works, so you can do something about it."

The notion of the "spiritual eye" and its seamless association with the camera is not an exclusive feature of the video/Christianity nexus. It is part of a broader regime of visibility that links up with indigenous divination practices. In these practices the surface of water in a calabash is employed to reveal the unseen to the priests with their proverbial "third eye" or "second pair of eyes." Representations of the calabash as a kind of mirror or camera (not unlike a crystal ball) can be found in various media, including narratives, posters, and of course movies. For instance, in a scene in *Stolen Bible* the ritualists to whom Ken owes his occult powers follow his deliverance in church via the "screen" of a calabash. A piece of cloth may also function like a screen on which the pictures of a person conjured by the priest appear (as in *Ashanti* [Danfo B. A., 2008]). Significantly, in popular parlance the capacity to access the spiritual is often explained by invoking an analogy to the medium of film. Not only are God and the devil, and by implication the indigenous priests who are taken as his servants, believed to use camera-like devices to observe people, reproducing their lives as if they were films (Meyer 2010b, 123–26). Also, powerful preachers claim to have the Spirit of Discernment, which is said to work like an X-ray or airport luggage scanner that detects dangerous and prohibited contents. They claim the capacity to look through the surface of appearance and discern a thing's true nature (see also Mittermaier [2011, 225] for the metaphoric use of visual technologies as tools that "expand human sight and show us what we cannot ordinarily see"). Modern visual technologies have been incorporated not only into Pentecostal mediation practices (see also Morris [2000, 187], who makes a similar argument with regard to the "profound affinity" between photography and Thai spirit mediums) but also as metaphors to explain the superiority of God's omnivision. As we have seen, this is also expressed in the pastors' comments at the end of *Pastors Club,* when they endorse the use of the medium of film to teach a lesson to viewers.

The appreciation of film, and more broadly of technological devices that render visible what was thought to be hidden from view, stands in a remarkable contrast to staunch Pentecostals' iconoclastic attitude toward pictures of God and Jesus, which, in line with long-standing preachings that were central to nineteenth-century evangelization, are disqualified as "idols" or "fetishes." In contrast, film is regarded as a different medium. Consisting of "moving pictures" (at least on the level of perception), it focuses and zooms in, displays and exposes, allowing spectators to follow the lead of the camera and see for themselves rather than merely being subject to the gaze of a superior force. Film is held to offer a superior vision into the spiritual that moves audiences along via the gaze of the camera.[26] Addressed as full spectators of the theater of the world as a whole, which is shown as shaped by the entanglement of the physical and the spiritual, they are enabled to transcend the boundary between the accessible and the inaccessible using their ordinary senses. Movies of the kind discussed here not only *depict* the spiritual in line with a popular Christian imaginary, but above all they also mobilize a set of *sensory practices* that conjoin indigenous and Christian-Pentecostal ways of communicating with spiritual powers so as to access what lies "beyond" the reach of ordinary perception. Importantly, by converting to Christianity, people gain easy access to sensory practices of revelation without requiring any specific initiation, as is the case with indigenous priests for whom their "third eye" or "second pair of eyes" is a mark of distinction from their clients. This promise of "open access" to superior vision has been one of the attractions of Pentecostalism from the outset and a central trademark of a large number of movies that simulate this vision in the playful, yet all the same educative and didactic, setting of revelation movies.

Important here is the relation connecting seeing, speaking, and hearing. While the camera mimetically offers audiences the "spiritual eye," understood as a divine gift that temporarily replicates and makes accessible the "eye of God," movies do not make Him speak. Whereas evil spirits and the devil appear and talk to people, God is quiet, just hearing and listening to what people say, and shown to act via special effects. Many movies include scenes with quite dramatic speech acts, such as the powerful deliverance prayer voiced by the Reverend Akoto or the outcry "Jesus!" uttered in a moment of deep despair, as is the case with Bob in *Zinabu,* Dora in *Stolen Bible,* and staunch believers in many other movies. Saying the name of Jesus, Christians claim, is a powerful act. The formula "I command you, in the mighty name of Jesus, to come out" is central in performing exorcism. Combined with

laying on hands and other gestures, voicing this command is thought to force a spirit in hiding to manifest itself (Meyer 1998a; see also Asamoah-Gyadu 2013, 35–55). Not only are evil spirits thought to be disempowered simply by hearing the name *Jesus,* but uttering it also implies action: the Holy Spirit is mobilized to step in. This is shown evocatively in the Ghanaian-Nigerian movie *Time* (Miracle Films, 2000; see Agorde 2007 for an extensive analysis). About to perish in a fire as a sacrifice to a bloodthirsty spirit, a young woman loudly and repeatedly calls the name of Jesus in the midst of the native priest's barbaric incantations. Immediately the Holy Spirit, represented by a flash of fire, arrives and consumes the priest, allowing the woman to flee. Similarly, in *Pastors Club* the one and only genuine pastor also calls out the name of Jesus when he finds himself transposed, in a dream, into the company of angels assembled around a fire (as seen also by Pastor Matthew). Here, too, shouting the name of Jesus has a disruptive effect that deeply challenges Mami Water and her allies, dissolving the deceptive smoke screen through which they disguise themselves as Christians. Movies using the format of revelation show how oral appeals to God are effective in the spiritual realm. In this way movies claim to offer visual evidence that prayers, if uttered in faith, are powerful and efficacious.[27]

CRACKS: THE MATERIALITY AND TRANSGRESSIVE POTENTIAL OF JESUS PICTURES

Embedded in a dualistic structure of good and evil, the recurring plot of revelation movies is divine power's gradual exposure and victorious fight against the occult. Revelation movies offer above all a superior moral perspective that provides insight into this struggle in ways conducive to Pentecostal ideas. These movies entail intriguing cracks, however, through which they become more unstable and confusing cultural products than might be assumed at first sight. One issue is the depiction of the divine. Showing divine vision and power "at work" does not imply that the Christian God is depicted (for instance as an old man with a beard, as in the popular Western imagination).[28] As I have pointed out, in many movies divine power is displayed indirectly, by fusing the camera and the "spiritual eye" and by the use of special effects that invoke divine "spiritual" bullets and power streams fighting against demonic ones. But the divine is also shown to reside in Christian power objects that are closely associated with Catholicism. Depicting divine power at work, a

number of movies introduce prominent Christian objects, such as a cross or a Bible. The sight of the cross, especially, is shown to disturb witches and other demonic creatures as much as hearing the name of Jesus does. Notwithstanding their otherwise close relation with Pentecostal Christianity, which rejects the use of power objects as idolatry, filmmakers make movies with scenes featuring typically Catholic material objects in a positive manner. It seems that working with the audiovisual medium of film, filmmakers needed to make use of compelling pictures that symbolize divine power, even though a strict iconoclastic perspective would reject them as deceptive.

The same logic pertains to the use of pictures of Jesus, especially the famous motif of the Sacred Heart of Jesus. This long-standing, globally circulating Christian "icon" is omnipresent in southern Ghana in posters, prints, paintings, and stickers. It can be found in many living rooms and bedrooms, as well as in workshops and on cars and trucks (Meyer 2010c, 2013; Woets forthcoming).[29] Concomitantly, in a movie a picture of Jesus may be employed as a prop to signal the Christian identity of a protagonist (as in *Expectations,* where the picture is positioned in the bedroom of the good Christian housewife), or, again in line with popular ideas, the picture may be shown to move and act on behalf of a faithful believer. The use of pictures of Jesus, however, is heavily contested. Strict Pentecostals regard these pictures as a misguided Catholic equivalent of indigenous "fetishes" and hence as potentially dangerous because they threaten to become animated and look back (Meyer 2010c; see also Elkins 2002; Morgan 2005; Pinney 2004). The aforementioned film *The Beast Within* takes this up as a theme marvelously, showing a pious Christian housewife praying in vain in front of a picture of the Sacred Heart of Jesus, which— as the movie reveals at some point—serves as a mask for a juju from the village that uses the eyes of the picture of Jesus to wield visual control over those looking at the picture. This revelation reverberates with broadly shared suspicions about putting up such pictures in one's house: there could be "a spirit in that image," as actress Roberta put it (Meyer 2010b, 121), that is the very opposite of what it depicted. In other words it is feared that a picture of Jesus could function as a mask of the demonic.[30] From this perspective the use of a picture of Jesus is found unsuitable for revelation. On the contrary, its deceptive nature needs to be revealed.

In the face of ongoing debates around the deceptive and potentially destructive impact of pictures of Jesus, it is all the more intriguing that a number of movies, especially early ones, still display such pictures to pictorialize the divine side in the spiritual war between God and the demonic. For

example, in *Deliverance 2* a print of the Sacred Heart of Jesus is located on the altar in church with the pastor (Eddie Cofie) preaching underneath, under the authority of Jesus, so to speak. The final spiritual struggle between the pastor and one of the witches ends by showing the very same motif of the Sacred Heart of Jesus having moved into her head. This somewhat clumsy special effect suggests that her personal spirit is finally filled with and controlled by Jesus. This is all the more salient, as similar effects present her, before her deliverance, summoning the images of her victims into her head to harm them with her witchcraft. I find these effects particularly revealing because they spotlight how the transition of external pictures into internal images that literally occupy a person's mind was imagined. This resonates clearly with the idea of one's personal spirit being an open space, to be taken by one or the other spiritual power. Interesting here is that the location of the picture of Jesus in the head suggests that the person's mind is under divine control, whereas, in contrast, conjuring pictures of other people is a potentially destructive act. It suggests that photographs—understood as a double of the person depicted—may be employed "spiritually," being subject to an evil gaze through which harm is done to the person.

Throughout the course of my research the Sacred Heart of Jesus motif and other pictures of Jesus remained a recurrent, though, as far as I can see, rare, feature in video movies to depict divine power in action. *Love and Sex II* (Movie Africa productions, 2010), a movie involving relatively explicit nudity and sexual acts, includes a scene in which a picture of Jesus is vested with agency. Here the picture is not only used as a materialization of the presence of God on the spot but also is shown to intervene as a spiritual actor who draws a rift into an unprecedented, sexual transgression. This case reveals another line across which a crack occurs and a revelation movie trespasses into a forbidden area. An elderly man sits on the sofa in his living room, underneath a picture of Jesus designed after Warner Sallman's famous *Head of Christ* (see Morgan 1998). The man's ex-girlfriend, who had lived with him in the house and had committed adultery with another man right under the picture—and thus, the movie suggests, right under the gaze of Jesus—pays him a visit and seeks to seduce him. She puts her head between his legs and caresses him, hopeful that the love potion she got from a spiritualist will do its work of binding her ex-lover. The seduction scene comes to an end rather abruptly, as a shining substance emanates from the picture of Jesus into the man's body. He jumps up and pushes her aside. Here, the picture of Jesus is shown to observe what happens around it and to be mobilized into effective action, giving the man the

necessary push to overcome the weakness of the flesh. The presence of a picture of Jesus in such a sexually suggestive scene is fascinating. It spotlights the transgressive potential of the revelation format by stretching the logic of exposure to the limit. Here the use of the picture of Jesus that thwarts the woman's immoral seduction *enables* the display of sexual acts and intimate body parts that would have to be concealed according to the very Christian moral standards for which Jesus was also made to stand. In other words revelation was conducive to a prurient voyeurism that revels in transgressing the same norms that underpin revelation as a moral, educative endeavor.

CONCLUSION

The key concern of this chapter has been to demonstrate that the dynamics of conceiving and consuming movies of the film-as-revelation kind resonate with popular Christian audiovisual repertoires, particularly with regard to religious practices of looking, as well as of speaking and hearing. Moving beyond a dualism of religion and film that assigns each to a separate sphere, I have focused on technoreligious practices of trans-figuration through which movies are claimed to uncover the unseen. I call these practices "technoreligious" to stress the remarkable entanglement of the camera and Christian revelation (grafted onto and resonating with that of the calabash and indigenous divination). Video, I argue throughout this book, is an unstable medium in the making. How it is put to use depends on the social setting in which it is embedded. Taking into account its affordances or "action possibilities" *and* tracing its embeddedness in the popular imaginaries with which it resonates and that it feeds, this chapter challenges widespread commonsense ideas about film and religion as belonging to different domains, with film offering a secular substitute for a religiosity that became obsolete with modernity.

Video filmmaking produced moving pictures that materialized popular imaginaries and offered plastic figures for the personal imagination. Movies showed and asserted that the world of everyday lived experience was shaped and affected by the "spiritual," which was thought to be inaccessible to ordinary perception, and to require special religious techniques—the Spirit of Discernment—to be grasped. "Film supports sermon," to quote actor Eddie Cofie once again, by providing an audiovisual supplement to matters people only heard and talked about in, for instance, the church. The point here is that movies trans-figured Christian ideas from other settings, such as

sermons held in church, and in so doing incorporated these ideas into a new medium and transported them into a new cultural space of (reli-)entertainment. Framed as revelations, movies addressed the spectators in such a way that they mobilized broader notions about the connection between the spiritual and the physical in the process of watching. Promising to offer some kind of extraordinary vision, movies were made to feature as prosthetic devices through which the connection between the spiritual and the physical became clearer so that one knew better how to act.

Though producers, actors, and spectators strongly emphasized the aspect of "revelation," it would be misguided to analyze this aspect in terms of the visual alone. As this chapter shows, the extra- or super-vision offered by movies is embedded in a broader set of religious sensory practices of communicating with a spiritual "beyond." Resonating with a widely shared popular ontology, these movies endorsed the efficacy of, for instance, powerful prayer and uttering the name of Jesus. Representing popular Christian and Pentecostal sensory practices that include looking, speaking, and hearing, as well as making audiences mimetically engage in them, video movies offered *divine audiovision in action;* they provided audiences with the superior gaze (and hearing) that playfully simulated the perspective of God. In this way audiences were addressed as quasi eyewitnesses who were enabled to "see" the entanglements of the spiritual and physical realms that were normally hidden from view yet understood to be operative all the time.

Drawing audiences into the cinematic apparatus and calling them to identify with the gaze of the camera, which was at crucial moments framed as mimicking the "spiritual eye" derived from God, revelation mobilized persuasive techniques of make-believe. They engaged in the "localization of belief in vision" (de Certeau 1984, 187) rather than in something unseen that resists visual representation and precisely for that reason cannot be known but only believed. For de Certeau the "identification of the *seen* with what is to be *believed*" marks a new relation, epitomized by the simulacrum, between the visible and the real. While this may be an adequate analysis of the permutation of this relation in Europe, which was de Certeau's horizon, it cannot simply be applied to the Ghanaian setting. In movies, too, belief was vested in the visible or, better, in the act of making visible. But this was not an entirely new phenomenon. What was new was video as a technology, which was embedded into and affirmed long-standing indigenous techniques of making the invisible visible, albeit in a far more restricted, less public manner.

The reality revealed by the movies went further than what could be seen with the naked eye: it was the interference of the spiritual in the physical. This reality, movies claimed to their audiences, was not just there to be perceived via the ordinary senses but required special technical audiovisual devices *and* religious sensory practices to be made tangible: a perfect fit of technological possibilities and a lingering obsession to make visible the invisible. The reality thus conjured was a *product* of imagination and audiovisualization. I would like to stress once again that I do not understand "real" as an empirical point of reference located outside of the sphere of film and religion but rather as a product of mediation that persuasively uses technological representational possibilities to (re)produce a shared imaginary. Embedding the camera in this manner, films are designed to persuade by denying their own mediated nature and claiming "immediate" access to the real world in all its depth and complexity (Eisenlohr 2011; Meyer 2011b, 2013; Plate 2005). And yet, notwithstanding the constant problematization of the deceptiveness of appearances in everyday life and the warning to "be vigilant," even movies framed as revelations do not move behind and beyond the picture. The very fact that pictures are both a product of revelation and a source for deception spotlights the deep instability and uncertainty that goes with pictorial figuration (see Kruse 2014).

The close and positive link between video movies and Christianity, epitomized in films featured as revelations, weakened with the reemergence of the Ghanaian video film industry after 2005, when the spectrum of movies became more diverse. Nonetheless, revelation of the "spiritual" with more or less emphasis being placed on Christianity, remained the dominant perspective that many movies offered because it opened up spectacular possibilities to figure immoral acts, evil persons, and occult beings, as the example of *Love and Sex* shows so vividly. Initially framed as an act of looking that simulated a Pentecostal-Christian mode of looking, in the context of popular movies revelation not only paralleled Christianity but was also increasingly adopted as a perspective to cast light on hidden, problematic aspects of Christianity itself (as the example of *Pastors Club* showed) or was seized as a format for legitimating scandalous imagery. Directing the gaze of the spectators toward the outrageous, revelation was a multiedged endeavor designed to affirm the superiority of divine vision as well as the discomforting reality of the outrageous, the power of figuration as well as its ultimate impossibility.

Picturing the Occult

As a format of representation, "revelation" called for the fabrication of compelling pictures displaying "occult"—and by implication evil, ugly, violent, and erotic—matters that typify the "aesthetics of outrage" (Larkin 2008, 184) mobilized in a great deal of Nigerian and Ghanaian video movies. In Europe the term *occult*—from Latin *occultus:* hidden, concealed, secret—is usually associated with magic, alchemy, and astrology.[1] Along with the spread of missionary Christianity since the mid-nineteenth century, the term came to be used across Africa to refer to secret magical practices and demonized spiritual forces. Terence Ranger certainly had a point in warning against the danger inherent in recent anthropological studies that conflate "the African occult into one sinister phenomenon" (2007, 274). Still, I do not agree with his critique of such studies—in particular of those in the framework of "occult economies" and "the modernity of witchcraft"—for inventing an "aggregated African occult." For Ranger the notion of the occult is too generalizing and presentist to achieve insight into the modes through which various African societies grappled with questions of evil. Sharing his insistence on the importance of a historically grounded, ethnographically specific perspective, I think that it is the very historical process of aggregation—involving a recasting of specific spiritual entities under the banner of the occult—that requires detailed attention (see also Meyer 2009b; Bonhomme 2012; Geschiere 2013, 11–12).

In southern Ghana, *occult* is a generic term central to popular discourse. Belonging to a long-standing and broadly shared, cross-ethnic regime of visibility grounded in the distinction between the dimensions of the physical and the spiritual, as well as in a rigorous dualism between good and evil, it is employed to refer to the machinations of the "powers of darkness" that are to be dragged into the "light" of Christianity (as well as of Sufist Islam; see

Pontzen 2014). As a generic term, *occult* cuts across the specific names of spirits and gods known to various ethnic groups. Thriving within popular Christianity and supported by popular literature and movies, it is part of a generalizing vocabulary that transcends, but at the same time contains, specific indigenous notions and terms to refer to invisible forces that are perceived as dangerous and uncanny. This vocabulary should not be dismissed as a problematic misrepresentation of a diverse set of locally grounded ideas but instead should be taken as an evolving "mode of speaking" (in the Saussurean sense of *parole*) that encompasses and cuts across cultural and religious specificities throughout Africa *and* the world at large. Ghanaian and Nigerian movies deploy this global mode of speaking, vesting it with pictures, and it is one of the main concerns of this book to unravel it.

How are we to represent and write about occult forces that are real to people in Africa but not necessarily to the anthropological researcher? Under the guiding phrase "occult economies," over the past twenty years narratives about the occult have primarily been analyzed as metaphors, as pointing to underlying socioeconomic issues that often relate to the morality of exchange in an era of millennial capitalism (e.g., Comaroff and Comaroff 1993, 2000; Geschiere 1997; Kiernan 2006; Meyer 1995; see also Sanders 2003). Recently, this approach has been criticized from various angles. One of the key charges is that it reduces occult forces to symbols of something else (signifying deprivation, anxieties, and the like) rather than taking them as what their indigenous beholders take them to be (Ashforth 2005, 114; Marshall 2009, 22–34). The problem signaled by Ruth Marshall is that the refusal of researchers (especially anthropologists) to take the occult at face value serves to "underline the hegemony of the master narrative that enables us to decipher the truth of these local practices, the secular discourse of social science" (Marshall 2009, 31). She rejects any "hidden form of functionalism" (Marshall 2009, 33)—which she finds epitomized in the use of the notion of occult economies—because this misrepresents religion as being a mere ideological expression of an underlying real. Instead, she argues, religion itself is real and thus to be analyzed "*as such* in its political significance" (Marshall 2009, 18 [italics in original]). I agree with her call to approach religion *as such,* and hence as a set of actual, historically situated material practices—indeed, as "modes of *action* on the world" (28 [italics in original]). But I think that taking these modes of action as a starting point for analysis need not exclude a scholarly interpretation of them. Why should we deprive ourselves of the ability to say something *about* them (e.g., inspired by Marxian analysis, especially regarding his important notion

of commodity fetishism, see Tonda 2011, 2015), certainly as the people we encounter also grapple with their own interpretations thereof? Of course, the point here—as befits good ethnography—is to closely follow the understandings ventured by our interlocutors. As will become clear, people's narratives about occult forces may be grounded explicitly in experiences of the encroachment of capitalism and the concern with "quick money" on social relations and notions of personhood. So, even though I acknowledge that the framework of occult economies leans too much toward metaphorical or symbolic analysis and thereby risks overlooking actual practices (and pictures), I still think that it is able to draw us much closer to local perceptions and concerns than its critics suggest.

In fact, Marshall leaves me wondering about her take on the ontological status of the spiritual beings around which religious practices evolve. I have difficulty grasping the implications of her statement: "If we cannot take religious or occult practice *at its word,* then we can only find its rationality insofar as it performs another action and function" (Marshall 2009, 32 [my italics]). Does "at its word" mean accepting the reality of "occult practice" (in the sense of action, as outlined above) or also the reality of the spiritual beings such as witches that feature in such practice (and hence in a metaphysical sense)? The second option would draw her close to the protagonists of the ontological turn in anthropology (from which she distances herself explicitly in a recent piece: Marshall 2014, S347), in general, and in the anthropology of religion in particular.

From this angle anthropologists are expected to take the existence of spirits seriously instead of explaining them away via some kind of cultural translation, thereby "de-ontologizing the 'reals' of others" (Goslinga 2012, 388). This stance also engenders a fundamental critique of the notion of occult economies as formulated by the Comaroffs (see, e.g., Pedersen 2011, 29–40, for a nuanced discussion). Drawing a (moralized) contrast between "taking seriously" and "explaining away" the spirits is a typical, but in my view unproductive, move on the part of ontologists. Framing anthropology as an endeavor that seeks—and yet by definition fails—to grasp entirely different ontologies is problematic.[2] I question the strong claim about fundamental differences between modes of being, all of which have their own uncontestable (and it seems quite fixed) "reals," such as the alleged existence or nonexistence of spirits and gods. In my own research I found that such ontologies have less force and stability and are less "different" than their anthropological proponents may claim. In fact, people were rarely concerned with ontological

issues, per se (that is, as a philosophical problem), but rather addressed the entanglement of the spiritual and the physical and the issue of (evil) spirits on the level of everyday practice, seeking ways to deal with them. Moreover, exploring the nexus of video and religion in Ghana, I noted a constant recuperation and reworking of globally circulating ideas and pictorial representations, rearranged and fused under the banner of the occult. This is part and parcel of a dynamic process of world making at the interface of the local and the global, characterized by "extraversion" (Bayart 2000; see also my introduction) rather than by insistence on a separate, bounded ontology.

So, how do I represent and write about occult forces? Seeking to achieve a deep understanding of the phenomenological world of my interlocutors, I explore the mediations through which a world of lived experience and its specific ontologies and epistemologies are realized. This entails not only asking about what is regarded as real but also inquiring into *modalities* of being real (involving notions such as visible and invisible, physical and spiritual, through which something understood as real may still be understood to be invisible or exist spiritually), and practices of *making something real* (for example, through figurations of the occult). At the center of my analysis is the materiality of pictures of the occult and their constructive role in shaping everyday worlds by populating imaginaries and making people speak and act in particular ways. In other words picturing the occult takes place within a particular phenomenological world with its specific regime of visibility in which the notion of the "occult" makes sense (and is sensed). A material approach to images, imaginaries, and the imagination does not remain stuck in a mentalist approach but takes the media on which figuration depends as a starting point for analysis. This is fruitful because it directs our attention to actual practices of figuration that represent the occult rather than taking abstract ontological ideas about spirits and the occult as a starting point or reducing narratives about the occult to underlying anxieties and moral critiques. Pictures of the occult are real *as* pictures, even though there may be disagreement about the status of the reality of what they represent. My focus, in other words, is the world-making potential of the use of various media in shaping, reforming, and extending imaginaries of the occult by producing real pictures (rather than ontological "reals" that are ultimately impossible to convey beyond the ontology to which they belong).

How is the occult figured and trans-figured? As anthropologists we cannot study the occult "as such" but only *mediations* of the occult via various oral, written, and visual media, including rumors, stories, testimonies, sermons,

songs, posters, and movies, paying attention to the specific affordances of these media. I opened this book by recalling my thrill at recognizing that the film *Diabolo* reverberated with *narratives* and *rumors* about satanic riches that circulated in society and that were at the core of my earlier research. Ghanaian films are born out of and feed back into stories. Narratives, Albrecht Koschorke points out, yield the sedimentation of fictions in a collective consciousness: "narrative elements sink into the language of societies; there with time they solidify into lexical phrases, into ways of speaking and thinking, into concepts and object-terms" (2012, 24 [my translation]). Through this process narratives metamorphose into real facts; their original artificiality is forgotten, until—with hindsight or in the light of a competing narrative—the aura of the real is cracked and they appear once again as fictions. This understanding of narratives as potentially world-making cultural forms guides my analysis of the trans-figuration of narratives from one medium to another.

Yet with its particular expressive possibilities and limitations film is a distinct medium that needs to be taken seriously in its own right. With hindsight I acknowledge that in my earlier work I tended to analyze movies primarily as stories, thereby failing to take fully into account their pictorial dimension and their affective potential for engaging spectators through multisensory registers (see Green-Simms 2012).[3] Making up for this shortcoming, this chapter looks at pictures of the occult, focusing on the specific cinematic iconographies of ghosts, witches, and mermaids, as well as the moral narratives in which they are embedded; the next chapter pursues the issue of the figuration of the occult by following the trajectory of working with pictures from the set to the editing room and to advertisement. The main concern of this chapter is to grasp the dynamics through which Western iconographies and cinematic conventions in mediating the uncanny are creatively deployed and fused with indigenous and Christian imaginaries of the occult, so as to develop an aggregating pictorial "mode of speaking" that is meaningful with regard to the specific setting of southern Ghana and that transcends it at the same time.

SHAPING THE OCCULT

The title of this chapter invokes a paradoxical combination of the visible—a picture—and its invisible referent—the occult. Following Achille Mbembe's stimulating analysis of the relation between "the thing and its double" in

African postcolonial settings, I regard video film pictures of the occult as a "transcription of a reality, a word, a vision, or an idea into a visible [and, I would add, audible] code that becomes, in turn, a manner of speaking of the world and inhabiting it" (2001, 142). At stake here is the capacity of a picture to invoke for its beholders a sense of likeness to what it represents, "while, in the very act of representation, masking the power of its own arbitrariness, its own potential for opacity, simulacrum and distortion" (Mbembe 2001, 142). Intrinsic to pictures is a fundamental ambiguity that evolves around the gap between what they represent and the audiovisual codes mobilized for the sake of representation. In other words a picture is a medium that, by virtue of its technological affordances, renders present a mental image or figure in the imagination that "is not present the same way its medium is present" (Belting 2011, 20). Through an act of animation—from an outsider's perspective, a deceptive or illusory act—beholders imagine the image as an immediate presence by overlooking or looking through the presence of the medium. The medium, which is the precondition for the very expression of the image and its material grounding, becomes transparent, so it "disappears" from the act of looking (Eisenlohr 2009, 2011). Mediation, by virtue of operating *and yet* being transparent, is the precondition for the perceived immediate presence of the image (Meyer 2011b). The complexity of mediation through which images are made visible is particularly marked in the case of pictures of the occult because concealment is the very essence of the occult.

Showing in a video movie how the physical and the spiritual interlock—which is what divination and revelation are all about—requires an act of figuration through which "the occult" is shaped. Entailing the mastery and use of authorized media to make something visible and tangible, figuration is a political-aesthetic practice. In his sketch of African conceptions of "figurative representation" Mbembe explains that "having the power to represent reality (to make images, carve masks, and so on) implied that one has recourse to the sort of magic and double sight, imagination, and even fabrication, that consisted in clothing the signs with appearances of that thing for which they were a metaphor" (Mbembe 2001, 145). In precolonial and early colonial times priests and chiefs wielded such world-making power; in the wake of colonization and modernization, administrators, politicians, and, most important for my purposes, Christian (and especially Pentecostal) preachers intervened, shaping new imaginaries.

I would like to propose that the representation of occult forces in video movies can be understood as analogous to the making of "images" (pictures

or figures, in my vocabulary) or the carving of masks referred to by Mbembe (see also Tonda forthcoming). Not unlike carvers and priests, filmmakers have the power and means to represent the world of everyday lived experience, understood as encompassing the physical and the spiritual, to movie audiences. Referring to a domain of partly hidden and secret forces and practices, "pictures of the occult" are special mediations of the invisible. Such pictures "could not but be the visible and constructed form of something that had always to conceal itself—a reality that the often widely used categories of fantasy or 'double' must fail to adequately comprehend" (Mbembe 2001, 146). Pictures of the occult owe their enchanting appeal to their ambiguity: they suggest some kind of triumphant exposure yet retain a lure of secrecy (saying, as it were, "this is what the occult looks like—but not quite"). They are phantasms, that is, impossible representations that thrive in the vertiginous limbo of the visible and the invisible, the audible and the inaudible, pinned down as pictures and yet elusive.

Video filmmakers were not only positioned within a wider field of figurative practices that included traditional priests, prophets, and pastors who all shared an engagement in "bringing what is hidden or unknown into the open" (Pype 2012, 118). In the practice of picture-making, they also had at their disposal the capacity of (video) film technology to afford the fabrication of ghostly pictures. In a sense they may well be regarded as high priests of the imagination, who gave cinematic body to ideas and images that, in turn, populated imaginaries and showed up in dreams, generated stories, and so on. Unique about the cinematic trans-figuration of these ideas and images via video is that iconographies of the occult are made public on an unprecedented scale. Video filmmakers engage in a public performance of revelation. By contrast, the indigenous regime of visibility, asserting that modern media as film and photography are unable to reveal "the real thing," rather endorsed a "public performance of secrecy" (van de Port 2006).

Standing in for something secret and yet becoming its pictorial substitute, revelation is deceptive. This deceptiveness is well-captured by Joseph Tonda's (forthcoming) fascinating notion of *éblouissement,* a dazzling and blinding glare that paradoxically dissolves visibility into invisibility, vision into blindness. Tonda suggests that the Ghanaian, Nigerian, and Gabonese movies that project pictures of the devil—Fallen Angel of Light and Master of Deception— make real an invisible "postcolonial empire." It is, to invoke Rider Haggard's *She,* "an empire of the imagination," in which screens and computers act as passageways and mediators of a global mode of enchantment that unduly and

deceptively associates the West with cold rationality and Africa with heated emotions, magic, and superstition. My central concern in this chapter is to highlight the entanglement of pictures of the occult across old colonial divides. I will focus on specific iconographies of prominent occult figures that are associated with the "Christian" devil, epitome of modern enchantment and product of missionary import. I understand these iconographies as the product of constant negotiations of popular stories on the part of video filmmakers, who directed their trans-figuration into the medium of video film, tapping into Western imagery and deploying cinematic techniques of staging the uncanny to reify and make public popular imaginaries of the occult.

OCCULT FORCES ON THE SCREEN

Ghosts

Throughout my research I heard and read many stories that involved the return of the dead in the form of ghosts—a scary event that disturbed the normal course of things through, to invoke Jean-Claude Schmitt, a "reverse movement between the dead and the living in the travels to the hereafter" (1998, 1). From a traditional point of view, persons dying a "good death" are believed to move to the realm of the dead and become ancestors who protect their living relatives. Those dying a "bad death," however, be it by car accident, snakebite, death in childbirth, witchcraft, drowning, warfare, or even murder, are feared to come back and haunt the living.[4] Their unruly spirits must be pacified to restore the cosmological order, in which the dead become ancestors who are remembered by, and protect, the living. Pouring libations, both in everyday situations when people pour some drops of their own drink on the ground for the ancestors and in more formal ritual settings that involve a long libation prayer by a priest, is a common and at the same time contested practice in southern Ghana. From a strict Christian perspective the veneration of ancestors is considered problematic (Meyer 1998a, 324)—a point also emphasized by Pentecostal-charismatic churches that affirm a modern ethos that cannot accommodate ancestors, let alone unruly ghosts, as positive spiritual counterparts to the living.

It would be too simple to state that people either believe or do not believe in the reality of ghosts. Their existence is negotiated via stories, as well as films. In the early 1990s a number of spectacular video movies featured

"revenge ghosts" coming back to punish their murderers. On the level of production the representation of ghosts offered an occasion for video film-makers to experiment with the possibilities of video technology to picture what remains occluded to ordinary sight but is figured in the imagination. In this sense ghosts offered an apt way to explore how the medium of video could afford picturing the spiritual at large.

This is reminiscent of Tom Gunning's intriguing analysis of Murnau's *Nosferatu*. "Forging a technological image of the uncanny," early twentieth-century filmmakers encountered new technical possibilities by which to explore "the play between the visible and the invisible, reflections and shadow, on- and off-screen space" (Gunning 2007, 97). The point is not simply that film technology became enchanted. At stake was a use of film to lend visibility to what normally remained invisible, thereby establishing it as a medium of the phantasmatic, that is, of liminal figures that blended presence and absence via an eerie alternation of concealment and revelation that invoked horror (see also Carroll 1990, 184). In this sense ghost films not only pictori-alize uncanny beings but also epitomize "the uncanny power of cinema" itself (Gunning 2007, 100).

The Ghanaian blockbuster *Ghost Tears* (Movie Africa Productions and Hacky Films, 1992) is about the return of the ghost of a rich, bossy woman, named Dee, who was murdered in a bathtub by her niece and maid, Esi, who then married Dee's husband, Kwesi (Garritano 2013, 105–10).[5] Echoing sto-ries about how ghosts appear to the living, at first she just appears in the market as an ordinary woman to her daughter Yakwaa, who does not remem-ber her. Gradually, by way of a superimposed, somewhat transparent picture, Dee appears as a phantom, able to pass through a wall, to suddenly be present in or disappear from a room and to watch over her daughter, weeping when she witnesses Esi (hence the suggestive title). Dreaming about Dee (dreams are considered an important source of information about what goes on "in the spiritual," and movies often use them as a frame to make it appear) and sensing her ghostly presence in the house, Kwesi gets ever more frightened and worried. Tellingly, the question "do ghosts exist at all?" is raised explic-itly in a conversation he has with a friend *within* the movie. Both assure each other that "ghosts don't exist." This is clearly what Kwesi would like to believe, but the movie shows that he must know better. Haunted by the ghostly appearance of his murdered wife, he experiences a crisis of vision and perception: which impressions to trust? Articulating and rejecting the pos-sibility to disbelieve in the existence of ghosts, the movie offers a kind of eerie

FIGURE 17. Ghost, screenshot from *Step Dad*.

evidence that they do, albeit as a "paradoxical figure of vision" (Gunning 2007, 103) that is deeply uncanny. Here, too, "as revenants of things past, ghosts make vivid to us the pairing of memory and forgetting" (Gunning 2007, 116). The murder cannot be forgotten, even though the perpetrators pretend they can. Eventually, ever more disturbed, Kwesi discloses the truth to Yakwaa. Overhearing the conversation, Esi kills Kwesi by hitting him on the head with a bottle. Dee's ghost is shown entering Yakwaa through a quite spectacular pictorial superimposition. They strangle Esi: revenge fulfilled. The ghost disappears and Yakwaa is left behind weeping.

Another spectacular ghost movie, by the same makers, was *Step Dad* (Movie Africa Productions and Hacky Films, 1993). It is about a stepfather who seduces and impregnates his stepdaughter, Sabina, while his wife is away on a business trip. Once Sabina discloses that she is pregnant, he kills her and dumps her body by a lagoon. The movie masterfully shows Sabina's ghostly apparition, for she is both visible and invisible, depending on the beholder. She is shown sitting at the dinner table next to her mother, who, as spectators are made to understand, cannot see her, while they can. The ghost stares at her stepfather, who is deeply disturbed by its appearance. Spectators are made eyewitnesses to the recurring, frightening appearances of Sabina's ghost that drive her stepfather into ever deeper despair and madness (fig. 17).[6] The movie offers two levels of visibility to spectators. At times the stepfather is shown to make quite strange movements, making him look like a fool and engendering laughter among spectators (as I noticed when watching the movie together with others). Audiences are made to understand that this is how his wife, who is not able to see her daughter's ghost, sees him. At times spectators are offered a superior perspective, characteristic for revelation films that show

how the spiritual is present in the physical, in which the frightening appearance of the ghost—dressed in white and accompanied by a high-pitched metallic sound—is disclosed, while the wife is still stuck with her limited sight. The appearance of the ghost, thanks to the use of special effects, is typically accompanied by dark classical music or eerie metallic sounds that indicate a sense of danger and anxiety.[7]

A Mother's Revenge (Ananse System, 1994) involves a plot similar to *Ghost Tears;* here a mother who has been killed by another woman who wants to steal her husband appears in a dream to her daughter, Tracy, a young woman who returns to Ghana from overseas. The director, Ernest Abbeyquaye, told me that he wanted to make a movie that took as its theme young educated Ghanaians' lack of knowledge of their culture: "The parents are still steeped in their culture, but the young ones are not consciously educated into it. Even when fathers talk about ghosts, they [the young] think about the thing in terms of European ghosts" (interview, 11 June 1998). As a film director affiliated with the GFIC, Abbeyquaye wanted to remain close to local understandings, while at the same time transgressing the established format of educational movies (which is why he produced the movie privately, outside of the GFIC). His film features both witchcraft and ghosts, resonating with Akan understandings, but all the same making use of conventions of representing the appearance of ghostly phantoms onscreen (fading, sound). The stepmother is shown to have a witchcraft pot under her bed and to have put a curse on her husband's family. With the arrival of Tracy the stepmother realizes the limits of her power: her witchcraft spirit even informs her that, if she is not able to destroy Tracy, she will go mad.

Gradually, through recurrent dreams, Tracy is made to understand her mother's sad fate. In these dreams the mother appears in traditional Kente cloth, usually located by the bank of a river that marks the boundary between the world of the living and the dead. Intriguingly, the beads she hands over to Tracy in the dream also materialize in real life (she is wearing them when she wakes up)—much to the shock of the evil stepmother, who recognizes them immediately as belonging to her dead rival. At times the mother is shown appearing in what is real life within the universe of the movie, as ghosts are also said to do, placing all protagonists in the same physical realm. At times she is shown emerging in dreams, which, in line with southern Ghanaian understandings, are taken as messengers of hidden truths and as opening up a gateway to the spiritual realm. The reality of the spiritual is asserted by showing that people's acts and experiences in their dreams may

engender real effects in the physical. The mother's ghost tells Tracy to remain a virgin (even though her boyfriend puts pressure on her to sleep with him) and to recollect, in the setting of a dream, a lost horn so as to lift the witchcraft curse imposed by the stepmother on the family. Eventually, against all odds, Tracy is able to retrieve the horn with the assistance of her mother's ghost, and the stepmother goes mad. Like *Ghost Tears, A Mother's Revenge* explicitly refers to the possibility of skepticism. In this case it is the white mother of Tracy's British-Ghanaian boyfriend who initially expresses her doubts that juju, evil forces, and ghosts are real but who finally acknowledges that this is so. Here again, the movie features negotiations about the reality and plausibility of the existence of ghosts, conveying audiovisual evidence that this is the case within the plot and, in so doing, in the phenomenological world of lived experience of the audiences.

Watching these movies together with people in our living room during my first period of fieldwork in Teshie in 1996, I noted the extent to which the appearance of such phantoms excited audiences, who were quite convinced about the existence of ghosts, even though such beliefs were despised from the perspective of representatives of the state film establishment and the perspective of (Pentecostal) churches, which rejected a positive valuation of (revenge) ghosts. For the former, ghosts belonged to the same category as other occult forces that were discarded as "superstitions" that stood in the way of the educative mission of cinema. This mission was predicated on an alternative construction of reality in which ghosts were nonexistent or, at least, on a regime of visibility in which their figuration was taboo. For Christians (Pentecostals in particular), featuring ghosts was problematic because this was at loggerheads with Christian cosmology, according to which, after death, a person's soul would either go to heaven or hell rather than roam the earth among the living. The Reverend Osei Akoto, for instance, explained to me that believing in and picturing ghosts was "biblically not right," because "the scripture says: the dead have no part in the land of the living."[8] Concomitantly, ancestor veneration and the pouring of libations were discarded, and movies about ghosts were frowned upon. Ambivalent beings in their own right, ghosts—and ancestors in general— were a thorny issue for many Christians. Unlike other spiritual beings, as manifestations of the ancestors, ghosts could not easily be demonized and fitted into the rigid dualism of Satan and God that underpins (Pentecostal) Christianity. Nonetheless, for a staunch Christian it was problematic to identify with a revenge ghost as the prime positive force in a movie. In the

face of such complicated debates, in which they saw both the state film establishment and pious Christians as opponents, many filmmakers concentrated on depicting other spiritual forces that were less problematic from a Christian viewpoint.[9] Nonetheless, over the years there have been a number of movies that feature returning lovers who refuse to join the dead,[10] ghosts of mothers who seek to help their children in difficult situations, revenge ghosts of murdered wives, mothers, and friends, and the like.

Importantly, most video filmmakers took great care that ghost movies, and movies involving the occult in general, were not framed as portraying typically African imaginaries with their distinct iconographies but as incorporating these imaginaries into a Western cinematic repertoire and pool of pictorial representations. Thus, these movies explicitly fuse indigenous ideas about ghosts as they prevail in southern Ghana, on the one hand, and a Western imaginary of ghosts reminiscent of Hollywood horror movies, on the other hand. Far from striving to remain true to specific ethnic or pan-African ontologies, the key concern of a great number of filmmakers (though there were exceptions, such as Abbeyquaye) was to tap into a Western, globally circulating format of ghost films, into which a variety of local imaginations of dead people haunting the living could be inserted and at the same time transcended. African imaginaries of ghosts, the movies assert, are neither specific to Africa nor exotic but are part of broader repertoires of representing the uncanny. Their fusion with local imaginaries is another instance of embedding Africa in a wider world that makes for the appeal of this type of video films across Africa and the African diaspora. Ghanaian movies about ghosts, and occult forces in general, thrived thanks to the fact that cinema—and, by extension, video—proved to offer a suitable modern technique, pictorial resources, and a broad framework for representing the occult and uncanny that encompasses local ideas and imaginaries and at the same time embeds them in a broader cinematic framework.

Witches

Throughout my research in southern Ghana I noted that witchcraft is a matter of great concern and fear to many people, across all layers of society. The use of the English term *witchcraft* as interchangeable with local terms such as *adze* (Ewe), *bayie* (Akan), and *aye* (Ga) testifies to the process of aggregation through which such specific beings have been lumped together. It is important to recall that the phrase "modernity of witchcraft" was coined by Peter Geschiere (1997)

to capture the elasticity and creative adaptation of indigenous imaginaries of witchcraft to modern conditions, seeking to grasp the capacity of discourses around witchcraft to "invest the global in the familiar, and vice versa" (Geschiere 2013, xix). This creative adaptation also occurred in Ghana. From the outset of missionary activities in the mid-nineteenth century, witches were reconfigured as demons operating under the auspices of the devil (see Meyer 1992). This process introduced a dualistic framework in which evil and good are mutually exclusive, with witches placed on the side of evil. While fears and accusations of witches existed in precolonial times, several sources suggest a rise in witchcraft anxieties alongside the rise of social and economic cleavages between rich and poor,[11] with successful family members and friends suspecting or even accusing the poor of seeking to bring them down through witchcraft. Conversely, the rich are also prone to being suspected of owing their wealth to unnatural, spiritual means associated with *blood money* or *nzema bayie,* a kind of witchcraft not transmitted within a family but purchased from a native priest. I read the emphasis on witchcraft, greatly enhanced by Pentecostal-charismatic churches that devote much attention to the topic, as a symptom of an emergent modern notion of personhood striving for some sense of closure—psychological, social, and economical—regarding blood ties.

This is part and parcel of a broader transformation, highlighted by Margaret Field (1960) and elaborated further by Leith Mullings (1984) in her seminal study of healing among the Ga, in the course of which traditional collective forms of worship have been dwindling, entailing a shift toward the use of more individual forms of magic and a strong emphasis on the importance of individual success (see also Onyinah 2002). The statement of one of Mullings's interlocutors captures the point: "The difference is that these are modern times. More people want to destroy than want to help. Within your own family, someone will envy you; they will go to a sorcerer and do something to destroy you. . . . People love money too much" (Mullings 1984, 74). Using similar wordings, my interlocutors identified people's love for money and their preparedness to "spiritually" sacrifice even their loved ones in exchange for wealth as the distinctive feature of "modern" times. Many also referred to witchcraft as "African electronics," identifying it as an efficient and potentially constructive technology that was—alas—used by Africans primarily for selfish and socially destructive ends.

Stories about witches, who could be either male or female, usually (r)evolve around family relations but also include bad friends. In this sense, as Geschiere (2013) argues, witchcraft expresses the uncanny dimension of

intimate relations and the ultimate impossibility of trust. Jealousy is understood to be the driving force behind witchcraft. People who are well-to-do or strive for prosperity and personal progress are especially concerned that the witchcraft they fear will be directed at them by poor relatives in the village. Conversely, owners of fabulous riches may also be the targets of witchcraft suspicions (but they may also have amassed their wealth through a pact with other occult forces, such as Mami Water). Pentecostal-charismatic preachers, in particular, intervene in popular narratives about witchcraft, stressing that it is part of the work of the devil.[12]

Witches are popularly imagined to be persons who secretly possess a pot that contains beads, herbs, possibly a snake, and some bodily traces—fingernails, hair—of the persons they bewitch and to have some kind of spiritual ability to take the shape of an animal—snake, frog, cat, owl, vulture, or centipede—that they carry with them (in another form) in a belt made of snails or shells around their waist and that can materialize at certain moments.[13] They are regarded as able to leave their own physical bodies while asleep, to travel in spirit and attend the witches' meeting in the bush, where they feast on the bodies of family members whom they have brought to the nocturnal meeting "in spirit." As a result of this spiritual cannibalistic attack the victims are said to eventually fall sick or even die "in the physical." People state that to gain immunity to witchcraft attacks, special spiritual means are required to reduce one's spirit's permeability to intimate others. They look for personal protection and spiritual strengthening in churches or, often secretly, in traditional shrines. This search for protection is, of course, conducive to striving for what Charles Taylor calls a "buffered self" (2008, 243; see also chapter 2) that is relatively closed to family and friends and thus may, in turn, generate the very suspicion and jealousy that is at the core of witchcraft attacks. Narratives about witchcraft have a strong moral undertone. Even though wealth is cherished as a sign of success, a distinction is made between moral and immoral ways of achieving and spending it. I regard witchcraft as the negative, but fairly symmetrical, counterpart of the Pentecostal Prosperity Gospel, according to which wealth is a divine blessing showered on the born-again believer. While the Prosperity Gospel championed by Pentecostals is seen in positive terms, wealth allegedly gained through witchcraft (and other occult forces) is despised and thought to be spendable only in unproductive endeavors that will ultimately lead to the death of the owner (Meyer 1995, 2008). In popular stories witches are downright evil and, as a real threat, call for spiritual protection and vigilance.

If Pentecostal preachers affirm the existence of witchcraft in their sermons and deliverance prayers, video filmmakers tend to do so in their movies (see also Geschiere 2013, 187–97). Both contribute to heighten witchcraft as an aggregated threat—"not as a local struggle but as part of a wider battle between good and evil" (Geschiere 2013, 201). While some movies use dreams as frames in which to make witches appear,[14] others opt to feature witches appearing outside settings marked as dreams or visions. But what are witches made to look like?

Here I want to invoke the beginning scene of *Zinabu III,* in which the camera zooms in on the cover of *The Encyclopedia of Witchcraft and Demonology,* by Rossell Hope Robbins. Zinabu's husband, Bob Mensah, who was able to break her witchcraft thanks to his strong faith, is shown reading the book attentively (fig. 18) to deepen his understanding of the phenomenon and, by implication, to know how to defeat it. Drops of blood start falling on his white shirt. This signals that, although Zinabu herself became born again, her former coven is determined to attack her and Bob—to no avail, as it turns out in the end after many battles. For scriptwriter Richard Quartey witchcraft is not simply a local or African phenomenon. He stresses this by featuring the *Encyclopedia,* suggesting that the case of Zinabu was just one instance of the pervasive problem of witchcraft. In a documentary on the Ghanaian video film industry by Tobias Wendl (*Ghanaian Video Tales,* 2005) Quartey is shown next to his bookshelf. Explaining that for his work as a director he has to read widely, he pulls out the same *Encyclopedia,* which, he says, dives deeply into "demonology and witchcraft as practiced in the occult world." He appears to be interested above all in the "weird images" in the book, such as one showing "the head of the evil demons" (Robbins 1959, 20). Pointing at a picture of Satan represented as Pan, with goat legs and long horns and blowing a flute, he says, "This is the way they try to perceive or portray the devil." Totally neglecting Robbins's critical deconstruction of witchcraft as an outrageous fiction confined to the Western past,[15] Quartey took it as a visual resource for his imagination and for audiovisual representation of the demonic world. After having commented on the *Encyclopedia,* he goes on to show a number of books, including one about Satan with a foreword by Billy Graham, that take Satan and witchcraft at face value. Quartey quotes from these sources to authorize his movies as truthful depictions of the occult in general and witchcraft in particular.[16]

The iconography of witchcraft that recurs in many movies is deeply indebted to European imaginaries of witchcraft, as documented by the 250 figures in the *Encyclopedia* and American horror movies, that are blended

FIGURE 18. Reading the *Encyclopedia of Witchcraft, Zinabu III*, screenshot.

FIGURE 19. Witch attack, *Zinabu III*, screenshot.

with Ghanaian imaginaries of what witches look like and how they act. The imaginaries, in turn, are fusions of indigenous and missionary iconographies—another testimony to the emergence of an aggregated occult, consisting of a growing assemblage of pictured witches—in the course of evangelization and exposure to Western cinema.[17] Understood as demons working under the auspices of Satan, witches are often depicted as wearing black cusp caps and long, floating gowns (fig. 19). As I have mentioned, they may be male or female and usually have long fingernails and bushy hair, which may be brown, black, red, or white. They meet in their coven at nighttime. Usually they convene in the bush, where they are shown feasting on human flesh, cooked in huge African pots. Often there are candles, and death heads are used as decoration or as cups. Sometimes Satan is present, as well, recognizable by his ugly face, horns, and evil laughter, in line with medieval and early modern European representations. But the witches may also meet in ultramodern settings, such as an office building, as is the case in *The Witches of Africa,* which depicts the witches' coven as hypermodern.

In line with indigenous understandings, witches are shown to be able to leave their bodies behind, sleeping—a favorite special effect—and transform themselves into various animals, above all the owl (whose cries often are used as a soundtrack for witchcraft scenes), but also vultures, cats, frogs, and snakes. They also command fire and can morph into a fireball. Along with attending meetings in the bush, witches are also shown at home in their secret room with a pot that contains their witchcraft paraphernalia. Some movies show them receiving their occult powers from a priest and now using it for their personal purposes, such as snatching and totally disorienting

another woman's husband by the use of a charm, such as a voodoo doll. Many movies suggest that the boundary between witchcraft and juju is blurred, and they depict how, through the deployment of occult means, a witch takes control of a person's spirit or soul. This is represented by showing the witch being in command of a miniature double (a voodoo doll or a photograph) of the bewitched person, who is shown to enact in the physical what the witch does to him or her in the spiritual. For example, in *The Witches of Africa* the witch presses a hot iron on a doll; her action is followed by a scene in which her victim is shown feeling desperately hot. As I noted in chapter 4, in this movie the power the witch wields over her victim is depicted by special effects, showing the insertion of a still photograph of the victim into the head of the witch, suggesting that she is able to summon and control his spirit (see also Behrend 2013).

With the rise of digital editing, ever more optical tricks were employed to show witches flying horizontally through the air, riding on a carpet or a donkey, as has been marvelously shown in *Kyeiwaa* (Movie Africa Productions, 2007–12), a tremendously popular fourteen-part serial about a witch (fig. 20). In their coven the witches are shown with magical devices—often a calabash filled with water whose surface operates like a mirror or camera—that allow them to see what happens elsewhere and to conjure the spirits of persons to their meeting place in the bush (fig. 21). They react allergically to hearing the name of Jesus mentioned, suggesting that staunch Christians who have His name on their lips are likely to be protected against witchcraft attacks. With the increasing possibilities provided by digital special effects, witchcraft scenes became more elaborate, but the basic features are still the same.

Typical plots of movies about witchcraft involve all sorts of mishap—barrenness, miscarriage, sickness, death, an evil mother-in-law, losing one's husband to a bad woman, unsuccessful business, and so on—that audiences recognize immediately and that echo their experiences and anxieties. In line with the typical format of revelation, movies about witchcraft claim to offer insight into the spiritual dimension of the mishap experienced in the physical, exposing how witches supposedly operate and are ultimately defeated by divine intervention. Fusing indigenous and European imaginaries of witches as they have been mediated by Christianity and pictorializing them on the screen, video movies engage in a figurative technoreligious practice that, as it were, battles witches by exposing their imagined operation via moving pictures. This exposure, though offering temporary satisfaction in the diegetic universe of a movie by catching a witch by drawing it into the limelight of the

FIGURE 20. Flying witch, screenshot from *Brenya 4*.

camera, however, ultimately affirms the threat of witchcraft as resisting full representation and understanding (see Siegel 2006; and below).

Mami Water

A beautiful light-skinned lady with a fishtail, Mami Water is an exemplary double or hybrid: human and animal, land and water, beauty and monstrosity, foreign and local. Born out of trading relations between Westerners and local populations along the West African coast, her current iconography in popular imaginaries and video movies can be traced to a particular picture: the studio photograph of a female South Asian artist, Maladamajaute, which shows a young woman in an exotic costume, with bushy hair, coins around her waist, a python around her neck, and a penetrating look. This photograph was taken as the basis for a full-color poster to advertise an Indian snake charmer in the *Völkerschau* organized by Carl Hagenbeck in his zoo in Hamburg in the late nineteenth century (Drewal 1988; Jell-Bahlsen 2008; see

FIGURE 21. Witch meeting in the bush, screenshot from *Brenya 4*.

also Faber and Sliggers 2013, 127–39).[18] Feeding the European hunger for the exotic, her photograph "epitomized the *otherness,* the mystery and wonder of the Orient" (Drewal 2002, 195). The upper half of the woman in the photograph was remediated by a lithograph, designed by Adolf Friedländer, that was mass-produced as a poster and circulated widely throughout Europe and beyond. It reached Nigeria via sailors by the end of the nineteenth century, where it inspired local woodworkers to depict the locally known female water spirits via this new, foreign iconography, yielding representations that combine the upper body of the so-called Indian snake charmer with a fishtail. The lithograph became the iconographic basis of the emergent Mami Water cult that spread along the West African coast, where it became embedded in the worship of *vodun* among the Fon and coastal Ewe.[19] On the West African coast, too, the lithograph was employed to imagine otherness, in this case by engaging with Europe and Asia from an African perspective. Prominent items in the poster of the snake charmer spoke to the imagination: along the West African coast, hair was regarded as a powerful substance, and the

python was seen as a messenger linking humans to the world of ancestors and spirits. Reprinted several times (in the 1950s Indian traders reprinted five thousand copies in Bombay and distributed them in West Africa and Jamaica; Faber and Sliggers 2013, 134), the poster remained a constant source of inspiration in figuring Mami Water. The circulation of the Mami Water iconography is a fascinating example of a global icon that travels across space, becomes embedded in a shared popular imaginary, is incorporated into the personal imagination as a mental image, and generates ever more external pictures that remediate the icon via various media. These media extend from paintings in shrines to the body of the priestess during posses-sion: a picture that is not just a depiction but, in a sense, becomes animated and generates a cult that celebrates the spirit of modernity (Wendl 1991; Drewal 1988).

In contrast to neighboring Togo, in Ghana cults devoted to worshipping Mami Water are scarce.[20] During my research Mami Water was invoked above all from a popular Christian perspective and regarded as Satan's most seductive demon (Meyer 1999b). I encountered countless stories, often based on testimonies from former adepts, about her attempts to seduce men and women into worshipping her, offering erotic pleasures and wealth. This, the stories insist, always comes with a price; being a jealous and capricious spirit, Mami Water does not allow her adepts to engage in what are taken to be normal and normative sexual and reproductive relationships with other humans. If witchcraft is about the "dark side of kinship" (Geschiere 1997), Mami Water is about the "dark side of (erotic) pleasure." Both mobilize a sense of the uncanny dimension of intimate relations with others, consisting of the threat of being let down by kin and spouse in the case of witchcraft and of being sexually hooked to a spirit at the expense of what is taken as normal sexual and social relations in the case of Mami Water. Narratives about both address the morality of wealth and success, in general, and conceive of witches primarily as making persons lose what they have been able to achieve (money, children, spouse), or preventing them from achieving their desires in the first place, and Mami Water as making persons accumulate more and more yet keeping it for themselves. Issues of personal closure with regard to sexuality and mutual moral obligations of sharing are dominant and manifest themes emphasized over and over again. So it would be wrong to state, as critics of the "occult economies" approach claim, that such issues of problematizing moral economies, kinship, and reproduction are merely the figments of a

macrosociological anthropological interpretation that remains outside of local ontologies (see Bonhomme 2012 for a discussion of the criticisms). In southern Ghana these issues are recognized as prime themes that are explicitly expressed in imaginaries around witches, Mami Water, and other occult figures.

Keen to gain access to popular imaginaries of Mami Water, during our stay in Teshie my husband, Jojada Verrips, asked a popular painter to make a picture of Mami Water for us. Some days later we received a colorful painting of a bare-breasted blond lady, with a pinkish fishtail, lying on the beach. It was clearly inspired by the Hollywood movie *Splash* (dir. Ron Howard, 1984). Put up in our living room, it became an issue of great concern on the part of our visitors—especially the young girls who often passed by and who attended the Church of Pentecost. Shrieking with horror and disgust, they shouted "Jesus!" and explained that the painting was not a mere depiction or piece of popular art, as I claimed. To them it was a potentially animated artifact that could bring Mami Water to life in the midst of my life, allowing her to destroy my family. As I have pointed out in greater detail elsewhere (2006b, 19; see also Meyer 2008, 383), this response alerted me to the potentially uncanny dimension of a picture that becomes what it depicts on the level of my interlocutors' experience, and it prompted me to ponder the relation between actual pictures and the imagination—and hence its materiality—in general.

Intriguing about the iconography of Mami Water is its openness and—befitting a water spirit—fluidity. As a figure that embodies otherness, it has been deployed over and over again. This is not simply a question of African imitation of Western imagery but a creative process of quoting and reconfiguring that is typical of what Bayart circumscribed as "extraversion": a process of incorporating and appropriating initially foreign ideas and images into ever dynamic African schemes. This also extends into the sphere of video movies, which I regard as main exponents of extraversion through the use of modern cinematic technologies and pictorial repertoires. *Women in Love* (Movie Africa Productions, 1996), a movie in two parts about a rich businesswoman who is a devotee of Mami Water and lures poor women into a lesbian relationship in exchange for riches taken from the bottom of the ocean, makes use of pictures drawn from *Splash*. A priest on the beach is consulted to conjure Mami Water. He shouts "Look deep!" and then the camera focuses on a bowl filled with bubbling water, drawing the gaze of the protagonists,

together with that of the audience, in a spiral movement down to the bottom of the ocean from where the sea goddess appears. First she appears as the mermaid in *Splash,* and in the next shot a fair-colored young woman wearing a bindi (mermaids are often said to be Indian) emerges from the sea. She is shown to be a harbinger of much-desired luxurious items (cars, clothes, mansions), if only her adepts refrain from having sex with a man and worship her by having sex with each other. Claiming to be based on a "true story" in which ultimately the power of Jesus overcomes Mami Water, *Women in Love* employs the framework of revelation to offer pictures of lesbian sexuality intended to be heavily transgressive of established norms (for a further analysis of the movie see Meyer 2003b; and Green-Simms 2012).[21] While these pictures resonated with the many rumors about Mami Water's lesbian orientation—an independent woman who has sex solely for pleasure, neither wife nor mother, not under male control—I noted that female spectators in particular disliked these pictures, even though they were embedded in a confessional narrative that dismissed Mami Water, same-sex relations, and the wealth gained through immoral, utterly antisocial, and selfish acts as evil. This reveals not only a typical tension between the moral closure entailed by the plot, on the one hand, and the affective potential of transgressive pictures to crack it, on the other. Misgivings expressed by women—who were, after all, the intended prime audiences of video movies—also highlight that this movie was less tailored to their needs and expectations than was normally the case. The movie appealed primarily to a male gaze and anxieties of losing control over successful females.

Women in Love was remade and expanded under the telling title *Jezebel I-IV* (Movie Africa Productions, 2007, 2008), making much more prolific use of special effects and adjusting icons of wealth to a new level (ever fancier mansions, replacing the Benz with a Hummer, and so on; see Green-Simms 2012, 41–47). Identified as *Jezebel,* a key icon of false female prophecy and idol worship,[22] in this movie Mami Water is conjured by a priestess immediately recognizable as a representative of the Spiritual Churches that Pentecostals charge with occultism. With light skin and blue eyes Mami Water is pictured in close-up, superimposed against the background of the ocean, in line with the popular imaginary of this spirit as foreign, beautiful, capricious, erotic, and ultimately cruel (fig. 22). The film shows Jezebel not only in her spiritual shape but also as morphing into a sexy woman who moves around among humans, seeking to seduce devout Christians and ulti-

FIGURE 22. Mami Water, screenshot from *Jezebel*.

mately destroy them and bring them down to hell. Obviously, this allows for a host of scenes with transgressive pictures that may be rejected morally but at the same time provide prurient pleasure.

The association of Mami Water with Satan is common in many movies. They resonate with the Pentecostal idea that in the era of the "end time" that precedes the Second Coming of Christ, Satan will pull out all the stops to be able to drag along as many as possible in his own imminent downfall. While many, as a result of their worldly lifestyle, are held to "belong to Satan already," his key targets are seasoned "men of God." As his most seductive demon, Mami Water is said to play a prominent role in this satanic counter-missionary project that thrives through temptation and deception, thereby tying into downtrodden, male Christian imaginaries of women as potentially dangerous and in need of male control. Movies often show Mami Water in her human manifestation, posing as a Christian—little makeup, decent clothes that cover breasts and thighs—who lures pastors and staunch

believers into her power through erotic arousal and seduction (see the Nigerian movie *Karishika* as the paradigmatic example).[23] For this reason revelation movies around the figure of Mami Water are prone to flip into soft porn quite easily. Intriguingly, Mami Water is also shown to be behind the establishment of Pentecostal churches, through which fake pastors make a great deal of money, as in the Nigerian movie with the telling title *Church Bu$ine$$* (House of Macro Productions, 2003). As we saw in chapter 4, the issue of the satanic taking the appearance of the Christian as a perfect mask also comes to the fore in *Pastors Club*. Represented in the usual way as a light-skinned spirit with penetrating turquoise eyes and as assuming both pious and seductive human shapes in her human avatar, Mami Water is exposed as being in league with a medieval-looking Satan and his demons, making her adepts go to hell. As an embodiment of ambivalence and deception, her figure signals that nothing is what it seems. Video movies around Mami Water peel off her appearances layer by layer, uncovering a deceptive beauty that provides a perfect screen to hide a beast. In this way the depiction of Mami Water in video movies accentuates for spectators the need to, indeed, "look deep" to find out what an appearance conceals.

"Naming" the Occult

Let me conclude this roadshow of iconographies of prominent occult figures by pointing out what their figuration has in common. I understand ghosts, witches, Mami Water, and other spiritual beings as part of a shared imaginary through which inner-personal tensions, ridden with desires and anxieties, that are the flip side of interpersonal relations, are expressed and experienced (see also Thoden van Velzen and van Wetering 1989). Taking part in generating and sustaining particular notions of personhood, these figures are imagined as external forces. Their figuration occurs both on the level of socially construed and transmitted iconographies that play a formative role in shaping moral notions of personhood and identity and on the level of mental images in the personal imagination. Socially construed and imagined as beings that engage and potentially attack and destroy their human victims, these occult forces evoke a diffuse anxiety and are feared to intrude into and interfere with a person's spirit in one way or another.

I understand the effect of the figuration of occult forces as analogous to what James Siegel (2006) called "naming the witch." He argues that witchcraft gives a name to and thereby enables people to grasp and control an uncanny

sublime that nonetheless remains elusive. This is so because the witch "names the foreign within oneself as the effect of an alien force hidden under the guise of one's neighbor" (2006, 220). Witchcraft is invoked with a culturally specific formation of the self. Hovering around an uncanny sublime that is ultimately located within the person, "naming the witch" is an ambiguous process that pins down witchcraft and yet fails to capture entirely what it is about.

A similar dynamic pertains to the figuration of ghosts, Mami Water, and other occult forces (such as spirits in the sky and in the bush, as well as Satan and his demons in hell). As I have pointed out, people face diffuse, partly realized, or repressed internal tensions about themselves in relation to significant others as an external threat that is represented by iconographies that stress otherness and monstrosity. Ghosts, witches, and mermaids are all liminal beings in a shadow realm between life and death, day and night, land and sea; their monstrous otherness is further accentuated by the use of Western-derived imagery and their location in a strict dualism that construes them as the evil other. Imagined and pictured as separate, and from a Christian standpoint downright evil, agents that threaten the self and call for protection and closure, these occult forces personify a difficult-to-grasp alterity *within* the person that ultimately is part of the person's own sociality, brought about through blood ties (kinship) and sex (marriage and reproduction). By virtue of being externalized, this alterity can, literally, be faced as an outside and alien force. The partial recognition of the external as internal, I propose, is the reason why references to and representations of occult figures have a strong affective appeal for audiences of all kinds of genres and in various media. Offering figurations of occult forces that, by definition, eschew being seen, movies play a prime role in producing compelling pictures that resonate with and continuously inform the inner mental images held by the beholders. The cinematic picturing of occult forces relates to fundamental issues of personhood, invoking questions of (in)dependence, attraction, repulsion, and alienation in relation to significant others and the self in a transforming socioeconomic setting, in which individual striving for wealth and its flip side, envy of the success of others, are the order of the day. As central nodes in crystallizing and transmitting modern iconographies of occult beings, video movies play an important role in trans-figuring a shared imaginary of the occult. This has yielded a set of more or less fixed iconographies that are embedded in a moralized dualism of evil and good yet at the same time affirm the status of the occult as elusive and imperfectly depicted, calling out to be "named" over and over again.

As this chapter has shown, the figuration of the occult forces that populate Ghanaian films is embedded in long-standing dynamics of trans-figuration across various media, including sermons, rumors, posters, and films, and across space, connecting European and African imaginaries in an ever deeper entanglement. Film and video provide suitable and proven techniques for a staging—in German one would say *Inszenierung*—of occult forces in the interface of visibility and elusiveness (see also Doll et al. 2011). Pictorializing occult forces that, by definition, resist being seen, movies play a prime role in producing figures that resonate with the inner mental images held by the beholders and that, in addition, personify repressed, alienated, barely acknowledged aspects of the self that cannot easily be accommodated within prevailing moral notions of gendered personhood.

Featured in the framework of a moral movie plot that legitimates and triggers playful transgression of the limits stipulated by social norms, pictures of occult forces confront spectators with their own hidden anxieties and desires. Evoking strong emotions, these movies speak to ongoing negotiations of moral personhood in a neoliberal setting that challenges long-standing patterns of mutual moral obligations and responsibilities. Showing extremes is part of a proven moral strategy to point out the right track (Verrips 2001), which is, however, challenged from within by the strong imagery employed. Situating "spectral affects" (Green-Simms 2012) that are designed to generate in audiences mixed feelings of pleasure and anxiety, appeal and repulsion, recognition and alienation, within a moralizing and revelatory framework, these movies are deeply ambivalent. Figuration of the occult relies on a tech-noreligious strategy of exposure that is never entirely contained in a moral plot. The educative message and the imagery used are thus potentially at loggerheads. Spectators recognize this tension, as shown by the example of the young girls with whom I worked in Teshie, who deployed an ethics of watching to shield off the disturbing potential of pictures that they believed to be transgressive, and by the Reverend Akoto, who insisted on the importance of a closure brought about by the ending of a movie that offers a moral frame. At the same time, occult imagery is appreciated as exciting and delightful, hooking people to the screen (in the same way as they are fascinated by the exorcism of demons during deliverance prayers in Pentecostal churches).

The fact that filmmakers embrace Western iconographic models as put forward in horror movies (that, in turn, tap into long-standing Christian

imagery and even offer pictorial backlashes grounded in orientalist stereotypes about Africa), and fuse them with local imaginaries, testifies to the cross-cultural translatability and mobility of figures of the occult and monstrous. For filmmakers and their audiences it is of tremendous importance to depict the embeddedness of popular imaginaries of the occult in southern Ghana (that were, in turn, shaped by encounters with Western imaginaries, conveyed via missions, literature, and Hollywood movies) in a larger framework. They deliberately want to eschew a narrow scope of their films—and, by implication, of their everyday lifeworlds—as being distinctly Ghanaian or African. In this way movies partake in the aggregation of the occult so as to deploy a crosscutting and cannibalizing pictorial "mode of speaking" that encompasses and can speak to various local imaginaries.

How do Ghanaian movies that involve occult beings relate to the Western genre of horror, which was one source of inspiration for the filmmakers? Posing this question is instructive. Drawing attention to the assumed relation between the forces depicted in the cinema and the outside world, it sharpens our understanding of what is distinctive about these movies. It is important to recall that the horror genre is a post-Enlightenment phenomenon, signaling the possibility of a playful, though all the same possibly frightening, encounter with the occult. The conditions created in the Age of Reason prompted a romantic concern, in literature as well as in film, to engage in a new manner with the spiritual beings that had populated minds in the past and that were still held to be a forceful reality to the "primitive" peoples encountered in the course of Western colonial expansion (giving rise to the genre of the Imperial Gothic and novels like *She*). These beings were, at least in the dominant reasoning, dismantled as "superstitions" (and positioned in an evolutionary scheme by scholars in anthropology and religious studies). Yet by the same token they were recast as the "uncanny" that was evoked via various strategies of representation or "techniques of the uncanny" (Doll et al. 2011, 11). From the outset the potential of modern audiovisual media, including film, was deployed to explore possibilities of representing phantoms and to experiment with film as a medium of the uncanny (Gunning 2007; Wünsch 2011).

In his book *The Philosophy of Horror* Noël Carroll argues that works of horror evolve around "impossible beings"—that is, monsters that are *not* taken for real by the intended audiences, who have learned to despise "superstitions." Without disbelief the genre of horror could not exist. Carroll takes as a starting point that "audiences know horrific beings are not in their

presence, and indeed, that they do not exist, and, therefore, their description or depiction in horror fictions may be a cause for interest rather than either flight or any other prophylactic enterprise" (206). As pictures, occult beings and monsters are an "objective reality" in the Cartesian sense of "the idea of the thing *sans* a commitment to its existence" (like a unicorn or Dracula) (Carroll 1990, 29). Rather than prompting spectators to run away, these pictures produce a sense of "art horror" and the concomitant emotion of fear. Carroll contrasts the modern Western setting from which "art horror" arose, on the one hand, with earlier societies and societies elsewhere, in which people took the existence of spirits to be real in the ontological sense that typifies religion, on the other. As horror is predicated on disbelief, horror and religion cannot go together.

I find the contrast drawn between "art horror" and "religion" too simplistic. Carroll creates the wrong impression that within the framework of religion people believe that spirits "exist" in a straightforward sense. In so doing, he fails to take into account that "religion" may well offer a more complicated, layered understanding of the "reality" of spirits and the divine and concomitant conventions of representing them. This is certainly the case in southern Ghana, as it was for nineteenth-century European missionaries or contemporary Pentecostals everywhere. Like the ideal-type Western audiences Carroll has in mind, audiences in southern Ghana are of course aware that they are watching a movie and not encountering occult beings directly on the screen. The crucial difference is that, if we follow Carroll's argument, the former can enjoy such movies because they do not attribute any existence to the monsters outside of the movies,[24] whereas the latter tend to enjoy them because they believe that the occult figures featured on the screen also exist outside of it, "in the spiritual"—hence their preparedness to take movies as genuine revelations exposing forces that can only be seen with the "spiritual eye." While Western art horror is characterized by play with revelation and concealment of the phantasmatic *within* the movie that grips the beholder and is a source of thrill and fear (Carroll 1990, 181; see also Wünsch 2011), the featuring of occult forces in Ghanaian movies is intended not simply to effect a playful anxiety but rather to invoke a sense of recognition of their depictions as fitting into a shared imaginary of the "spiritual" that is understood to be real.[25] Spectators are invited to adopt the gaze that comes with the format of revelation, through which they usually know better and see more than the protagonists onscreen, who are in a state of fear. As I pointed out in chapter 4, the format of revelation adopted by filmmakers is grounded in

popular Christian ideas about revelation and concealment that pertain to their view of everyday life as a whole and whose operation is exemplified in movies.

Ghanaian movies featuring occult forces thus do not fit in the genre of horror as it evolved as a Western phenomenon. Ghanaian movies could more aptly be circumscribed as "occult melodramas," a new hybrid cultural form "that is made possible by the flexibility of video technology" (Green-Simms 2012, 26; see also Larkin 2008). Melodrama emerged in the West in the aftermath of the French Revolution and thus alongside—and, given the emphasis placed on the ordinary and banal, in strong distinction to—the genre of horror, which was about the uncanny. Both are genres designed to elicit emotions. While horror movies create fear by invoking the uncanny, melodramas construe the world as an affective space in which the deployment of moral virtues is adamant (Elsaesser 2008, 12), conveying a kind of moral education that works largely through emotions. Claiming that underlying forces govern what happens on the surface of everyday life, melodramatic writers posit the need "to go beyond the surface of the real to the truer, hidden reality, to open up the world of spirit" (Brooks 1976, 2). In melodramas the forces operating beneath the surface of appearances are what Peter Brooks calls the "moral occult, the domain of operative spiritual values which is both indicated within and masked by the surface of reality. The moral occult is not a metaphysical system; it rather is a repository of the fragmentary and desacralized remnants of sacred myth" (1976, 5, 20). Importantly, the realm beneath the surface is rendered in moral, rather than individual, psychological terms: inner conflicts are depicted as a dualistic struggle between good and evil (Brooks 1976, 19–20)—a struggle bemoaning the loss of the sacred that once formed the backbone of society and that was central in the arts. This genre has an obvious appeal to people in the Ghanaian setting, characterized as it is by the prominence of the format of revelation, which is predicated on a strict dualism of good and evil and claims to offer insight into the current "spiritual war" by triggering strong emotions.

And yet there is a mismatch as well. Both horror and melodrama evolved at a moment when religion was no longer taken for granted in the West but became, albeit from a modern enlightened, secularist perspective, a matter of the past. At the same time, old religious tropes and themes were channeled into new art forms. If horror required disbelief, yet tapped deeply into long-standing religious repertoires by featuring monsters, melodrama, as Brooks has pointed out, made up for the perceived loss of religion. Elsewhere I have

argued in some detail that Ghanaian video filmmakers adopted and adapted melodrama as a style of representation that matched the Christian format of revelation (Meyer 2004; see also Pype 2012, 126–27). Of course, given the predominance of Christianity, in southern Ghana melodrama could not function as a "form for secularized times," offering "the nearest approach to sacred and cosmic values in a world where they no longer have any certain ontology or epistemology" (Brooks 1976, 205). Instead, what emerged was what Green-Simms felicitously called "occult melodrama," a cultural form that did "not seek to make legible hidden spiritual values in the same way that Western melodramas do" but rather presented "a world in which supernatural forces operate side by side with the daily lived realities of postcolonial precariousness" (Green-Simms 2012, 31). Synergizing a concern with the horrific *and* the banal, occult melodrama emerged not at the expense of and possibly as some kind of substitute for religion but coexisted alongside it. Nourished by locally grounded imaginaries of the occult and the modalities of rendering it (in)visible, this cultural form operates as a kind of switch point that articulates the local in the global and vice versa.

SIX

Animation

Having explored the cinematic iconographies of pictures of the occult that function as templates to be recycled and reworked in movies, I focus in this chapter on the aesthetic practices by which these pictures were produced. Moviemaking entails the creation of an artificial setting in front of the camera to yield moving pictures that are cut and recombined on the editing bench into a film designed to be recognized by audiences as a truthful representation of the entanglement of the physical and the spiritual in the phenomenological world. This chapter is devoted to the actual process of the "making of" movies that feature occult forces.

Staging the occult is not merely a question of techniques on the level of camera work and editing; it also involves the participation of people and objects. Studying moviemaking on a basic, down-to-earth level of people working with pictures is instructive because it draws attention to the groundedness of film in the world of everyday lived experience. In film and cinema studies, however, fictional films are usually analyzed as accomplished audiovisual products. Taking the film itself as a starting point, scholarly inquiry is devoted to the effects of camera work and techniques of editing through which spectators are addressed and involved in the cinematic apparatus and to the processes of reception through which they vest with life the two-dimensional pictures that make up a movie.

Little attention is paid to the practices of working with pictures in front of the camera that are the sine qua non of a movie. Certainly for the purpose of this book, which explores the resonances among Ghanaian films, the world of everyday lived experience, and popular imaginaries, it is necessary to follow the lines from practices of working with pictures in front of the camera, to the editing that yields the movie as a fixed audiovisual production,

to the subsequent practices of reception and incorporation. Acknowledging the material grounding of film pictures in things, spaces, and flesh-and-blood people is a prerequisite to understanding the embeddedness of movies in everyday life, as well as the overlaps between cinematic and religious practices of mediation that typify the movies that are central to this book.

In several steps this chapter will follow the trajectory of working with pictures as part and parcel of the trans-figuration of a popular imaginary of the occult into Ghanaian movies. I will attend to set design, to the use of props and the risks induced by mimesis in acting, to editing and special effects, and to advertising. I examine practices of imagining, creating, working with, and relating to pictures of the occult on the part of filmmakers, actors, technicians, editors, and, to some extent, spectators. Which practices of cinematic representation are implied in trans-figuring the occult, as it is popularly imagined, into horrific movie pictures on set? And how do those involved in making films that feature occult forces experience their participation in picturing them, often by mimetically enacting—and for the sake of the film: "becoming"—occult beings or native priests? How is the occult conveyed practically via pictures on the level of editing, involving special effects? How are these movies advertised? Addressing these questions step by step, I delve into the intricacies of figuration and animation that precede the depiction of occult forces in a movie yet are at the same time inflected with the ideas and imaginaries about the occult that are found in the world of everyday life.

ON SET: IMITATION AND THE "REAL THING"

In his celebrated and much debated *Nollywood* project, the South African photographer Pieter Hugo presents a series of photographs from the sets of Nigerian video movies (Hugo 2009; see also Belting, Buddensieg, and Weibel 2013, 350–51). Asking actors to pose for him and look directly into the camera, Hugo used the sober format of the portrait to spotlight a central feature of the Nigerian—and, by implication, Ghanaian—video film industry. Looking at the film set through Hugo's eyes conveys a sense of the presence of the horrific, absurd, and uncanny in the quotidian. Most of his photographs feature one or the other horrible spiritual figure in a rather mundane environment, such as a hairy monster with a bottle of Coca Cola, a red-eyed female vampire against a run-down wall, a mummy standing in front of a

messy heap of old chairs, three white-powdered spirit children against the horizon of posh multistory apartment buildings, a man with a devil's head sitting on a chair next to a staircase, a zombie in a wretched car, the devil seated next to a woman dressed in lavish lace in front of a cyclone fence, an almost naked white Darth Vader (the photographer himself) at a garbage dump. For me, the photographs crystallize the seamless coexistence of the spiritual and the physical in everyday lifeworlds that I, like Hugo, came to identify as a key aspect displayed in Nigerian and Ghanaian video movies.

One may wonder how viewers unfamiliar with the Nollywood phenomenon might view Hugo's photographs. I suppose that to some extent the photographs confirm, yet also disturb, stereotypical imaginaries of Africa because they convey a weird bricolage of supposedly typical African and Western features. This is epitomized by the photograph with actors Chris Nkulo and Patience Umeh: the devil (the iconography is reminiscent of the surrealist figure of the Minotaur) seated next to a woman dressed in a gown made of expensive green lace (itself a dress style that emerged in the interface of encounters between Nigerians and lace producers in the Austrian Voralberg [Plankensteiner and Adediran 2010]). Tellingly, the book is framed, as the publisher put it on its website, as offering "surreal tableaux rooted in local symbolic imagery."[1] I find it intriguing that "local symbolic imagery" is embraced under the rubric of the surreal. As I will point out in my epilogue, invoking the surreal opens up refreshing perspectives on the Nigerian and Ghanaian video film industries that transcend the worn-out criticisms in the name of state and art film discourses about African cinema. At the same time, in Hugo's book I miss a deeper probing into the "local symbolic imagery" trans-figured by these industries. For me the photographs evoke pressing questions about the actors posing for Hugo that the book leaves unanswered: how did actors position themselves in relation to "the local symbolic imaginary" (and how "local" is it anyway)? How did they feel and think about playing the role of—and hence lending their body to the look of—a monster, given that in Ghana occult forces tend to be taken as dangerous others that are real in the spiritual? And what were the ideas and experiences of those engaged in filmmaking in general when they shot scenes that staged horrible-looking occult forces or the evil priests conjuring them?

These questions are central in this section. Filmmaking, as Hugo documents, requires building sets, designing costumes, and using props, that is, constructing a material world that involves flesh-and-blood people, tangible things, powerful words, and varying rhythms. Even though this world is

constructed just for the purpose of recording motion pictures that circulate as video films, it is not perceived as an entirely artificial setting. Especially in the early phase of my research in Ghana (up to 2003), but also more incidentally later, I noted that many of the actors I met and interviewed, and others involved in the process of shooting on set, had second thoughts about imitating the occult. This reluctance resonates with the findings of Katrien Pype's (2012) impressive study of a Pentecostal troupe, Cinarc, that produced melodramas for television in Kinshasa. While this troupe was explicitly tied to a Pentecostal church and took part in its evangelizing project (very much in line with the logic of revelation that I examined in chapter 4), in southern Ghana video movies were made independently of Christian organizations. As noted, while some producers embraced the Pentecostal project, others did not see themselves as staunch Christians. Yet they all believed that the revelation format was conducive to screening sensational motion pictures that would impress audiences. So they made movies resonating with the popular Christian imaginary that shaped and underpinned everyday life. Likewise, actors and others involved in movie production at various stages were more or less involved with Pentecostal-charismatic churches, ranging from nominal to staunch born-again Christians (see also Asare [2013, 202–4], who reports a number of public conversions of—especially Nigerian—actors to Christianity). Yet, while everyone on set was of course aware that films are artificial, human-made productions, there were nonetheless numerous moments and occasions when they were gripped by the uncanny that they sought to portray persuasively. During my research I witnessed a number of these moments and heard about them through conversations and interviews.

I heard lots of stories about devices that ceased to work exactly when a scene was to be shot; many believed this to reveal how "the powers of darkness" operate. In situations of technological failure or mishap, those involved in shooting were quite prepared to endorse that spirits or demonic forces were able to affect the camera, stopping it or making it impossible to take certain shots. The NAFTI-trained director Dugbartey Nanor told me that, while the camera may be "neutral in principle," there was "the belief that spirits can work on the camera, that they can stop the camera, or that you don't get the shot you want" (interview, 3 Oct. 2002). Some could take this as evidence that the devil did not like to be exposed through movies. In popular Christian teachings Satan was seen as a master of deception who did not want to be unmasked. In this view, showing and giving audible expression to

normally hidden occult forces was a process of controlling and defeating them through vision and sound. At the same time, however, the very act of revelation could be thwarted by demonic counteraggression. Many technicians, filmmakers, and actors shared the popular ontology, with its distinction between the physical and the spiritual. This was made explicit especially in particular moments when the imitation of the occult became uncannily realistic or when actors faced certain problems that they blamed on having played a particular role at some point. Taking recourse to this ontology could render strange experiences plausible and underpin claims that occult beings were real (Ashforth 2005, 123).

I found it intriguing that, as Dugbartey Nanor put it, spirits would only "conquer [the person] who believes they can," a viewpoint reiterated over and over again by many of my interlocutors. As my friend Adwoa put it: "When you believe in it, it works for you" (20 Sept. 1999) and one could add "against you," as well. In this understanding occult forces' capacity to affect a person depended above all on the person's attitude.[2] The point here is that belief was not tied to an ultimate truth of which the believer was convinced and of which he or she wished to convince others but was understood as an embodied disposition that makes people act, feel, and fear in a particular way—a folk understanding of what social scientists call habitus. Of course, actors distinguished playing a role from who they were in their ordinary lives. Acting, certainly in the case of the roles involving the occult (or sex), required the ability to bracket off one's personal moral convictions and to enact attitudes one would normally despise. Even though it was agreed that the film set was an artificial environment, many actors could not simply and fully suspend their belief in the existence of spirits and in the efficacy of certain (speech) acts in conjuring them. The film set was therefore experienced as an ambiguous space between illusion and reality. As spirits were held to be able to interfere everywhere and in any possible way, many actors and crew members believed that one had to be alert and vigilant. I do not want to suggest that they perceived the film set as a site of permanent enchantment. My point is that since they found that imitation could possibly call into being the "real thing," they took practical measures, grounded in their religious experience, to keep spiritual forces out of bounds.

One important measure taken was prayer. Collective prayer is a recurring and ordinary public practice in a broad array of settings, including state institutions, and on most film sets every day began and ended with prayer (even among less pious filmmakers and actors). Actors who were to play the roles

of (evil) spirits or their custodians made sure to fortify themselves through prayer and fasting, often with the support of their pastors (see also Pype 2012, 131–32). The Reverend Akoto explained that playing occult roles would create "an open door, and something may intrude." The purpose of prayer was to shield actors against unwanted intrusions. As the Nigerian actress Joke Silva put it poignantly, she prayed so as to take Jesus as her "hedge" that would block evil powers from taking possession of her personal spirit (interview, 10 Nov. 2007). Many of those on set experienced prayer as protective, reassuring, and comforting and would attribute mishap and failure to a previous lack of (sincere) prayer. Pype distinguishes two "distinct kinds of mimesis" involved in the Cinarc troupe's acting: "Firstly, 'acting' equals 'becoming,' and secondly, when the performers have prayed enough, 'acting' is merely 'simulating' without altering or modifying the artists' being" (Pype 2012, 138). I recognize both kinds of acting in my research, but I found that prayer seemed less efficacious at disentangling them than Pype suggests. One was never entirely on the safe side, that of mere simulation.

As in other movie industries around the world, many actors were somewhat amused and at times flattered by spectators' propensity to treat them as if they really were the character that they had played in a given movie—approaching Eddie Cofie as if he were a pastor, or fearing that Bob Smith might really be the snake-man Diabolo (see Pype 2012, 131, for a similar conflation of actors and roles in Kinshasa). This propensity was increased by the fact that many producers selected actors on the basis of their proven qualification to play a particular kind of character. For example, with his deep voice, broad posture, and confidence-inducing face, Eddie Cofie was the ideal pastor, while light-skinned young women would make a perfect Mami Water or other capricious female spirit, and seasoned actresses like Grace Omaboe and Grace Nortey were destined to play quarrelsome old ladies. Such designations of roles based on physical features were conducive to typecasting, blurring the distinction between the character impersonated and the assumed personality of an actor in public opinion. Some actors enjoyed playing with this confusion of levels. In 2008 there was a craze in Accra about *sakawa,* a cult whose members were said to make pacts with a dangerous, bloodthirsty spirit in order to secure success in perpetrating Internet fraud, popularly called 419.[3] The fascination with *sakawa* was reflected and fueled by a host of popular movies made about it (Garritano 2013, 182–94; Oduro-Frimpong 2011).

Actor Lord Bentus, alias Ato Blinx,[4] very much enjoyed becoming the face of the typical *sakawa* proponent (a rich guy in a posh SUV with a massive

sound system, fancy clothes, and a lot of bling) and was quite thrilled that many people on the street—even those he took to be "real" *sakawa* boys—mistook his role for his true personality (interview, 25 August 2009). Yet the fact that actors laughed about this confusion did not imply that they themselves were always able to strictly distinguish between their own personality and a film character. Some thought that playing a character might somehow affect their life. This pertained above all to roles that involved occult forces (and the immoral behavior, including nudity, that this entailed). Lord Bentus, for instance, told me that he knew that his mother, who was a member of the Church of Pentecost like him, and other people were praying for him to ensure that he would not be affected by his role. He also confided to me that he had been appalled when he was told on set to remove his pants for a scene in which he had to face a native priest; he did so only with some hesitation, for the sake of the role, but believed that this was not good for his reputation. To depict such a scene realistically, he had to expose his buttocks, but he still felt a bit ashamed, as this kind of revealing of intimate parts to the public is normally taboo. Certainly, as spectators tend to confound the character played with the actor, he feared that they might judge him an immoral person.[5]

Many actors experienced scolding from spectators for playing evil characters. For instance, having played a witch in *Expectations* (Miracle Films, 1999), Edinam Atatsi faced criticism from members of her family and church (the Seventh Day Adventists). *Expectations* was a blockbuster at the time, with spectacular special effects that for the first time had been designed in Ghana (at Nankani editing studio, rather than at Mad House studio in Lagos, as had been the case before). The movie features witches meeting in their coven in the bush late at night, feasting on the spirits of those overpowered by witchcraft. Edinam played the role of Dufi, a jealous village girl who causes her happily married sister, Gifty, to have a miscarriage. A spectacular scene presents a special effect, showing how a—normally invisible—poisonous substance is put into her food by a "spiritual" hand and becomes operative because Gifty, in contrast to her pious mother, fails to pray over the food—leading to many problems until part 2 closes with a happy ending. Edinam smilingly told me about a little boy who, having watched the movie, stated, "Auntie Edinam is now a witch." Other relatives and friends also disliked her playing this role.[6] Invoking the typical view of Ghanaian movies as offering moral education, she asked her critics whether they had learned anything. And indeed: "Yes, some girls said, we learned that we have to pray before we eat, otherwise

Auntie Edinam will put something into our food. So this is what the film teaches, you always have to pray." Despite this Christian lesson, her fellow church members "made noise" about her acting. Her pastor expressed his disappointment about her wearing earrings (a practice not acceptable to Seventh Day Adventists). She told me that she explained to him: "But it was a film!!! I do it as a character, don't look at that as Edinam. When there are plays in churches, somebody has to play Judas and the devil. Does that make a person a Judas or a devil? You do it for a purpose, to teach a lesson." On the whole she did not bother much about such challenges. But she made sure to pray over all the roles she played, asking God for protection and help to do well.

According to Edinam, shooting the witchcraft scenes was scary, as it took place in the bush after midnight, at a time when all the "powerful ones" whom the actors were simulating were out. The actors imitating the witches held each other's hands and prayed, for it all was so "horrible and frightening." There also was a strange bird (possibly an owl) making frightening sounds; tellingly, it would stop only after the actors had prayed together. Actor Emmanuel Armah,[7] who played Gifty's husband in *Expectations*, told me that there were many problems, "so what we needed to do was to start praying, to chase the devil away" (interview, 8 Nov. 2002). He also believed that it was a challenge to shoot the witchcraft scenes around midnight, which was, after all, "the time we believe they fly and they go to eat [i.e., feed on their victims' spirits] and they do everything." While time and location were appropriate to make the film appear realistic, he thought the shooting might disturb the "real witches" out there, and this would in turn bode ill for the actors. So Armah insisted on seeking divine spiritual support: "Things happen sometimes, you know, because you end up playing a role . . . and then you need to pray about it." He thought that it was particularly important to be careful about scenes that came very close to or even threatened to merge with the spiritual occult reality behind the visible physical realm. Clearly, imitation entailed the risk of rendering present the forces that were staged for the sake of a movie. For instance, he told me about one time on a film set in Nigeria: "We were playing with a lady and nobody knew the lady because she came to audition and she was given the role and she was acting as a ghost. Now, when they finished the scenes at the cemetery . . . until now nobody has seen her!" Not only could actors invoke and enliven the occult forces staged, but making a film could even attract a ghost to come and act as herself. He found that the work on set was rougher and more dangerous in Nigeria, where they would "go deep into witchcraft" to the degree that the urge to

depict the occult made them get dangerously close to reality. For Armah, as for many Ghanaian actors involved in the Nigerian film industry, shooting movies about the occult was an outrageous experience that confirmed their suspicions and prejudices about Nigerians' engagement with rituals, blood money, and other extreme spiritual endeavors. In contrast, he found that Ghanaian movies were less excessive, and more care was taken on set to keep evil spirits at bay. He told me that in a "movie we did recently, we had to put Pascaline [Pascaline Edwards, a famous Ghanaian actress who also played lots of roles in Nigerian films] as a dead person on a bed, and we put her in a coffin. But when we wanted to do that we prayed, we prayed so much, even in the cemetery, at least to let her know that we were not trying to do anything bad and that this is a movie. You know, people believe in it."

Even though there was agreement that it was absolutely necessary to feature evil spirits as well as occultists and their clients in revelation movies, several actors were not all too eager to undertake such roles. There were quite a number of stories about actors who attributed illness to having played such a role, which was understood as potentially disturbing one's spiritual balance and physical health (see also Pype 2012, 135).[8] Akwetey-Kanyi told me that on the set of *Sacred Beads* (Aak-Kan Films, 2009), an epic movie situated in precolonial times, one of the actresses playing the role of a "fetish priestess" started to dance, turning round and round, and was "caught" (that is, possessed) by a deity from her family house that had been abandoned long ago. In the end they had to put a local broom (made of a bundle of palm fronds) into her hair so as to stop the spirit from trying to possess her.[9] This event was remarkable, as the actress was a Christian who normally attended church. However, once she had dressed and started to move as a priestess, that spirit apparently took its long awaited chance to get hold of her (interview, 26 August 2009). Such things, my interlocutors in the film industry claimed, could easily happen if an actor belonged to a family that had a long-standing link with a particular spirit. Certainly if a family spirit was neglected or abandoned, which often occurred as a consequence of conversion to Christianity (Meyer 1998a), it might take advantage of the opportunity to get into an actor imitating a native priest or priestess. I understand these feared spiritual intrusions as crystallizations of imagined family ties that were no longer socially operational but were still embedded in a person's memory and identity (see also Meyer 1999b, 180–87).

Setting up an artificial shrine also evoked the possibility that what was represented for the sake of the movie would assume a real presence.

Interestingly, such film shrines bore little visual resemblance to actual shrines. The latter did not necessarily consist of much colorful visual material and, in addition, their audiovisual representation with photo and film cameras was severely restricted to keep them secret (see de Witte 2008; this issue is addressed more extensively in chapter 7). Violating this secrecy and bringing out into the open all the items that make up a shrine, of course, was one of the ways Christian missionaries sought to defeat "pagan" religion; converted traditional priests were expected to reveal their secrets, display the interior of the shrine, and burn the power objects (or hand them over to the missionaries, who would put them into ethnographic collections). This strategy of exposure is replicated in the cinematic format of revelation. As I have pointed out, it produces representations of the occult that are taken as potentially dangerous (given the evocation of likeness through figuration) and yet at the same time as ultimately impossible (given the restrictions on the use of modern media). Shrines in movies should therefore not be understood as truthful audiovisual copies of a model existing in the setting of indigenous religious cults. Instead, film shrines are characterized by a bricolage of elements from Hollywood movies, Indian films, voodoo imagery,[10] photo books of African culture, and tourist art. Yet shrines in films and shrines in actual use have a crucial feature in common: they are understood from within the same "semiotic ideology" (Keane 2007) that stresses the importance of human acts in setting up an abode for spirits.[11] In the context of indigenous religious cults, the importance of good craftsmanship in making sculptures and furnishing a special room for them was regarded as a necessary prerequisite for the gods to come and dwell in these artifacts (Rosenthal 1998, 45; Blier 1995, 74; see also Meyer 2010c, 109). In the semiotic ideology underpinning indigenous cults, human action and material objects are indispensable for getting in touch with spirits. Instead of being understood as supernatural forces that act, as it were, ex nihilo and according to their own logic, spirits are thought to depend on appropriate human acts and use of objects in order to operate. In other words in indigenous religious traditions the human role in making or fabricating gods and mediating the spiritual is openly acknowledged (see also Barber 1981), and this stance could also flare up on the film set. This indigenous semiotic ideology was not abandoned with the rise of Christianity but incorporated into it. Even though Christian—and especially Protestant—discourse employs an anti-idolatry and antiritualistic rhetoric, indigenous religious practices are still regarded as powerful, albeit as prone to conjure demons. Concomitantly, from the perspective of popular

Christianity, Christian practices such as prayer and worship are also understood as effective tactical maneuvers rather than merely as expressions of an inner disposition.

Recognizing effective acts and empowered things as central to indigenous religious practice implied that setting up a film shrine as an abode for occult forces, even though intended for the mere purpose of a movie, was considered potentially tricky.[12] Film shrines were regarded as on the verge of shifting from being artificial sites to animated ones. Since it was believed that many spirits were roaming about in search of new dwelling places, one had to take care that they were not attracted to intrude on the set. As Nnenna Nwabueze, a well-known Nigerian actress who had played the female lead in the Nollywood classic *Living in Bondage* and a set designer who worked in Ghana in 2002, put it: "Here, the belief is still that there are spirits in the sky [and, by implication, roaming about in search of an abode]. When you create an idol, they can get into the idol." Using the notion of the "idol," she employed a Christian semiotic ideology according to which human-made artifacts employed in contacts with spirits were qualified as instances of "idolatry" or "fetishism." Importantly, the use of the term *idol* signals that such objects were not dismissed as baseless "superstitions" but acknowledged as powerful and real, albeit satanic, powers (Meyer 2010c).[13] In other words these things were recognized as material media that made a strong spiritual impact on their users. Since such "idols" were held to be loaded with spiritual power, they could affect persons. This was certainly the case for those who believed—in the sense outlined above—in the existence of the spirits involved in "idol worship." Having a personal spirit that was permeable and hence potentially receptive to spiritual intrusion, they needed to be vigilant and alert and to shield themselves spiritually against these forces.

For this reason Nnenna had to balance between setting up a compelling shrine that looked real to the spectators (fig. 23), on the one hand, and making sure that it remained an unanimated "fake" that would not affect the actors and crew, on the other. In other words the better the imitation, the greater the risk that it would become real on set. Her work as a set designer took her to stalls in the market where "fetish" things were sold. She purchased only newly carved masks but never anything "dirty," because she feared that she would also receive the spirit that was inside. Often she only looked at these items carefully and then reproduced them with alternative materials (such as Styrofoam) to mimic the "real thing." She also engaged in extensive prayers and fasting to protect herself against inviting actual spirits

FIGURE 23. Shrine on the set of *Turning Point* (September 2002). Photograph by author.

into her masterful work of imitation.[14] Retaining a film site as a nonanimated artificial simulation was not the default situation but required heightened spiritual engagement. When I pursued this issue in further conversations with Akwetey-Kanyi, he explained to me that he always made sure to replace some of the ingredients required in setting up a film shrine with substitutes (e.g., blood with red paint, alcohol with water, maize powder with cassava and white paint, to avoid attracting spirits that are usually fed with alcohol and maize) and to recite only fake incantations in a nonexistent language. The audiovisual appearance should be convincingly similar, but the substance should definitely be different. By all means one had to prevent the artificial shrine from being activated in the process of acting.[15]

This shows not only how objects referred to as "idols" and "fetishes" were incorporated into a Christian semiotic ideology that was invoked to denounce, yet at the same time affirmed, the reality of "heathen" worship but also how this semiotic ideology seamlessly extended into the world of filmmaking. Clearly, the trans-figuration of popular imaginaries into film pictures was a material process grounded in the phenomenological world of life shared by actors, film crew, and audiences. Trans-figuration of occult matters necessarily required creating a likeness between film pictures and shrines—similar to sympathetic magic. Thanks to persuasive imitation, film pictures could appear as plastic figures, but at the same time practices of imitation always entailed a risk of bursting out of the confines of the film set, unintentionally creating a shrine perceived as a compelling sensational form that conjured spiritual forces.

The degree to which the blurring of fake and real that haunted attempts to offer convincing and realistic cinematic representations of audiences' beliefs and imaginations was regarded as threatening, became crystal clear to me in September 2002 when I was at the set of *The Turning Point* (T. Print

Productions, 2003), a movie about a woman who becomes born again. For this reason she is saved from the evil intentions of her boyfriend, an occultist, who wanted to sacrifice her for his bloodthirsty spirit. It was already late at night when a scene with the occultist in his shrine was to be shot. When we heard drumming, which was identified as coming from a "real fetish shrine," in the neighborhood, I joked that now there was no need to underlay the scene with its own soundtrack. The actor who played the occultist, Victor Lutterodt,[16] retorted immediately that he was not prepared "to get into the real thing," as that would be dangerous. I found it intriguing to learn that the sheer sound of a drum was held to potentially have a spiritual effect on those hearing it, even if they did not participate in the ritual to which the drumming belonged. This incident shows again the extent to which religious practices mattered in the Christian semiotic ideology employed by many of those involved in film production: these practices were credited with the power to effect something, to act on and affect those who believe in spirits and hence, albeit unwillingly, open themselves up to them. The sound of drums beaten in indigenous cults, in particular, was understood as having immense power to encroach on professed Christians who wished to keep their distance from "heathen" soundscapes (Meyer 2006b, 44n40; see also Friedson 2005; Peek 1994). Sound, in other words, was taken to be heavily intrusive, challenging the maintenance of a closed, self-contained self (and set) that was shielded against potential intrusions.

The point here is that in the process of imitation that was necessary to make a successful movie with compelling figures, new spiritual presences of occult forces could be generated. At stake is the mutual interference of two opposing logics: while films framed as revelation claimed to offer a superior perspective into the hidden operations of the "powers of darkness," pinning them down via audiovisual *representation,* the imitation of occult figures and shrines on the set was believed to potentially generate the *presence* of these powers. Even though filmmakers and actors did their best to sequester the "real thing" from cinematic representation by praying or making use of certain substitutes, the boundary between them remained permeable and unstable. What started as fictional representation, set up in front of the camera, could create a presence of its own that was even more visually and acoustically compelling than the reality it initially set out to represent and was thus perceived as all the more dangerous. In line with the popular ontology and the dominant semiotic ideology in which filmmaking was embedded, simulation was held to always entail the risk of mimesis: "duplication accordingly

entails invocation" (Pype 2012, 138; see also Taussig 1993, 105–8). In the murky zone between model and imitation there emerged new figures that were not fully contained within the universe of filmmaking. Rather, through the logic of sympathetic magic that was unleashed by imitating religious objects and practices, the spheres of religion and film were blurred. Religion is understood here as involving effective human *acts,* the mimicking of these acts through *acting* was thought to be prone to invoke spirits—a matter of "miming the real into being" (Taussig 1993, 105).

The fear that what was intended as mere imitation could bring forth a frightening reality of its own resonates with theories of ritual as perform-ance. Involving "performatives" (Austin 1962; see also Rappaport 1999)—that is, acts and utterances that bring about what they say—ritual is a social-aesthetic technique for making real an imagined, partly invisible, and inaudible world, be it in the setting of a shrine or on a film set. In other words the artifacts and acts involved in trans-figuring a cultic setting for the pur-pose of film gave rise to the emergence of a sensational form that is not lim-ited to merely representing a model out there. The performance of likeness was likely to generate the "real thing."

This possible slippage through which a film set and the props employed could become the "real thing" was a constant topic in my conversations with filmmakers throughout the years. As time went by, actors and crew consid-ered it increasingly normal to imitate involvement with occult forces in front of the camera. They worried less about the potential impact and even engaged in it playfully, as was the case with actress Rose Akua Attaa Mensah, who played the lead role of Kyeiwaa, a witch, and stated tongue in cheek that she was a witch herself on the occasion of receiving an award at the Ghana Movies Awards on 25 December 2011.[17] Yet cases of becoming possessed in the course of playing the role of a traditional priest continued to occur, espe-cially if a movie was shot in a village. In 2008, when it was fashionable to shoot movies in village settings, Akwetey-Kanyi told me that some actors became quite nervous about trespassing onto actual sacred spaces. One time they were shooting in the vicinity of a sacred tree; he had already said "quiet on set, rolling," when he saw that the actor who was to play the role of a dying chief was moving his lips. He was praying out of fear that something might happen to him in this potentially dangerous location, which was not just a film set but also a sacred space in the village topography. Akwetey-Kanyi told me that he was intrigued that, as long as actors and crew did not know that they were close to a dwelling space of spiritual forces, there was no fear. The

fear only came once they knew that a certain place was not "neutral" but spiritually loaded. This observation resonates with Dugbartey Nanor's point that technology is neutral in principle. Clearly, all those involved on set took filmmaking as basically a prosaic enterprise; it could, however, be disturbed by spiritual forces in moments when their representation was experienced as uncannily realistic. Once they had already been shooting near and in a river for some time in Fotobi (an Akwapim village) when it occurred to him that he and his crew should retroactively ask permission from the village chief to film. After they handed the traditional gifts of a bottle of schnapps and money (in this case GHS 210) to the chief, they were informed that there were thirty-one gods in the river. Akwetey-Kanyi was happy that they had been ignorant beforehand about this abundance of spiritual forces on location (and possibly this had been a strategic choice on his part), as knowledge about this would have impeded the shooting (interview, 20 Jan. 2008). This diffuse anxiety lingered on. As Lord Bentus put it somewhat later when we discussed the implications of shooting movies in a rural setting, viewed by many actors as a dangerous abode of the occult in contrast to the city: "Actors fear the presence of real spirits in the village, and they are afraid that a spirit may enter them and be carried home to Accra" (interview, 22 April 2010).

The film set was a constructed material environment in which the imaginaries trans-figured by popular movies achieved a tangible and potentially uncanny and dangerous shape. The fact that imitation was not understood as mere acting, but rather as a performative act able to conjure the spiritual presence of the forces that were to be represented, testifies to the embeddedness of filmmaking in the broader world of everyday experience shared by audiences, actors, and film crew. The close relation between those making and those consuming movies is one of the distinctive features of this popular industry. On the set, in front of the camera, the mental images that populated the personal imagination were trans-figured into concrete practices and objects, which in turn were trans-figured into sets of motion pictures. The next step in the trajectory of trans-figuration that underpins moviemaking leads to the editing room.

EDITING AND SPECIAL EFFECTS

Given the short time span used for shooting (often less than a week for a movie with two or more parts), editing was important for correcting all kinds

of mistakes to produce a montage of pictures that was a more or less coherent and compelling whole. The importance attributed to editing as an effective corrective for shortcomings in filming is expressed pointedly in Safo's typical statement, made when he rushed through plenty of scenes on the set and impatiently warded off suggestions for a better take: "We'll fix that in the editing room." If working on the set with materials that trans-figured the occult compellingly and convincingly was experienced as potentially danger-ous, those doing the editing understood it to be a work of make-believe. This also pertained to designing the special effects needed to show how spiritual forces operate. Notwithstanding the poor technological equipment, the very first films, including *Zinabu* and *Diabolo,* featured special effects produced by copying one clip onto the other with two video recorders. Private film-makers were quick to find NAFTI-trained editors who worked at GFIC/Gama and would privately edit movies and produce special effects on a Betacam editing bench. The first movie that excelled through its special effects was *Ghost Tears.*

For years the GFIC/Gama-employed editors Marc Coleman and George Arcton-Tettey were in charge of designing special effects for private produc-ers. Their names stood for the highest quality. Both were extremely experi-enced, imaginative, creative, and able to fix all kinds of mistakes that had been made during principal photography. Along with the GFIC/Gama premises, a number of Pentecostal churches, ministries, and private compa-nies also offered Betacam editing facilities. Producers had to pay for both the services of the editor and the use of the editing bench. Editing was a costly and time-consuming affair: benches were not always available, and top edi-tors often had many assignments at the same time. Producers who had to do editing on credit were often left waiting for a frustratingly long time.

Even when movies were already being shot with digital cameras, for some years editing still required digital pictures to be downloaded into the analog format suited for Betacam. With the shift to digital editing technology (starting around 2000) the possibility to produce special effects was no longer limited to those who had access to expensive Betacam editing facilities. As we saw in chapter 1, with the spread of personal computers and editing pro-grams such as Adobe Premiere, new players entered the scene, enabling pri-vate producers to sever their dependency on formally trained editors and expensive studios. Small digital editing studios arose in popular neighbor-hoods and were run by self-trained IT virtuosos, such as the Big Star studio operated by Afra—alias Bin Yahya (Big Daddy)—in Nima. From 2005 on

FIGURE 24. Creating a special effect, Movie Africa Productions (January 2008). Photograph by author.

producers purchased their own computers and editing programs and were able to employ and train their own editors (fig. 24).[18] The availability of digital editing technology led to a marked increase in special effects. Mainly employed to represent the occult, special effects were lamented by representatives of the state film establishment, who found that the new technological possibilities encouraged producers even more to make movies about the occult and juju. Many producers, in turn, just shrugged their shoulders over what they perceived as an arrogant and old-fashioned attitude. They saw themselves as occupying the cutting edge of technological developments in digital filmmaking and saw the state film establishment as lagging behind in both technology and understanding.

Akwetey-Kanyi's films, in particular, were known for their spectacular special effects, which he regarded as his "house style." He regarded his ability to come up with special effects as a special gift: "When I close my eyes I see the pictures in me. I have the third eye, my instinct tells me how to do it" (interview, 26 August 2009). His special effects, like those realized by his peers, pertained to extraordinary acts deemed to be impossible without spiritual interference: a person who suddenly disappears or shows up, someone

FIGURE 25. Captured spirit double, screenshot from *Mariska*.

morphing into another person or into an animal, a woman flying in the air, a ghost passing through a wall, a person shrinking to fit into a bottle or calabash, and so on. Many of his movies were populated by spirit women with magical names who flew through the air on a carpet, as in *Namisha* (1999), doing evil with their penetrating gaze, as in *Babina 1* and *2* (2000, 2003), or keeping their lovers' spirit double under a calabash (fig. 25), as in *Mariska* (2001). There were also earth spirits shown emerging from nowhere and quickly morphing into a human being or a dead woman whose spirit returns to her body so that she can live on, as in *Tasheena* (Aak-Kan Films, 2008). Although Akwetey-Kanyi's films rarely feature powerful Christian pastors or staunch prayerful believers in prominent roles, the logic of revelation underpins all his movies: special effects are used to depict how the spiritual is linked to and present in the physical world, albeit invisible to the naked eye.

I witnessed numerous editing sessions, especially with Akwetey-Kanyi, and later with the editors working for him in his own studio. Editing was meticulous work that required great concentration. Watching the editor at

work, I never completely understood the intricacies of editing and making special effects on the basis of specific computer software. Special effects had to be prepared well on set. For all sorts of special effects—sudden appearance or vanishing, morphing, flying—it was necessary to have both an "empty frame" and a frame that contained the person, animal, or thing that was to appear in or disappear from the empty frame. For example, to depict a spirit in a tree, it was necessary to have a shot of the tree (used as an "empty frame") and a shot of a "spirit," taken in front of a blue cloth to make it easy to "cut" the picture of the "spirit" from the blue background, then downsize it and paste it into the shot with the tree. With the help of a special program called Feather Edge, the inserted picture would be made to fade at its margins, creating the impression that the "spirit" was *in* the tree. Working with pictures in this way, the editors and filmmakers consciously engaged in creating optical illusions with the technological possibilities at hand. I was impressed by the virtuosity with which editors—some, of course, more skillful and experienced than others—did their work to satisfy filmmakers' expectations. Depending on substantial mastery of technology and careful work with motion pictures and soundtracks, editing was the most tedious step in filmmaking (and to me, I confess, the most boring one to witness).

What intrigued me all the more were editors' thoughts and comments about the possibilities offered by digital technology for easy manipulation of pictures. As Alex Bannermann put it when we met at Kishore Nankani's editing studio (1 Nov. 2002), with digital editing technology "real pictures become more abstract," that is, subject to ever easier optical manipulation. Editors were very conscious that, in using all kinds of optical tricks, they were creating illusions. In this sense editing and the making of special effects was a down-to-earth, technical affair based on skills. A good special effect would bear no traces of the procedure used to make it; this would heighten its aesthetic appeal for the beholder. At the same time, however, editors were very much aware of the larger project of trans-figuration in which filmmaking and editing were involved. Understanding cinema as a "matter of making images seen" (Ferdinand Leger, quoted in Gunning 1986, 63), editors (and filmmakers in general) knew that appealing special effects would have to resonate with popular imaginaries and trigger the personal imagination. In this sense producing special effects was a matter of externalizing mental images via the medium of film. This becomes very clear in the use of morphing techniques. As Louise Krasniewicz points out, for image producers morphing is "a matter of technology and technique," whereas for viewers it "breaks expectations

and rules, violates 'natural law,' and, like shamanistic metamorphosis, can open the door on a different layer of life" (Krasniewicz 2000, 46). Editors of Ghanaian movies employed techniques of morphing to represent the capacity of certain persons, for instance witches, to leave their human body and take the shape of an animal or ugly monster, or of mermaids to take various female shapes, from decent to seductive. At the core of concerns about the deceitfulness of appearances is the idea that personal human shape is not stable. In editing Ghanaian movies, new digital morphing programs were found to be highly suitable to satisfactorily represent long-standing imaginaries about occult forces' shape-shifting capacity, thereby opening up a "door on a different layer of life": the spiritual. While such imaginaries prefigured the technological potential for figuration that came with digital editing, the new morphing techniques were also employed to express heightened concerns about the potentially deceitful appearances of people and things—another instance of the technoreligious crossover that characterizes the entanglement of video and religion (see Sobchack 2000, xiv).

Notwithstanding the importance of special effects, the Ghanaian film industry did not produce a mere "cinema of attraction," as Gunning (1986) analyzed for early silent film. Taking extreme care to ensure continuity of time and space, editors found it important to stick to a narrative structure or "story line" into which the effects would fit and that would be the backdrop against which audiences would understand the effects. Offering both effects *and* a narrative that was, importantly, *not* contained in a "self-enclosed diegetic universe" (Gunning 1986, 68) but deeply embedded in and leaking out into the world of everyday lived experience and its popular imaginaries, Ghanaian (and Nigerian) video movies engaged in a "dialectic of spectacle and narrative" (Gunning 1986, 68). In putting together movies this way, editors sought to create suitable conditions for the conversion of the make-believe that went into the technological production of illusions into beholders' belief in what they saw on the screen. To invoke Green-Simms, one could say that editors sought to convey to the spectators a "*spectraphilic* pleasure: a pleasure derived from feeling the occult's presence, from experiencing the wonder and anxiety of its visible invisibility" (Green-Simms, 2012, 47).

To summarize the second step in the work of trans-figuration: in contrast to the film set, where imitation threatened to slip into animation, the editing room was a site of sober work with recorded pictures. Making skillful use of the technological affordances that came with analog and digital editing, editors were quite cool about, and not at all enchanted by, the pictures they used

to create a movie. They cut, manipulated, and reassembled the recorded pictures in the most effective manner so as to yield a movie that audiences experienced as compelling and that included a number of scenes that generated a sense of wonder and amazement. They thereby did their best to vest special effects with appealing and persuasive aesthetic effects for the beholders. The editing room, in short, was a site for the animation of pictures in a technical sense, making full use of available technological possibilities to trans-figure the wider popular imaginaries from which movies originated and into which they were reinserted.

ADVERTISING SPECIAL EFFECTS AND HOW THEY ARE SEEN

Special effects—or in short "effects"—were regarded as one of the major selling points for Ghanaian movies. As I learned from J. B., who exhibited Akwetey-Kanyi's movies in small video parlors in the suburbs of Accra, the countryside, and neighboring Togo for a long time,[19] audiences with minimal formal education, in particular, liked movies with lots of "effects." Such movies were usually advertised as "miracle" or "ghost" films. The use of these terms to refer to special effects signals the blurring of technologies that produce tricks and illusions, on the one hand, with acts of conjuring ghosts and performing miracles, on the other. In the popular imaginaries reflected and shaped by these films, effects, ghosts, and miracles all belonged to the same domain of wonder and amazement.

This brings to mind Hent de Vries's intriguing proposition "that the special effect should be understood against the backdrop of the religious tradition, in particular, the miracle, and that the miracle has always been characterized by a certain 'mechanicity' or technicity" (de Vries 2001, 51). For de Vries religion and the new media do not relate to each other instrumentally, "as if media formed the mere vehicle of religion or as if the medium could ever succeed in creating religion in its own image" (42), but are intrinsically related. Advocating a material, practice-centered approach to religion as mediation, I share his idea of thinking about religion in terms of effects and vice versa. Nonetheless, the proposed analogy between miracles and effects cannot be applied to the production and reception of revelation movies in a straightforward manner. Audiences would contest it and insist that a miracle performed by a pastor in a church service was of another order than a

recording thereof or an amazing scene in a feature movie. As audiovisual tricks and illusions, special effects pertained to acts deemed to be impossible *without* spiritual interference. Conversely, *with* spiritual interference virtually anything was deemed to be possible, the problem being that a great deal of all this remained invisible in the "physical." Hence the need for a superior gaze. Spectators did not regard special effects as immediate "live" recordings but as based on simulation for the sake of a movie that was considered to be truthful in showing how things occurred in the spiritual. In this sense effects were likened to miracles (as both could render ghosts and other phantoms visible) but not taken as a full synonym. I will pursue this issue further below.

Trailers advertising a new film on television proudly displayed a set of special effects; likewise, film posters, the older hand-painted advertisements on canvas, and prints on paper or vinyl featured extraordinary phenomena, suggesting the use of special effects. Depicting the most sensational aspects of a film, film posters offer clues about what particularly appeals to audiences in a movie. Take for instance the poster for *Babina Part 2* (fig. 26), the aforementioned movie by Akwetey-Kanyi about the spirit woman Babina, who snatches the husband of a barren woman, gives birth to an evil spirit child, and terrorizes her environment with her spiritual gaze, which brings sickness, mishap, and death. Against a yellow background with a painted red frame the poster (signed right in the center by "Mr Brow Art") depicts a number of scenes involving special effects: a priestess with a second pair of eyes; sexy Babina (actress Kalsoum Sinare) with ultralong catlike fingernails that betray her as a witch; and her evil, powerful gaze, represented by red streams coming from her eyes (the usual visual language used to depict spiritual power); and, at the lower left corner of the poster, a pastor holding a Bible in his right hand and a cross in his left, from which streams of power emanate, chasing Babina away. Making use of a visual language developed to remediate the cinematic representation of spiritual interventions, the poster advertised *Babina* as just the right mix of a rewarding story—a spiritual fight between good and evil—and lots of amazing effects. Assembling a pastiche of stills taken from the advertised movie, the printed posters, which have gradually replaced the hand-painted canvas, used a similar visual language, showing spiritual forces in action: over and over again colored streams emanating from eyes and powerful objects.

How can we understand the process that leads audiences to invest special effects, which pretend to make occult forces and their operations visible and audible, with truth, rather than seeing—and possibly dismissing—them as

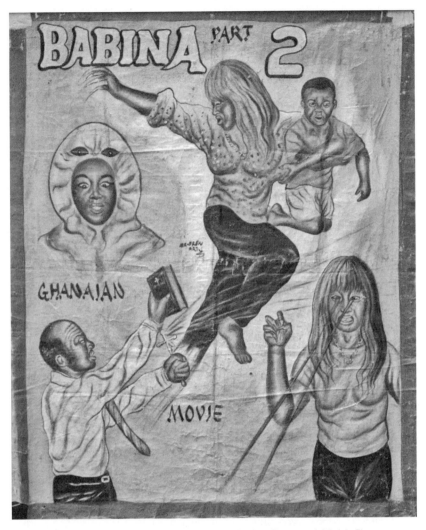

FIGURE 26. Poster for *Babina Part 2*. Mandy Elsas collection. Photograph Mandy Elsas.

the illusionary fictions that they still were in the editing room? Here it is instructive to turn to Gertrud Koch's (2006) argument that the fabrication of illusions is not a backward, simplistic strategy to entertain the lower echelons of mass spectatorship but a carefully crafted aesthetic strategy that relates to specific visual regimes. Viewing a movie necessarily involves an entanglement of seeing *and* believing in relation to the screen pictures (Koch 2006, 53). Strictly speaking, special effects are not illusory in the sense of being unreal: spectators see real pictures on the screen and are invited, so to

speak, to believe what they see and hear. Watching film pictures, in general, and special effects, in particular, thus by definition entails a basic degree of illusion, be it for audiences of Ghanaian films or elsewhere. Koch explains: "I regard this entanglement of the technically produced and the psychically/ physically perceived as the 'aisthetic' quality of film, which belongs to it as far as its medial properties are concerned even prior to the differentiation of 'film' into distinct objects (for instance genres). Thus, the 'aisthetic' dimension of film is the one that constitutes illusion" (Koch 2006, 57, my translation).[20] From the neophenomenological perspective that informs Koch's (as well as my) analysis, film cannot be reduced to the audiovisual product as such. It is a medium that includes the spectators and appeals to their potential for animation; film "needs" spectators, so to speak, to make its pictures real through perception and sensation. Once again we see that audiences' engagement with film constitutes "the expression of experience by experience" (Sobchack 1992, 3).

Of course, the effective constitution of an illusion via the "aisthetic" or sensory encounter between spectators and screen pictures need not imply that the spectators claim that the real pictures they see on the screen are also real in a wider sense. To explore the extension of reality claims *beyond* the screen pictures to a world "out there," the distinction Frank Kessler articulates between the "profilmic" and the "afilmic" is helpful. Kessler draws on Etienne Souriau (Souriau and Agel 1953), who "defines the profilmic as everything that has been in front of the camera and was recorded by it, whereas the afilmic refers to what exists in our world 'independent of the art of film or without any specific and original destiny in relation with this art'" (Kessler 2009, 192). This distinction can be read as follows: while the profilmic is either photochemically transcribed or digitally coded, the afilmic remains irreducible to such a recording. The indexical "claim on the real," in other words, can never go beyond the profilmic (Kessler 2009, 192). Referring to something put together for the sake of being recorded and shaped by analog or digital editing, film pictures are real in the sense of having a direct, physical, and thus indexical relation to the profilmic. In contrast, the afilmic circumscribes "a construction against, and in reference to, how the represented is understood, evaluated, judged, accepted or rejected, etc. by the viewer" (192). Thus, motion pictures are real in their own right, because they index something that was recorded, edited, and is now seen by the spectators. The definition of the relation between the profilmic pictures seen and the afilmic world beyond the camera—and thus the issue of whether the former can be

claimed to realistically pictorialize the latter and broader ideas about representation—is subject to culturally and historically situated discourses about film (and other audiovisual media). Stipulating the value and reality of pictures in relation to the world out there, such discourses (or semiotic ideologies) underpin practices of looking and interpretation. Ultimately the degree of reality—profilmic or afilmic—attributed to motion pictures depends on beholders and the regimes of visibility in which they have been socialized. Ethnographic research, including mine, is needed to unpack the complexity and diversity of human-picture relations and the degree of reality attributed to motion pictures in specific settings.

In the early years of Ghanaian popular cinema some of the filmmakers I interviewed claimed with much amusement that a number of spectators still thought that what they saw on the screen was a straightforward shot of a real phenomenon in the spiritual realm, thus assuming a full convergence of the profilmic and the afilmic. This resonates with the effect early cinema supposedly had on audiences that were not yet familiar with the medium and really thought that, to invoke the most famous example, a locomotive was bearing down on them (Gunning 1989). I take these ideas as fantasies that tell less about actual audiences than about the filmmakers' self-understanding as being able to fool audiences to believe in the reality of an imagined world projected on the screen (fig. 27). As I noted in chapter 1, audiences in Africa, as elsewhere, became acquainted with the medium of film quickly and would not mistake a picture of a person, animal, or object for that person, animal, or object. Gradually, spectators of video movies became aware of the technological processes used to make special effects (see also Larkin 2008, 9). By the late 1990s, filmmakers even started to end their films with funny "behind the scenes" clips that showed the actors staging their roles in front of the camera. Obviously, such clips were made with a second camera that recorded the camera shooting the movie, thereby creating a degree of (disenchanting?) distance to the profilmic for the spectators.[21] However, this exposure did not necessarily prompt spectators to unmask video films as mere illusions that had nothing to do with the afilmic world out there and to regard cinematic representations of the occult as fake and thus as false. For instance, Akwetey-Kanyi recounted how an old acquaintance who had seen some of his films asserted, "You have occult powers!" even after he had been told that the effects were computer-designed. How otherwise could Akwetey-Kanyi show pictures of a person transforming into someone else, imprison miniature doubles of a bewitched person in a pot in a wardrobe, or have witches fly

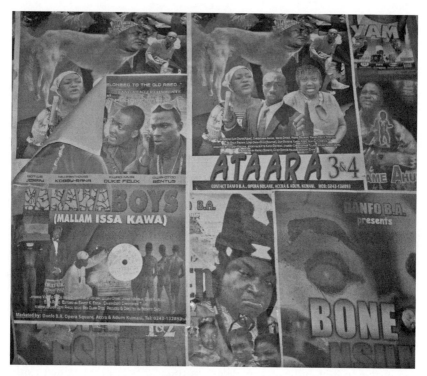

FIGURE 27. Posters visualizing special effects (August 2009). Photograph by author.

through the air on a carpet? Audiences acknowledged that, of course, movies were fabricated by working with pictures recorded on set and reassembled through editing and that special effects were designed by computer programs. They knew very well that, after all, they were watching a movie. But this knowledge did not prevent them from enjoying the effects or from regarding movies as truthful portrayals of popular ideas about the world as consisting of a physical (and hence visible and audible) dimension and a spiritual (and hence normally invisible and inaudible) dimension. As one female teacher (and frequent filmgoer) put it with regard to Mami Water spirits (much talked about at the time of our conversation [11 Nov. 1996]): "These things are real, but sometimes, we don't see them with our naked eye. You see? We don't see them with our naked eye, but they are real." The occult, then, is held to be real and yet not visible to the naked eye because it is manifest on the level of the spiritual, requiring revelation to be seen.

Depictions of humans morphing into animals or spirits and vice versa, souls leaving or entering into sleeping or dead bodies, ghosts passing through

walls, and red power streams emanating from eyes were taken as real because they resonate with popular understandings that are also transmitted through other channels, such as rumors, papers, posters, sermons, radio talk, and the like. Far from standing on its own, a film is generated through a series of trans-figurations across various expressive forms—mental images, oral narratives, written scripts—before reaching the profilmic level of the material film set, where pictures are recorded, which in turn are rearranged and manipulated by editing. Building on and remediating each other, each of these expressive forms, whose trajectory I have followed in this chapter, is anchored in the fabric of everyday lived experience, which is harnessed to invest these forms with truth. The relation between film and world suggested here is to be understood as a spiral circulation (rather than as a closed circle), with motion pictures being one station in a larger trajectory of continuous trans-figuration that converts mental images and ideas into various external figures (spoken, textual, pictorial), synergizes the personal imagination with a shared popular imaginary, and in so doing generates its own reality effects.

CONCLUSION

Following the genesis of powerful motion pictures, which starts with the film set, this chapter has sought to add a new dimension to our understanding of Ghanaian movies. The trajectory from the set to the editing room and, via advertisement, to the spectators spotlights a playful engagement with the (un)reality of spirits, the creation of reality effects, and practices of animation. At all times the actors, cameramen, editors, others involved in filmmaking, and finally the spectators were fully aware that they were dealing with a movie, and hence an artificial product. Working with pictures on set, in the editing room, and in advertising entailed different aspects of animation, which I understand in the broad sense as a practice of "bringing to life" or "enlivening" (Lat. *animare*).

Let me recapitulate. First, working with pictures on set involved the creation of an artificial world that, by an intriguing slippage, could become the "real thing." Here animation was a practice of enlivening a space, prop, or character through simulation. The better the simulation, the better the shot. Practically, this meant that realistic shrines had to be set up and that actors had to lend their bodies to figure the monsters that they and their spectators feared and that were to appear on the screen as required by the format of

revelation. Although simulation was necessary to produce powerful motion pictures, it entailed the risk of bringing to life the artificial world staged in front of the camera to such an extent that those who set it up could no longer control it. Simulation enacted representations that threatened to exceed being figures in an audiovisual "code" that merely simulated a world out there to become, quoting Achille Mbembe again, "in turn, a manner of speaking of the world and inhabiting it." The simulacrum became real. Lending one's body to an invisible force comes close to spirit possession, which is a central part of an indigenous religiosity that most actors deeply dismissed. From a Christian perspective, the fusion of a person's body with an alien, "demonic" spirit is an outrageously fearful act. The fear of opening oneself up to being possessed by a spirit that is simply simulated for the sake of a movie prompted actors and others to take recourse to proven spiritual modes of closure and damage control, especially prayer. Concomitantly, making a shrine also required all sorts of protective measurements that would prevent the double from becoming "the thing itself." Paradoxically, movies *about* the occult got *involved with* the occult, which thus resisted mere representation within the frame of a movie, threatening to become animated and to burst out of that frame. On set, animation was both invoked and curtailed.

Second, the audiovisual shots generated on the set were the raw materials for the work in the editing room. If animation of the occult was a specter on set, editors were determined to represent the occult as realistically and terrifyingly as possible. Techniques of animation were employed to produce special effects that would "expose" the imagined spiritual operation of occult forces, as well as the divine war against them. Here animation was a matter of computer-based simulation of the movement of a series of pictures to create illusions of supernatural actions. Special effects were intended to suggest the existence of a spiritual reality that was made visible within the confines of a movie. Movies were framed as sensational forms that would organize the perception of the movie and call on spectators to animate the pictures on the screen with their "looking acts," in line with the revelation format.

Third, movies about the occult were advertised by announcing a conundrum of effects-ghosts-miracles, and audiences were invited, and often prepared, to recognize these pictures as revelations of the spiritual powers that held such a central place in popular and personal imaginaries. Knowledge of technological devices and techniques for the production of special effects, on the one hand, and belief in the existence of demonic forces, on the other, easily went hand in hand or even appeared to reinforce each other (see Stolow

2012). Spectators were prepared to regard special effects as realistic and convincing because they understood the profilmic to depict, and even to pin down, the occult as it was thought to exist in the afilmic world out there, in the limbo between the spiritual and the physical. In contrast to the actors and set designers, who engaged in the raw work of simulation and had to do their best to keep at bay the results of skillful animation, the audiences confronted the pictures and effects produced within the format of film as revelation, which offered a double-edged moral framework entailing both strong emotional impressions and a moral lesson.

In sum, studying the actual work with pictures and practices of animation in moviemaking offered a deeper grasp of the operations with which occult beings were made real—as pictures, and beyond. This making real developed out of an intricate entanglement of simulation and enactment that has a striking affinity with indigenous religious practice. In this sense a focus on moviemaking also teaches important lessons about the practices by which spirits are enlivened by human acts and hence about the world-making potential of imaginaries and the imagination.

Mediating Traditional Culture

The prominent depiction of occult figures and juju, involving primitive-looking evil priests and their mischievous clients, was a recurrent bone of contention between video filmmakers and their critics, who measured the video scene against the ideal of the value-driven filmmaker who wanted to educate audiences about the nation's cultural "heritage." This ideal is spelled out poignantly in the following quotation from a speech delivered by the chairperson of the National Commission on Culture (NCC), Professor George Panyin Hagan,[1] held on the occasion of the first anniversary of the Ghana Academy of Film and Television Arts (GAFTA)[2] on 31 October 2002 on the NAFTI premises:

> So the filmmaker who is looking at his own values, the identity of his people, seeking to preserve it, should look out to the dangers coming from outside. To the images coming from outside, to the values coming from outside, to see what would be good for his own society or what would be bad. A filmmaker has to make very serious decisions, all the time. A filmmaker has also the responsibility to look back into history and unfold it. Especially in Africa, film is seen as an instrument for national development. Therefore, it is important to see what we can capture from our history and preserve it for the future.... This confronts the filmmaker with another responsibility, to choose between good and evil.... Indeed, Ghana is devoted to preserving their cultural values, their *good* cultural values, and presenting a heritage, a *good* heritage.... I hope, NAFTI has captured that heritage. This is to say that it is very important that at our vocational schools our heritage and cultural values are taught.... Art and creativity often demand freedom.... This freedom must be exercised with responsibilities.

Professor Hagan's statement was a prime example of state officials' often reiterated, moral appeal to the responsibility of Ghanaian filmmakers for the

preservation of Ghana's "cultural values" and heritage, as well as the protection of the nation against bad, external influences. The speech foregrounded the responsible filmmaker who produced appropriate representations of a "good" cultural heritage in the service of "development." Obviously this sketch was in line with the mission of the GFIC, according to which film was part of a modernizing project to uplift and represent the nation. The speech reiterated the discourse of film as education that survived long after the state film industry had been dismantled in the course of neoliberal privatization. While Hagan expressed the hope that NAFTI would take seriously its responsibility to "capture" heritage and by implication to provide a positive rendering of Ghana's diverse traditional cultures, he did not say much (either here, or in the remainder of his speech) about the private video filmmakers in the audience who clearly were the intended addressees of his appeal. Normally, on official occasions representatives of the state film establishment criticized them for disregarding cultural values and misrepresenting traditional culture, always making the wrong choice to depict "bad" culture. Interesting about Hagan's speech is that, in a truly pedagogical move, it refrains from reiterating the same criticism, outlining instead the ideal from which the recurrent criticisms stemmed.

Of course, culture and the related notions of "tradition" and "heritage" invoked to signify a positive valuation of certain elements of the past are not given but are subject to a historically situated political-aesthetic process of framing (Bendix 2012; Brosius and Polit 2011; de Jong and Rowlands 2007; de Witte and Meyer 2012; Kirshenblatt-Gimblett 1998). Hagan's speech and the larger project of Sankofaism that promotes a selective appraisal of cultural resources from the past acknowledge this. Any claim to retrieve the past involves a selective appropriation, objectification, and mediation of historical resources defined as valuable and in danger of extinction if no effort is made to preserve them. In Ghana, as elsewhere, the act of recovery depends on authorized practices of mediation through which the "past" becomes present as an authenticated part of national culture. Dominated by state institutions such as the Institute for African Studies, NAFTI (and, as long as it lasted, the GFIC), the NCC, and the Ministry for Tourism, the recovery of the past and the representation of culture constitute an eminently political project with its own partly implicit conventions, styles, preferences, and taboos. Violating these conventions and tending to showcase precisely those aspects of traditional culture that are considered unworthy of preservation, video movies were disturbing to those involved in the state film establishment and those

in favor of the Sankofaist project in general. This was conveyed to me over and over again, together with partly implicit misgivings about my choice of this research topic and my rather sympathetic stance (in the sense that I did not join in the chorus of rather stereotypical, somewhat paternalistic criticism).

So far, in this book I have sought to demonstrate how Ghanaian video movies were embedded in the lifeworld of those involved in movie production and their urban audiences in southern Ghana. The past three chapters, in particular, explored the intricacies and ambiguities involved in the trans-figuration of the occult, laying out the format of revelation that directed the spectators' gaze to the outrageous (chapter 4), pondering the paradoxes implied in depicting the occult (chapter 5), and showing that, on the film set, the enactment of occult forces through acting was experienced as potentially dangerous because it threatened to bring them to life (chapter 6). In this final chapter it is time to situate these movies and their makers in the wider arena of agents and institutions engaged in (debates about) the representation of traditional culture. Even though video filmmakers followed their own course, by entering the void left by the dysfunctional and eventually defunct state film industry, video movies did not stand apart from debates about the cinematic representation of culture. The guiding idea of this chapter is that these movies, precisely because they were so vexing to their critics, form a seminal starting point for drawing a fuller picture of the wider discursive and political-aesthetic arena in which the value, use, and representation of cul-ture, tradition, and heritage are negotiated. The first part of this chapter sketches the genesis of this arena and the complexity involved in the use of terms such as *tradition* and *culture*. This is followed by an exploration of how video filmmakers critically engage with the implications of the Sankofaist perspective and its constant call to take recourse to tradition so as to produce heritage. The third part is devoted to a number of (early) video movies' unfa-vorable cinematic representations of chiefs, who were profiled as key icons of traditional culture and heritage in state-driven cultural policies. Finally, I will explore the "epic" genre and other attempts by video filmmakers to depict tradition and heritage in a more positive light. Although the epic remained a somewhat marginal phenomenon, I regard it as indicative of a fresh attitude toward culture, tradition, and heritage that foregrounds aes-thetic qualities and design. The overall concern of this chapter is to map out the discursive frameworks underpinning the understandings and representa-tions of culture that were mobilized and negotiated in (debates about)

Ghanaian (and Nigerian) video films, as well as in "African cinema" in general.

"BUILDING UPON THE OLD"—CULTURE, TRADITION, HERITAGE

The NCC was instituted in 1990, toward the end of J.J. Rawlings's military regime. Rawlings sought to continue Kwame Nkrumah's African Personality project under the name of *Sankofaism*. The NCC developed the "Cultural Policy of Ghana," in which Sankofaism was laid out, during George Hagan's chairmanship throughout the 1990s; it gained approval from Parliament in 2000. I read this initiative as an attempt by the state to retain its hegemonic position in the representation of culture at a historical moment when this position was being challenged. The policy was formulated in the midst of the transitions kicked off by the liberalization of the economy, privatization of state services, and deregulation and commercialization of the mass media— in short, the very conditions that facilitated the expression of previously silenced voices in the public domain, including the rise of the popular video film industry, that were severely critical of Sankofaism. At the same time, with the rise of diaspora tourism—the "homecoming" of African Americans to commemorate the atrocities of the slave trade and seek redemption on the sites of the former slave castles (explicitly profiled as world heritage sites since the 1990s) in Cape Coast and Elmina[3]—*Sankofa* became the key symbol for a shared black heritage (Schramm 2010). Organizing events such as the biannual theater festival Panafest (organized in 1992) and Emancipation Day, celebrated as a Great Homecoming and involving the reburial of the remains of two "slave ancestors" in 1998, the Ministry of Tourism championed the celebration of culture and heritage. Ironically, while Ghanaians challenged the importance of Sankofaism, members of the black diaspora cherished it (Schramm 2010, 198–200; see also Schramm 2004b).

The "Cultural Policy" is an excellent source that showcases what motivates the current state politics of culture. *Culture* is defined as "the totality of the way of life evolved by our people through experience and reflection in our attempt to fashion a harmonious co-existence with our environment. This culture is dynamic and gives order and meaning to the social, political, economic, aesthetic and religious practices of our people. Our culture also gives us our distinct identity as a people" (National Commission on Culture 2004,

9). This broad definition, according to which anything could count as culture, is made more specific by bringing in "our concept of Sankofa, which establishes linkages with the positive aspects of our past and present. The concept affirms the co-existence of the past and the future in the present. It therefore embodies the attitude of our people toward the interaction between traditional values and the demands of modern technology within the contemporary international cultural milieu" (9). According to this understanding, the past is a repository of positive traditional values that need to be recaptured, to "build on the old," as Hagan put it in his introduction to the policy—hence the emphasis placed on tradition and heritage. In many respects similar to tradition, heritage accentuates a positive valuation of traditional culture that is found to be in need of "preservation"; it is regarded as endangered yet also as a prime commercial resource (see Comaroff and Comaroff 2009). Building on Nkrumah's African Personality project, the protagonists of the policy stipulate the use of "culture as a necessary tool for national integration and development" (National Commission on Culture 2004, 8). Bad customs, as also pointed out by Hagan in his speech, are to be abolished, while "appropriate customary values" are to be deployed. Along with this, the policy is also geared to the promotion of the country's ethnic festivals (especially those tied to chieftaincy), the arts and dance, traditional medicine, and tourism, and it seeks to involve various cultural entrepreneurs, including those working in the film business, in its actual implementation.

It is important to note that the "Cultural Policy" itself builds on a long-standing politics of culture rooted not only in Nkrumah's ideas about African personality but also in colonial rule. If in the early years of British colonialism in the Gold Coast, tradition was predominantly framed as a repository of local beliefs and customs that were attributed a different, "backward" temporality, after the 1920s "colonial officials came to see African traditions as the basis on which the progress of the nation could be built, so long as Western ideas, institutions, and skills could be grafted onto them" (Coe 2005, 58). What this constructive use of tradition retained was its definition as a reified and codified matter of the past that was held to be at the core of what it meant to be African (see Ranger 1983, 1993). The point here is that colonial rule produced a notion of tradition as a set of local ideas and practices considered valuable yet at the same time distinct from what was regarded as "Western" and "modern." The traditional-modern dualism conveyed a particular politics of time through which tradition, even though existing side by side with modernity, was not taken to be coeval with it

(Fabian 1983). With the past taken as a positive resource and the cradle of African identity, tradition came to be regarded as the typical, distinctive feature of Africa and Africans that was to be retrieved and "performed," distinguishing them from Westerners. The repercussions of this temporalizing juxtaposition of tradition and African with modern and Western still haunt contemporary articulations of African identity and "modes of self-writing" by directing the main thrust of inquiry toward the past and deploying a language of loss (Mbembe 2002; see also Appiah 1992, 61–71).

Protestant missionary societies invoked a logic similar to that of the colonial administration. Echoing a romanticist Herderian stance, nineteenth- and early twentieth-century missions regarded "native" culture and language as the preferred and presumably most fertile ground for the rise of Christian personalities and ethnic cultures, hence the emphasis placed on local-language literature, including translations of the Bible, proverbs, and folktales (Meyer 2002). However, as I noted in my historical research on the Bremen Mission among the Ewe, there were tensions with the colonial administration because of the latter's valuation of "indirect rule," which endorsed minimal interference in "native" customs, including traditional worship, as long as it underpinned law and order. From a Christian perspective "traditional religion" was viewed as "pagan" and "backward," and Africans were encouraged to reject local gods and spirits and convert. The dismissal of old gods and the modes of calling on them (involving dancing and drumming as practices of worship) implied what I would like to call "the production of heathendom," understood as "backward" and yet still alive and kicking. For this reason many African Christian converts came to regard traditional religion as the abode of the "powers of darkness." This was especially true of those who were part of the mission churches founded by the Pietist Bremen Mission and its sister organization, the Basel Mission, among the Ewe, Ga, Krobo, and Asante.[4]

To make a long and complex story short, colonial and missionary understandings of and practices toward culture, tradition, and traditional religion gave rise to a particular discourse in which these terms were made to signify basically the "past," standing in tension with a teleological, future-oriented Western-influenced notion of "progress," "civilization," and, since the 1950s, "development." This discourse also has long informed Western stereotypical representations of the continent up to the present. For instance, when entering the global arena of art, African artists are still expected to use certain traditional markers that profile their artworks as authentically African

(Woets 2011). The same expectation governs movies made in the framework of African cinema, even when the turn to the past and tradition occurs from a critical emancipatory perspective (see Ukadike 1994, 288–303).

At the same time, anti- and postcolonial critiques took, and still tend to take, this discourse as a starting point. The scenario of Sankofaism, with its motto "go back and fetch it," was predicated on the view that Africans had been brainwashed to such an extent that they lost pride in and became alienated from their traditional culture and hence from their own identity. Sankofaism's symbol of the bird looking back encourages a positive, albeit selective, retrieval of the past, framed as culture, tradition, or heritage for the sake of the future. The fact that Sankofa is part of the set of *Adinkra* symbols that stand for proverbs and important events in Akan history testifies to the policy's strong bias toward Akan traditional culture and chieftaincy. Tradition is perceived as a noble resource for cultural heritage, cleansed by the elements the state deems "bad." In this view of tradition there is no room for forces such as witchcraft and juju, and believing in and relying on such practices is dismissed as "superstition."

Christian churches did not remain unaffected by the state discourse about and policies toward tradition and heritage. This became a pressing issue in the aftermath of independence. Struggling with the by now classical question "How is it possible to be Christian and African at the same time?" (see Meyer 1992), historical Protestant mission churches and the Catholic Church started to rethink the foundational missionary representation of African traditional religion as backward and even potentially demonic. Within these churches there have been deliberate attempts, applauded by liberal Western partner churches in the World Council of Churches and supportive of Vatican II (held between 1962 and 1965 to modernize the Catholic Church and rethink its relation to other religions), to undertake the Africanization of Christianity to combine "the best of both worlds" (Meyer 1999b, 134–40). Certain Christian circles came to accept acts such as the pouring of libation to the ancestors, long dismissed as "pagan" and hence in conflict with state cultural politics (Sarpong 1996). Conversely, however, in the mid-1980s Pentecostal-charismatic groups began to counter openly the state politics of tradition and identity, as well as the affinity between historical mission churches and these politics. Linking up with long-standing grassroots Christian views, in which the devil and demons played a central role, they adamantly represented indigenous religious traditions as dangerous rather than as a noble resource for cultural heritage and identity. Many Pentecostals

contested, in particular, the cultural lessons taught in school because they did not like the idea of their children being exposed, via drumming and dancing, to traditional spiritual forces they considered demonic (Coe 2005, 75–84, 112–34). In the aftermath of democratization, Pentecostals filed numerous complaints about the public performance of tradition, including the pouring of libations at public functions (van den Bersselaar 2007, 237–41) and the obligation to refrain from making noise—including the use of microphones in church—prior to the annual Ga festival of *Homowo* (van Dijk 2001). This indicates that Sankofaism ceased to be the hegemonic stance toward tradition and heritage articulated in the public sphere.[5]

Those in favor of tradition and cultural heritage framed along the lines of Sankofaism found themselves in a defensive position vis-à-vis the Pentecostal assaults. Both parties addressed and "talked back" to each other in terms that had long been set.[6] As Pentecostalism became a dominant public force in southern Ghana, the vision of tradition as a ground for cultural heritage and national identity was ever more challenged, though it was commercialized and put on display for Western and African diaspora tourists at the very same time. Ironically, those who most feared the spirits that they believed were enshrined in tradition tended to resist a view of tradition as a respectable national cultural heritage, while many of those endorsing this heritage did not believe in the actual existence and efficacy of these spirits. For the latter, as Hagan's speech also intimates, tradition and heritage were repositories of values symbolized through a cultural code rather than domains powered by "live" spiritual forces. In short, the framing of culture, tradition, and heritage as a code representing values was prone to produce a more or less *harmless* folklore. Many Christians were not prepared to adopt such a symbolic stance toward these representations and took them as potentially *harmful,* prone to awaken and render present the real thing.

Ironically, the Sankofaist scenario, with its appraisal of traditional culture, appears to be more in line with colonial policies of using tradition and culture as repositories of African identity than many of its proponents might be prepared to recognize. Critiques of colonialism as alienating Africans from their culture fall short of recognizing the effective political use of culture and tradition in, for instance, the framework of indirect rule used to keep Africans in their place, at least one step behind Western "civilization," that was called on to legitimate colonial rule. More important, the time frame that underpins the scenario of Sankofaism reproduces an objectified and static understanding of tradition and heritage as matters of the past. As

Katharina Schramm points out, "in the ideological framework of nationalist cultural policy, the inherent complexity of 'tradition' was ignored so as to be able to incorporate a reified version of it into the new (and in itself complex) framework of Ghanaian national culture" (2004a, 159). This static view of tradition is still echoed in the phrasing used by the protagonists of the "Cultural Policy" that Sankofaism achieves "the co-existence of the past and the future in the present." Traditional culture is denied its own modernity but is claimed to depend on a state-governed retrieval. In other words, even though the project of Sankofaism is intended to break with the inferiority complex instilled through the humiliating experience of colonial rule, it does not radically break with the politics of time that produced such limited, temporalizing views of traditional culture as "old" in the first place. This stance, as will be pointed out below, also informs state attitudes toward chiefs.

A sheer reversal of valuation that posits African culture, tradition, and heritage as "authentic" and Western modernity as alienating and un-African is problematic because it fails to fundamentally question the very categories that always already structure the discursive field in which these terms are imbued with meaning (Appiah 1992; Mbembe 2002). Paradoxically, taking an "African" position in this field implies talking back by taking recourse to the very same terms that have been imposed by colonial and missionary discourse. This constrains the modes of speaking about culture, tradition, heritage, and identity for contemporary Africans (Comaroff and Comaroff 1992, 235–63). Unavoidably, people not only speak *about* but also *with* culture and all the related terms that were already encoded in colonial times and that partook, and still partake, in the social construction of the world. This pertains to both the fans of Ghanaian video movies *and* their critics.

SANKOFA AND FILM

NAFTI was one of the institutions that remained attached to Sankofaism after the commercialization of the media and the sale of the GFIC in the wake of democratization. As pointed out by Anne Mette Jørgensen, who conducted research at NAFTI in 1998 and with whom I had many conversations about our respective research projects, the "Sankofa symbol and the cultural policies dominant among the elite at NAFTI constitute a strategic choice of elements selected to constitute a conception of a common Ghanaian cultural heritage" (Jørgensen 2001, 121). Determined to counter foreign

cultural domination and internal ethnic divisions within Ghana, NAFTI lecturers encouraged students to make films that would support both nation building and a more general pan-African identity (Jørgensen 2001, 130). Students were advised to make use of African symbols to produce "authentic" African films. An "authentic African film," as NAFTI-teacher Middleton-Mends asserted many times in our conversations, was a story situated in and about Africa that was written, produced, and filmed by Africans. In practice this definition was not sufficient, as the constant criticisms of Ghanaian video films show. Written, produced, and filmed by Africans, many of these movies were nonetheless regarded as un-African because they foregrounded juju and witchcraft and made extensive use of special effects to depict the operations of occult powers. NAFTI students were strongly admonished to refrain from doing this. In her compelling analysis Jørgensen points out that NAFTI students had mixed feelings about the Sankofaist orthodoxy of their teachers and sought to develop alternatives to their "narrow-minded dictated version of what 'Africa' was," instead figuring out their "own Africanness" (Jørgensen 2001, 135). I met a number of NAFTI graduates, including Ezekiel Dugbartey Nanor, who radically shifted gears and gained fame by making movies with spectacular witchcraft scenes, of course at the cost of being disparaged by the establishment.

On the whole video filmmakers have been little inclined to *represent* tradition in line with NAFTI's and the film establishment's dominant discourses about tradition and heritage or as found in a great deal of African cinema. Keeping close to audience expectations, they are primarily interested in audiovisualizing the petty stories that resonate with the lifeworlds and imaginations of ordinary people. Ernest Abbeyquaye, who had long been associated with the GFIC but kept some distance from its film-as-education stance, told me that he found it quite unfortunate that so much energy was being put into big debates about the representation of culture, framed as a national issue, while overlooking what really mattered: "People's way of life is their culture, what makes me laugh, makes them laugh, what makes me cry, makes them cry, what makes me offended, makes them offended" (interview, 11 June 1998). From this perspective people's actual way of life, not Culture (with a capital *C,* as defined by the authors of the "Cultural Policy" and implemented by the affiliated institutions), was the stuff out of which filmmakers were expected to—and in fact did—make their movies.

In a similar vein Seth Ashong-Katai, who had long been affiliated with the GFIC and Gama and knew Sankofaism inside out, pointed out to me that it

failed to capture the dynamics of culture: "When we say Sankofa, we mean that we should pick elements from the past for the future. But we get stuck in the past. Sankofa should rather reflect what is happening in the here and now. Sankofa is a cultural whirlpool; we cannot get out of it and are bound to the past, which is not good. Sankofa is about old-style sandals, stools, cataloging the story of the past. But culture is dynamic" (interview, 15 Jan. 2008).[7] Yet, such criticisms voiced by people fairly close to the film establishment notwithstanding, Sankofaism remained the constant backdrop of the criticism of how video filmmakers represented traditional culture. One such recurrent occasion was national film awards. Time after time state officials and representatives from NAFTI complained about video filmmakers' obsession with the "supernatural"—with juju and special effects. As Esi Sutherland-Addy, speaking on behalf of the NCC, put it on the occasion of the Ghana Film Award ceremony on 11 November 2002, videos are "too negative about our own cultural traditions. But we need them, any country respects its traditions." Minister of Information Jake Obetsebi-Lamptey affirmed this stance and criticized the movies for conveying "a negative image of Ghana." He drew a contrast between Ghanaian and American filmmakers, claiming that the latter would show the "nice places" and skip Harlem or the Bronx, thereby making movies that enticed foreigners to visit the United States. His advice to Ghanaian video filmmakers to do the same strikes me as ironic given that, as we saw in chapter 2, this is exactly what they attempted to do in representing Accra as a modern city. However, this display of urban beauty did not prevent them from looking behind the facade, depicting juju-related matters (just as many American films are about violence, corruption, and other ugly matters). The minister's statement makes it clear that moving pictures, along with being regarded as an instrument for educating and uplifting the nation, were expected to create a favorable image of Ghanaian culture to imagined spectators from outside. In the same vein, at the closing ceremony of the Eighth Pan-African Students' Film and Television Festival, in July 2007, the former mayor of Accra Nat Nunoo Amarteifio complained: "Movies that portray superstition, witchcraft and other beliefs make people in the western world who patronize them think that Africa is still in total blackout and does not know where it is heading towards." He also said that "the emotions, imaginations and some negative traditional practices that were portrayed in movies were so devastating that most Europeans thought they were part of African tradition." His concern that, by focusing on "superstition, witchcraft and other beliefs," video movies would misrepresent "African tradition" and

confirm the worst stereotypes and prejudices held by Westerners was widely shared by critics, including Kwaw Ansah and Audrey Gadzekpo.[8] They expected Ghanaian (video) filmmakers to create decent representations of African tradition and culture under the banner of Sankofaism.

Obviously, this concern was far removed from the video filmmakers themselves. They did not aim to produce flattering representations of Ghanaian culture that might act as audiovisual ambassadors to potential Western observers. Instead, they took popular imaginaries as a source of inspiration and did not feel constrained to screen out all sorts of disturbing aspects of everyday life, including witchcraft and occult matters that were the talk of the town. In our conversations video filmmakers often expressed their misgivings about the dominant national politics of culture that still were invoked long after the breakdown of the state film industry. William Akuffo, with his usual outspokenness, explained that he found Sankofaism outmoded; it was a policy run by Nkrumah and Rawlings that had long passed. "This is a very stupid idea; go back and pick WHAT?" he asked with contempt. He hated that "whole idea of going back—should we wear loincloth?"—and insisted, "We have our own age; why should we go back to someone else's era?" Involved in making TV advertisements for fancy goods, he was well aware of Ghanaian creative industries: "Woodin [a famous fashion designer and producer of fancy cloth located on Oxford Street] makes great prints, African prints. There are African designers who can compete with Lagerfeld! We only have to show it to the world. . . . Showing the modern Africa is what I mean. We want it to be modern" (interview, 11 Jan. 2008). Given their dependence on audiences, video filmmakers tended to couch the modernity of Africa in a Christian frame (even though Akuffo was tired also of "all this Pentecostal crap"). This made them echo the Christian-Pentecostal stance, according to which tradition and heritage were potentially dangerous, living matters of the present from which one had to dissociate. This stance contrasts sharply with the perspective of Sankofaism, according to which traditional culture needs to be preserved.

The urge to recover the past was also the central message of Kwaw Ansah's famous movie *Heritage Africa,* which exemplified the message of Sankofaism. The central figure in this movie is a misguided, Westernized black district commissioner who has been brainwashed and alienated from his African cultural roots. After presenting an heirloom, given to him by his mother to protect him and symbolizing his African cultural heritage, to his British superior, he becomes mentally disturbed. By retrieving the heirloom (and in

the process killing the white superior), he is able to regain a sense of pride in being African. In contrast, in many video films traditional items and practices are represented as a major source of trouble and anxiety—a curse more than just heritage—that must be gotten rid of (Meyer 1999a).

Sitting with audiences, I often noted an almost instinctive reaction to the appearance of traditional objects; these were immediately taken as evil "fetishes" or "idols" that would have a bad influence on people. For example, when watching with Kwaku a scene in *A Mother's Revenge* in which the protagonist visits the Accra Arts Centre and looks at Asante gold weights, he immediately exclaimed that he did not at all like such objects because "the devil can easily make use of them." Similarly, in a movie I once watched with Mabel, one of the teenage girls who often kept me company during my first fieldwork period in Teshie, there was a scene with on old man and a native pot. Even though it was clear from the story line that the old man was a good character, she immediately turned her face away, so as to not see—and hence engage with—a supposedly demonic object. Frequent spectators obviously internalized the audiovisual language employed by the movies, assuming that the featuring of traditional objects and heritage items spelled danger rather than being neutral or featuring as attributes of a good person. This attitude began showing cracks with the emergence of the "epic," around 2002, to which I will turn in the last part of this chapter.

PICTURING CHIEFS: IGNORANCE AND SECRECY

In current Ghanaian society chiefs and so-called traditional priests are the main institutions that hark back to precolonial society. But there is little continuity. Colonialism brought about a decisive rupture with precolonial modes of governance and worship, reproducing these institutions in a new manner. As I have noted, the postindependence state inherited the category of tradition into which chieftaincy and priesthood (often combined in one and the same person) were embedded. While chiefs could be profiled as embodying the nation's rich cultural heritage, priests met with much more ambivalence as a result of the strong impact of Christian missions in southern Ghana. As Christianity came to be widely accepted as a modern religion, indigenous practices of worship were increasingly regarded as backward and shameful. A reversal occurred through which Christianity became publicly professed, whereas traditional worship was pushed to the margins. Many of

those who converted to Christianity would still secretly consult the services of traditional priests in times of need but would make sure to keep up their public image as Christians. The public performance of traditional rituals for the sake of the lineage or village fell into disfavor, with more and more people refusing to take part.

As I have pointed out, the indigenous priests depicted in many video movies are terrifying and primitive figures located in liminal settings, such as the beach or the bush, and are usually consulted at night. This depiction echoes the marginalization of priests that occurred with the rise of Christianity that recast traditional religion as its demonic other and associated it with juju and witchcraft. During the military regime of J. J. Rawlings, attempts were made to support and facelift traditional religion to reverse the prominent role of Christianity. For this purpose the neotraditional Afrikania movement that sought to develop a modern, respectable format for the expression of traditional religion (de Witte 2008) was granted fixed airtime on radio to address the nation. Positioned against Christianity, Afrikania developed a discourse about traditional religion that was nonetheless informed by Christian terms. This yielded an expression of traditional religion in a Christian format—involving formal church services on Sunday, scripture reading, and singing of hymns that were far removed from practices of worship in the indigenous shrines that Afrikania claimed to represent. With the turn to democracy in 1992, however, which yielded a phenomenal presence of especially Pentecostal Christianity in the public environment, the state policy of profiling Afrikania was doomed to fail. Tellingly, the "Cultural Policy" barely addresses the position and standing of traditional priests, probably because, in public opinion, they are strongly associated with negative values. Recently, however, this negative attitude toward traditional religion has been eroded to some extent by the marked presence of the neotraditional priest Kwaku Bonsam in the public domain since 2008. Bonsam gained spectacular publicity by openly accusing Pentecostal pastors of secretly relying on juju rather than on the Holy Spirit. The degree to which his public appearance, coming at a moment when many Pentecostal preachers face scandals and public suspicion, will yield a more nuanced and positive appreciation of traditional priests, and perhaps even challenge the still strong position of Pentecostals in the public domain in southern Ghana, remains to be seen.[9]

On the whole chiefs proved suitable subjects to be profiled as icons of traditional culture. As Katharina Schramm has pointed out, in Ghana "the institution of chieftaincy functions as a major cultural symbol—an emblem

of authenticity" (Schramm 2004a, 158). Chieftaincy regalia, such as the stool and the sword, have been adapted in postindependence political culture as state symbols (Senah 2013). Taking chiefs as key markers of heritage displayed during lavish traditional Durbar festivals, the protagonists of the "Cultural Policy" deploy a culturalizing and, by the same token, depoliticizing attitude toward the institution of chieftaincy. The current constitution, implemented in 1992, guarantees the acceptance of chieftaincy as a traditional institution with its own representative organs, the Regional and National House of Chiefs.[10] Taking chieftaincy mainly as a matter of culture and heritage, however, the state does little to support the political institution of chieftaincy in its actual operation—much to the dismay of chiefs, who seek to avoid being trapped in the dichotomy of "modernity and tradition," for instance by pursuing development projects on the level of their constituencies.

Chieftaincy provides an excellent focus for exploring how Ghanaian video movies represent what a Sankofaist perspective profiles as traditional culture and heritage. Chieftaincy is not a dominant theme but still recurs; for this reason I will discuss a number of movies as examples. Mediating chieftaincy in their own critical way, these movies explore the popular imaginary surrounding chiefs and offer insight into the ways audiences thought (and think) about this traditional institution. In the urban context of Accra, characterized by multiethnic occupations of space and a long-standing, unresolved conflict over the succession of the late Ga Mantse, chiefs wield less authority over people's actual modes of conduct than they do in the village. Most urbanites do not have any links with actual chiefs in their everyday life but read and hear about chiefs—and most often about chieftaincy conflicts—in newspapers, on the radio, on television, and in film. In the following section I focus on a number of movies made in the early 1990s that deploy rather critical perspectives.

Chieftaincy versus Development

The film *Baby Thief* (GFIC, 1992) is based on a moral geography in which the city (Accra) is profiled as the space of modernity, contrasted with the village as "backward" (there is no electricity, and the elders are stubborn) and in dire need of development. The film begins by showing a woman leaving the village in the North (a region always coded as backward) at dawn because "her time has come." She claims she has to leave to deliver her baby in the city. In truth she is not pregnant but determined to return to the village with a stolen baby

in order to cover up the impotence of her husband, who is a member of the royal family. After a long voyage she reaches Accra and enters a hospital. She tells Mrs. Mensah, who has just given birth to a baby girl, that she is a relative from the village. Once she is left alone with the baby, she quickly leaves for home and takes the infant with her. The baby's parents are devastated. The father is an agricultural officer who, incidentally, works in the North, where he tries to convince the village to participate in a developmental farm and adopt new methods and plant new crops. The baby thief's impotent husband, Yawo Mensah, also meets the young agricultural officer, and they are at loggerheads immediately. Yawo Mensah cannot stand it that such a "small boy" is sent from Accra to act as a "big man": "You keep fooling us with new things, you people in Accra," he shouts, and leaves the project. After a few years Yawo Mensah is enstooled as village chief. His wife is extremely annoyed with his attitude and insults him whenever she sees him: "You idiot! What is a man without his manhood! You impotent fool!" It fits in with her contempt of her husband that she is in favor of "development." The film greatly accentuates the opposition between development and backwardness, embodied by the agricultural officer and the chief. The agricultural officer gets a permanent post in an area near the village of Yawo Mensah, the baby thief, and "their" daughter, Sima. The chief is now carried in a palanquin and wants to have Sima initiated as a traditional priestess. His wife insults him in public—"You spineless fool"—and does not allow him to take Sima out of school. The agricultural officer is accompanied by his little son, Junior, who was born in the meantime (although his depressed wife refused to have sex for a long time, and only got pregnant after her husband raped her). Junior befriends Sima and one time sees a little mark on her back that is identical to a mark on his mother's back. So it is discovered that Sima is his long-lost sister. The chief still insists on turning Sima into a priestess and tries to capture her in the night. He also wants to kill the agricultural officer but accidentally shoots his wife, the baby thief, who confesses everything on her deathbed.

This film suggests that chieftaincy and development are completely incompatible. Not only is the knowledge of the agricultural officer superior, but he also has morality on his side (that he raped his wife is pardoned: a man is held to need sex and even more to father a child, as the doctor asserts). The chief is ignorant, stupid, quarrelsome, and violent. He not only insists on rejecting the wisdom of the "small boy from Accra," but he is steeped in local religious traditions and wants to make Sima a priestess rather than allowing her to pursue her education. Thus, the film, which was very popular for many

years after it came out in 1992, defends the necessity of development at the expense of traditional rule and religion. Development here has to come from Accra and is a project of state representatives against local authorities. Interestingly, its director, Ashong-Katai, told me that he did not necessarily want to make a negative statement about chiefs in general but rather to address the problem of power. Featuring a chief who received his power from a "fetish," he sought to draw attention to the problem that "people get their power from powers that they can't control." Indeed, the problem of wielding *power* over people thanks to a link with spiritual *powers* is an important topic in the imaginary around chieftaincy and, for that matter, around politics in general, as the next section shows.

Chiefs, Powers, and the Abuse of Power

If in *Baby Thief* the chief appears as a backward fool, in *Nkrabea My Destiny* (Amahilbee Productions, 1992) and *Mataa: Our Missing Children* (Galaxy Productions, 1992) chieftaincy is associated with evil powers and "blood money." *Nkrabea,* a film allegedly based on a "true story," deals with chief Nana Addae from Sefwi-Bekwai, who makes money by worshipping the bloodthirsty spirit Degadu. This spirit, who occupies a secret room, offers money and power in exchange for human heads. The film revolves around the sad case of the boy Kofi, who is killed and beheaded by his own uncle to be sacrificed by Nana Addae, who wants to offer the boy as a blood sacrifice in order to become rich (for a detailed analysis see Meyer 1998c). Here the chief is exposed as a cruel, money-hungry monster.

In *Mataa* a rich and cruel cocaine dealer (Jonas), who terrorizes his (fishing) village and even wants to become chief, has made a pact with Mami Water, here depicted as a beautiful fair-skinned lady usually dressed in a black gown, with long dark hair, modest makeup, and long red fingernails. In return for the money and protection she provides him, she requires the sacrifice of little children. Eventually she wants the ultimate sacrifice: the heart of a dear blood relation. When Jonas is reluctant to kill his little niece, Mami Water chases him and even hands over a sharp knife to him, warning him that "time is running out" and that she will cease protecting him if he fails to follow her orders. Eventually, Jonas does what she wants and takes the little girl's heart to the goddess. Assured that nothing can harm him, he faces a man who persecutes him because he got wind of the crime, and a fascinating dialogue about the power of money ensues. Almost in a delirium, he shouts:

It's money
It's power
It's everything
The ability to punish and reward at the same time
To reward, I have to be CHIEF
I want to be CHIEF
Every Ghanaian wants to be CHIEF.
That's why they want to kill me
But tell them I am invisible
No man, no gun, can harm me
Tell them, Jonas is invisible
Jonas is invisible.

Having said this, he plunges the knife Mami Water gave to him into his own body and dies.

Both films explicitly address the problem of receiving "power through powers," which featured only as a side issue in *Baby Thief.* And both films reference precolonial chieftaincy practices, in which chiefs derived their power from the "black stool" sanctified with human blood (usually that of slaves).[11] These practices, as Michelle Gilbert (1995) shows, were banned by the British colonial administration as barbaric and incompatible with "civilization" and are regarded by present-day Ghanaians with mixed feelings of pride and shame. In contrast to *Baby Thief* the films do not depict chiefs (or in Jonas's case, an aspiring chief) as backward. They use the spiritual powers long associated with chieftaincy to improve their position in modern society. Nana Addae has a posh mansion and cars, drinks whisky, and takes his girl-friend out to expensive restaurants in Accra. Jonas deals in cocaine and is approached as the one able to lead people outside the confines of the village; as his drugged girlfriend says with a much-quoted sentence: "Jonas, take me to America." In his delirious speech Jonas echoes the long-standing Akan practice of rewarding the individual accumulation of wealth with titles (Wilks 1993), but now chieftaincy seems to be within reach for anybody with money, including criminals.

Thus, the problem *Mataa* and *Nkrabea* address is that the title of *chief* has become increasingly attractive for individuals who misuse their power at the expense of their subjects. The problem is not chieftaincy as a traditional, "backward" institution, as in *Baby Thief,* but the link between chieftaincy and accumulating personal wealth and power through antisocial, inhumane, or even occult means. In the early 2000s numerous spectacular Nigerian films (e.g., *Blood Money;* see Meyer 2001, 2007a) problematized the phenomenon

of "big men" or "chiefs" as new immoral figures of power and success. The attraction of these films lies in their taking the mystery of power as a point of departure and setting out to make visible the powers that give Jonas and Nana Addae the power they wield. Jonas even claims that this power renders him invisible to his enemies. To grasp this nexus of "power through powers," it is useful to invoke Emmanuel Akyeampong's point that the "culture of power" in Ghana is characterized by different and shifting epicenters of power that "are rooted in the fusion of the secular and sacred worlds" (1996, 167). This not only prevents attempts, for instance by the state, to monopolize and centralize power but also implies that access to spiritual forces—from old village gods to the forces of the wilderness, from new spirits at the bottom of the ocean to the Holy Spirit—is a prerequisite for generating power and accounts for its dynamics. In a sense video films like those I have discussed here claim to lay bare the mysteriousness of chiefs' power. In so doing they throw light on the spirit-related aspects of chieftaincy that are shrouded in secrecy and blocked away in representations of chiefs in the format of heritage, in which "the representation of chieftaincy is *in principle* limited to such elements as attire, dance, and public functions, whereas another great and important part of it remains non-representable" (Schramm 2004a, 172).

Interlude: A Chief's Comment

What do chiefs think of such representations? Fortunately, at the beginning of my research I had the chance to talk to Nii Kojo Armah II, subchief at Jamestown and a professional photographer (interview, 4 Dec. 1996). He had been a member of the film censorship board for more than twenty-five years and was installed as a subchief in the early 1980s. He told me that he had not been present when *Baby Thief* was presented to the board. If he had been on the committee, he might have rejected the film because he found the representation of chieftaincy as backward quite problematic. In our conversation he also expressed his criticism of the representation of spiritual forces or juju:

> I like action films, thrillers, melodrama. Films carry a lot of educational aspects for the younger generation. But when it comes to these juju things, they are doing certain things they don't understand. When they start playing with juju I don't like to watch it, because I find it childish. The real thing itself is there, but they are using their imagination to create something that they don't know. I will sleep [I will fall asleep]. We can't fight it, because when you are in this status [of chief, like him] you go through the real thing. I can't talk

about it here, but you experience the real thing itself [up] to a point where I didn't know where I was.

What struck me most in our talk was that Nii Kojo Armah criticized video filmmakers for just making up in their imagination how juju worked, yet at the same time he insisted that the "real thing" could not be depicted. He told me that he himself had experienced it during his installation as a subchief, when he was kept in a dark room for a week. The following conversation between us spotlights the intricacies not only of the full representation of chieftaincy beyond its mere public visual markers but also its very capacity for depiction:

NII KOJO ARMAH II. And there are certain places [i.e., sacred ones], where you go with a camera and the camera cannot function. It has happened to me. I was holding a camera and the camera just got locked. I took another camera and I started trembling. Instead of loading the camera the flash would not work. I thought, "Am I nervous?" I put everything in order and went back. It was worse.

B[IRGIT]. *What did you want to photograph?*

N.K.A. A shrine. It got to a point where I couldn't do anything. Indeed, there were many secrets and nobody talked about them.

B. *But why is there no film that deals with it in an adequate way?*

N.K.A. Who is going to give you the secrets? When I go to a ritual I won't tell you. . . . The things that happen to you, when you come [out again], you can't even talk about them. When I see people creating these things in a movie, they are fooling themselves. They don't know what they are playing with. Somebody may tell them this is the way it is, the way they do it, but the real thing itself, they do not understand. The first time I had to go in a palanquin, there was nothing wrong with me, but when the elderly men came, I was held and they took me. And the old men poured libation [one after the other] and after the second one, I felt as if my legs were not there. And then the third one, I was not there. All of a sudden all I could remember [was that] I was off.

Speaking from his experience as a photographer *and* a chief, in these reflections Nii Kojo Armah II opposed secrecy, which underpins the power of chiefs and thus chieftaincy as an institution, and visual depiction. The two appear to be incompatible: how it really is cannot be shown. Thus, the point is not simply that video filmmakers offered inaccurate visualizations of what

otherwise remains secret and inaccessible to the public. There can *only* be incorrect visualizations, because the things that movies claim to reveal "refuse to be photographed" (Spyer 2001) or filmed and represented to the outside world. A clear line is drawn here between a set of clandestine rituals that make a person a chief and form the base of his power, on the one hand, and his public image, on the other. The power(s) on which chieftaincy relies are (claimed to be) shrouded in secrecy and thus inaccessible and undepictable via modern audiovisual media; only the public aspects of chieftaincy seem to lend themselves to truthful depiction. This is what contemporary documentaries about chiefs (e.g., the videos of the funeral of the late Asantehene Otumfo Opoku Ware II and the installation of his successor Otumfuo Nana Osei Tutu II in April 1999) usually convey, thereby confining chieftaincy to its public dimension and keeping more or less silent about the issue of "power through powers" that is central to feature films like those discussed above.

The impossibility to depict, so succinctly indicated by Nii Kojo Armah II, also pertains to local religious practices and juju in general: here, too, as I noted in chapters 4 and 5, the most important aspects are held to be barred from view (de Witte 2005). During my research many people confirmed Nii Kojo Armah's position. Toward the end of my field research in April 2010, actor Lord Bentus told me that when trying to shoot a sacred place in the village, there may be "nothing on the tape, it is blind. You don't see anything. Supernatural powers exist in the villages, and these gods do not want to be revealed. When you go to a shrine and try to take a picture, the picture becomes dark; you do not see anything" (interview, 22 April 2010). This invisibility—or more precisely, the setting apart of particular items and practices as secret—collides with the drive toward revelation that characterizes many video films. At work here is the logic of the secret, which by its very existence appears to extend reality, as Simmel put it when he wrote that "the secret offers, so to speak, the possibility of a second world next to the manifest one, and the latter is influenced by the former in the strongest way" (1922, 272; my translation).[12] Of course, more or less detailed knowledge about what happens in the confines of secrecy circulates in society. Secrets trigger the imagination. Video movies of the kind that annoyed Nii Kojo Armah II challenge official representations of chieftaincy by making public what is imagined as its secret dimension.

Claiming to reveal what is held to be undepictable, video films do not simply expose and demystify the powers behind chiefs. Indeed, just as "attempts to unmask appearances may actually compound the mystery thereof," video movies also vest what they claim to reveal with new mystifica-

tions, engaging in the "mystery-making impact of unmasking" (Taussig 1999, 56). So it is too simple to associate the refusal to be photographed with the presence of the aura, and video technology with its loss, as a straightforward reading of Walter Benjamin's "The Work of Art in the Age of Mechanical Reproduction" would suggest (Spyer 2001; see also Dasgupta 2006). As is the case with spirits believed to resist being captured via photography in Heike Behrend's fascinating analysis of photographic practices in East Africa, "by bringing (potential) enlightenment, the substantial powers of the photographic flash allegorize modernity's aporia, revealing while at the same time blinding, giving something to see while at the same time withdrawing it. . . . 'Primitive' aura, if I may say so, attempts to escape photographic visuality" (Behrend 2013, 237). Compelled to capture through pictures what allegedly is unrepresentable, video filmmakers created new enchanted figures, without, however, giving audiences real access to these powers (Behrend 2013, 239).[13] In practice this creation of audiovisual substitutes for a secret, invisible realm was a difficult process. Video filmmakers realized that the sphere of tradition and chieftaincy was, per se, not easily convertible into compelling pictures. So they took recourse to popular imaginaries to elaborate the appearance of shrines and secret practices. Indeed, I heard many of them assert that instead of seeking to depict how traditional culture and religion really is, they merely sought to mirror how their audiences imagined it to be. Hence, as I noted in chapter 6, they used all sorts of objects that in reality would never be found in a shrine, for example colorful masks produced for tourists. Depicting a simulacrum involved a constant search for new attractive pictures from a global repertoire of—often exoticizing—symbols signifying Africa, through which tradition was made available without fully capturing it. Yet even these "impossible" visualizations, made to stand in for an allegedly undepictable void, were able to instill anxieties in the actors who depicted them with their bodies; and audiences recognized them as truthful.

"TRADITION AND COLOUR AT ITS BEST"

Video films did not remain trapped in reiterating a negative valuation of tradition and heritage by either setting chiefs in opposition to development or exposing their uncanny secrets. The emergence of the production of "epics" around 2002 offered alternative perspectives that foregrounded pleasurable display. The genre of "epic" films—or, as marketers and audiences usually call

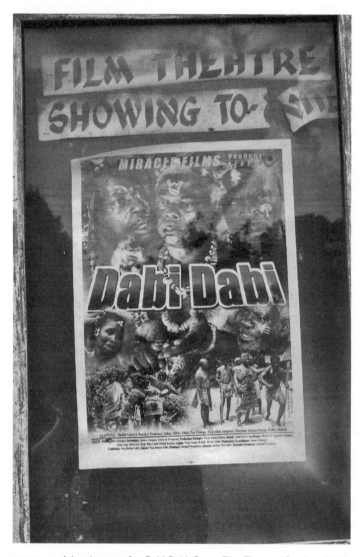

FIGURE 28. Advertisement for *Dabi Dabi*, Gama Film Theatre (October 2002). Photograph by author.

them, "history" or "old times" films—emerged first in Nigeria and was introduced to Ghana by Samuel Nyamekye, owner of the video production company Miracle Films and self-assuredly dubbed as Mr. Quality in his self-advertisement.[14] In 2001 he brought out *Asɛm* and in 2002 *Dabi Dabi I* and *II,* all directed by Kenny McCauley (fig. 28).[15] These films are situated in an imaginary village located in the past, long before the intrusion of colonialism

and Christian missions. At the beginning of the trailer, *Asεm* promises viewers "tradition and colour at its best" and frames the narrative via the following introduction, given in Twi, but subtitled in English: "A time long ago, the deeds of men held the traditional community through taboos and laws. But when the deeds, words, taboos and laws outlive their time, will there be the needed change? In the quiet serene village of Sekyerekrom taboos and laws are upheld. But the peace is about to be shattered in this quiet village. Will the old stand or will the old pass?"

The characters in *Asεm* wear white cotton loincloths, supplemented, in the case of women, with a brassiere made from the same material; all walk barefoot. Both men and women wear beads around their necks, feet, and arms. The women have their hair plaited and also wear beads around their waists. They inhabit a small village, situated in the bush, in houses made of mud and sticks, roofed with grass. They live by farming and hunting. The priest plays an important role in restoring the moral order because when he is in a state of possession, he can see into people's minds. Regularly the chief (usually dressed in antelope skin and also adorned with beads), his elders, and the queen mother meet under a tree, all seated on Akan stools. Although the elders speak Twi (subtitled in English), the chief himself speaks English. At this time the rules are strict: if a taboo is broken, the perpetrator is banished from the village or put to death. Interestingly, by showing "tradition and colour at its best," the film aestheticizes traditional culture but at the same time criticizes the irrationality of traditional law. This is already conveyed by the blurb on the back of the tape cover, which of course has to advertise the film to potential buyers: "In the kingdom of Sekyerekrom tradition is supreme and reasoning is nothing. Opanin Kufour is accused of murdering the king's daughter. He is found guilty and sentenced to death by the traditional laws. He is innocent. Will the traditional law listen to his plea?" As is to be expected, the chief, as the ultimate embodiment of "traditional law," does not listen and thus makes a terrible mistake.

The genre of epics, by concentrating on and to some extent even cherishing traditional village life, diverged markedly from all the video films I had seen thus far. Yet epics were virtually always situated in a time long before the arrival of Christianity, thus avoiding taking the side of one religion at the expense of another. Audiences, in any case, were much more sympathetic to tradition when it was depicted as an all-encompassing lifeworld located in a distant past to which no commitment was expected than when it was an option to choose at the expense of Christianity. As I have noted, video films

that were explicitly critical of Christianity in favor of a positive valuation of tradition and heritage usually flopped, as many of my video filmmaker friends painfully experienced. During fieldwork in 2002 I watched quite a number of epics in small video cinemas in Accra and noticed that young urbanites in particular appreciated them, stating that these films gave them an impression of the past and a village culture unknown to them. They also enjoyed, they said, the depictions of nature, especially the wildness of the bush—sites that they had never visited before. I began to realize, through conversations with these young people, that these epics did not pretend to offer a historical representation of the past so much as an imaginative account, feeding as much on creative invention as on historical fact.

I have to confess that my first reaction to this new genre was quite negative. I felt uncomfortable and disappointed. Initially I was pleased that, at long last, a new type of movie had emerged that bravely transgressed the deeply Christian-Pentecostal modes of filmic depiction, with their negative representation of tradition as demonic, but to my dismay these movies invoked yet another stereotypical view of tradition that violated historical facts. Knowing a bit about Ghanaian history, I believed these films were all too made-up. Assuming that the producers, directors, and actors, as well as the audiences, took these movies as truthful portrayals of the precolonial past, I felt an urge to adduce historical facts to show that the past had not been like that. In principle video films echoing a Christian-Pentecostal perspective also engage in inventing tradition by visualizing a Christian imaginary thereof. That these movies were part of an ideological project that presented a negative view of tradition was beyond doubt to me. In the case of epics, however, I somewhat naively expected a genuine search for accurate historical depictions rather than deliberate imaginaries of the past with little attention to facts. I found it quite unfortunate that they posited the "truthfulness" of depictions that I, with the hindsight of the historical anthropologist, could recognize as "invented" and that misrepresented the realities of precolonial Africa (Ranger 1983, 247). The reactions from people in the state film establishment echoed my own discomfort. While the turn to tradition was regarded as positive, many critics also found that these movies presented a strange hodgepodge of elements from various local traditions of chieftaincy and therefore lacked historical accuracy. In other words the epics digressed from the canonized representation of tradition in the framework of Sankofaism that distinguished among different ethnic groups and promoted their cultural festivals.

I soon realized that my stance was misguided. An interview with Samuel Nyamekye (21 Oct. 2002) made me realize that he had adopted the epic for rather prosaic reasons. It was convenient for him to respond to and fuel audiences' interest in village scenes. This was a solution to the difficulty he faced in making films that could compete with the ever more lavish and conspicuous display of costumes, cars, and mansions in Nigerian films. It dawned on me that he saw the epic not so much as a truthful representation of the past but as an imagination feeding on iconized traditional materials and practices as much as on creativity.

My understanding was greatly furthered in an interview with Emeka Nwabueze, a Nigerian living in Ghana, who owned First Image Creations, a company devoted to creating props for films. Emeka worked with Miracle Films and, together with his wife, Nnena, had a great influence on Ghanaian set design. I was introduced to him by Akwetey-Kanyi and met him in the latter's house. At the time of our interview (20 Nov. 2002) he was thirty-four years old. He told me that he had been a civil servant at Enugu, but because he loved the arts—especially painting and writing—he started to do some work for people in the film industry. He took part in major video film productions yet never received the full amount of money he had been promised. He talked about his huge suite at Presidential Hotel at Enugu in Anambra State in southeastern Nigeria, which he described as a "Film Treasure Museum," filled with many props, dummies, and similar artifacts, all made by him. He showed me two videotapes that showcased his company and achievements. When I looked at the sculptures of lions made from foam, human skulls made from fiberglass, and African costumes, Emeka told me that he could make any sort of animal from foam or latex. He explained to me that he would buy certain things, such as animal skins, in the market and was able to transform a cow skin into a bush cat or leopard skin by employing tie-dye techniques. He would also buy feathers, animal skulls, and snake skins far up in northern Nigeria. Certain things were easier to copy than to buy. For instance, he once saw a real human skull in the market. However, if he were caught with it, he would have a problem, so he only used dummies. He confirmed what Nnena had told me before on the set of *The Turning Point:* he always prayed before going to "fetish" markets and also over the things bought there because "there may be dangers," and the things "can harm you if you don't pray."[16]

Emeka's great passion was the creation of props for films about chiefs, and he proudly showed me numerous photographs of his creations on film sets in

Nigeria. When I expressed my surprise at how tradition—if understood, in line with common sense, as a matter transmitted from the past—was being created in the here and now, he said, "We create an unexisting culture or an unexisting tradition, something absolutely new." This he repeated many times in his attempt to explain to me that artistic creativity was needed to create tradition, which consisted in making new combinations of materials. The challenge for Emeka was to make different items for every film, *not* to use the same costumes and props, so as to always "show tradition in a new way." He said, for example, that he knew that "in the past every hut was red," but for the sake of recreating traditions, he decided in one film to make the huts in different colors. "Set design is everything," he affirmed. He also created "new traditional dances." As Emeka kept on insisting, it was "important to create something unique for every film or story; there should be no repetition in making tradition," thereby turning upside down conventional understandings of tradition as repetitive.

I asked him how his attempts at "creating unexisting traditions" or even "new traditions"—terms that initially struck me as oxymoronic—informed his use of certain materials. He answered that he employed only materials that he knew were common in and belonged to Africa: beads, feathers in different colors, skins, certain signs printed on white cloth, raffia, and snail shells. He also once created a brassiere from cobra skin, although in the olden days women did not wear brassieres. He told me that he got his inspiration from photo books on African arts and culture; he mixed different materials to create "imaginary cultures" that have little resemblance to real ones. It was not his aim to depict an "authentic" traditional culture that had "truly" existed once upon a time but to design appealing figures to evoke a sense of tradition itself as beautiful. The fact that he often talked about traditions in the plural also marked the opening up of traditional cultural repertoires to creative imagination.

Listening to our conversation, Akwetey-Kanyi, who had often accompanied me on my rounds and anticipated the kinds of questions I might ask, also got involved. He asked Emeka why he did not simply "depict shrines as they are." Emeka retorted that most true shrines were empty and did not look special at all. "The real thing," he said, and Akwetey-Kanyi immediately concurred, is often "scanty and small." Yet "tremendous powers may reside in just one small pot. In that one pot there may be more power than in all these other objects." Emeka found that such a space could not be represented in movies just as it was. For film, he said, "you need to exaggerate, to bring in something new. People will not complain that what they see is not the culture of Nigeria; people want something new."

I was excited by this conversation, which offered food for thought about the broader discursive field in which tradition, culture, and heritage were framed.[17] Next to the colonial and Christian understandings, and the anti- and postcolonial critiques they invoked, for instance in the name of Sankofaism, there was an alternative understanding, which Emeka formulated explicitly and brought across in epic movies. This understanding took tradition as consisting of strong, evocative, and colorful materials that lend themselves to lavish pictorialization. I realized that my initial discomfort betrayed an approach to tradition that took for granted certain canonized modes of representing the past. Obviously, these modes are anchored in a politics of cultural representation in which different players mobilize, imagine, and figure the "past" for different ends. In the shadow of the clash between Sankofaism's positive view of tradition and Pentecostalism's negative stance, there emerged a third point of view that bypasses this opposition.

With this in mind, let us return to *Asɛm*. The question posed at the beginning—"Will the old stand or will the old pass?"—is, of course, rhetorical. It was answered long ago, as audiences know from their own experience. Today, at least in an urban multiethnic setting, old laws and taboos no longer structure the course of everyday life in binding ways. The imaginary chief with his insistence on maintaining the old ways of the ancestors is not presented as an option in a Sankofaist sense but is showcased only as a figure invoking nostalgia for a long-lost world. Again, as in *Baby Thief,* the chief is shown stuck in an ultimately backward and potentially cruel traditional order. In contrast to a Pentecostal-oriented imaginary of tradition as a virulent and threatening presence, epic films such as *Asɛm* assign tradition firmly to an imagined past and celebrate it, from the safe distance of the present, through a vibrant visual aesthetic. In these epics the imagined past did not inspire awe or command fear, and it was not seen as having bearing on or importance for the present. The point here, it seems, was not the need for a "break with the past," understood as an abode of occult forces (the common Christian-Pentecostal understanding), nor a reappraisal of the values and norms of the past (the state view of tradition and heritage as mobilized in the "Cultural Policy"). The epic film deliberately displays tradition through a set of well-crafted signs. Tradition, here, is not a set of cherished values rooted in the past but rather a style or a mode of signification designed to appeal by its beauty (as McCall [2007] also argues with regard to "Nollywood's invention of Africa"). In this sense epic films offer an alternative to the moralizing discursive framework of Christianity versus traditional religion, which

prompts people to take sides and identify themselves with one option. Instead of relating to the past in an attempt to retrieve it, the epic involves "a temporality that is very much of the present," adapting tradition to the global age (Comaroff and Comaroff 2009, 114).

Signaling the development of a new aesthetics of African tradition (see Becker 2008), epics are but one instance of a much broader, visually centered take on tradition that also informs fashion, beauty, furniture, and other cultural expressions (Corstanje 2012; Gott and Loughran 2010; Kaupinnen 2010). Tradition is a resource for designing a particular style that, by using traditional iconized materials, indexes an African identity. Interestingly, this invocation of tradition bypasses the need to make decisions in favor of or against moral values and African personality; it rather allows for a playful use of tradition as a practice of signification (de Witte and Meyer 2012; see also Ferguson 1999, 96). The development and use of tradition as a style is a symptom of a broader commercialization of culture in the neoliberal era. Drawing on long-standing Sankofaist symbols that are, however, severed from the Sankofaist message, African tradition and heritage are repackaged in new appealing formats that emphasize pleasure (Becker 2011, 539; Comaroff and Comaroff 2009; Shipley 2009a; Thalén 2011).

After 2005 (when the Ghanaian video film industry got back on its feet, making full use of digital technology) the trend to offer more positive, pleasurable displays of tradition and heritage continued, often featuring spectacular, digitally produced special effects to depict spiritual powers of old. During my visit to Ghana in August 2009, Akwetey-Kanyi had just finished editing his epic movie *Sacred Beads I* and *II*. I had the chance to preview this movie, which involves a chief, his daughter, and a number of competing suitors. He told me that the inspiration for this film came from the biblical story of King David, who sent his chief warrior Uriah into battle so that he would be killed. David had impregnated Uriah's wife, the beautiful Bathsheba, and wanted to marry her (see 2 Samuel 11). Akwetey-Kanyi gave the story a different twist. In *Sacred Beads* the chief warrior comes home from war and finds that his wife is missing. During his absence, the chief had seduced and murdered her after she gave birth to a girl, the princess, who now lives in her father's palace. The film starts when the princess has come of age and wants to get married. However, the chief had lost the sacred beads that are required in the marriage ritual in the "evil forest," and, as in a fairy tale, he now informs the suitors that the one who recovers the beads will be allowed to marry the princess.[18] He employs all means to prevent her from marrying the

son of the chief warrior, who is in fact her stepbrother, yet with whom she is in love and whose child she carries. As the young man is able to get the beads—with the support of the spirit of their deceased mother—he is eligible to marry the princess. At the very moment in which he places the beads around her neck, the chief dies. This is the chief's punishment for being responsible for the possible violation of the taboo against marriage between brother and sister. Had he not had illicit sex with the chief warrior's wife and not kept secret the true mother of the princess and his own treacherous deed, the whole incest drama would not have occurred.

According to Akwetey-Kanyi it would have been easy to transpose the film's story, like the biblical narrative on which it was based, to a modern setting. The reason he still wanted to make an epic was that audiences, he said, longed for movies set in beautiful, green villages situated in times immemorial, "way before people knew Mohammed and Jesus." This implied that they could just give themselves over to enjoying a lavish representation of tradition as an all-encompassing way of life, without having to position themselves morally, as would be expected from a good Christian (or Muslim). And he himself was tired of the dominance of the typical Christian-Pentecostal dramatic structure that underpinned so many movies. Making an epic offered a way out of this straitjacket.[19] Like Emeka, Akwetey-Kanyi asserted that he was inspired by different kinds of representations of Africa in books and other movies. Indeed, I have noted that there was an emergent visual language of the epic that made chiefs, priests, and commoners easily distinguishable by their dress, behavior, and symbols. Transcending existing ethnic groups and cultural settings, this visual code could be described as "African" in a broad, sweeping sense. Akwetey-Kanyi also stressed that in this film he had to *create* images of tradition and heritage. To make the movie pleasurable for viewers, it was important to choose beautiful bright colors, even though in the past people wore plain, light cotton cloth. Also, in view of anticipated protests on the part of Christian women's groups, he decided to create beautiful brassieres rather than ask the actresses to expose their bare breasts (which might also have been more costly, I suspect). The importance of pleasing the audiences with colorful pictures also implied that shrines and palaces were to be made more visually appealing (fig. 29). While an actual shrine, as mentioned before, often consisted simply of a pot and some kola nuts or cowries, a film shrine required more props, such as masks—which, it should be noted, were for sale to tourists but not used in indigenous religious practice—and other symbolic markers reminiscent of Akan Adinkra symbols.[20]

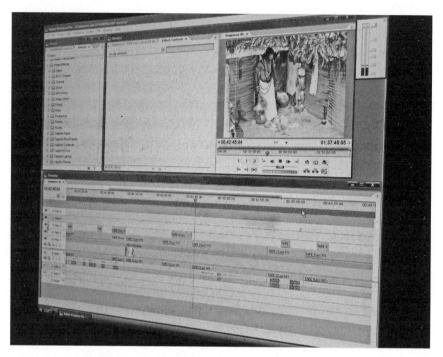

FIGURE 29. Editing a shrine scene for *Sacred Beads* (January 2008). Photograph by author.

The masks, Akwetey-Kanyi told me, could be rented at the Accra Arts Centre, which supported the art of traditional carving and other crafts. He was well aware that his epic movie did not depict tradition as it had really been in the past but in line with how it was popularly imagined in modern times. Even though the film itself was set in "the olden days," it was implicitly related to the presence of Christianity. Not only was it inspired by a story in the Old Testament, but it also took into account Christian restrictions on the exposure of the female body. In this sense Christianity was still part of the frame in which the film operated, even though it did not feature openly in the movie itself.

This also was the case with regard to the film *Spirit of Heritage* (Sarbah The Great Films, 2008), a two-part movie situated in an imaginary village in the past, which is the stage for a conflict over the right heir to chieftaincy. Two opponents, both backed by ancestral spirits that are made to appear via special effects and that fight by mobilizing spiritual powers, struggle with each other until the rightful chief defeats the false one. The film ends with the tune "Spirit of Heritage," composed as a soundtrack for this movie, *and* the featuring of the statement "To God Be the Glory." This framing of the

FIGURE 30. African royalty, screenshot from *Princess Tyra*.

film in a manner reminiscent of revelation movies (which also often invoke God at the end) is remarkable. It suggests that epics are not situated entirely outside of the Christian dualistic framework promoted by revelation movies (and Pentecostalism), in which good eventually overcomes evil. In a conversation with the director in August 2009, I learned that he planned a third part that would fully address the question of Christianity. As he did not regard the "return" to tradition (as advocated by Sankofaism) to be a good solution, he was still trying to figure out how to evoke Christianity and modern times in relation to tradition.[21]

The film *Princess Tyra* (Venus films, 2007), nominated for many awards at the 2008 African Movie Academy Awards, goes further than the epics. As producer Abdul Salam Mumuni put it, the movie depicts "new styles of royalty." What films such as *Princess Tyra* and epics have in common is the visualization of tradition and heritage as colorful and aesthetically pleasing. In the spectacular opening scene African royalty arrive in their Mercedes-Benz (fig. 30). The women are wearing high heels and fashionable dresses with

African prints, always accompanied by maidservants in somewhat strange costumes, who strew flowers before their feet.

This scene resonates with current self-representations of chiefs in Ghana (as well as in Nigeria). They do not position themselves as traditional in opposition to modern but actively appropriate modern forms into the ongoing, "living" tradition of the institution of chieftaincy. Taking the modernity and malleability of tradition as a starting point, *Princess Tyra* excels in offering a dazzling fashion show of traditional customs that mark the princess and her father as royals—much to the dismay of her fiancé, a prince from another kingdom who dislikes this kind of lavish display. Notably, films such as *Princess Tyra* thus offer a new take on tradition by depicting it not as a repository of "good" state-endorsed values (in the manner of Sankofaism), nor as emanating from the realm of the "powers of darkness" (echoing Christian-Pentecostal views), nor as situated in a distant visually appealing but fabricated past (as in epics), but as modern and firmly grounded in the present. In so doing, this film and others of its kind offer a critique of tradition from a new angle that questions, via the sober critique of the fiancé, the exuberance of a supposedly superior, privileged class that exploits the masses in the name of tradition and heritage.

CONCLUSION

The central concern of this chapter has been to situate Ghanaian movies' depictions of traditional culture and heritage in general, and chieftaincy in particular, within the broader discursive frameworks in which these terms are negotiated. In conclusion I would like to raise three points. First, the retrieval of tradition and heritage, and the value and meaning bestowed on them, depends on more or less authorized modes of mediation. The recognition of these mediations as truthful is produced through a complex politics of authentication that has long been dominated by the framework of Sankofaism. Although the symbol of Sankofa and the related motto "Go back and fetch it" suggest a selective appreciation of tradition from the perspective of the present, it is clear that, by virtue of being coined by the state, Sankofaism produced and authorized rather fixed notions and policies toward heritage that were meant to be considered morally valuable. As I have shown, in contemporary Ghana ideas about tradition, culture, and heritage are part of a discursive field in transformation, which entails tensions and

contestations about their meaning and implications for the present and future. Since video films from the outset offered alternative views that challenged state-driven cultural policies, they proved to be excellent entry points into such tensions and contestations.

Second, the filmmakers' more recent interest in producing epic films suggests an intriguing shift from the Christian-Pentecostal casting of "the past" as a potentially evil and dangerous resource to its (tempered) celebration through elaborate visual aestheticization. In this way "the past" is represented as located in a rural realm that offers pleasure yet requires no moral or other commitment (and is not claimed as anyone's in particular). While it may be an overstatement to interpret the tacit approval of the genre of the epic as a turning point, this new genre has managed to give a form to an alternative understanding of tradition and heritage that at least a part of the usual video film audiences embraced. That Christian ideas still inform these representations, be it by placing the epic in a time prior to the arrival of Christianity or through the use of closing statements such as "To God Be the Glory," shows that there is no radical rupture from Christian-Pentecostal-oriented understandings of tradition and heritage in video films. All the same the emergent genre of the epic spotlights a new interplay between the usual Christian-embedded dualistic representational framework (wherein tradition is more or less identified with ignorance, backwardness, and evil) and new modes of depicting tradition through more ambivalent frameworks, leaving room for positive evaluations.

Particularly fascinating in this regard is the *deliberate imaginative invention* of tradition as an aesthetic form. Instead of defining tradition as a practice of transmission that extends from the past into the present, filmmakers developed a more constructive stance in relation to tradition. The provocative statement Emeka Nwabueze made that he was creating "unexisting traditions" captures this stance exceptionally well, showing that the deconstruction of traditions as "invented" or "imagined" is not the sole privilege of cultural analysts. Emeka's and Akwetey-Kanyi's insistence that a "true" representation of heritage would be dull and visually unappealing, and would thus not satisfy the visual requirements of the medium of film, also suggests a deliberate creativity in developing a general aesthetic of video filmmaking. The colorful visualization of tradition and heritage in the epic suggests a new emphasis on style and aesthetics aimed at affording viewers a pleasurable experience that cuts across various expressive forms, including cultural performances such as dance, fashion, and other ways of performing Africanness (see also Brosius and Polit 2011, 8–10; Probst 2011).

Given that these films operate within a wide social arena, they may well indicate a visual-aesthetic turn in the cultural politics of tradition and heritage in which lavish display and pleasure are more emphasized than the moral values enshrined in these terms. Of course, it would be incorrect to posit that moral values no longer matter; the point rather is to signal an increasing emphasis on appearance, which raises new questions about the association connecting heritage, aesthetics, and ethics. In the current neoliberal era new mediatized and commercialized forms of heritage seduce audiences to "buy into attractive identities designed to fit globalized consumer lifestyles that make them feel good and on top of the world as Africans" (de Witte and Meyer 2012, 60).

Third, while until recently scholars of African video filmmaking and African cinema have been operating in more or less separate fields, the adoption of the epic casts doubt on the continued viability of this division. Although for a long time a distinct feature of many video movies was the negative attitude displayed toward tradition and heritage (as I, too, have argued; see Meyer 1999b), this is no longer the case. The epic bears a striking family resemblance to the "Return to the Source" genre in African cinema, which is characterized by a particular aesthetic visualizing an African identity unaffected by Western influences (Diawara 1992, 142), but seems to differ with regard to the very conscious invention of "new" traditions. This, in turn, suggests unexpected links between video filmmakers who produce epics and directors of African cinema, such as Ousmane Sembène, who refuse to inscribe into their films an essentialized notion of Africa as "pure" and "authentic" and who "make creative use of the past for the sake of contemporary audiences" (Dovey 2009, 9; see also Murphy 2000). It also suggests a salient affinity between NAFTI modes of teaching students a particular symbolic language to depict tradition by taking recourse to particular symbols marked as African and the creative use of markers of tradition and heritage in epics. In both video films and African cinema the notion of traditional African culture, understood in essentialized terms, is deeply problematic (McCall 2007). In fact, the invocation of a reified tradition often does not come from the filmmakers themselves but from film critics and the discourses mobilized at African film festivals, where a broader, global audience has been accustomed to tropes of "African authenticity" and expects them to be confirmed (Saul 2010). In scholarly analysis these tropes should be subjected to critical interrogation to unpack the politics of their use rather than being taken at face value. This is what I have tried to do in this chapter.

In closing, let me mention a small encounter. In November 2002 Ashong-Katai and I bumped into the actress Kalsoume Sinare on Opera Square. Prior to becoming an actress she had been a model, and in 1989 she was second runner-up in the Miss Ghana Competition and represented Ghana in 1990 as Miss Model of the World. She was the brand face for many products and shot a lot of commercials. She was famous for her beauty and her stylish outfits with tight tops, miniskirts, and high heels, and known as the spouse of soccer player Tony Baffoe. At the time, she was immensely popular for playing the lead role in *Babina*. When we met, I was wearing a quite simple dress from locally produced batik prints (called Adwoa-yanke) that Ashong praised for being "traditional." Kalsoume looked at me from top to toe, agreeing that my dress was nice. "But," she said, "you are already modern. So we like it even more if you dress traditionally." This struck me as a crucial statement: a person like me, who was "*already* modern," could easily adopt a traditional style, while a person like her, when wearing the same kind of dress, might be seen as "*still* traditional." A traditional style was desirable but only if it could be worn without being mistaken as premodern because the modernity of the wearer was beyond doubt, as seemed to be the case with me. At the time, Kalsoume, and many young women like her, opted to dress in modern styles to punctuate their modernity. It seems to me that the epics that began to be made at the time of our meeting signal the rise of new modes of representing tradition, culture, and heritage that emphasize design and style. More or less uncoupled from earlier morals and meanings that dominated cultural heritage production under the aegis of Sankofa, these new cultural styles lend themselves easily to adoption by people to perform African identities in ways that are both traditional and modern and that may ultimately challenge the Pentecostal impact on the representation of culture.

Epilogue

I began this book by recalling my excitement about discovering that *Diabolo* resonated with a corpus of stories about satanic wealth that were ubiquitous in southern Ghana, circulating as rumors and testimonies and as part of sermons. But I could not yet grasp what the medium of video did to the contents with which I was already quite familiar. This launched my trajectory into the evolving video film industry, which I explored as both a symptom and facilitator of profound transformations of the public sphere in southern Ghana. Emerging under the new condition of media deregulation, the video film industry was positioned historically in the void of the defunct state film industry, whose organizational and ideological structures were still partly in place. Movies were not produced within fixed structures but entailed the making of video as a medium. For all those involved in the emergent industry, this entailed negotiating new possibilities in the light of long-standing legacies of cinema and the representation of culture. As this book documents, the making of video as a medium required complex concerted action, including fund-raising; winning audiences and keeping them hooked; deploying attractive themes and a compelling aesthetic; spotting and training good actors and making stars; developing the skills required for all aspects of video production, from set design to editing; mastering techniques of video for the actual work with pictures; creating infrastructures for the exhibition and circulation of cassettes; dealing with censorship; facing criticisms from the state film establishment, intellectuals, and artists; controlling illicit reproduction; and so on. Coordinating all these activities on various levels, producers are at the center of the video film industry. They are like spiders in the web, not unlike the legendary trickster figure of Ananse the spider, who is a master of speech, the god of stories that, as a rule, go deep into deplorable immoral acts to convey a lesson.

I have pointed out that Ghanaian movies were designed and appreciated as occasions for learning. For audiences it was important to "get something out of a movie," and this required that they "got in" in the first place. Watching movies had to offer excitement and pleasure but also yield a lesson that could be carried into one's personal life. In this epilogue I want to reflect on what I got out of my study of the video film industry that has kept me hooked on it for so many years.

What "got me in," so to speak? I was fascinated by the producers' and other players' inventiveness and improvisation. Following the larger process of the making of video as a medium that occurred around the production of specific movies, I realized that I was witnessing, from close up, the emergence of a new "informal" culture industry under insecure neoliberal conditions. In many respects the problems faced by the producers—how to make a movie that would be a hit and earn some money for the next production?—ran parallel to the concerns of their audiences, who wondered how to lead a successful life under new conditions that offered unprecedented possibilities but also brought problems and troubles. The movies generated in the close interactions between producers and consumers bear the imprint of the instability that characterizes the current climate, which I found aptly expressed in the motto "Your world is about to change." They pose questions rather than offering answers. They are open products that need audiences to be realized in full.

Like the audiences, I was prepared to look past technological shortcomings. In this respect it may have been helpful that I was not trained as a film scholar and was not involved in the study of African cinema but approached the movies from the vantage point of my expertise in the study of popular culture and religion. I was amazed to see many familiar themes deployed in a new medium and articulated in new locations. The central point I have sought to convey in this book is that movies mediate popular imaginaries, putting up on the screen what prior to 1992 had been largely expressed through other channels. Distinctive about them is not their content, per se, but how they mediate it. Appropriating the film and television screens, which had hitherto been under state control, the rise of Ghana's video film industry signals a new era in which popular forms of expression have achieved a wide public presence.

The movies that fascinated me most are those that propound a view of (being in) the world by taking recourse to two intersecting oppositions—that between the physical and the spiritual and that between God and the devil.

This grid is the structure on which many movies evolve, but in the deployment of plots it is also challenged and on the verge of being subverted from within. Showcasing divine power requires putting evil into the spotlight, but this opens up an excessive depiction of transgressive imagery of the occult, sex, and violence. The moral premise that legitimates the use of such pictures breaks down from within. Thereby the movies exemplify the perverse logic of Pentecostalism to constantly reproduce, in ever more sensational ways, what it rejects. This is reminiscent of Goethe's *Sorcerer's Apprentice* (1797), whose unfortunate antihero sighs, "The spirits that I summoned up I now can't rid myself of." Similarly, deploying the format of revelation, movies "claim" to spot the spiritual behind the deceptive level of surface appearances in the physical. In so doing, they cannot help but offer pictorial representations that ultimately do not escape the logic of revelation and concealment. Pictures show and hide, so videos convey both a trust and distrust in the possibility to represent. In sum, movies offer moral orientations and a revealing perspective, but in so doing, they cast doubt both on the morality they propound and the vision they claim to offer (this arguably also pertains to Pentecostalism). Movies are not what they seem to be. This questioning from within that was integral to movies as a popular cultural form is what ultimately got me hooked and what guided the analyses I have offered in this book.

What, then, did I "get out of" this study? Each of the chapters conveys lessons learned. Here I would like to make explicit two issues that arose from my own engagement in debates about video movies and that I find particularly important in view of current debates and future research.

One lesson concerns the representation of culture coded as African. Standing in for the defunct state film industry, yet being a profoundly dissimilar substitute, video movies triggered strong criticisms. As I have outlined, critics were disturbed by the negative depictions of indigenous traditional cultures that echoed long-standing Western stereotypes and were also affirmed by Pentecostal-charismatic churches. It was feared that this kind of movie would disorient African spectators and lead them to adopt a negative stance toward their cultural past rather than drawing on it as a valuable resource for future development. Moreover, critics were concerned about the impact of these movies on Western spectators, who might see lingering stereotypes about Africa confirmed. Video movies were taken to task for failing to represent African traditional culture in a respectable manner, opening up an abyss instead. The worries expressed about video movies point to a

normative view of African cinema from which video movies are found to digress. I took it on myself to venture into sheer endless debates with various representatives of the film establishment in Ghana, trying to suggest different entry points into video movies without necessarily defending their message and the imagery deployed.

This also meant that I would engage with audiences at home in the Netherlands. The video producers who were my main interlocutors expected me to act as their ambassador and, if possible, sales agent. In March 2000 I helped organize a video film festival featuring a number of Ghanaian video filmmakers at the theater of the Royal Tropical Institute in Amsterdam, during which Akuffo, Akwetey-Kanyi, Ashong Katai, and H. M. were present, and their movies were screened. From the outset it was clear that these films did not fall into an existing category of world cinema; to the dismay of our Ghanaian guests they were therefore introduced as "popular video soaps." Thinking that knowledge about the local context in which these movies were produced and watched in Ghana would be helpful for the audience in the Royal Tropical Institute, I briefly presented the film industry from my ethnographic angle and introduced the filmmakers prior to the screenings. Bringing into play my expertise as an anthropologist, I tried to persuade audiences that, if they were truly interested in Africa, they should try to appreciate these movies for offering insights into a living popular culture. And perhaps even the annoyance about their peculiar aesthetic, which these audiences found difficult to swallow, could be turned around to prompt a rethinking of implicit habits of viewing and ideas about Africa. Many spectators, however, like the critics in Ghana, were put off by the low technical quality of the movies (poor sound, very slow pace, static camera, bad acting) and disturbed by the plots and imagery, which often involved the demonization of tradition. Over and over again, on various occasions, I noted that these movies, as well as Nollywood productions, collided with the expectations of audiences who were accustomed to watching African movies that were more in line with *Heritage Africa* or high-profile francophone movies shown at FESPACO (see also Haynes 2000; McCall 2002, 87). This is one of the reasons why video movies, some exceptions notwithstanding, did not break through into the circuits of African film festivals in Europe and America. They collide with established imaginaries of what Africa is and how it should be represented.

My point is not to celebrate video movies as alternative representations of culture that could successfully compete with African cinema (which I also

like). The important lesson I draw concerns the limits of a normative and often taken-for-granted representational approach to African cinema as showing what is valuable and right. This is simply not what video movies set out to do, and it would be unfair to judge them in this light. Seeking to understand these movies in their own right, I asked what they are and what they do for their actual producers and consumers. I discovered that movies operate as mediators between personal and collective imaginaries that play an active part in world making. There is no Africa that calls for truthful cinematic representation; even in the case of epics the imagery invokes "unexisting traditions." Instead, in the movies, we encounter people in Africa who struggle to shape their lives and expect a better future, just like their audiences. And just as the protagonists are shown striving to be part of a larger, globalized world, rather than being locked up in the confines of the local, filmmakers, too, make abundant use of imagery and cinematic resources from elsewhere that are synthesized with concerns on the ground. On the level of movies, as in everyday life, it is impossible to distinguish clearly between African and foreign markers. It would be misguided to identify the picture of the Sacred Heart of Jesus, which is profusely present in public and private spaces in southern Ghana, as either Western or African. Likewise, it is impossible to pin down the iconographies of ghosts, witches, and Mami Water that populate video movies. Paraphernalia in film shrines is inspired by Hollywood representations of voodoo. And as I saw over and over again, my producer friends were not interested in representing Accra in line with Western imaginaries but as a city of the world that was in part still envisioned as "yet to come" (Simone 2004). What I find especially intriguing here is the assemblage of imagery derived from so many places; video movies are fascinating vehicles by which to study the creative appropriation, recycling, and circulation of "images on the move"(Spyer and Steedly 2013; see also Svašek 2012).

What makes these movies African is above all informed by the attitude that drives these depictions. Bayart's term *extraversion* describes the willingness all over Africa to take in materials from elsewhere, in a kind of cannibalizing move that easily incorporates the foreign—for better and for worse: for worse, because the movies bear the traces of long-standing colonial imaginaries that associate Africa with the primitive, the pagan, and the demonic that have been incorporated in the context of conversion to Christianity and ever since thrive "in the negative" under the figure of the devil and his divine counterpart, the Holy Spirit; for better, because the movies signal an admirable openness and preparedness for improvisation that stands in marked

contrast to modern attempts to produce cultural closure and identify cultural canons that require proper representation. In short, Africanness is not necessarily shown in the correct display of African markers but in the attitude the movies espouse toward the world. That the movies, which engage so strongly in practices of "worlding" (Simone 2001; see also Adejunmobi 2007), are popular across Africa and African diasporas suggests that they tie into a prevailing mood that deploys pan-Africanism in a new style that lends itself to an experimental bricolage with audiovisual materials (see also McCall 2007).

The second lesson came to me by surprise. Attempting to facilitate the circulation and appreciation of video movies in the circuits of African cinema, I understood it as my task as an anthropologist to help provide a context. Offering a thick ethnographic description, I sought to suggest alternative vantage points from which to look at these movies. Much to my astonishment, however, about a decade ago I came across a number of young avant-garde visual artists who were fascinated by the Ghanaian and Nigerian video phenomenon. For instance, in 2006 the German video artists Monika Gintersdorfer and Knut Klassen, who developed various productions with African artists in Europe and Africa, contacted me.[1] Intrigued by the creative use of video technology and the marketing of films in Ghana, they wanted to launch a video there through local channels. They did not need me as an interpreter who could familiarize them with a foreign phenomenon that happened outside the radar of African cinema—the role I had defined for myself in communicating with European audiences of African art films—but as someone who knew about actual infrastructures. I gave a short presentation about this issue during an art performance in Düsseldorf, a setting I was not at all familiar with. This made me ponder how such a new setting that involved so far unknown audiences could make me expand the frame in which I looked at video movies.

In 2011 the Dutch performance artists Sander Breure and Witte van Hulzen invited me to an event titled *Lost in Nollywood,* organized in Amsterdam. They showed clips from various Ghanaian and Nigerian movies, interviewed a Ghanaian Pentecostal pastor who worked and lived in Amsterdam South East, made a live Skype call with a Nigerian producer who was on his way to the airport in Lagos, and asked me to give a short presentation about my research. Breure and Van Hulzen were much intrigued by the visual language the movies deployed, which they found raw, wild, and direct. They were fascinated by the overlaps between Pentecostal imagery and video

films, and they juxtaposed pastor Emmanuel Adeshina Jayeola's sermon, the movie clips, and my PowerPoint presentation as part of the same performance, without distinguishing among the various genres.[2] The room was packed with a much larger crowd than I had ever seen in a screening of Ghanaian or Nigerian movies held in the Netherlands. Some members of the audience appeared to be quite annoyed by my (ethnographic) presentation, which struck them as too academic and know-it-all, undoing the spell of the powerful pictures and the preaching. Here my anthropological contribution of providing a local context and generating a sympathetic understanding for what might otherwise look so weird and strange was not in demand. These pictures were capable of speaking for themselves.

Of course, I have some problems with this dismissal of my academic work. I think that pictures operate within political-aesthetic regimes that shape how they are seen and sensed. I do not want to go here into the sphere of avant-garde visual art and its valuations and ways of engaging with pictures (which may be much more steeped in colonial stereotypes than its proponents would be prepared to admit). The point is that I was struck by the deep fascination of people in these circuits with the imagery deployed by video movies (and even their affinity with Pentecostal preaching). This fascination is also conveyed by the *Nollywood* project of South African photographer Pieter Hugo (2008), for which he went to Enugu, one of the prime film sets in southern Nigeria, and asked actors to pose in self-chosen costumes and settings. And so, as the curators of the exhibition *The Global Contemporary* put it in their catalogue, "There arose vivid portraits of intense theatrical moments in a process of collective imagination, in which cinematic fiction was scarcely distinguishable from social reality" (Belting, Buddensieg, and Weibel 2013, 351). I have noted already that, as an anthropologist, I miss information about the context in which these portraits were taken; the first part of chapter 6 was devoted to offering that missing context. This is one of the recurrent criticisms of Hugo's work, which is also charged with inviting a voyeuristic and exoticizing gaze.[3] A similar criticism could easily be made of Breure and Van Hulzen's performance setup. And it is of course telling that the video film phenomenon is not present in its own right but mediated through interlocutors in the sphere of art who zoom in on particular powerful pictures rather than on whole movies. This also shows in the interest raised in Ernie Wolfe and Mandy Elsas's collections of movie posters that were initially used for advertising and that offer fascinating still pictures of central themes in the movies.

I find these ways of looking at the video phenomenon on the level of its sensational pictures and the contestations evoked by them refreshing.[4] I have to admit that I grew increasingly bored by the recurrent criticisms of video movies in the name of African cinema and the state discourse on film as education, which implied a deadlock for the way I could position myself in debates and for my own imagination. The fact that artists started to regard video movies as compelling audiovisual resources alerted me to a previously little-recognized dimension. I started to take a closer look at the imagery put up on the screen, and I realized its affinity with the surrealist movement. The concern of surrealists like André Breton and Max Ernst was to liberate the imagination by opening up the spheres of dream and trance as registers of the surreal, calling for mind-blowing excursions into terrains beyond the limits of logic and rational thinking. The idea of the physical and the spiritual as being entangled, albeit partly invisible to the naked eye, resonates with the idea of the real as being enveloped in a wider sphere of dreams. Following this trail, surrealism's project of making the surreal dimension visible and the revelation undertaken by movies not only strike me as similar; the similarity also points to the capacity of video movies to appeal to much broader human concerns about the sphere of the unseen, the anxieties and desires evoked, and the potential of their depiction. In this sense they are not exotic cultural forms that are peculiar to Africa, albeit in a way that seems vexing and stubborn to some, but first and foremost instances of a broader human quest to picture the unknown that is part of life itself.

NOTES

1. Coming to power in a second coup d'état in 1981 (the first coup having taken place in 1979, yielding a civil government), Flight Lieutenant J. J. Rawlings ruled the country as a military dictator. Initially using socialist discourse to sort out the major economic crisis that hit the country in 1983, Rawlings's People's National Defense Council (PNDC) government embarked on close collaboration with the International Monetary Fund (IMF) in 1984. Aiming to stabilize Ghana's economy and ensure growth, Structural Adjustment Programs (SAP) promoted the private sector. This entailed reducing government expenditures, cutting down employment in the public sector, and reforming state-owned enterprises (Jonah 1989). The PNDC prepared for a democratic "political environment," bringing about the Fourth Republic in 1992. Rawlings's party, the National Democratic Congress (NDC), won the first elections.

2. In Ghana these video movies are referred to simply as films. Initially, video technology was appropriated as a valid substitute for celluloid; only gradually were other affordances of video technology deployed. I use *video film*—a term that may at first sight be taken as pairing mutually exclusive terms—to refer to this hybrid audiovisual form; this book documents how video films are a "medium" in the making.

3. My approach to these movies is much inspired by the groundbreaking work of Faye Ginsburg on the anthropology of media in general, and indigenous filmmaking in Australia (2006) in particular.

4. The 2010 census gives the following figures with regard to the religious affiliation of the Ghanaian population: Christian 71.2% (Pentecostal/Charismatic 28.3%, Protestant 18.4%, Catholic 13.1%, other 11.4%), Muslim 17.6%, traditionalist 5.2%, other 0.8%, none 5.2%; see www.statsghana.gov.gh/docfiles/2010phc/Census2010_Summary_report_of_final_results.pdf (40).

5. In his recent reflection on the state of the art fifteen years after he launched the "anthropology of Christianity," Joel Robbins concedes that "now that the

anthropological impulse to analyze away the Christianity of the people anthropologists study has been largely stilled, there is room to ask what the anthropology of Christianity might learn from research on ambivalent or only tenuously committed Christians or on groups of people who are not Christian but define themselves in important respects in relation to Christianity" (2014, S166). I very much welcome this move and see this book as a contribution to extending the previous and in my view too narrow scope of the anthropology of Christianity. It remains to be seen, however, what the implications of this widening are for the identity of this subfield and its future research agenda. In my view, what was distinctive about the rise of the anthropology of Christianity as a new field was not so much its subject matter, per se (in fact, as many critics remarked, anthropologists, certainly those working on Africa have long studied Independent Christian movements [e.g., Meyer 2004]), but its theoretical stance, characterized by the assumption of a living Christian tradition (analogous to Islam [e.g., Asad (1986) 2009; Robbins 2003, 194) and a strong interest in doctrine (and even systematic theology) and "emic" perspectives. Extending the scope beyond Christianity implies that this stance will have to be questioned and at least complemented. In fact, the Anthropology of Christianity series, of which this book is part, offers a heterogeneous set of contributions, many of which surpass the scope of the anthropology of Christianity as an intellectual field focused on the "Christian tradition."

6. See Kamper (1981, 86–106) for a brief sketch of the paradox of the imagination being regarded as a low, embodied form of cognition, as well as the indispensable condition of cognition in post-Enlightenment Western thought. In her perceptive summary of the status of the imagination in the Western rationalist tradition Amira Mittermaier (2011, 16–20) pleads that the social dimension of the imagination should be taken into account. Her study of the social and material life of dreams in Cairo calls for an anthropology of the imagination that strongly resonates with my approach.

7. The ascription of meaning to things through the imagination is not a question of a mere cognitive operation on the level of the mind. Indeed, "it would even be superficial and insufficient to say that each society 'contains' a system of interpretation of the world. Each society *is* a system of interpretation of the world, and again, the term *interpretation* is here flat and inappropriate. Each society is a construction, a constitution, a creation of a world, of its own world" (Castoriadis 1997, 9).

8. There is a strong affinity between my approach to (religious) imaginaries and the imagination and the latest book produced by the German Arbeitskreis Religionsästhetik (working group aesthetics of religion). Grounded in the motto "back to the body and the senses, and back to the things" (Traut and Wilke 2015, 20), the members of this working group engaged in a systematic exploration of the so far ill-theorized notion of the imagination as a critical term in the study of religion. Importantly, the authors reject a mentalistic understanding of the imagination (which is grounded in the Platonic contrast of body and soul) and lay out a materially and bodily grounded take on the religious imagination that evolves around specific material media. Here too, imagination, sensation, and material forms are understood as intimately linked.

9. For a critique of the neglect of materiality and the senses (or aesthetics) in sociology see Reckwitz (2002, 2012), who developed a praxeological approach that synthesizes ideas from Bourdieu, Latour, and Rancière and strongly resonates with my approach.

10. This is a succinct definition: "The term aesthetic formation . . . highlights the convergence of processes of forming subjects and the making of communities—as social formations. In this sense, 'aesthetic formation' captures very well the formative impact of a shared aesthetics through which subjects are shaped by tuning their senses, inducing experiences, molding their bodies, and making sense, and which materializes in things" (Meyer 2009b, 7).

11. Therefore, "the picture is the image with a medium" (Belting 2011, 10; see also Mitchell 2005, 85; 2008, 16–18). This is not simply a hairsplitting issue of vocabulary but a content-driven distinction grounded in a media approach.

12. As Belting points out, the "distinction between image and medium is rooted in the self-experience of our body. The images of memory and imagination are generated in one's own body; the body is the living medium through which they are experienced" (2011, 11).

13. "During long periods of history, the mode of human sense perception changes with humanity's entire mode of existence. The manner in which human sense perception is organized, the medium in which it is accomplished, is determined not only by nature but by historical circumstances as well" (Benjamin 1999, 222). Contrasting contemplating a painting with watching a movie, Benjamin refers to the shock effect of film, which organizes a new mode of looking.

14. For the development of an aesthetic perspective along this line see Böhme 2001; Meyer and Verrips 2008; Meyer 2009b; Pinney 2004; Reckwitz 2008; and Verrips 2006; see also the important work of the German Arbeitskreis Religionsästhetik: www.religionsaesthetik.de.

15. Elsewhere (Meyer 2013), I have discussed the fruitfulness of Krämer's (2008) theory of media as messengers (in the literal sense of [German] *Bote*) for anthropological research on mediation.

16. In his description of the trajectory of image perception, brain researcher Wolf Singer explains that, on the level of the brain, seeing is always interpretative, because the brain is a self-referential system that makes use of stored information to embed actual sense perceptions into a coherent image of the world. Sensing constitutes reality. "Unsere Kognition fußt also auf Wahrscheinlichkeitsberechnungen und Inferenzen. Das Faszinierende dabei ist, daß wir das Ergebnis dieses interpretativen Aktes als Wirklichkeit auffassen. Wir merken nicht, daß wir konstruieren, sondern wir glauben, daß wir abbilden" (2009, 125).

17. Here I do not intend to go into the recent debates about the notion of "affect" in film philosophy (for an excellent overview see Morsch 2011) and beyond. Taking mediation as a starting point, I am suspicious of theoretical approaches that take the body, the senses, and affect as prior to—rather than as targets and instruments of—aesthetic formation. The understanding of affect as automatic, visceral, raw, nonsignifying, and hence independent of sense-making and ideology is problematic because

it resuscitates the opposition of *logos* and *aisthesis* rather than transcending it. As Ruth Leys has argued, the new affect theorists (e.g., Massumi, Connolly) share (albeit without necessarily realizing this) with neuroscientists (e.g., Damasio) the idea "that there is a gap between the subject's affects and its cognition or appraisal of the affective situation or object, such that cognition or thinking comes 'too late' for reasons, beliefs, intentions, and meanings to play the role in action and behavior usually accorded them. The result is that action and behavior are held to be determined by affective dispositions that are independent of consciousness and the mind's control" (Leys 2011, 443). She shows that the affect theorists, by adopting the Basic Emotions paradigm according to which a set of universal "affect programs" is located subcortically in the brain, posit an ultimately reductionist model of analysis. I agree with her critique. It is unfortunate that current critiques of representation tend to overstate their case in profiling affect and the body, or things, as ultimately real. The challenge, both in neuroscience and social analysis, is to come up with a viable synthesis that captures the entanglement of ideas/representations/ideology with sensation/affect/emotion. See also the previous note on Singer.

18. For an extensive outline of this approach see Meyer 2011b, 2012, 2013.

19. The term *religious real* was coined by Adrian Hermann and formed the central term of a recent workshop, titled "Religious Evidences: Audiovisual Media, Narrativity and the Production of the Religious Real," organized by Hermann, Annalisa Butticci, and myself (10 October 2014).

20. Although the term *Nollywood* elides the diversity of video film production in Nigeria (Yoruba, Igbo, Hausa), it "is here to stay because it expresses the general Nigerian desire for a mass entertainment industry that can take its rightful place on the world stage, but both the term and the phenomenon need to be read as signs that the global media environment has become multipolar, rather than that Hollywood's example is unavoidable" (Haynes 2007, 132).

21. The "African Film" conference organized by Mahir Şaul and Ralph Austen in 2007 marked a new beginning (see Şaul and Austen 2010). As Dovey explains, "African cinema" is a misleading term because it conceals major differences in style (Dovey 2009, 2). Moreover, it is problematic to reserve "popular" for video movies, thereby falsely assuming that movies in the category of African cinema do not appeal to the popular imagination. This remains to be seen. *Deadly Voyage,* for instance, was popular in Ghana (though people would have preferred a happier ending).

22. As David Murphy has argued, "the definition of an 'authentic' African cinema has remained deeply problematic. What should an African film look like?" (2000, 239).

23. I stayed in Accra to do fieldwork in the following periods: September to December 1996 (with my family), June 1998, September 1999, May 2000, mid-September to mid-November 2002 (partly with my family), January 2003, January 2008, August 2009, and mid-April to mid-May 2010 (partly with my son). The long gap between 2003 and 2008 was the result of directing a large-scale research program and accepting a full professorship, which made it impossible to do my own research. I received visits from producers in Amsterdam in December 2000,

September 2001 (for the Africa in the Picture Film festival), March 2002 (shooting *See You Amsterdam*), and September 2002. In July 2005 the movie *Idikoko in Holland* was shot partly in our house. As I will explain in chapter 1, in early 2003 the Ghanaian video film industry collapsed almost completely and only began to recover in 2005. Initially it was my plan to write a book covering the period between 1985 and 2003, documenting the rise and fall of the industry. When, much to my surprise and delight, things improved, I decided to do more fieldwork.

CHAPTER ONE

1. The history of colonial cinema in Ghana has hardly been a topic of research. Ukadike's (1994) and Diawara's (1992) overviews of African cinema also deal with the Ghanaian situation. More recently, the German anthropologist Kerstin Pinther addressed the history of cinema in Ghana up to the present in the context of her research on the cities of Accra and Kumasi (Pinther 2010, 93–107); and Carmela Garritano (2013, 26–00) offered a short sketch of colonial cinema. In the National Archives of Ghana, files on cinema in the Gold Coast are kept under CSO 15/8 (not addressed by Pinther or Garritano). The files offer insightful glimpses into the history of cinema. These files mainly offer information about the attitude of the colonial administration toward cinema and do not offer an extensive view of commercial cinema, which is addressed via lists of theaters and in relation to censorship. In my own interviews on the history of cinema in Ghana, the main point of reference for my interlocutors was cinema after Independence.

2. Pinther refers to Allister Macmillan's *Red Book of West Africa* (1968) as her source of information. Bartholomew was also trading in (Ford) cars, (Castrol) oil, and (Westinghouse) batteries. According to Mensah (1989, 8) the Palladium was the first cinema opened. I regard Pinther's source, which also contains a picture of the Cinematographic Palace, as convincing.

3. CSO 15/8/40, G. A. S. Northcote, Acting Governor Gold Coast, to Lord Passfield, 17 March 1931. Lord Passfield (Sidney James Webb, a British socialist, economist, and reformer, as well as a cofounder of the London School of Economics) was secretary of state for the colonies from 1929 to 1931. See also Burns 2002, 23–36, on Passfield's dispatch and its effects in southern Rhodesia.

4. CSO 15/8/7, containing Request from the "International Institute of Educational Cinematography to the Secretary of State for the colonies, dated 18 November 1932"; and Reply (29 March 1933).

5. Earlier letters and reports with regard to cinema kept in the National Archives of Ghana display a somewhat disapproving attitude toward cinema, with officials stressing how little personal interest they have in the medium.

6. CSO/5/8/26, Secretary of State, London, to Governor, Accra, 1 March 1940, telegram.

7. Sakyi (1996, 9) states that the Opera was opened in 1949, but Munir Captan (interview, 8 Nov. 2002) gave the year as 1940.

8. Chaplin, of course, countered the self-image of the West created by colonial film. As Morton-Williams indicated, audiences were wild about his films: "the response [of African audiences] to the old Chaplin films in particular being no less hilarious than that of the [Western] audience they were made for" (Morton-Williams 1953, 37). See also Larkin 2008, 95.

9. To my knowledge there are only two unpublished theses about the SFC/GFIC and its predecessor, the Gold Coast Film Unit (established in 1945): Mensah 1989; and Sakyi 1996. Another unpublished thesis (Collatos 2010) focuses on the rise of video in the period between 1982 and 1990. During my research I tried, to no avail, to access the archives of the GFIC; and with the transition to Gama, I learned, they no longer exist. On Nkrumah's attitude toward mass media see Anash (1993). Though the author does not refer to film, the article gives a good impression of how firm state control over mass media was under Nkrumah.

10. The Cinematograph Act included the obligation for exhibitors to have every movie passed by the board of control, which was in charge of censorship, as well as the obligation to show "films produced or sponsored by the Ghana Film Production Corporation" (1961, 4). This act resonates by and large with the colonial Cinematograph Exhibitions Regulations (1932).

11. In public debates in Ghana the strong presence of and audiences' preference for foreign movies was (and still is) often attributed to the private commercial exhibition networks run by Nankani and Captan. Such criticisms neglect the fact that the GFIC itself took an active part in screening foreign movies.

12. Ernest Abbeyquaye, interview by the author, 11 June 1998.

13. Of all cinema houses in Accra, the Dunia Cinema, located in Nima (a heavily populated quarter with mainly Muslims from northern Ghana and other West African countries), was regarded as the least "civilized." Kodjo Senah, who was born in 1948 and grew up in Osu, recalled that in his youth viewers who had no opportunity to enter the Dunia to watch an action-packed movie would express their frustration by hurling excreta and other offensive materials into the cinema hall. This may also betray a view of Nima as bastion of the primitive, echoing southern Ghanaian stereotyped views of the (Muslim) North.

14. Kofi Middleton Mends, interview by the author, 4 Oct. 2003.

15. Another internationally well-known Ghanaian filmmaker is King Ampah. His movies *The Road to Kukurantumi* (1983), *Juju* (1986), and *No Time to Die* (2007) were well received outside but barely known within Ghana.

16. Mensah states that "according to the records at Rex, Orion and Globe cinema theatres, the film was screened at the three cinema theatres simultaneously from July 1980 for several weeks with Rex cinema alone showing it continuously for two months at 6:30 p.m. and 8:30 p.m. each night" (Mensah 1989, 67).

17. Until the late 1980s, more than 95 percent of the films exhibited were foreign (Mensah 1989: iv).

18. U-matic is the video technology, developed by Sony in 1971, that preceded Betacam. Even though Betacam was already developed in 1982, in the first years U-matic was used in Ghana. Those who had invested in video at an early stage, and

thus adopted the more easily accessible U-matic technology, faced the problem of being surpassed by latecomers to the field, who immediately adopted Betacam, which became the standard.

19. It is interesting that Gyimah did not work with the GFIC, which he described as virtually defunct, but with GBC television, which produced plays in local languages and broadcast them on a daily basis. Gyimah worked together with the then highly popular Osofo Dadzie group and employed GBC cameramen and technicians. Along with producing a number of video films, Gyimah ventured briefly into satellite TV. His big clash with the state came after he had set up a satellite dish in his cinema Video City (Accra) in 1989. Police surrounded his house and made him take the dish down. According to Gyimah the government was suspicious of his activities because of his long-standing friendship with General Afrifra, who had been toppled (and executed) by the Rawlings regime (interview by the author, 3 Nov. 2002).

20. While video cameras had already been used for some time to record theater plays, Akuffo is credited with being a pioneer in the industry because he was the first to make and screen a Ghanaian movie in a cinema. The neglect of pioneering work by Gyimah may be because while Gyimah just shot his movies in collaboration with people involved with GBC television, Akuffo publicized his work more effectively and in established cinema venues, such as the theaters run by the GFIC (see also Garritano 2013, 68–69). In the case of Akuffo the relation between video and state cinema was made more explicit. At NAFTI video technology had been adopted in the late 1980s, thanks to support from the Friedrich Ebert Foundation, but the productions of NAFTI students were shown on television, not on the "walls" of the cinema houses.

21. Tellingly, the communications scholar Kwamina Sakyi, who was the secretary of the film censorship board when I met him in 1996, stated in his thesis, "The violence in foreign films and the pornographic films exhibited by some unscrupulous cinema/video theatre operators teach the youth to do evil and to indulge in immoral activities which have increased the incidence of teenage pregnancies" (Sakyi 1996, 38).

22. This implied new measures to bring exhibition and rental of videos under state control. In 1988 the Ghana Cinematograph Exhibitions Board of Control (Ministry of Information) ordered a number of raids on illegally operating video centers. All centers were required to reapply for licenses and pay their taxes, and a new law was prepared to regulate video. This operation was based on the aforementioned Cinematograph Act of 1961. I received a draft version of the new Cinematograph (Films and Video Tapes Exhibition Control) Law 1990 from Kwamina Sakyi, but to my knowledge it has never been officially installed.

23. For more detail on *Love Brewed, Heritage Africa,* and other Ghanaian films of the pre-1990 era see Ukadike (1994, 130–41, 297–303).

24. He directed and produced *Harvest at 17*, a video film warning against teenage pregnancy, for the National Commission on Culture (1992) and *Crossroads of Trade,* a documentary video film on slavery funded by the Smithsonian Institution (1994). For Ansah, however, video was only a temporary possibility and no substitute for celluloid. For an illuminating interview with Ansah see Pfaff (1995).

25. I have often been amazed by producers' willingness to attend the funerals of family members of people in the industry. Clearly, funerals were and still are important opportunities for people involved in the industry to meet.

26. Since its foundation up to the end of my research in 2010, the organization has been chaired by Steve Asare Hackman from Hacky Films.

27. Initially, this cinema had been built for purposes of previewing (and of censorship).

28. Producing posters depicting spectacular characters and scenes on canvas would deserve a separate study. I have been able to access a large number of canvas posters through the Dutch collector Mandy Elsas, also known as "Emaillekeizer," who runs a shop with African stuff near the Albert Cuyp market in Amsterdam.

29. The first video shot by the GFIC was *Dede* (dir. Thomas Ribeiro, 1992). This movie was shot both on video and on black-and-white celluloid, and the success of the video version played a vital role in convincing the GFIC board and directors to adopt this medium.

30. According to Garritano (2013, 73), in the early phase of video production (between 1985 and 1992), there were few video movies that portrayed occult forces. I do not agree with this statement. Next to *Zinabu 1–4*, in this period, in which only a few video movies were registered (seven by independent producers between 1989 and the end of 1991), a considerable number of movies involving occult forces came out, such as *Cult of Alata* (World Wide Motion Pictures, 1991), *Deliverance from the Powers of Darkness* (Sam Bea Productions, 1991), as well as the *Diabolo* series. As noted, producers claimed that they took the witchcraft scene in *Heritage Africa* as a source for inspiration.

31. This is quite different from Ganti's observation of Bollywood producers who are looking down on and are "othering" their audiences (Ganti 2012, 21). Ghanaian producers tend to cherish them and invest in striking a shared "common sense."

32. All the same Ansah also said that he was "very hopeful. I want to believe that it's better late than never. The issue of, for instance, Nigerian films not really according the positive values of Africa to me is temporary. I'm sure it can be rectified very soon. One day minds will meet to really set the stage for the African cinema to continue" (quoted in Ayorinde and Barlet 2005). Notwithstanding the major differences in outlook between Ansah and the popular private video filmmakers, they shared the same predicament of a lack of funding from the state. While Ansah quit making films and turned to setting up his own television station, private video filmmakers continued to struggle to produce films without state support.

33. Gama pursued the GFIC policy, started in 1994, of offering special production packages, including the renting of equipment (cameras, lights, microphones, vans), personnel (cameramen, gaffers, sound technicians, drivers), and postproduction facilities (editing, sound).

34. Othman attended the Sithengi television festival in Cape Town to sell movies to South African countries, and he sought to reach out to francophone Africa by dubbing the company's films into French. These initiatives, however, did not prove successful, as pointed out by Akwetey-Kanyi (e-mail message, 4 Oct. 2008).

35. This garbage heap eventually stirred public criticism of the sale of state property to an Asian private investor. The famous actor and talk show host David Dontoh brought the issue to the press. Gama defended itself by stating that the garbage consisted only of old tins.

36. Being a hybrid medium, video can be projected on both TV and theater screens, while at the same time it offers new possibilities of easy reproduction and a virtually uncontrollable illicit circulation—the specter of piracy that accompanies video filmmaking.

37. The cost of a cassette was GHC 10,000, with GHC 5,000 going to the producer, GHC 3,000 to the distributor, and GHC 2,000 to the seller.

38. At this time movies were usually shot with a Betacam camera, digitalized for the sake of editing, and then retransferred to Betacam for copying.

39. Though the Ghanaian industry started earlier than the Nigerian, the latter has the advantage of scale. Because of the huge size of the Nigerian market, it was easier for Nigerian producers to make large profits that could be reinvested in high-quality productions. With time a huge gap emerged between the quality and popularity of Nigerian and Ghanaian movies (Haynes 2007, 107–8). As we will see, however, the Ghanaian industry eventually came back.

40. These stars included Zak Orji, Liz Benson, Regina Askia, Sandra Achum, Saint Obi, Patience Ozokwor, Ramsey Noah, Richard Moffe Damijo, Genevieve Enaji, Omotola Jalade Akinde, and Stella Damascus.

41. One such movie was the aforementioned Dutch-Ghanaian coproduction *See You Amsterdam*. Other movies shot in Amsterdam were *Back to Kotoka* (Movie Africa Productions, 2001), *Amsterdam Diary* (Danfo B. A. Productions, 2005), and *Idikoko in Holland* (Great Idikoko Ventures, 2005). I was present on the set of all these movies, and my house was used as a location for *See You Amsterdam* and *Idikoko in Holland*.

42. It would be a mistake, however, to assume that the "influx" of Nigerian movies was beneficial to Nigerian producers, who suffered greatly from the fact that their movies were easily pirated, thus allowing those producing illegal copies to profit. On the whole the spread of Nigerian, as well as Ghanaian, movies through Africa occurs informally, involving networks of piracy (for an analysis of patterns of distribution of Nigerian movies see Jedlowski 2013).

43. At the same time, the Nigerian video film industry also faced major financial problems as a result of the very same issue: the piracy and illegal circulation of movies by people who had no investment in production.

44. Between 1967 (in the aftermath of the revolt against Ghana's first president, Kwame Nkrumah) and 2007, the so-called new cedi (GHC) was the country's official currency. Subject to heavy inflation, it was replaced by the Ghana cedi (GHS) at an exchange rate of 1:10,000. After 2007 many Ghanaians still referenced prices in terms of the old system. In this book I have adjusted such statements for the sake of consistency.

45. I saw the first VCD of a Ghanaian movie in Alexiboat's shop in October 2002. At that time, however, the VCD cost substantially more than a VHS tape

(GHC 25,000 compared to GHC 13,000), and Danfo B. A. did not find the time ripe for shifting to VCD. Very few people had the equipment to play these disks at that time. In the same period I also had a discussion with shop owner Alexiboat, who was considering importing cheap VCD players from Korea.

46. Doug Hendrie gives a lively sketch of Safo's way of talking and operating in the context of his Newtown office (Hendrie 2014, 162–66).

47. Interestingly, training was organized in line with the established apprentice system, through which a person aspiring to learn certain skills affiliated himself or herself with a master. It was up to the master, who received some gifts and a fixed sum in advance, to train the person until he or she was able to master the work.

48. In 2011 Salam (sometimes spelled Sallam) Mumuni released a different, more hard-core, version of *Dirty Secret* than the version accepted by the censorship board; for this reason he was "banned" for one month. See "Abdul Sallam Mumuni of Venus Films Banned," http://articles.entertainmentinghana.com/abdul-sallam-mumuni-of-venus-films-banned.html.

49. At the time, these criticisms enhanced people's interest in these movies. For Safo controversy proved to be a good promotional strategy. In 2011, however, opinion leaders initiated big critical debates that led to more severe restrictions on the part of the censorship board. Having to classify a movie as "adult only" implied that it could not be screened in public venues (and was not likely to be bought for general domestic use); this made it no longer lucrative to invest in this kind of movie. See Lotte Hoek (2013) for an exploration of a quite different way of handling pornographic scenes. In Hoek's account of Bangladeshi cinema, although "obscenity" was widely debated, movies nonetheless contained "cut-pieces," porn scenes that traveled along with the reels and could be inserted. Hoek describes a breathtaking cat-and-mouse game in which the censors chase the exhibitors of these pieces.

50. Up until 2003 the term *Nollywood* was not used in Ghana; instead, people referred to Nigerian films. Documentaries—e.g., *Welcome to Nollywood* (dir. Jamie Meltzer, 2007) and *This Is Nollywood* (dir. Franco Sacchi, 2007)—and written works (e.g., Okome 2007a) gave the name global currency. At times, to the dismay of Ghanaian movie producers, their films are subsumed under Nollywood. On the impact of Nollywood on film production and consumption in Africa see Şaul and Austen (2010); and Krings and Okome (2013).

51. They opted for *Ghallygold* because gold is Ghana's primary national resource, and Ghana is often called the "land of gold."

CHAPTER TWO

1. He told me that he knew that the people in Bukom would not like the film but that he wanted to make it, nonetheless, "to teach the people in the offices, who just talk and talk" (interview, 19 Nov. 2002).

2. In the same vein, when some filmmakers and actors attended a Ghanaian video film festival that I co-organized with the Royal Tropical Institute in Amsterdam in March 2000, many of them were quite disappointed by the look of the city—all these old, dark, smallish houses, canals, and other items that featured as prime tourist attractions were of little interest to them. When looking for suitable film spots, they found them rather in Amsterdam Southeast, an area many Dutch people intensely dislike because of the functionalist 1970s architecture on a grid topography with high-rise and, as time went by, increasingly dilapidated buildings.

3. Inspired by Edward Soja and Pierre Sansot, Lindner proposes a material approach to urban space that explores how the imaginary shapes the way physical urban space is perceived and experienced (Linder 2006, 2007). The two levels are deeply entangled. Therefore, Lindner insists, the imaginary is not arbitrary and interchangeable but is part of a real world of everyday lived experience. See also Quason, who stresses the importance of taking into account "the ephemeral" as a central aspect of urban studies, next to the usual emphasis placed on the built environment and physical urban forms (2014, 240–41).

4. *Jaguar* was the first movie I saw in Africa. When I stayed in Kpalime, Togo, for nine months in 1984, a black-and-white celluloid version was screened in a local open-air cinema. I still remember how amazed I was at the high "development" of Accra and the attraction it had for migrants from the North already in the 1950s. At that time I had not yet visited Ghana; in 1983–84 the country was completely run-down, and people were hungry. Many Ghanaians left the country, hoping to find greener pastures elsewhere. In retrospect I can say that watching *Jaguar* in Kpalime was a key experience that intrigued me and encouraged me to find out more about both modernity and cinema in Africa. A striking contrast exists between Rouch's movie and *The Boy Kumasenu,* the only feature film shot by the CFU of the Gold Coast (dir. Sean Graham, Accra 1951). With its English-language voice-over, this movie shows the complications faced by the Ewe boy Kumasenu once he leaves his village and heads toward Accra. The city is represented as a space of danger—rife with immoral activities such as drinking, dancing in bars, illicit sex, and theft, with evil things committed by people dressed liked figures in American gangster movies—that is contrasted with the peacefulness of village life. For an analysis of *The Boy Kumasenu* see Bloom and Skinner (2009); and Garritano (2013, 32–46); the short version of the movie can be seen on the website of the British Film Institute, www.colonialfilm.org.uk/node/332. The paternalism that informs the attitude toward the city in The *Boy Kumasenu* and its implicit dismissal of urban people taking up role models from outside (such as the look of the gangster) clashes with the playful representation of the Jaguar people in Rouch's movie, which asserts a more successful appropriation of the city by young Africans.

5. This was partly because the World Bank and the IMF had asked the state to divest its interest in these projects as part of the measures to restructure Ghana's economy, which had suffered severe strains under Nkrumah (Jonah 1989).

6. I remember that, in 1989, there were two spots—Bus Stop, on Accra Ring Road near Nkrumah Circle, and Afrikiko, near Sankara Circle—where global food

items such as french fries, roasted chicken, salad, and hamburgers were available. When I came back to Ghana in 1996 to start my research on video, I was amazed by the increase in this type of place, which has continued ever since.

7. The figures are based on the 2000 National Population Census (Ghana Statistical Service 2000). According to the 2010 Population and Housing Census the population of Greater Accra is close to four million (Ghana Statistical Service 2011). See www.statsghana.gov.gh/docfiles/2010phc/2010_POPULATION_AND _HOUSING_CENSUS_FINAL_RESULTS.pdf.

8. Oxford Street is the popular name of that street. Kodjo Senah told me (April 2011) that the official name is *Osu R. E. Street* (with *R. E.* standing for "Royal Engineers," whose premises occupied a large space, now used by the Police Hospital and the United Nations Development Programme (UNDP). The name *Oxford Street* came about through the initiatives of companies that organized fancy shows and carnival-like festivals to promote their products. The very name *Oxford Street,* referring to the famous model in London, is another indication of the desire, especially of youth, to partake in global consumption. According to Quason, the initial name was *Cantonment Road.* See his evocative description of a walk through Oxford Street (2014, 14–19).

9. An intriguing exception to this moral geography in which city and village were contrasted in terms of "modern" and "traditional," or "developed" and "backward," is the genre of "epics" that came up around 2000 (see chapter 7).

10. Kodjo Senah explained to me that the adoption of liberal democracy played a stimulating role in the building boom. Ghanaians outside of Ghana were prepared to come back to Ghana and invest in houses only once they trusted that it was not likely that the government would confiscate people's property, as had happened under Rawlings's military rule in the 1980s.

11. Steve Tonah (2007, 3) reports that it is estimated that 1.5 million to more than 3 million Ghanaians live abroad. The figure of 3 million is in line with an EU estimate given in 2004; see www.modernghana.com/news/63055/1/about-3-million-ghanaians-live-abroad.html.

12. Kodjo Senah is currently researching the implications of these processes on the traditional family house (see Senah 2010). See Kilson (1974) on Ga kinship and housing.

13. I got to know Floxy through my friend Adwoa Asiedu, for whom she also sewed clothes. I initially visited her to get some dresses made. In my conversation with her I found out that Floxy was a real fan of Nigerian movies. She and her girls would talk about movies a lot during work. Tragically, in 2004 Floxy died in childbirth.

14. Actually these publications offer a lot of information about the particularities of the male and female body and even go as far as to explain how to arouse one's partner—for example, by encouraging couples to have sex entirely naked and also by explaining how a woman can reach orgasm.

15. The importance of blood as a substance through which descendants are related to each other is not limited to the Ewe but also prominent among the Ga

(Kilson 1974, 17). For the matrilineal Akan blood *(mogya)* connects a person to his or her mother's lineage *(abusua)*, whereas the father passes on personal characteristics *(ntoro)*. Importantly, despite ethnic specificities, African notions of personhood in southern Ghana share a sense of being a moral person within a larger social web. Moral personhood is traditionally a matter of gradual achievement that involves taking mutual moral obligations seriously (see Wiredu 2009 for a philosophical analysis of notions of personhood in southern Ghana).

16. Pentecostal-charismatic preachers often assert the importance of buying land to build a house. Some churches even have their own gated community construction projects.

17. Senah (2010) indicated that, among the Ga, the common sign for a family house *(we)* is the *otutu,* which is a conically shaped concrete mold located in its center. On top of this is a piece of iron, and its sides are covered with cowries. The *otutu* represents the ancestors of a particular lineage and is nowadays subject to serious conflicts between born-again and other family members.

18. Interestingly, when Kodjo Senah and I watched a lot of Nigerian and Ghanaian movies on the satellite channels Africa Magic and Africa Magic Plus, we noticed a striking difference between the depiction of the fence in Nigerian and Ghanaian movies. While in the former the fence was often not well-painted, and even dirty, in the latter it was clean and well-kept. This could be taken as a sign of a stronger urge to depict a good image of one's house—and perhaps even one's personality—to the outside world on the part of Ghanaians.

19. De Boeck and Plissart show how the dream of accessing a Western version of the good life, embodied in the vision of the colonial and early postcolonial city as a site of mimetic reproduction of the model of Western modernity, has been eroded. Mimesis of the West having become an increasingly unfeasible option, inhabitants of Kinshasa developed alternative readings and visions of the city: for instance, as a hunting ground similar to the spaces of wilderness and as ultimately governed by the forces of a shadow world in which the boundary between visible and invisible is blurred, turning life in Kinshasa into an apocalyptic experience. This is somewhat different from the vision of Accra, in which old promises of "progress" and "development" are still cherished and are mobilized within neoliberal modes of action.

CHAPTER THREE

1. From 1989 on, video movies offered to censorship by private producers emerged on the list of movies censored by the board (three in 1989, one in 1990, six in 1991, and twenty-one in 1992). As part of my research I asked the censorship office to compile a list of all the movies taken to the board for approval as of the beginning of my research in 1996. Later the list was updated gradually until 2010, thanks to the intermediation of Ashangbor Akwetey-Kanyi. Between 1985 (the year *Zinabu* came out) and 1 September 1996 the list gives a figure of 237 movies registered with the censorship office. *Zinabu* was not registered because the structures were not yet in

place. A number of registered movies are celluloid productions, such as *Heritage Africa,* but also movies that are not African-made registered by churches. My figure of 220 refers exclusively to locally produced video movies. One the one hand, the actual number could be a bit higher because it is possible that not all producers registered their products. On the other hand, since in the early phase most of the money made with movies was via the box office, and public screening required that a film had been registered, I assume that the figure is reliably accurate. Though I know that by far not all films screened and sold in Accra have gone through censorship, the list gives a good impression of the rise of Ghanaian video movies, the role played in this process by independent video producers and the GFIC, and the influx of Nigerian videos.

2. Against the background of this initially frustrating experience, Spitulnik's (2000) plea to "de-essentialize" the audience and widen the frame of reception studies is well taken; for good reasons the study of media has moved from "subject-centric" approaches, which focus on reception as if audiences existed in isolation, to what Spitulnik calls "sociocentric" ones, which take into account the potential of media to stimulate the creation of social spaces that involve audiences by virtue of their media use. This is the concern of this chapter. During my research I also found inspiration in Gillespie's (1995) notion of "TV Talk," developed in her research on practices of watching television among the Indian community in Southall. What distinguishes her approach from mine is that I worked with both producers and audiences, allowing me to grasp how the latter's "film talk" and spontaneous responses were taken up by the former so as to improve their subsequent movies.

3. Maurice Merleau-Ponty (1968, 155) distinguished the living exchange between *perception,* through which we sense from *within* the lifeworld of which we are part with our bodies, and *expression,* which is the domain of signification, of making sense of that world from *without,* through language. From this perspective perception and expression are understood to be "reversible," involved in a continuous dynamic in which one feeds on the other. This dynamic entails a material understanding of language that is both the embodied ground of being—a constitutive part of a lifeworld—and the domain of making meaning about that world.

4. Sobchack, of course, recognizes film's ideological dimension and its operation as ideology, rhetoric, or poetics but distinguishes this dimension from the primary structures of "cinematic communicative competence." In so doing, she brackets ideology within a broader "secondary (but always present) notion of systematic 'distortion'" (1992, 8). My point, in contrast, is to spot ideology in the feedback or conversion of "mediated" expressions into "direct" perceptions.

5. Most filmmakers did not find producing for television attractive because TV stations were not prepared to pay a realistic price for a movie or a series. Filmmakers often exchanged the right to screen one of their old movies for slots in prime time to advertise their latest video movies on television.

6. This is how Veronica Quarshie, NAFTI-trained director of several blockbusters (*A Stab in the Dark,* 1999; *Shadows from the Past,* 2000; *A Call at Midnight,* 2011;

Ripples 1–3, 2003; *Forbidden Fruit,* 2003) produced by Princess Films, explained this feedback dynamic:

> Sometimes when we finish the film and the film is showing, when we listen to the audience, we get new ideas from them. It was from the views of the audience that we got *Ripples*. Somebody just came up with this idea like "you can still continue from this angle." That was all a person said. And we took it from there and we got *Ripples*. Recently somebody came back and said, "I think I like *Ripples*, why don't you bring the two girls together?" That is all the person said. And out of it, *Raid* [I did not find that movie in the list of the censorship board] is coming. (interview, 30 June 2000)

7. After 2005 Socrate Safo, in particular, deployed a remarkable talent in "hyping" his movies via the radio, for instance by creating some kind of scandal around the central actors (e.g., letting listeners debate whether it was acceptable for a boyfriend to leave his girlfriend because she acted in a movie, playing a role in which she was almost nude). This hyping culminated in his high investment in "love and sex" movies.

8. Tobias Wendl (2007) distinguishes three major genres—melodramas, comedies, horror films—and one evolving genre: epic films. He also notes, however, that the genres tend to flow into each other. My main point of difference is that I regard melodrama as crosscutting. See also my conclusion to chapter 5.

9. I learned from Kwamina Sakyi, secretary to the board when I started my research, that five persons were invited for a preview of a Ghanaian movie and that three being present was considered sufficient. If a film was put on review, that is, if revisions were requested, at the next screening seven persons officially had to be present and agree to pass the film. The number could be fewer, as I found when I participated in preview sessions.

10. This is remarkable, compared with the operation of video film censorship in northern Nigeria in the context of Sharia. As Adamu (2007) has shown, the censorship board in Kano successfully banned scenes depicting dance and showing body parts that were regarded as *haram* from an Islamic perspective. For filmmakers this implied a constant mode of experimentation to find out what appealed to audiences and was acceptable to the board. In 2011 the Ghanaian government stepped in and restricted the publication of soft porn.

11. This is how the movie was described for the board:

> Contemporary Ghana is saddled with a social cancer of moral degeneration. People crave for material things without giving much thought to the means by which they achieve this. The crave for wealth and lust has seen people kill, enter the drug trade, engage in fraudulent need to satisfy one's amorous feeling has also brought in its negative tendencies in society. Intruder is a social drama which highlights the above in society. It has great lessons for all. A man goes through thick and thin to win the love of a woman. Another man obsessed with the desire of winning women due to lust also uses the supernatural to win the woman. The question is, what does it profit

a man if he gains the whole world and loses his soul? This story is unfolded through the use of dramatic techniques such as irony, flashback, parallel actions, fore shadows and symbols among others.

12. Having just finished his master's thesis on cinema in Ghana (Sakyi 1996), Sakyi was still in a research mood and showed a strong interest in my work, which he kindly supported. While I myself might not have used the method of a questionnaire, it turned out to be suitable to generate valuable information both about practical matters (i.e., issues of logistics) and opinions about the industry.

13. Even though filmmakers took it as an insult when movies were likened to "concert parties," it is clear that the two occupy much common terrain, especially with regard to the ethos conveyed (Barber 2000; Cole 2001).

14. This is remarkably similar to Barber's analysis of Yoruba popular theater audiences, who, though "appreciating the possibility to laugh," spoke disparagingly of those people who went to plays "just to laugh rather than to extract a valuable message" (Barber 2000, 209).

15. Capturing a sense of being moved—set in motion—through emotions, the term *motional* is intended to provide a glimpse of the prevailing, usually implicit, aesthetics of persuasion attributed to successful movies.

16. Asare's detailed study of Christian audience responses to Ghanaian video-movies (2013) confirms my findings to a very large extent. His chapter 6, in particular, offers many fascinating interview fragments that reveal the extent to which these movies are expected to offer moral education and are prone to receive severe criticisms if spectators find this dimension lacking (as is the case with movies that are found to dive too deeply either into the realm of the occult or sex).

17. Because of copyright restrictions, video filmmakers refrained from using popular Ghanaian music, such as highlife or hiplife. This was one of the reasons why there was much use of European classical music.

18. I once was present when Safo edited *Together Forever* (2002) and worked very hard to rerecord the dialogue in correct English and underlay the pictures with correct sound. This was a rather tedious process. However, at that time Safo still insisted on this because he believed that the use of correct English was important in order to elicit recognition from the film establishment. Later he cared less because he had given up on getting this recognition.

19. Visuality has long dominated the study of film. My point is not to dismiss the visual but to look at picture and sound together. Sound, as Elsaesser and Hagener point out, can operate "as a force or a special carrier of authority" that impinges on pictures in a specific manner. Sound possesses the "power to attach, invade or manipulate" (Elsaesser and Hagener 2010, 138). See also Hughes (2009).

20. Charles was assisting me with my research at that time; he not only accompanied me on occasion but also translated for me what audiences said during the movies. The following quotes and summaries are his translations of statements originally made in Ga.

21. Opened in 1977 by a private owner, the Lascala was the first cinema in Teshie and initially belonged to the highest class of cinemas (such as the Rex and the Globe). It has a seating capacity of two thousand. The rise of video centers since 1987 has spoiled the market, especially for screening foreign movies (in contrast to Ghanaian movies, it was easily possible to show foreign movies in video centers even when there were no formal exhibition rights). At the time of my stay in Teshie Ghanaian films were screened in the Lascala on the weekends (interview with the owner, Mr. Theophilus Ashitey, alias Mr. Tolla, 16 Nov. 1996). The cinema was never well-attended and appeared quite run-down. Like many other cinema houses, it was transformed into a church.

CHAPTER FOUR

1. His narrated account follows the master format of a conventional biblical visionary narrative, containing the experience of the vision itself, the mentioning of witnesses, the documentation of the vision, and its reception. My thanks to biblical studies scholar Terje Stordalen, who pointed this out to me.

2. See Luke 9:28–36 for the transfiguration scene, which reports that Peter, John, and James prayed together with Jesus. "And as he was praying, the appearance of his face was altered, and his clothing became dazzling white" (verse 29). Moses and Elijah appeared, and Peter suggested building tents for them and Jesus. Then a cloud came, out of which God spoke, declaring: "This is my son, my chosen one. Listen to him." The meaning of this revelatory event has not only been deliberated extensively in theology but also became a major theme in art (painted many times, including by Bellini [ca. 1490] and Rafael [1520]). The Transfiguration of Christ takes as its theme the miraculous metamorphosis of human nature into divinity. Painters faced the complicated task of depicting the ungraspable divinity of Jesus. This resembles the task filmmakers face in depicting revelations. Intriguingly, the representation of the trans-figuration by Rafael also seems to appeal to African Pentecostals, as Nigerian photographer Andrew Eusebio's stunning photograph of preachers of a Nigerian Pentecostal church in Italy praying in front of a huge reproduction of the upper part of Rafael's piece shows (Butticci 2013, 62).

3. It is, however, a genre in classical literature and explicitly named in the Bible as the Revelation of John (Greek: *Apokalypsis*).

4. But see Cosandey, Gaudreault, and Gunning (1992) on early cinema. It seems that in Europe cinema has from the outset been profiled as part of a field of secular entertainment, often frowned upon by strict Christians, who were, above all, critical of the space of the cinema itself as morally problematic. Work on secularity over the past decade has pointed out, however, that the secular does not necessarily imply a clean break with the religious but instead incorporates many religious elements (e.g., Asad 2003). It would be intriguing to trace the religious roots of cinema from a postsecularist perspective that does not take secularity as signaling a radical break between modernity and a previous religiously dominated past. This is precisely why

the case of Ghanaian popular cinema, which taps heavily into Christian and other religious resources, is such an interesting case for rethinking the relation between religion and cinema.

5. The list of movies registered and previewed at the censorship office contains the following movies produced by Quartey's Paragon Pictures: *Zinabu IV* (1992), *Menace* (1992), *Bukom Lion* (1994), *Demona* (1995), and *Abaddon* (1996 and again in 1997). The list is not exhaustive; Quartey, like many others, also released movies that he did not have reviewed. He also made *Wicked Romance* (2004). Only this film and *Menace*, a movie about AIDS, are what he calls secular movies. All others address the realm of spirits.

6. Quartey was the only filmmaker I met who kept an extensive archive. Also, because there is no official archive of this industry, this is a highly valuable resource. Thanks to these materials and his passionate accounts, I got a very vivid impression of the beginnings of Ghana's video film industry.

7. In the following, *She* refers to the novel as a whole; She is the short version of "She-who-must-be-obeyed," the name that outsiders use to refer to the title character; and she is used as a pronoun.

8. H. Rider Haggard framed the novel as a story within a story. The outer frame is the "editor," who publishes the narrative he received from Horace Holly, whom he once met briefly "at a certain University, which for the purposes of this history we will call Cambridge" (1887, 1). The editor occasionally writes footnotes about certain issues in the main text. And so does Holly, the narrator of the story. These footnotes serve to enhance the truth effect of the novel. The narrative is underpinned by a thick Christian subtext, easily recognizable for anyone versed in biblical literature, such as a large portion of the British audiences of H. Rider Haggard's time, as well as contemporary Ghanaian ones.

9. This quote from *Hamlet* figures in the document that Holly received via Leo's late father and that offers the information that convinces them to set off for Africa. In a footnote Holly observes that there is a small mistake in the quote (in the original, *Horatio* is not placed at the end of the sentence but between *earth* and *than* in the original) (Haggard 1887, 41). This tiny mistake allows Holly to date the edition of which the quote is part to the mid-eighteenth century. He proposes that the author, one of Leo's ancestors, used an acting copy of *Hamlet* that appeared around 1740. Remarkably, the editor wastes no word on the far more salient convergence of names between the Horatio in *Hamlet* and Horace Holly in *She*. Obviously, already by virtue of his name, the latter is predestined to question "his philosophy" and open it up to the reality of the imaginary.

10. Shepstone's key question was how to rule in the absence of an army or other institutions—how to coerce local populations to submit to British sovereignty? H. Rider Haggard assisted Shepstone when the British secretary of state for the colonies put him in charge after the annexation of the Transvaal in 1877. His encounters with colonial officials and ethnographers had a profound influence on his later writings. Establishing himself as a widely read commentator on British policies in South Africa, in particular regarding the Zulu kingdom and the British-Zulu war (1879),

Haggard criticized British policies, demanding a return to Shepstone's system of governance, which was based on incorporating the Zulu system of political authority.

11. Quartey told me that he did not like the movie (I do not know which of the many versions he meant), which he saw long after he had made *Zinabu*.

12. I took a photograph of this text and transcribed it afterward. Here I present it with minimal editing of punctuation to convey the typical style in which Quartey writes and speaks.

13. There have been four parts of *Zinabu*. The first two parts were not registered. *Zinabu III* was registered by Akuffo's World Wide Motion Pictures in 1991; *Zinabu IV* was registered by Quartey in 1992. Unfortunately, there is no institution in Accra that archives video movies. Producers do not always keep copies, as the industry is driven to make ever better movies. Of the original set, I have only been able to watch *Zinabu III* (I received it on the tape that Akuffo presented to me along with *Diabolo* in 1992) and a remake of part 1, titled simply *Zinabu*, that was reshot in 2000 (dir. W. Akuffo and R. Quartey, World Wide Motion Pictures / Paragon Pictures, 2000). Since *Zinabu*, being counted as the first Ghanaian feature video movie, was still very much alive, I heard a lot about this movie.

14. But it goes further than the pact with Mami Water, which requires sexual abstinence from her adepts with regard to real people in daily life but entails a sexual-erotic relation—"in spirit"—with her.

15. Akuffo told me that the censorship board objected to this scene, as it was found to be culturally inappropriate to show a male pastor pray at the bed of a woman in labor. Eventually, he cut the scene for the sake of the preview at the censorship office but reinserted it for the version that circulated.

16. In Ewe, for instance, *spiritual* and *physical* are called *le gbɔgbɔme* (*gbɔgbɔ* meaning spirit and breath; *gbɔgbɔmenue* could be translated as "it is spiritual") and *le nutilame* (*nuti* meaning body and matter). This resonates with the ideas about the relation between the "spiritual" and the "physical" among the Ga (who use *mumɔn* and *gbɔmɔtsɔ;* a "spiritual matter" is called *mumɔn nii*) and Akan-speakers (who use *sunsum* and *honam;* a "spiritual matter" is called *ɛyɛ sunsum asem*).

17. Ironically, the missionary project engendered a shift from approaching the "spiritual" as a domain understood to be opened up via *knowledge gained through superior vision,* as was the case traditionally, to an emphasis on the "spiritual" as involving *belief in an invisible God.* One of the central ideas underpinning nineteenth-century Protestant missions, including the Basel Mission and Bremen Mission active in southern Ghana, was the trope of the unknown God, who was recognized (albeit according to missionary documentations of their conversations with local people) as governing the order of the world and yet held to be inaccessible and unrepresentable, per se. Therefore, the high God (*Mawu* in Ewe, *Nyame* in Twi, *Nyonmo* in Ga) played a minor role in the religious imagination and practice, which evolved around specific gods (*trɔwo* or *vɔdu* in Ewe, *abosom* in Twi, *dzemāwɔn* in Ga). The missionaries called Africans to turn away from the worship of these gods to the worship of the Christian God (the local names were retained) and take Jesus

Christ as intermediary. This missionary Protestant project boiled down to propagating a modern, mentalistic idea about religion in terms of belief that African converts, however, deeply contested.

18. This echoes the language of nineteenth-century and early twentieth-century Western Spiritualist experimentations with spirit photography. Embedded in séances, the camera was framed as a device to "materialize" a spirit in a photograph. As Heike Behrend points out lucidly: "'Materialization' signified the capacity of the spirit to become a picture, to gain a visible shape out of light, vapor, smoke, or ectoplasm" (2013, 230; see also Stolow 2008). Behrend contrasts the Spiritualist framing of photography as a suitable technology to make a spirit appear with African practices of spirit possession in which persons are the prime medium of spirits, whereas photography is rejected because it is taken to freeze the spirits that are understood to be in motion. I will pursue this issue in chapter 7.

19. I introduced Akuffo to Jolyon Mitchell, whom he told in an interview (later broadcast by the BBC) that his movies "don't reflect my belief at all. They've got nothing to do with my belief because to start with I don't believe in all the Christian crap that is going on around me, although I don't believe in this Africanian [Afrikania Mission, the neotraditionalists] thing so . . . I am not an atheist; but I believe there should be a supreme being somewhere but since I haven't seen him, I don't bother myself very much about him. I don't think my films reflect what I think at all" (Mitchell 2007, 110).

20. Sometime later, the Opera was turned into a shopping center, which meant the end of the building's use as a cinema and as a church.

21. In April 2004 the Nigerian Broadcasting Corporation (NBC) banned the broadcasting of this kind of miracle on TV and radio because, as it was put, the pastors were unable to verify them. The reactions of those defending the broadcasting of these miracles were very interesting. As expected, it was argued that faith transcends reason, but it was also claimed that the NBC itself failed to offer scientific standards of providing evidence. Perhaps most interesting, it was claimed that the ban violated the constitutional right of freedom of religious expression. The popularity of such programs shows—albeit in extreme form—how Pentecostals engage in various audiovisual techniques of make-believe to make themselves seem successful and make others believe.

22. One time he told me (interview, 11 Sept. 1999) that he had also accepted the role of a bad pastor, but this didn't go down well with the people who preferred to see him as a true Man of God. This was the case in *Diabolo IV*, where he played the role of a pastor who was lured into doing evil by the devil. In Cofie's view the important message of that film was that "when Satan comes into you, he uses you to destroy, and in the end you yourself are destroyed. The devil can just use you irrespective of your standing, even if you are a pastor." He told me that audiences wondered why a pastor should swallow a snake (as happened in that movie). He himself found that it was very realistic that even pastors might be so weak that the devil gained access to them (a topic that became much debated in the early 2000s). However, believing that God always overcomes the devil, he did not agree with Akuffo's

idea of letting the pastor die in the movie. Because of this disagreement, they stopped shooting for a whole week, until Akuffo came one Sunday to tell Cofie that the pastor would not perish but instead be exorcized by a senior pastor.

23. Filmmaker Augustine Abbey introduced me to Akoto, and we had an interview in his home in Madina on 22 November 2002.

24. As Onookome Okome (2007b) has argued (see also Haynes and Okome 1998; Oha 2000), the prototype for this kind of movies is Kenneth Nnebue's blockbuster *Living in Bondage* (dir. Chris Obi Rapu, NEK Video Links, 1992]).

25. The omnivision of the Christian God is figured compellingly in an artwork by the popular painter Almighty. He used a broken mortar and adorned it with lots of eyes and a not always grammatically correct text, stating, "The Supernatural eyes of God the Father Sees all Things. So we must be extra careful. When you go under the sea, the great eyes have seen you. I am afraid of the eyes of God. If you hide under a mortar God have seen you. God saw you. Be careful."

26. This resonates with long-standing missionary attitudes toward vision. For instance, the lithograph *The Broad and the Narrow Way* (Meyer 1999b, 31–40) places the all-seeing eye of God at the top of the universe, while all images in the lithograph are accompanied by biblical references. Here the Bible is introduced as the key to understanding the meaning of pictures. In Pentecostalism the all-seeing eye of God is mimetically appropriated as the Spirit of Discernment. This again, is audiovisualized in the movies.

27. This material attitude toward speech among Christians resonates with long-standing ideas that, as Peek argues, exist across Africa that speech "is not *about* something, it *is* something" (Peek 1994, 475). This attitude spills also into communication with the spirit world: "The utterance of prayers has acoustic significance because special sounds, not simply sacred texts and ritual behaviours, insure that the prayers will be heard" (Peek 1994, 479).

28. This resonates with indigenous ideas about the dangers inherent in seeing the spirits face-to-face. Normally spirits are rendered present through mediation, especially spirit possession. Spirits are held to appear, as it were, as themselves in the night, and ordinary persons must be careful *not* to meet them, as this would drive them mad. During my field research in Peki in 1991, people warned me about the dangers involved in my nightly bicycle trips, which led me past a silk cotton tree that was held to be a site where spirits met. And I might also come across the god of the market, a bare-breasted woman who was moving about. I never saw any spirits. Later, during my research in Teshie in 1996, I was warned about the danger of being on the beach at night, where Mami Water could appear. I was told that those who dared to call her had gone mad. Stressing that seeing the spirits would result in madness, the accounts spotlight the dangerous, maddening potential of revelation through which these occult forces are rendered visible.

29. It is rooted in the mystical encounter with Jesus experienced by the seventeenth-century French nun Margaret Mary Alacoque (1647–90), who experienced a trancelike vision of Jesus holding his bleeding heart in front of her (Morgan

2012, 112–20). Speaking to the popular Catholic imagination, Alacoque's experience triggered a number of visual representations. Pompeo Batoni's *Sacred Heart of Jesus* painting (1767), placed in the Jesuit Il Gesu Church in Rome, became the prime pictorial model around which the devotion of the Sacred Heart of Jesus spread (Morgan 2012, 119). Recycled in numerous versions, it circulated and still circulates via prints, posters, tattoos, and, recently, devotional websites and online shops all over the world. Its use is no longer confined to or controlled by the Catholic Church.

30. This debate touches on the complicated issue of the (im)possibility of representing the divine in Christian theology. The fear that a picture of Jesus could operate as a mask for the satanic comes with its own ironies. As Hans Belting points out, the Roman Church Fathers understood Jesus as a "mask" (in the sense of *persona* or role) of divine nature, performed by Jesus just as an actor also performs his role (Belting, 2013, 68–69). This positive understanding of the mask, as necessary for conveying divine nature to humans, collides with deep concerns expressed by strict southern Ghanaian Pentecostals about the deceptiveness of figures attempting to represent the divine—hence the keen interest in a mimetic appropriation of divine vision.

CHAPTER FIVE

1. In his illuminating genealogy of the notion of "occult sciences" Wouter Hanegraaff shows that this notion emerged in the context of twelfth- and thirteenth-century scholasticism in the aftermath of the rediscovery of Aristotle's writings. The concept of the occult operated as an "instrument for disenchantment used to withdraw the realm of the marvelous from theological control and make it available for scientific study" (Hanegraaff 2013, 7; see also Lambertz 2015, chap. 2). This is remarkably distinct from the nineteenth-century association of the occult with irrationality. As far as I can see, a systematic study of the spread of the term *occult* across the world, taking into account processes of translation and adoption into local settings, remains to be written. Regarding Africa, my impression is that the term *occult* had a dual reference that echoes its association with (secret) knowledge, on the one hand, and the realm of the demonic, on the other. With increasing pentecostalization, the second association became increasingly dominant.

2. This is not the place to discuss in detail the implications of the ontological turn to the study of religion. Let me just note that I acknowledge the critical potential in the ontological turn to question "how anthropology makes its object" (Fabian 1983) via the use of distancing concepts and to offer a "technology of description, which allows anthropologists to make sense of their ethnographic material in new and experimental ways" (Pederson 2012). But I have a problem with the lure of the real that is mobilized by those who are "in" the turn. The very notion of ontology refers to *statements* about being, not being as such, as tends to be claimed by current ontologists. Also on the ground level of our interlocutors in the field, we do not simply face a real that is just there but a world constituted through modalities of

making sense. Therefore I agree with James Laidlaw and Paolo Heywood's (2013) perceptive critique of the ontological project for failing to acknowledge (a) the contradiction enshrined in the claim of ontology referring to both being (the real thing) and being plus theories about it and (b) its own metaontological epistemology. See also Meyer, forthcoming.

3. While the film scholar Green-Simms agrees with my point that there is a shared ground between Pentecostal ideas about vision and Ghanaian video movies (Meyer 2003b), she criticizes my earlier work on video movies—rightly so—for neglecting the use of "domestic dramas and visual effects to successfully recreate the sensuous impact of occult rumors" (Green-Simms 2012, 32). In the meantime, as this book also shows, I have developed a neophenomenological approach to film that takes perception's groundedness in the body as a starting point (see also Meyer 2009a, from which point I develop the notion of aesthetic formation).

4. During my stay in Teshie in the fall of 1996, many people talked about the spectacular story of the ghost of a schoolteacher who had continued teaching his class at the respectable Labone Secondary School for some days after his death (according to some stories, up to twenty-five days, according to others just for two days). Incidentally, this teacher was the half-brother of Edwin Akita, one of my main interlocutors at the time, who gave me more details about the story. His half-brother had two wives living in different places, which is why at first he was not reported missing. Eventually, the family consulted a diviner in Togo, who disclosed that the man's body could be found in a mortuary in Accra, where it turned out that he had been hit by a car. Edwin attributed the fact that his half-brother could still go and teach to the fact that, as a Buddhist, he had special powers. The case was widely reported in the newspapers. People tagged other stories about returning ghosts onto this news item, so I heard a lot about people's anxiety that their departed family members might return as ghosts. In the course of my earlier research among the Ewe I learned much about *ametsiava,* the ghosts of people who had died a violent death and could be controlled only if they were worshipped. Temporarily possessed by these ghosts, priestesses reenacted the accident that had caused the death (Meyer 1999b, 183–84).

5. Analyzing the movie on the level of content, Garritano argues that *Ghost Tears* is oriented toward the interior of the middle-class home, suggesting a moral economy according to which "it is unrestrained self-interest that destroys familial and social ties, and it is gender that organizes this morality. Kwesi is weak and indecisive, while his wives are violent, brutal and controlling" (Garritano 2013, 108–9). Although I agree with this analysis, my interest here is not the moral plot of the film, per se, but the more narrow issue of the modalities through which the ghost is pictured.

6. Compelled to return to the place where he disposed of her body, he is beaten by her ghost with a stick. He reaches home bleeding profusely and, in dying, asks his wife to forgive him.

7. This resonates with the point made by Peek (1994) about speech from the otherworld. Made to speak in a distorted manner, involving nasalization, buzzing,

howling, and so forth, spirits assume an awesome sonic presence. Peek argues that this way of speaking operates in analogy to the mask that conceals yet also reveals. It is intriguing that video filmmakers, in audiovisualizing ghosts and other spirits, synthesize cinematic conventions with regard to the use of sound to convey an uncanny presence with long-standing ideas about spirit speech.

8. In so doing, he affirmed the fight against ancestor worship that was already undertaken by the scribes who wrote the biblical literature, as in Deuteronomy 18:11 and Isaiah 8:19, which was apparently just as relevant then as it is now in Ghana and elsewhere in Africa.

9. They did so with some regret, though. This became very clear to me when, in December 2000, I watched the Hollywood movie *What Lies Beneath* (dir. Robert Zemeckis) together with H. M. and actor Victor Lutterodt in the Amsterdam Pathé Cinema. The movie is about the wife of a university professor who feels haunted by a ghost in her house and gradually realizes that this is the ghost of her husband's first wife, whom he murdered. H. M. was thrilled by the use of sound, which made the film quite frightening (at least in my experience), and complained that ghost films had become so contested in Ghana.

10. Safo, who directed *Ghost Tears* and *Step Dad,* pursued the ghost theme later on in *Together Forever* (Movie Africa Productions, 2002). This is a remarkable movie about two lovers engaged to each other via a blood covenant. The man, a Ghanaian fireman, is an intern at the New York City Fire Department in September 2001 and perishes in the flames of the 9/11 disaster. He returns to his fiancée in Ghana as a ghost, although the fiancée is not aware of his death. They make love, and she even gets pregnant, when, to her shock, she receives a visit from the fireman's boss, who tells her that her fiancé died in the World Trade Center disaster. Here a ghost does not return to take revenge but to take possession of his girlfriend out of love sealed by blood. This resonates with stories people told me about ghosts who return to their spouses, too jealous to allow them to find a new partner. As usual, the movie asserts the existence of the ghost, in this case by the frightening fact that the woman becomes pregnant.

11. See, e.g. Debrunner 1961; Field 1960; McCaskie 1981; and Meyer 1995, 253nn23, 27; see Onyinah 2002, 96–97, for a summary review in the context of his impressive dissertation on Akan witchcraft. Onyinah stresses that in explaining the rise of witchcraft fears and new antiwitchcraft shrines visited to redress a sense of insecurity, authors tended to overlook that the colonial administration banned traditional means of dealing with witchcraft: "Since the chief's power was weakened and the colonial masters did not have enough knowledge about the Akan system, people were bound to resort to these new shrines to redress their problems. Thus the proliferation of these cults can be linked with the disintegration of traditional institutions, especially the chieftaincy, by the colonial government, which resulted in the lack of control of new *suman* ('fetish'); any self-claimed *ɔkɔmfoɔ* [priest] could function without controls from traditional authorities" (Onyinah 2002, 97). This issue of the disintegration of traditional institutions is addressed in more detail in chapter 7.

12. I heard countless references to witchcraft during sermons and prayer sessions. Prayer is taken as an effective means to both protect a person from falling victim to witchcraft and to deliver a witch from his or her craft. Witchcraft talk is also reproduced in booklets and recorded sermons. See, for instance, three very popular CDs, all devoted to the topic of witchcraft, by the Bishop James Saah (Christian Action Faith Ministries; see Asamoah-Gyadu 2013, 52–54). I do not know the year in which these CDs were published; I bought the set in 2010.

13. Onyinah explains that the Akan notion of *ahoboa* is thought to be an indispensable aspect of a witch as "the animal power that is within me" (2002, 73). It can be carried on the body of the witch, for instance in traditional beads, or be kept in the genitals. He concludes: "it can be said that the witch-spirit animal is thought to be the real power that the witch possesses; without *ahoboa* there is no witchcraft. The belief that both the witchcraft object and the witch-spirit animal are spiritual, places *ɔbayifoɔ* (the witch) above the level of an ordinary human being—'a human spirit-being'" (Onyinah 2002, 74).

14. *See You Amsterdam* (Vista Far Reaching Visuals and H. M. Films, 2002) was based on the experiences of a Ghanaian migrant to the Netherlands. The script, by Pius Mensah, included a witchcraft scene. It took Mensah and others (including me) a long time to convince Seth Ashong-Katai, who had been invited to the Netherlands to direct the movie, to shoot such a scene. A fervent critic of superstitions, he refused to represent witchcraft in his movie. As a compromise he eventually agreed to use a dream as a frame for witchcraft, as was also the case in *Love Brewed,* implying that a dream belonged to the sphere of fantasy. Ironically, however, for many spectators a dream is a medium for realistic revelation.

15. Salient here is that Robbins's *Encyclopedia* is a scholarly work that "attempts a rational, balanced history of the three centuries of this horror" (the persecution of witches in Europe), pointing out that as "witchcraft is a Christian heresy, the subject is clearly delimited to western Europe, and, by extension, to the brief flicker at Salem.... Sorcery, as practiced in Africa, Central and South America, or elsewhere is not treated in this volume" (Robbins 1959, 1).

16. The scene ends with Quartey pulling out a copy of *Making Horror Costumes and Disguises* (Malcolm Carrick 1978), a children's book that teaches how to make costumes of werewolves, mummies, and the like.

17. This long-standing fusion makes it impossible to sketch the iconography of a witch in precolonial times, that is, not yet shaped by Christian witchcraft imaginaries. Important in local (Akan and Ewe) imaginations of witchcraft is the forest monster Sasabonsam, described by Yao Adawua, alias Bonsam 'Komfo (e.g., "the priest of a *Bonsam*"—note the family resemblance between this title and the one taken by the current Kwaku Bonsam [see chapter 4]), to colonial anthropologist Rattray as follows: "'Sasabonsam is my master, he helps the nation, he is very tall, has long thin legs, long hair, very large red eyes, sits on an odum tree and his legs reach the ground'" (Rattray 1927, 29). *Sasabonsam* was held to operate in league with *mmoatia* (little people or dwarves) and *ɔbayifoɔ* (witches) at night in the bush. Rattray opined that he "cannot help thinking that the original *Sasabonsam* may possibly

have been the gorilla" (28). Among Christians, Sasabonsam is also understood as an avatar of Satan (Meyer 1992).

18. Hagenbeck started as a fish merchant in Hamburg, the city Drewal calls "Europe's gateway to the exotic" (2002, 194). Feeding the romantic appetite for the exotic, he organized spectacular shows and opened his—still famous—zoo. Pictures like that of the Indian snake charmer represented an orientalized otherness for Europeans. Intriguingly, along the West African coast the same picture was taken as an icon of the lure of the foreign as imagined from an African perspective. The use of the same picture to imagine identities from significantly different vantage points complicates facile ideas about the homogenizing effect of the spread of global imagery and points to its colonial substrate.

19. These cults were grafted onto older imaginaries of water spirits. See Isichei (2008, 229) on water spirits in Igbo communities between the Niger Delta and Douala: "Mami Wata is, in a sense, a generalized and mutated form of a multitude of local cults of water spirits, often, but not always perceived as female." Snakes and crocodiles, as amphibian animals, have long been associated with these spirits, who were imagined as being partly human and partly animal.

20. During my earlier research in Peki, I came across quite a number of women who claimed to be possessed by Mami Water and who were initiated into the Abidjan Mami Water shrine at Adomi Bridge (Meyer 1999b: 202–4, Opoku and O'Brien Wicker 2008).

21. On the representation of same-sex relations in Ghanaian movies see Green-Simms and Azuah (2012).

22. In the Bible the books of 1 and 2 Kings feature Jezebel, a Phoenician princess, instigating her Jewish husband Ahab to convert from worshipping Yahweh to Baal. Jezebel has been taken as the prime exponent of a false prophet and false and fallen woman.

23. During my stay in Teshie in 1996, this movie was wildly popular; young women in particular talked about it a lot and brought a copy of the movie to watch in our house. Invoking Emmanuel Eni's best-selling testimonial account *Delivered from the Powers of Darkness* (1988), the story linked up seamlessly with testimonies given in Pentecostal churches about sexual encounters with Mami Water, a hot topic at the time.

24. Carroll's sketch of Western audiences is not based on reception research but part of his "philosophy" of horror. I agree that the reconfiguration of religion in post-Enlightenment Western societies was a key condition for the rise of the horror genre. But this does not imply that all members of these societies shared the typical stance of disbelief sketched by Carroll. As I have mentioned, I myself find it difficult to watch movies or read stories designed to effect horror because I easily feel frightened to death, feeling compelled to withdraw by closing my ears and eyes, yet I am somehow intrigued. I am certainly not the only person who feels like this. The horror genre generated critical debates among Christians, as recent American fundamentalists' and Pentecostals' objections to the dangerous impact of Harry Potter also show.

25. In a recent essay on Indonesian horror movies Mary Steedly explains that even though "audiences may believe in the existence of secret powers at work beneath the surface of the visible world, they do not confuse the occult images displayed in cinema with the real ghosts. Everyone knows that these are imaginative re-creations, illusions produced by camera tricks and special effects" (Steedly 2013, 282–83). She argues that the "forms of authentication" employed within the movie to vest ghosts with truth "situate the occult media image within a field of truthfulness that is itself a fiction" (282–83). Critically engaging with one of my essays (Meyer 2003a) on, as she puts it, "popular horror movies in Ghana," Steedly questions my point that movies promise to "paradoxically reveal an invisible, mystical ('unmodern') world," arguing that this promise would be "undercut by the inner logic of these films." Here she refers to the Indonesian horror movies that are central to her analysis. From the way she describes these movies, I get the impression that they are designed quite differently from the Ghanaian movies engaging in revelation (which then and now I would not call "horror movies"). In the Indonesian movies the ghosts are made to emerge in conditions of "limited visibility," making the spectator look for the ghosts, and in so doing realize that he or she is being seen. By contrast, as I have pointed out, the format of revelation in Ghanaian movies operates in a different manner, primarily mimicking the "spiritual eye." Although I find Steedly's work compelling, I do not see how her Indonesian case material can be invoked to criticize my work on Ghanaian film, which, as I argue throughout this book, is deeply intertwined with popular Christianity. The difference calls for a comparative study of the horror genre.

CHAPTER SIX

1. Although the book's web page is no longer available, the synopsis is available at www.amazon.co.uk/Nollywood-Pieter-Hugo/dp/3791343122; for the picture see www.pinterest.com/pin/65443619320722228/.

2. Significantly, people often congratulated me on being an outsider who did not "believe" in (the existence of) such spirits and hence could not be affected by them. Even though my interlocutors themselves would prefer not to believe at all that such spirits existed, they could simply not help doing so, because spirits were part of the world into which they had been socialized (and, as noted, popular Christianity confirmed these spirits' existence as demons). Combining a relative and an absolute component, this use of the notion of belief leads beyond the usual Western distinction between "believing in" (a statement that assumes certainty about the existence of what is believed, along with personal commitment) and "believing that" (a propositional statement that could be proven wrong) (see Robbins 2007, 14).

3. *Sakawa* was the craze of the town in 2008 and 2009. Trans-figuring rumors into tangible pictures, a number of video movies were made that became a serious part of public debates about sakawa (*The Dons of Sakawa* [Venus Films, 2009]; *Sakawa 419, 1 and 2* [Miracle Films, 2009]; *Sakawa Girls* [Blema Productions,

2009]; *Sakawa* [Big Joe Productions, 2009]). Recognized as revelations, these movies were taken as proof of the reality of the phenomenon. In 2010 concern about *sakawa* had died down. In a conversation on the set of *Sakawa Girls* in Tema (25 August 2009), Safo told me that he did not take *sakawa* for real. I challenged him: "But your films may be cited as evidence, while you yourself do not even believe that *sakawa* exists!" He told me that there had been a discussion on Peace FM that was critical of filmmakers like him for reinforcing rumors with their movies. He found, however, that as a filmmaker and artist he was free to make "films about stories in society" to "educate people." This was what he did, and he did not see anything wrong with it. Of course, he made a lot of money, especially with the first *sakawa* series *Sakawa Boys (Mallam Issa Kawa) 1, 2,* and *3* (Movie Africa Productions, 2009), of which he sold about 122,000 copies (given that he needed to sell about thirty thousand copies to break even, this meant a tremendous profit). For Safo *sakawa* meant "something like hitting the jackpot"; it was "a way of making money out of nothing" (and, as such, related to older money-generating occult phenomena like *nzema bayie* [see chapter 5]) that also yielded a huge income for those reporting about it. Here the claim to be making movies that reveal the machinations of occult forces as talked about in rumors actually flips around into making films that generate rumors, hence bringing about the very phenomenon that they claim to report.

4. I met Bentus for the first time on the set of *Sakawa Girls* in August 2009. At that time he was twenty-five years old. He deeply admired Safo for having a "good nose" for appealing themes that he could quickly convert into movies. Bentus got into acting when he was a youngster and played roles—including that of Jesus—in theater plays in school. At first he hung out on movie sets, lending his services whenever needed. He worked as a PA (production assistant) and could handle the boom and record sound, but his dream was to be an actor. Combining several tasks in the process of filmmaking allowed him to make some money. The first movie he played a role in was Safo's *Subcity* (2006), a movie about the dangers of HIV in Bukom. He claimed that he introduced Safo to one of his friends who had been down and wretched yet all of a sudden had money and cars and went to the Internet café: a clear sign of involvement in *sakawa*. At that time his friend was withdrawing from it and was prepared to "reveal a lot about it." His story inspired *Sakawa Boys,* in which Bentus played one of the lead roles.

5. It also happened regularly that an actress, once she was engaged, would refuse to play scenes that involved kissing, often at the request of her future husband's family. Playing the role of lover could potentially harm a woman's reputation of being a decent wife.

6. Trained as an actress and working for the National Theatre, Edinam Atatsi was one of the most respected actresses around, especially in the early years of my research. She was lauded for having worked in big productions, such as *Harvest at 17,* by Kwaw Ansah. I met her many times, also on the set of *See You Amsterdam* in Amsterdam. The information given here is based on an interview conducted on 1 June 2000. Given her standing, her acceptance of playing the role of Dufi generated criticism from audiences, who found it difficult to accept that one of the stars and

moral heroines would play the role of a witch. These misgivings are a symptom of typecasting: because Atatsi was famous for playing the roles of positive heroines, spectators were appalled by her taking the role of witch.

7. Emmanuel Armah was a well-known, middle-aged, popular actor who had been acting on the stage since 1986 with his troupe Theatre Mirrors and who also had participated in the film industry since the early 1990s. He was trained and kept working as a tailor in addition to acting and also produced clips for product advertisement to make ends meet. He played the male lead in many films. In 1998 he went to the United States at the invitation of a cultural foundation to perform on the stage. This turned out to be a disappointment, however, so he started working and returned with a considerable sum of money. He played roles in Nigerian films, as well. Producers saw him as easygoing and reliable. These qualities made him quite special in comparison to other stars who were notoriously late, refused to learn their lines, and the like. I met him many times, and he became one of my key interlocutors.

8. Pype (2012, 145–46) recounts a shocking event in which she played the role of a mermaid and was almost injured by another actor who nearly cut into her eye with a knife. The born-again actors in her troupe immediately related the near accident to her lack of faith. It was regarded as extremely dangerous to play the role of an occult force like Mami Water, certainly for a person like Pype, who was vulnerable (but at the same time, given her white skin, a very suitable actress to play a mermaid). In principle the leader of the troupe would assign the roles of evildoers only to people with a strong Christian spirit (Pype 2012, 135).

9. Traditionally, in southern Ghana a broom is used to cleanse a site of pollution and to whisk away misfortune.

10. Note the irony involved in this pictorial representation: exoticizing, stereotypical Hollywood imaginations of voodoo, which referred to the cults developed in Haiti by former slaves from West Africa, were appropriated to picture the indigenous cults around *vodun* at home. An instance of a transatlantic circulation of imagery initially from West Africa and deployed in the Caribbean coming back to its cradle: a pictorial backlash.

11. Developed in analogy to Silverstein's notion of "language ideology," according to Keane the notion of semiotic ideology refers to a largely implicit definition and valuation of signs—words, things, pictures—that underpin practices of speaking and other modes of signification in everyday life. I find the notion of semiotic ideology compelling because it situates semiotic issues on the level of the status and value ascribed to cultural forms and thus on the level of the very conditions that make signification possible. Rather than merely asking about the content conveyed by signs, the prime question is how they are valued and what they are believed to do. This approach is useful to trace overlaps between attitudes to pictorial representations and human acts in the sphere of traditional religion and Christian practice, on the one hand, and on the film set, on the other.

12. The reverse—simulation of divine power becoming real—was also believed to occur. On the whole actors were not at all fearful about the possibility of

simulating Christian practices such as prayer, sermonizing, exorcisms, and the spiritual battle against demons, probably because most of them saw this as positive. Akuffo recalled, however, that when shooting *Zinabu III,* the actress playing Zinabu did not like real pastors praying for her. Initially, when she was touched by them she moved her legs violently, making the camera almost fall to the ground. Akuffo looked on in amazement and saw that the "pastors really delivered the woman." Then they went on shooting (interview, 1 Oct. 2002).

13. Ironically, dismissing the practices and objects used in indigenous cults (and, for Protestants, also in Catholicism), this semiotic ideology tends to downplay or even deny the material dimension of Christian worship (Meyer 2012). This applies to a greater extent to Protestants and Pentecostals than to Catholics, who tend to be more prepared to acknowledge the role of humans, the performance of rituals, and the use of sacred artifacts and pictures in religious worship. At the same time, especially on the level of popular grassroots Christianity, religious acts of calling on the Christian God are regarded as effective and the Holy Spirit as the epitome of hyper-effective power.

14. Interview on the set of *The Turning Point,* 29 Sept. 2002. Setting up a shrine is understood to be potentially dangerous not only by Christians (like this set designer) who fear the demonic power of the "idol." Local indigenous priests also take various precautions. As Blier points out in her detailed study of the fabrication of *bociɔ* figures in the Fon-speaking area (including the Ewe among whom I conducted my first research), these figures demand that their users be "prepared for the unknown": "For in initiating an action through the making of such objects, one is entering into the realm of the unfamiliar (i.e., if every *bociɔ* is unique, there is no real way of knowing how it will work)." Hence, "many perceive there to be a very real danger in the process of uniting things which are by nature opposed. The production of this sort of mixed metaphor in which matter is detached from its original context and pressed into [a] new combination of elements is clearly risky" (Blier 1985, 72–73).

15. This resonates with the distinction that many local cults make between carving figures for use in a shrine and their activation by a priest, involving the use of alcohol, saliva, blood, incantations, and the like (for an explanation of activation in the case of *vodun* see Blier 1985, 74–82).

16. Victor Lutterodt was a famous actor in the 1990s and early 2000s. He often played the good guy and romantic lover but also took some roles as an occultist. Along with acting, he worked as an immigration officer at the airport. Lutterodt was married and a member of a Pentecostal church. Once his pastor called him and expressed his disappointment about his playing evil characters and having love affairs. Lutterodt retorted, just like Edinam, that the movies served "a better, moral purpose" and that, to achieve this, someone had to play the devil. He told me that he would listen to his wife, who would read the scripts and then tell him whether he should accept the role. She did not want him to go too far sexually, whereas "the juju things are no problem" (interview, 2 June 2000). He acted because he loved film and greatly enjoyed his roles as a lover, in particular. In December 2000 he visited

Amsterdam together with H. M., and they both stayed with my family and me. This gave me the chance to have a lot of conversations with him about the industry.

17. She said that she had received her witchcraft from the two grand dames in Ghanaian popular cinema, Grace Omaboe and Grace Nortey. This statement triggered lots of comments on the website of Peace FM, where the "confession" was published. As many comments pointed out, Mensah's statement had to be interpreted as "ironic" or "metaphoric." See http://showbiz.peacefmonline.com/pages /movies/201201/88356.php. I find it intriguing that the commentators did not consider that Mensah may have been mobilizing an older, positive connotation of witchcraft as denoting genius, as also comes to the fore in the reference to witchcraft as "African electronics."

18. This was organized in analogy to the apprentice system, in which a person willing to learn a craft—hairdressing, sewing, car mechanics, editing—had to pay a large amount of money and a bottle of schnapps to a master, who would then train and let the apprentice work for him or her for a period of about three years.

19. J. B. was trained in repairing refrigerators, an activity he took up again in times when the video film industry was slack. When I met him for the first time, in 2002, he worked with Akwetey-Kanyi; in 2008 I found him working with Salam Mumuni (Venus Films). Throughout my research I often accompanied J. B. to film screenings in video parlors across Accra that the film establishment considered rough, low-class spaces. Through him I learned a lot about the expectations and mind-set of the audiences in these locations. We sat through many movies, and he translated for me the casual remarks made by spectators in the course of the movie.

20. This resonates with Belting's idea that, in order to see the image in the picture that acts as its medium, the image "needs" an "act of animation" so as to be perceived as being present. The agency of the image is asserted, yet it depends on human action. Animating the image, the human imagination organizes the gaze to see the image in the medium.

21. *Brenya 4* (Movie Africa Productions, 2007), a film about witchcraft situated in a timeless village setting, ends with a long making-of clip that shows a snake and the actress playing the river goddess filmed on a blue piece of cloth (as is necessary for producing a special effect). Safo told me that this clip was perceived as rather disenchanting by spectators, so he decided to stop ending his movies with such clips.

CHAPTER SEVEN

1. Trained in philosophy, African studies, and social anthropology, George Hagan (born 1938) is affiliated with the Institute for African Studies at the University of Ghana, Legon. He is known for his long-standing support of Nkrumahist politics and serves on many boards, including NAFTI. His intellectual background and political position predisposed him to be a spokesperson for national culture. I recorded the speech. He was the chairperson of the NCC until 2009, when the artist Ablade Glover succeeded him.

2. GAFTA was founded in 2001 as an umbrella organization to encompass all those working in the field of film, video, and television. The late Seth Ashong-Katai, who was the secretary at the time of the celebration, explained to me that there were different types of membership, depending on the member's formal training and experience in the field. Many video film producers felt disadvantaged and were reluctant to join, as they feared that GAFTA would reproduce long-standing hierarchies in the world of film-making, placing professionals trained in working with celluloid at the top.

3. Ghana joined UNESCO in 1958, and the fortresses were placed on the world heritage list soon after. However, they became important sites for the black diaspora much later. The movie *Sankofa,* by Haile Gerima (1993), about an African American woman who returns to Cape Coast as a photo model and is gripped by the spirits of her ancestors, was an important stimulus for reframing the forts as heavily emotional, sacralized sites of commemoration (Schramm 2010, 200–202). The visit Barack and Michelle Obama paid to Cape Coast Castle in July 2009 emphasized the symbolic importance of these locations before the eyes of the world. Scholars have pointed out differences between Ghanaians' and visitors' attitudes toward the former slave forts. This is a complex issue (Schramm 2010; see also Bruner 2004; Hasty 2002; Holsey 2008). Suffice it to say that for many of my Ghanaian interlocutors the forts stand for a very problematic and ambivalent heritage, inducing feelings of guilt about African participation in the slave trade. They have some difficulties relating to African American visitors' often emotional encounters with these locations, in particular at the Door of No Return. For many Ghanaians, however, this site is quite removed from their everyday experience and their sense of identity. Many do not like to be reminded of the slave trade and the role Africans played in it. It is indeed a *world* heritage, authorized by UNESCO, that doesn't address and grip them as much as non-Ghanaians. On the negotiation of the memory of the slave trade among youth in Elmina and their attempts to break out of the culture of silence see Holsey (2008, 221–32).

4. In the 1920s the Ewe musician and composer Ephraim Amu, who had been trained at Achimota College and taught music at the Basel Mission seminary at Akropong, started to Africanize church music and wear African attire. This was perceived as a strong challenge to the Westernized style of worship; the church did not adopt his innovations until thirty years later, around independence. It is important to note, however, that Amu, whom I met during my fieldwork in Peki in 1988 and 1991–92, did not endorse the use of traditional drums within church services and drew a strict distinction between Christianity and traditional religion (which he did not favor at all). See Agyemang 1988.

5. A telling example is the destruction of the public statue of the legendary Asante priest Komfo Anokye, who was said to have conjured the golden stool—the central icon of Asante royalty—from the sky. On 30 July 2001 a Pentecostal preacher vandalized the statue with a hammer, holding a Bible in his hand. He claimed that God had told him in a vision to destroy that idol (McCaskie 2008).

6. The dynamics of "talking back" have been marvelously deployed in Marleen de Witte's (2008) study of Afrikania, a neotraditional movement founded in the 1980s by an ex-Catholic priest, Damuah.

7. At the time of the interview I was preparing an application for a new research project on Cultural Heritage Dynamics (granted in 2009). Ashong-Katai and I had made plans for a future collaboration that never materialized because of his sudden death in 2009.

8. Ghana Base Lifestyle, "Avoid Superstitious Movies," 30 July 2007, http://lifestyle.ghanabase.com/movies/2007/99.asp.

9. Intriguingly, this positive image of a traditional priest resonates in a movie. *Gold Mask 1* and *2* (Blema Productions, 2009) is a film about a gold mask that moves about by itself to look for the city girl Mabel, who has been selected as the rightful priestess to succeed the dead chief priest. The gold mask and the spirit of the former priest appear to Mabel (via typical special effects) and in fact start haunting her. After being installed as a priestess in the village, Mabel tells her friends that the mask is "the soul of the people" (a quite Durkheimian statement). About herself she says, well in line with indigenous understandings of priests as having special vision capacities, "I am the eye of the people. I am the chief priestess." I find this movie, directed by Kafui Dzivenu, who long worked with Socrate Safo (writing screenplays and directing), intriguing because it marks a radical departure from the kind of movies that are the focus in this book. It seems to me that by the end of the first decade of 2000 there was room for much experimentation, as the rise of epics and other movies mobilizing tradition show. As I point out below, I regard these movies as symptoms of a new way of engaging with tradition.

10. This configuration echoes the colonial policy of "indirect rule" that evolved around chiefs and even entailed the invention of stools where there were none, yet at the same time it implied a rupture with long-standing forms of political organization. Profiled as "traditional," the authority of chiefs was curtailed and subsumed under the colonial administration. Chiefs who challenged colonial rule were prone to be destooled, or even, as was the case with Asantehene Prempeh I, sent into exile to the Seychelles. Because of the pivotal position of chiefs in the system of indirect rule, in which they were to collaborate with the colonial administration, Nkrumah looked upon them with suspicion (Rathbone 2000). The place and role of chieftaincy in postindependence Ghana remained a topic of debate for years. From a republican position there was no room for chieftaincy. Even so, it was acknowledged that chiefs wielded authority within their constituencies and could therefore play an important role in local governance and the implementation of "development." The emphasis on development also entailed the installation of foreigners—both Westerners and African Americans—as "development chiefs" (Steegstra 2006).

11. Another related practice is murdering people (especially strangers) to accompany a dead chief to the other world (see Gilbert 1995). Still, when a chief dies, people remark that it is important not to walk around in town at night, as the dead chief's relations may come and catch such a person. This is also a theme in the Nigerian film *Allegation* (Danga Movies Industries, 2002), allegedly a true story, in which a Nigerian boy goes missing in Ghana after the death of a chief but is able to free himself. In the meantime his own uncle has been falsely accused of ritually murdering the boy to make money. The nephew arrives too late to prevent his uncle's

execution. This film was very popular in Ghana during my research in the fall of 2002.

12. "Das Geheimnis bietet sozusagen die Möglichkeit einer zweiten Welt neben der offenbaren, und diese wird von jener auf das stärkste beeinflusst."

13. As Behrend (2013, 232) puts it: "Visualization is a process of creating new fictions, new images of something that remains hidden. The site of the invisible cannot be penetrated."

14. It is difficult to assess how and why the epic caught on in Nigeria and Ghana. One reason I often heard is that audiences definitely wanted a change and longed to see appealing views of nature and cultural display. In addition, producers found it logistically easier to shoot in a village environment than in a big city like Accra, where actors may have many appointments at the same time and want to be home at the end of the day. Next to epics there were also a number of comedies—revolving around concert party stars Santo and Judas. After 2005 a number of producers started to open so-called film villages in rural areas. The Twi-language Kumasi Films also involve village settings.

15. Trained at NAFTI, McCauley agreed to work on these films because they did not take as a point of departure the usual opposition of Christianity and "heathendom," nor did they engage in demonizing representations of tradition and culture. He was pleased with his training at NAFTI, except that he missed having learned the business aspects of filmmaking. To survive, however, one had to go commercial. Asked about his stance toward Sankofa he said, "When I went to NAFTI their whole idea was the Sankofa sort of thing to go back to your roots and make films depicting all these things, but then I said that for me as a filmmaker I am in a fast world, a real fast world. I mean the modern, I'm caught between the past, I'm caught between domination, you know I'm caught between domination of the colonial masters and of the African colonial masters, I'm caught between all that, so I have a fast history to make into film." He sometimes found it difficult to work with private producers who had no official training in filmmaking. A passionate film director with a vision, he confided to me his goal: "You know, my personal aim is to stand head to head with Stephen Spielberg and he would say to me, 'You know, you got talent and everything, but the only difference between you and me is money.' That's all and I would be very happy, because then he would realize that if he were to give me all his money I would even do better then him" (interview, 12 Nov. 2002).

16. At the time of our interview digital technology was not yet fully established as a means for creating special effects. Emeka feared, however, that in the long run the kind of work he was doing might become obsolete with the rise of more sophisticated programs for digital animation and simulation. This indeed happened in Ghana after 2005, when filmmakers gained access to programs like Adobe Premiere that enabled them to use a broad set of special effects.

17. My excitement comes across in my field notes: "I have to think about this more, the whole notion of creating un-existing traditions is crucial, I never heard anybody say this so explicitly, and perhaps it gives us insight into the aesthetics and politics of tradition today. Great to ponder!"

18. Beads are often presented in intergenerational family relations, involving mother or grandmother and (grand)child. They embody the spiritual link between giver and receiver.

19. Akwetey-Kanyi was quite critical of the Pentecostals. He had problems with the flamboyant appearance of the pastors, the focus on money, and the arrogant attitude toward other brands of Christianity. He himself was a member of an African Independent Church—the Celestial Church of Christ—run by his father in their family home. In his view this church, though often despised by the Pentecostals as occultist, maintained strict behavioral rules among its followers. Compared with this, he found the Pentecostals rather hypocritical, as many of them did not live up to the high standards demanded by a Christian way of life.

20. The place of the chief warrior was marked by all kinds of emblems, one even looking like a swastika. This was much to Akwetey-Kanyi's dismay. Unfortunately, the "boy" who had been asked to make these paintings just did a quick job that, due to time pressure, could not be changed. This shows again the extent to which tradition is imagined in the process of "imaging" it.

21. So far, I have not come across the third part, and I doubt that it came out.

EPILOGUE

1. See www.gintersdorferklassen.org/projekte/chefferie/chefferie.html.

2. See "Lost & Found: Lost in Nollywood, 11–11–2011," www.lost.nl/en /events/2011–11–11-lost-in-nollywood.

3. See, e.g., "A Response to Pieter Hugo's Photographs," http://amysteinphoto .blogspot.de/2009/10/response-to-pieter-hugos-photographs.html.

4. Another case is that of the American artist Doug Fishbone, who collaborated with two Ghanaian video producers (Emmanuel and John Apea Productions, 2010) in producing *Elmina*. In Ghana the movie circulated in the usual circuits and, thanks to Fishbone's support, could afford a splendid cast with star actors. At the same time, the movie was Fishbone's artistic project, which consisted in him, a white person, playing the role of the protagonist Ato Blankson, who gets involved in an endless struggle with the corrupt authorities and eventually is lured into conducting a ritual murder. His movie was shown at the Tate Modern, in the Stedelijk Museum, and at various art festivals outside of the circuits of African cinema. At a screening and discussion at the Edinburgh African Film Festival (October 2012) the film generated fierce debates for its experimentation with race. See www.tate.org.uk /context-comment/video/tateshots-doug-fishbone-elmina.

REFERENCES

Adamu, Abdalla Uba. 2007. *Transglobal Media Flows and African Popular Culture: Revolution and Reaction in Muslim Hausa Popular Culture.* Kano, Nigeria: Visually Ethnographic Productions.

Adejunmobi, Moredewun. 2007. "Nigerian Video Film as Minor Transnational Practice." *Postcolonial Text* 3 (2): http://postcolonial.org/index.php/pct/article/view/548.

Agorde, Wisdom. 2007. "Creating the Balance: Hallelujah Masculinities in a Ghanaian Video Film." *Film International* 5 (4): 51–63.

Agyemang, Fred M. 1988. *Amu the African: A Study in Vision and Courage.* Accra: Asempa, Christian Council of Ghana.

Akyeampong, Emmanuel K. 1996. *Drink, Power, and Cultural Change: A Social History of Alcohol in Ghana, c. 1800 to Recent Times.* Portsmouth, NH: Heinemann.

Akyeampong, Emmanuel K., and Charles Ambler, eds. 2002. "Leisure in African History." Special issue, *International Journal of African Historical Studies* 35 (1).

Allman, Jean Marie. 2004. *Fashioning Africa: Power and the Politics of Dress.* Bloomington: Indiana University Press.

Anash, P. A. V. 1993. "Kwame Nkrumah and the Mass Media." In *The Life and Work of Kwame Nkrumah: Papers of a Symposium Organized by the Institute of African Studies, University of Ghana, Legon,* edited by Kwame Arhin, 83–100. Trenton, NJ: Africa World Press.

Anderson, Benedict R. 1991. *Imagined Communities: Reflections on the Origin and Spread of Nationalism.* London: Verso.

Ansah, Kwaw P. 1995. "Interview 'Quotes': State of Film Production." In *The Republic of Ghana Celebrates the Centenary of World Cinema,* 18–23 Sept. Accra: Friedrich Ebert Stiftung.

Appadurai, Arjun. 1996. *Modernity at Large: Cultural Dimensions of Globalization.* Minneapolis: University of Minnesota Press.

Appiah, Anthony, and Allen R. Grossman. 1992. *In My Father's House: Africa in the Philosophy of Culture.* New York: Oxford University Press.

Asad, Talal. (1986) 2009. "The Idea of an Anthropology of Islam." *Qui Parle* 17 (2): 1–30.

———. 1993. *Genealogies of Religion: Discipline and Reasons of Power in Christianity and Islam*. Baltimore: Johns Hopkins University Press.

———. 2003. *Formations of the Secular: Christianity, Islam, Modernity*. Stanford: Stanford University Press.

Asamoah-Gyadu, J. Kwabena. 2005. *African Charismatics: Current Developments within Independent Indigenous Pentecostalism in Ghana*. Leiden: Brill.

———. 2007. "'Broken Calabashes and Covenants of Fruitfulness': Cursing Barrenness in Contemporary African Christianity." *Journal of Religion in Africa* 37 (4): 437–60.

———. 2013. *Contemporary Pentecostal Christianity: Interpretations from an African Context*. Eugene: Wipf and Stock.

Asare, Kofi. 2013. "Pentecostal-Charismatic Christianity in Video Films: Audience Reception and Appropriation in Ghana and the UK." PhD diss., University of Edinburgh.

Ashforth, Adam. 2005. *Witchcraft, Violence, and Democracy in South Africa*. Chicago: University of Chicago Press.

Auerbach, Erich. 1938. "Figura." *Archivum Romanicum* 22: 436–89.

Austin, John L. 1962. *How to Do Things with Words*. Oxford: Clarendon Press.

Ayorinde, Steve, and Olivier Barlet. 2005. "'We Are Doing Worse Than Hollywood': Interview with Kwaw Ansah." African Film Festival New York, www .africanfilmny.org/2005/we-are-doing-worse-than-hollywood-interview-with-kwah-ansah-by-steve-ayorinde-and-olivier-barlet/.

Bakker, André. 2007. "God, Devil and the Work of Television: Modern Mass Media and Pentecostal Christianity in an Evangelical Community in Brazil." Master's thesis, Vrije Universiteit, Amsterdam.

Bakker, Freek L. 2011. *Jezus in beeld: Een studie naar zijn verschijnen op het witte doek*. Utrecht: Van Gruting.

Barber, Karin. 1981. "How Man Makes God in West Africa: Yoruba Attitudes towards the Òrìṣà." *Africa: Journal of the International African Institute* 51 (3): 724–45.

———. 1997a. "Preliminary Notes on Audiences in Africa." *Africa* 67 (3): 347–62.

———, ed. 1997b. *Readings in African Popular Culture*. Bloomington: Indiana University Press.

———. 2000. *The Generation of Plays: Yorùbá Popular Life in Theater*. Bloomington: Indiana University Press.

———. 2007. *The Anthropology of Texts, Persons and Publics: Oral and Written Culture in Africa and Beyond*. Cambridge: Cambridge University Press.

Barker, Jennifer M. 2009. *The Tactile Eye: Touch and the Cinematic Experience*. Berkeley: University of California Press.

Bayart, Jean-François. 2000. "Africa in the World: A History of Extraversion." *African Affairs* 99 (395): 217–67.

Becker, Felicitas. 2008. *Becoming Muslim in Mainland Tanzania, 1890–2000*. Oxford: Oxford University Press.

Becker, Heike. 2011. "Commemorating Heroes in Windhoek and Eenhaha: Memory, Culture and Nationalism in Namibia, 1990–2010." *Africa* 81 (4): 519–43.

Behrend, Heike. 2013. *Contesting Visibility: Photographic Practices on the East African Coast*. Bielefeld: Transcript.

Belting, Hans. 2001. *Bild-Anthropologie: Entwürfe für eine Bildwissenschaft*. München: Fink.

———. 2005. "Image, Medium, Body: A New Approach to Iconology." *Critical Inquiry* 31 (2): 302–19.

———. 2011. *An Anthropology of Images: Picture, Medium, Body*. Princeton, NJ: Princeton University Press.

———. 2013. *Faces: Eine Geschichte des Gesichts*. München: C. H. Beck.

Belting, Hans, Andrea Buddensieg, and Peter Weibel. 2013. *The Global Contemporary and the Rise of New Art Worlds*. Karlsruhe: ZKM.

Bendix, Regina. 2012. *A Companion to Folklore*. Malden, MA: Wiley-Blackwell.

Benjamin, Walter. 1999. "The Work of Art in the Age of Mechanical Reproduction." In *Illuminations*. Edited by Hannah Arendt, 211–44. London: Pimlico.

Blier, Suzanne Preston. 1985. "Kings, Crowns, and Rights of Succession: Obalufon Arts at Ife and Other Yoruba Centers." *Art Bulletin* 67 (3): 383–401.

———. 1995. *African Vodun: Art, Psychology, and Power*. Chicago: University of Chicago Press.

Bloom, Peter J. 2008. *French Colonial Documentary: Mythologies of Humanitarianism*. Minneapolis: University of Minnesota Press.

Bloom, Peter J., and Kate Skinner. 2009–10. "Modernity and Danger: 'The Boy Kumasenu' and the Work of the Gold Coast Film Unit." *Ghana Studies* 12/13: 121–53.

Bloom, Peter J., and Véronique Cayla. 2010. *Découvrir les films de Jean Rouch: Collecte d'archives, inventaire et partage*. Paris: CNC.

Böhme, Gernot. 2001. *Aisthetik: Vorlesungen über Ästhetik als Allgemeine Wahrnehmungslehre*. München: Fink.

Bonhomme, Julien. 2005. "Voir par-derrière: Sorcellerie, initiation et perception au Gabon." *Social Anthropology* 13 (3): 259–73.

———. 2012. "The Dangers of Anonymity: Witchcraft, Rumor, and Modernity in Africa." *HAU: Journal of Ethnographic Theory* 2 (2): 205–33.

Brantlinger, Patrick. 1988. *Rule of Darkness: British Literature and Imperialism, 1830–1914*. Ithaca, NY: Cornell University Press.

Brooks, Peter. 1976. *The Melodramatic Imagination: Balzac, Henry James, Melodrama, and the Mode of Excess*. New Haven, CT: Yale University Press.

Brosius, Christiane. 2010. *India's Middle Class: New Forms of Urban Leisure, Consumption and Prosperity*. London: Routledge.

Brosius, Christiane, and Karin M. Polit. 2011. *Ritual, Heritage and Identity: The Politics of Culture and Performance in a Globalised World*. London: Routledge.

Bruner, Edward M. 2004. *Culture on Tour: Ethnographies of Travel*. Chicago: University of Chicago Press.

Buckley, Robert M., and Ashna S. Mathema. 2007. *Is Accra a Superstar City?* Washington: World Bank.

Buck-Morss, Susan. 1992. "Aesthetics and Anaesthetics: Walter Benjamin's Artwork Essay Reconsidered." *October* 62 (Autumn): 3–41.

Burns, James McDonald. 2002. *Flickering Shadows: Cinema and Identity in Colonial Zimbabwe*. Athens: Ohio University Press.

Butticci, Annalisa, ed. 2013. *Na God: Aesthetics of African Charismatic Power*. Rubano: Grafiche Turato.

Carrick, Malcolm. 1978. *Making Horror Costumes and Disguises*. London: Corgi.

Carroll, Noël. 1990. *The Philosophy of Horror, or Paradoxes of the Heart*. New York: Routledge.

Cassiman, Ann. 2008. "Home and Away: Mental Geographies of Young Migrant Workers and Their Belonging to the Family House in Northern Ghana." *Housing, Theory and Society* 25 (1): 14–30.

Castoriadis, Cornelius. 1997. *The Castoriadis Reader*. Oxford: Blackwell.

Clark, Lynn Schofield. 2003. *From Angels to Aliens: Teenagers, the Media, and the Supernatural*. Oxford: Oxford University Press.

Coe, Cati. 2005. *Dilemmas of Culture in African Schools: Youth, Nationalism, and the Transformation of Knowledge*. Chicago: University of Chicago Press.

Cole, Catherine M. 2001. *Ghana's Concert Party Theatre*. Bloomington: Indiana University Press.

Collatos, Adrienne. 2010. "The Politics, the Producers, and the People: The Arrival of Video Technology as Cultural Medium in Ghana, 1982–1990." Harvard University.

Collins, E. John. 1976. "Comic Opera in Ghana." *African Arts* 9: 50–57.

Comaroff, Jean, and John L. Comaroff, eds. 1993. *Modernity and Its Malcontents: Ritual and Power in Postcolonial Africa*. Chicago: University of Chicago Press.

———, eds. 2000. "Millennial Capitalism and the Culture of Neoliberalism." Special issue, *Public Culture* 12 (2).

Comaroff, John L., and Jean Comaroff. 1992. *Ethnography and the Historical Imagination*. Boulder, CO: Westview Press.

———. 2009. *Ethnicity, Inc*. Chicago: University of Chicago Press.

Cooper, Frederick. 2005. *Colonialism in Question: Theory, Knowledge, History*. Berkeley: University of California Press.

Corstanje, Charlotte. 2012. "Styling beyond the Nation: Positioning Up and Coming Ghanaian Fashion Designers in a Contemporary World of Fashion." Master's thesis, Vrije Universiteit, Amsterdam.

Cosandey, Roland, André Gaudreault, and Tom Gunning, eds. 1992. *Une invention du diable? Cinéma des premiers temps et religion*. Sainte-Foy: Les presses de l'Université Laval.

Csordas, Thomas J. 1990. "Embodiment as a Paradigm for Anthropology." *Ethos* 18 (1): 5–47.

———. 2004. "Asymptote of the Ineffable: Embodiment, Alterity, and the Theory of Religion." *Current Anthropology* 45 (2): 163–86.

———. 2007. "Introduction: Modalities of Transnational Transcendence." *Anthropological Theory* 7 (3): 259–72.

Dasgupta, Sudeep. 2006. "Gods in the Sacred Marketplace: Hindu Nationalism and the Return of the Aura in the Public Sphere." In Meyer and Moors 2006, 251–72.

de Abreu, Maria J. 2009. "Breath, Technology, and the Making of Community. Canção Nova in Brazil." In Meyer 2009c, 161–82.

De Boeck, Filip. 2002. "Kinshasa: Tales of the 'Invisible City' and the Second World." In Enwezor et al. 2002, 243–86.

De Boeck, Filip, and Marie-Françoise Plissart. 2004. *Kinshasa: Tales of the Invisible City.* Tervuren: Ludion.

Debrunner, Hans W. 1961. *Witchcraft in Ghana: A Study on the Belief in Destructive Witches and Its Effect on the Akan Tribes.* Kumasi: Presbyterian Book Depot.

de Certeau, Michel. 1984. *The Practice of Everyday Life.* Berkeley: University of California Press.

de Jong, Ferdinand, and M.J. Rowlands. 2007. *Reclaiming Heritage: Alternative Imaginaries of Memory in West Africa.* Walnut Creek, CA: Left Coast Press.

Deleuze, Gilles. 1991. *Das Zeit-Bild: Kino 2.* Frankfurt am Main: Suhrkamp.

Derrida, Jacques. 2001. "'Above All, No Journalists!'" In de Vries and Weber 2001, 56–93.

Desai, Amid. Forthcoming. "Cholamandal Artists' Village and the Making of the Creative City of Chennai, India." In *Creativity in Transition,* edited by Maruška Svašek and Birgit Meyer. Oxford: Berghahn.

de Vries, Hent. 2001. "In Media Res: Global Religion, Public Spheres, and the Task of Contemporary Comparative Religious Studies." In de Vries and Weber 2001, 3–42.

de Vries, Hent, and Samuel Weber, eds. 2001. *Religion and Media.* Stanford: Stanford University Press.

de Witte, Marleen. 2003. "Altar Media's *Living Word:* Televised Charismatic Christianity in Ghana." *Journal of Religion in Africa* 33 (2): 172–202.

———. 2005. "Insight, Secrecy, Beasts, and Beauty: Struggles over the Making of a Ghanaian Documentary on 'African Traditional Religion.'" *Postscripts* 1 (2/3): 277–300.

———. 2008. "Spirit Media: Charismatics, Traditionalists, and Mediation Practices in Ghana." PhD diss., University of Amsterdam.

———. 2009. "Modes of Binding, Moments of Bonding: Mediating Divine Touch in Ghanaian Pentecostalism and Traditionalism." In Meyer 2009c, 183–205.

———. 2012. "Television and the Gospel of Entertainment in Ghana." *Exchange* 41 (2): 144–64.

de Witte, Marleen, and Birgit Meyer. 2012. "African Heritage Design." *Civilisations* 61 (1): 43–64.

Diawara, Manthia. 1992. *African Cinema: Politics and Culture.* Bloomington: Indiana University Press.

———. 2010. *African Film: New Forms of Aesthetics and Politics.* Munich: Prestel.

Doll, Martin, Rupert Gaderer, Fabio Camiletti, and Jan Niklas Howe, eds. 2011. *Phantasmata: Techniken des Unheimlichen.* Vienna: Turia und Kant.

Dovey, Lindiwe. 2009. *African Film and Literature: Adapting Violence to the Screen.* New York: Columbia University Press.

Drewal, Henry John. 1988. "Performing the Other: Mami Wata Worship in Africa." *Drama Review* 32 (2): 160–85.

———. 2002. "Mami Wata and Santa Marta: Imag(in)ing Selves and Others in Africa and the Americas." In *Images and Empires: Visuality in Colonial and Postcolonial Africa,* edited by Paul S. Landau and Deborah D. Kaspin, 193–211. Berkeley: University of California Press.

———, ed. 2008. *Sacred Waters: Arts for Mami Wata and Other Divinities in Africa and the Diaspora.* Bloomington: Indiana University Press.

Dünne, Jörg. 2011. *Die kartographische Imagination: Erinnern, Erzählen und Fingieren in der Frühen Neuzeit.* München: Fink.

During, Simon. 2004. *Modern Enchantments: The Cultural Power of Secular Magic.* Cambridge, MA: Harvard University Press.

Dwyer, Rachel. 2006. *Filming the Gods: Religion and Indian Cinema.* New York: Routledge.

Eisenlohr, Patrick. 2009. "Technologies of the Spirit." *Anthropological Theory* 9 (3): 273–96.

———. 2011. "What Is a Medium? Theologies, Technologies and Aspirations." *Social Anthropology* 19 (1): 1–5.

Elkins, James. 2002. "The Object Stares Back: On the Nature of Seeing." In *Religion, Art, and Visual Culture: A Cross-Cultural Reader,* edited by S. Brent Plate, 40–45. New York: Palgrave.

Ellis, Stephen, and Gerrie ter Haar. 2004. *Worlds of Power: Religious Thought and Political Practice in Africa.* New York: Oxford University Press.

Elsaesser, Thomas. 1990. *Early Cinema: Space, Frame, Narrative.* London: BFI.

———. 2012. *Melodrama and Trauma: Modes of Cultural Memory in the American Cinema.* London: Taylor and Francis.

Elsaesser, Thomas, and Malte Hagener. 2010. *Film Theory: An Introduction through the Senses.* New York: Routledge.

Engelke, Matthew E. 2004. "Discontinuity and the Discourse of Conversion." *Journal of Religion in Africa* 34 (1/2): 82–109.

———. 2007. *A Problem of Presence: Beyond Scripture in an African Church.* Berkeley: University of California Press.

Eni, Emmanuel. 1988. *Delivered from the Powers of Darkness.* Nairobi: Scripture Union of Kenya.

Enwezor, Okwui, Carlos Basualdo, Ute Meta Bauer, Susanne Ghez, Sarat Maharaj, Mark Nash, and Octavio Zaya, eds. 2002. *Under Siege: Four African Cities—Freetown, Johannesburg, Kinshasa, Lagos.* Ostfildern-Ruit: Hatje Cantz.

Faber, Paul, and Bert Sliggers. 2013. *Een zee vol meerminnen: verleiding en bedreiging.* Teylers Museum: Lannoo.

Fabian, Johannes. 1983. *Time and the Other: How Anthropology Makes Its Object.* New York: Columbia University Press.

———. 1998. *Moments of Freedom: Anthropology and Popular Culture.* Charlottesville: University Press of Virginia.

Ferguson, James. 1999. *Expectations of Modernity: Myths and Meanings of Urban Life on the Zambian Copperbelt.* Berkeley: University of California Press.

———. 2006. *Global Shadows: Africa in the Neoliberal World Order.* Durham, NC: Duke University Press.

Field, M.J. 1960. *Search for Security: An Ethnopsychiatric Study of Rural Ghana.* London: Faber and Faber.

Film Classification Board Secretariat, comp. 2008a. "Classified Ghanaian Films in Ghana, 1983–2007." Edited by Akwetey-Kanyi Films. Author's personal archive.

Film Classification Board Secretariat, comp. 2008b. "Classified Ghanaian and Nigerian Films in Ghana, 1983–2007." Edited by Akwetey-Kanyi Films. Author's personal archive.

Film Classification Board Secretariat, comp. 2011. "Classified Ghanaian and Nigerian Films in Ghana, 2008–2010. Edited by Akwetey-Kanyi Films. Author's personal archive.

Film Producers Association of Ghana (FIPAG). 2002. "Influx of Foreign Films." Unpublished manuscript.

Flach, Sabine, Daniel Margulies, and Jan Söffner. 2010. Introduction to *Habitus in Habitat I: Emotion and Motion,* edited by Sabine Flach, Daniel Margulies, and Jan Söffner, 7–22. Bern: Peter Lang.

Foerster, Lukas, Nikolaus Perneczky, Fabian Tietke, and Cecilia Valenti, eds. 2013. *Spuren eines Dritten Kinos: Zu Ästhetik, Politik und Ökonomie des World Cinema.* Bielefeld: Transcript.

Forbes, Bruce D., and Jeffrey H. Mahan. 2000. *Religion and Popular Culture in America.* Berkeley: University of California Press.

Freedberg, David. 1989. *The Power of Images: Studies in the History and Theory of Response.* Chicago: University of Chicago Press.

Friedson, Steven M. 2005. "Where Divine Horsemen Ride: Trance Dancing in West Africa." In *Aesthetics in Performance: Formations of Symbolic Construction and Experience,* edited by Angela Hobart and Bruce Kapferer, 109–28. New York: Berghahn.

Fuglerud, Øivind, and Leon Wainwright, 2015. Introduction to *Objects and Imagination: Perspectives on Materialization and Meaning,* edited by Øivind Fuglerud and Leon Wainwright, 1–24. Oxford: Berghahn.

Gandoulou, Justin-Daniel. 2008. "Between Paris and Bacongo and Dandies in Bacongo." In Geschiere, Meyer, and Pels 2008, 194–205.

Ganti, Tejaswini. 2012. *Producing Bollywood: Inside the Contemporary Hindi Film Industry.* Durham, NC: Duke University Press.

Garritano, Carmela. 2008. "Contesting Authenticities: The Emergence of Local Video Production in Ghana." *Critical Arts* 22 (1): 21–48.

———. 2013. *African Video Movies and Global Desires: A Ghanaian History*. Athens: Ohio University Press.

Gbordzoe, Emmanuel Komla. 2000. *Your Winning Confessions*. Accra: Charis.

Geertz, Clifford. 1973. *The Interpretation of Cultures: Selected Essays*. New York: Basic Books.

Geschiere, Peter L. 1997. *The Modernity of Witchcraft: Politics and the Occult in Postcolonial Africa*. Charlottesville: University Press of Virginia.

———. 1999. "Globalization and the Power of Indeterminate Meaning: Witchcraft and Spirit Cults in Africa and East Asia." In *Globalization and Identity: Dialectics of Flow and Closure,* edited by Birgit Meyer and Peter L. Geschiere, 211–38. Oxford: Blackwell.

———. 2013. *Witchcraft, Intimacy, and Trust: Africa in Comparison*. Chicago: University of Chicago Press.

Geschiere, Peter L., Birgit Meyer, and Peter Pels, eds. 2008. *Readings in Modernity in Africa*. Oxford: James Currey.

Ghana Information Services Department. n.d. "Guide to Film Censorship." Folder. Author's personal archive.

Ghana Ministry of Information. 1995. "Draft of the National Film and Video Policy." Unpublished manuscript.

Ghana Statistical Service. 2000. *Population and Housing Census 2000*. www.statsghana.gov.gh/nada/index.php/catalog/3.

Ghana Statistical Service. 2011. *2010 Population and Housing Census. Provisional Results*. http://unstats.un.org/unsd/demographic/sources/census/2010_phc/Ghana/Provisional_results.pdf.

Gifford, Paul. 2004. *Ghana's New Christianity: Pentecostalism in a Globalizing African Economy*. London: Hurst.

Gilbert, Michelle. 1995. "The Christian Executioner: Christianity and Chieftaincy as Rivals." *Journal of Religion in Africa* 25 (4): 347–86.

———. 2000. *Hollywood Icons, Local Demons: Ghanaian Popular Paintings by Mark Anthony*. Hartford, CT: Widener Gallery.

Gillespie, Marie. 1995. "Sacred Serials, Devotional Viewing, and Domestic Worship: A Case-Study in the Interpretation of Two TV Versions of the Mahabharata in a Hindu Family in London." In *To Be Continued . . . : Soap Operas around the World,* edited by Robert C. Allen, 354–80. New York: Routledge.

Ginsburg, Faye, 2006. "Black Screens and Cultural Citizenship." *Visual Anthropology Review* 21 (1/2): 80–97.

Gold Coast Colony. 1932. *Cinematograph Exhibitions Regulations*. Regulations No. 19 of 1932. Accra: Government Printing Office.

Goslinga-Roy, Gillian. 2012. "Spirited Encounters: Notes on the Politics and Poetics of Representing the Uncanny in Anthropology." *Anthropological Theory* 12 (4): 386–406.

Gott, Edith Suzanne, and Kristyne Loughran. 2010. *Contemporary African Fashion*. Bloomington: Indiana University Press.

Grant, Richard. 2009. *Globalizing City: The Urban and Economic Transformation of Accra, Ghana.* Syracuse, NY: Syracuse University Press.

Grätz, Tilo. 2011. "Contemporary African Mediascapes: New Actors, Genres and Communication Spaces." *Journal of African Media Studies* 3 (2): 151–60.

———. 2013. *New Media Entrepreneurs and Changing Styles of Public Communication in Africa.* Abingdon: Taylor and Francis.

Green-Simms, Lindsey. 2010. "The Return of the Mercedes: From Ousmane Sembene to Kenneth Nnebue." In Şaul and Austen 2010, 209–24.

———. 2012. "Occult Melodramas: Spectral Affect and West African Video-Film." *Camera Obscura* 27 (2): 25–59.

Green-Simms, Lindsey, and Unoma Azuah. 2012. "The Video Closet: Nollywood's Gay-Themed Movies." *Transition,* no. 107, 32–49.

Groys, Boris, and Peter Weibel, eds. 2011. *Medium Religion: Faith. Geopolitics. Art.* Köln: Distributed Art.

Gugler, Josef. 2003. *African Film: Re-imagining a Continent.* Bloomington: Indiana University Press.

Gunning, Tom. 1986. "The Cinema of Attractions: Early Film, Its Spectator and the Avant-Garde." *Wide Angle* 8 (3–4): 63–70.

———. 1989. "An Aesthetic of Astonishment: Early Film and the (In)Credulous Spectator." *Art and Text* 34 (Spring): 31–45.

———. 2007. "Cinema and the New Spirit in Art within a Culture of Movement." In *Picasso, Braque and Early Film in Cubism,* edited by Tom Gunning, 17–33. New York: PaceWildenstein.

Hackett, Rosalind I. J. 1998. "Charismatic/Pentecostal Appropriation of Media Technologies in Nigeria and Ghana." *Journal of Religion in Africa* 28 (3): 258–77.

Hagan, George P. 1993. "Nkrumah's Cultural Policy." In *The Life and Work of Kwame Nkrumah: Papers of a Symposium Organized by the Institute of African Studies, University of Ghana, Legon,* edited by Kwame Arhin, 3–26. Trenton, NJ: Africa World Press.

Haggard, H. Rider. 1885. *King Solomon's Mines.* London: Cassell.

———. 1887. *She: A History of Adventure.* Leipzig: Tauchnitz.

Hahn, Hans Peter. 2008. *Consumption in Africa: Anthropological Approaches.* Berlin: Lit.

Hamilton, Carolyn. 1998. *Terrific Majesty: The Power of Shaka Zulu and the Limits of Historical Invention.* Cambridge, MA: Harvard University Press.

Hanegraaff, Wouter J. 2013. "The Notion of 'Occult Sciences' in the Wake of the Enlightenment." In *Aufklärung und Esoterik: Wege in die Moderne,* edited by Monika Neugebauer-Wölk, Renko Geffarth, and Markus Meumann, 73–95. Berlin: Walter de Gruyter.

Hansen, Karen Tranberg. 2000. *Salaula: The World of Secondhand Clothing and Zambia.* Chicago: University of Chicago Press.

———. 2005. "From Thrift to Fashion." In *Clothing as Material Culture,* edited by Susanne Küchler and Daniel Miller, 107–20. Oxford: Berg.

Hansen, Miriam. 1991. *Babel and Babylon: Spectatorship in American Silent Film.* Cambridge, MA: Harvard University Press.

Hansen, Thomas B., and Finn Stepputat, eds. 2001. *States of Imagination: Ethnographic Explorations of the Postcolonial State.* Durham, NC: Duke University Press.

Harrow, Kenneth W. 2007. *Postcolonial African Cinema: From Political Engagement to Postmodernism.* Bloomington: Indiana University Press.

Hasty, Jennifer. 2002. "Rites of Passage, Routes of Redemption: Emancipation Tourism and the Wealth of Culture." *Africa Today* 49 (3): 47–76.

———. 2005. *The Press and Political Culture in Ghana.* Bloomington: Indiana University Press.

Haynes, Jonathan. 1997. "Les guérisseurs: Perspectives on the City from Film." *Glendora Review* 2: 71–74.

———, ed. 2000. *Nigerian Video Films.* Athens: Ohio University Center for International Studies.

———. 2007. "Nollywood in Lagos, Lagos in Nollywood Films." *Africa Today* 54 (2): 131–50.

———. 2010a. "A Literature Review: Nigerian and Ghanaian Videos." *Journal of African Cultural Studies* 22 (1): 105–20.

———. 2010b. "What Is to Be Done? Film Studies and Nigerian and Ghanaian Videos." In Şaul and Austen 2010, 11–25.

———. 2011. "African Cinema and Nollywood: Contradictions." *Situations: Project of the Radical Imagination* 4 (1): 67–90.

Haynes, Jonathan, and Onookome Okome. 1998. "Evolving Popular Media: Nigerian Video Films." *Research in African Literatures* 29 (3): 106–28.

Heath, Carla W. 1999. "Negotiating Broadcasting Policy: Civil Society and Civic Discourse in Ghana." *Gazette* 61 (6): 511–21.

———. 2001. "Regional Radio: A Response by the Ghana Broadcasting Corporation to Democratization and Competition." *Canadian Journal of Communication* 26: 89–106.

Hendrie, Doug. 2014. *AmalgaNations: How Globalisation Is Good.* Richmond, AU: Hardie Grant.

Hermann, Adrian. 2015. "'True Facts of the World': Media of Scientific Space and the Transformations of Cosmo-geography in Nineteenth-Century Buddhist-Christian Encounters." In *Asian Religions, Technology and Science,* edited by István Keul, 11–30. London: Routledge.

Herzfeld, Michael. 2001. *Anthropology: Theoretical Practice in Culture and Society.* Oxford: Blackwell.

Hess, Janet Berry. 2000. "Imagining Architecture: The Structure of Nationalism in Accra, Ghana." *Africa Today* 47 (2): 35–58.

Hirschkind, Charles. 2006. *The Ethical Soundscape: Cassette Sermons and Islamic Counterpublics.* New York: Columbia University Press.

Hjort, Mette, and Scott MacKenzie, eds. 2000. *Cinema and Nation.* London: Routledge.

Hoek, Lotte. 2013. *Cut-Pieces: Celluloid Obscenity and Popular Cinema in Bangladesh.* New York: Columbia University Press.

Hofmeyr, Isabel. 2003. *The Portable Bunyan: A Transnational History of "The Pilgrim's Progress."* Princeton, NJ: Princeton University Press.

Holsey, Bayo. 2008. *Routes of Remembrance: Refashioning the Slave Trade in Ghana.* Chicago: University of Chicago Press.

Houtman, Dick, and Birgit Meyer, eds. 2012. *Things: Religion and the Question of Materiality.* New York: Fordham University Press.

Howes, David. 2003. *Sensual Relations: Engaging the Senses in Culture and Social Theory.* Ann Arbor: University of Michigan Press.

Hughes, S. P. 2009. "Tamil Mythological Cinema and the Politics of Secular Modernism." In Meyer 2009c, 93–116.

Hugo, Pieter. 2009. *Nollywood.* Munich: Prestel.

Hutchby, Ian. 2001. "Technologies, Texts and Affordances." *Sociology* 35 (2): 441–56.

Isichei, Elizabeth. 2008. "Mami Wata, Water Spirits, and Returners in and near the Igbo Culture Area." In Drewal 2008, 229–44.

Jackson, Michael. 1996. *Things as They Are: New Directions in Phenomenological Anthropology.* Bloomington: Indiana University Press.

———. 2005. *Existential Anthropology: Events, Exigencies and Effects.* New York: Berghahn.

———. 2009. *The Palm at the End of the Mind: Relatedness, Religiosity, and the Real.* Durham, NC: Duke University Press.

Jay, Martin. 1994. *Downcast Eyes: The Denigration of Vision in Twentieth-Century French Thought.* Berkeley: University of California Press.

Jedlowski, Alessandro. 2013. "Beyond the Video Boom: New Tendencies in the Nigerian Film Industry." *International Journal of Cinema* 1 (1): 99–111.

Jell-Bahlsen, Sabine. 2008. *The Water Goddess in Igbo Cosmology: Ogbuide of Oguta Lake.* Trenton, NJ: Africa World Press.

Jonah, Kwesi A. 1989. "The Social Impact of Ghana's Adjustment Programme, 1983–86." In *The IMF, the World Bank, and the African Debt,* edited by Bade Onimode, Vol. 2, 140–52. London: Zed.

Jørgensen, Anne Mette. 2001. "Sankofa and Modern Authenticity in Ghanaian Film and Television." In *Same and Other: Negotiating African Identity in Cultural Production,* edited by Maria E. Baaz and Mai Palmberg, 119–42. Uppsala: Nordiska Afrikainstitutet.

Kamper, Dietmar. 1981. *Zur Geschichte der Einbildungskraft.* München: Carl Hanser.

Kaupinnen, Anna-Riikka. 2010. "Faces That Change: Doing 'African' Beauty at Home, in Salons and on Stage in Accra, Ghana." Master's thesis, Vrije Universiteit, Amsterdam.

Keane, Webb. 1997. "Religious Language." *Annual Review of Anthropology* 26: 4771.

———. 2007. *Christian Moderns: Freedom and Fetish in the Mission Encounter.* Berkeley: University of California Press.

Kessler, Frank. 2009. "What You Get Is What You See: Digital Images and the Claim on the Real." In *Digital Material: Tracing New Media in Everyday Life*

and Technology, edited by M. van den Boomen and S. Lammes, 187–97. Amsterdam: Amsterdam University Press.

Kiernan, J. P., ed. 2006. *The Power of the Occult in Modern Africa: Continuity and Innovation in the Renewal of African Cosmologies.* Münster: Lit.

Kilson, Marion. 1974. *African Urban Kinsmen: The Ga of Central Accra.* New York: St. Martin's.

Kirshenblatt-Gimblett, Barbara. 1998. *Destination Culture: Tourism, Museums, and Heritage.* Berkeley: University of California Press.

Knibbe, Kim, and Peter Versteeg. 2008. "Assessing Phenomenology in Anthropology." *Critique of Anthropology* 28 (1): 47–62.

Koch, Gertrud. 2006. "Müssen wir glauben was wir sehen? Zur filmischen Illusionsästhetik." In . . . *Kraft der Illusion,* edited by Gertrud Koch and Christiane Voss, 53–70. Paderborn: Fink.

Köhn, Steffen. 2008. *Videofilm in Ghana: Neue Medien, religiöse Bewegungen und die öffentliche Sphäre.* Saarbrücken: VDM.

Koschorke, Albrecht. 2012. *Wahrheit und Erfindung: Grundzüge einer allgemeinen Erzähltheorie.* Frankfurt am Main: S. Fischer.

Kracauer, Siegfried. 1947. *From Caligari to Hitler: A Psychological History of the German Film.* Princeton, NJ: Princeton University Press.

———. 1995. *The Mass Ornament: Weimar Essays.* Cambridge, MA: Harvard University Press.

Kramer, Fritz. 2005. *Schriften zur Ethnologie.* Frankfurt am Main: Suhrkamp.

Krämer, Sybille. 1998a. *Medien, Computer, Realität: Wirklichkeitsvorstellungen und neue Medien.* Frankfurt am Main: Suhrkamp.

———. 1998b. "Sinnlichkeit, Denken, Medien: Von der 'Sinnlichkeit als Erkenntnis' zur 'Sinnlichkeit als Performanz.'" In *Der Sinn der Sinne,* edited by B. Busch, A. Müller, and J. Seligmann, 24–39. Göttingen: Steidl.

———. 2008. *Medium, Bote, Übertragung—kleine Metaphysik der Medialität.* Frankfurt am Main: Suhrkamp.

Krasniewicz, Louise. 2000. "Magical Transformations: Morphing and Metamorphosis in Two Cultures." In *Meta Morphing: Visual Transformation and the Culture of Quick Change,* edited by Vivian Sobchack, 40–58. Minneapolis: University of Minnesota Press.

Krings, Matthias, and Onookome Okome, eds. 2013. *Global Nollywood: The Transnational Dimensions of an African Video Film Industry.* Bloomington: Indiana University Press.

Kruse, Christiane. 2014. "Einleitung. Maske, Maskerade und die Kunst der Verstellung; Vom Barock bis zur Moderne." In *Maske, Maskerade und die Kunst der Verstellung: Vom Barock bis zur Moderne,* edited by Christiane Kruse, 7–14. Wiesbaden: Harrassowitz.

Küchler, Susanne, and Daniel Miller, eds. 2005. *Clothing as Material Culture.* Oxford: Berg.

Laidlaw, James, and Paolo Heywood. 2013. "One More Turn and You're There." *Anthropology of This Century* 7 (May): http://aotcpress.com/articles/turn/.

Lambertz, Peter. 2015. "Divisive Matters: Aesthetic Difference and Authority Production in a Congolese Spiritual Movement from Japan (Kinshasa, DR Congo)." PhD diss., Utrecht University.

Lamote, Frederik. 2012. "Small City, Global Scopes: An Ethnography of Urban Change in Techiman, Ghana." PhD diss., Leuven University.

Lanz, Stephan. 2013. "Assembling Global Prayers in the City: An Attempt to Repopulate Urban Theory with Religion." In *Global Prayers: Contemporary Manifestations of the Religious in the City*, edited by Jochen Becker, Katrin Klinghan, Stephan Lanz, and Kathrin Wildner, 17–43. Zürich: Lars Müller.

Largier, Niklaus. 2012. "Allegorie und Figuration: Figuraler Realismus bei Heinrich Seuse und Erich Auerbach." *Paragrana* 21 (2): 36–46.

———. 2013. "Zwischen Ereignis und Medium: Sinnlichkeit, Rhetorik, und Hermeneutik in Auerbachs Konzept der *Figura*." In *Figura: Dynamiken der Zeiten und Zeichen im Mittelalter*, edited by Christian Kiening, 51–70. Würzburg: Königshäusern und Neumann.

Larkin, Brian. 2004. "Degraded Images, Distorted Sounds: Nigerian Video and the Infrastructure of Piracy." *Public Culture* 16 (2): 289–314.

———. 2008. *Signal and Noise: Media, Infrastructure, and Urban Culture in Nigeria*. Durham, NC: Duke University Press.

Latour, Bruno. 2005a. "From Realpolitik to Dingpolitik: Or How to Make Things Public." In *Making Things Public: Atmospheres of Democracy*, edited by Bruno Latour and Peter Weibel, 4–31. Cambridge, MA: MIT Press.

———. 2005b. *Reassembling the Social: An Introduction to Actor-Network-Theory*. Oxford: Oxford University Press.

Laurent, Pierre-Joseph. 2008. "Éléments pour une socio-anthropologie de la défiance." In *Les cliniques de la précarité: Contexte social, psychopathologie et dispositifs*, edited by Jean Furtos and Guy Darcourt, 33–49. Paris: Elsevier Masson.

Leys, Ruth. 2011. "The Turn to Affect: A Critique." *Critical Inquiry* 37 (3): 434–72.

Lindner, Rolf. 2006. *The Reportage of Urban Culture: Robert Park and the Chicago School*. Cambridge: Cambridge University Press.

———. 2007. *Die Entdeckung der Stadtkultur: Soziologie aus der Erfahrung der Reportage*. Frankfurt am Main: Campus Verlag.

Lyden, John. 2003. *Film as Religion: Myths, Morals, and Rituals*. New York: New York University Press.

MacDougall, David. 2006. *The Corporeal Image: Film, Ethnography, and the Senses*. Princeton, NJ: Princeton University Press.

Macmillan, Allister. 1968. *The Red Book of West Africa: Historical and Descriptive, Commercial and Industrial Facts, Figures and Resources*. London: Cass.

Marks, Laura U. 2000. *The Skin of the Film: Intercultural Cinema, Embodiment, and the Senses*. Durham, NC: Duke University Press.

Marshall, Ruth. 2009. *Political Spiritualities: The Pentecostal Revolution in Nigeria*. Chicago: University of Chicago Press.

———. 2014. "Christianity, Anthropology, Politics." *Current Anthropology* 55 (10): 344–56.

Martin, Michael T. 1995. *Cinemas of the Black Diaspora: Diversity, Dependence, and Oppositionality.* Detroit: Wayne State University Press.

Mazzarella, William. 2004. "Culture, Globalization, Mediation." *Annual Review of Anthropology* 33: 345–67.

Mbembe, Achille. 2001. *On the Postcolony.* Berkeley: University of California Press.

———. 2002. "African Modes of Self-Writing." *Public Culture* 14 (1): 239–73.

McCall, John C. 2002. "Madness, Money, and Movies: Watching a Nigerian Popular Video with the Guidance of a Native Doctor." *Africa Today* 49 (3): 79–94.

———. 2004. "Nollywood Confidential: The Unlikely Rise of Nigerian Video Film." *Transition,* no. 95, 98–109.

———. 2007. "The Pan-Africanism We Have: Nollywood's Invention of Africa." *Film International* 5 (4): 92–97.

McCaskie, T. C. 1981. "Anti-witchcraft Cults in Asante: An Essay in the Social History of an African People." *History in Africa* 8: 125–54.

———. 2008. *"Akwantemfi*—'In Mid-Journey': An Asante Shrine Today and Its Clients." *Journal of Religion in Africa* 38 (1): 57–80.

McLagan, Meg, and Yates McKee. 2012. Introduction to *Sensible Politics: The Visual Culture of Nongovernmental Activism,* edited by Meg McLagan and Yates McKee, 9–26. Cambridge, MA: MIT Press.

McLuhan, Marshall, Jerome Agel, and Quentin Fiore. 1967. *The Medium Is the Massage: An Inventory of Effects.* New York: Random House.

Mensah, G. B. 1989. "The Film Industry in Ghana: Development, Potentials and Constraints." Master's thesis, University of Ghana.

Merleau-Ponty, Maurice. 1968. *The Primacy of Perception and Other Essays on Phenomenological Psychology, the Philosophy of Art, History and Politics.* Evanston, IL: Northwestern University Press.

———. 2005. *Phenomenology of Perception.* London: Routledge.

Meyer, Birgit. 1992. "'If You Are a Devil, You Are a Witch and, If You Are a Witch, You Are a Devil: The Integration of 'Pagan' Ideas into the Conceptual Universe of Ewe Christians in Southeastern Ghana." *Journal of Religion in Africa* 22 (2): 98–132.

———. 1995. "'Delivered from the Powers of Darkness': Confessions of Satanic Riches in Christian Ghana." *Africa* 65 (2): 236–55.

———. 1998a. "Commodities and the Power of Prayer: Pentecostalist Attitudes towards Consumption in Contemporary Ghana." *Development and Change* 29 (4): 751–76.

———. 1998b. "'Make a Complete Break with the Past': Memory and Post-Colonial Modernity in Ghanaian Pentecostalist Discourse." *Journal of Religion in Africa* 28 (3): 316–49.

———. 1998c. "The Power of Money: Politics, Occult Forces, and Pentecostalism in Ghana." *African Studies Review* 41 (3): 15–37.

———. 1999a. "Popular Ghanaian Cinema and 'African Heritage.'" *Africa Today* 46 (2): 93–114.

———. 1999b. *Translating the Devil: Religion and Modernity among the Ewe in Ghana.* Edinburgh: Edinburgh University Press.

———. 2001. "Money, Power and Morality: Popular Ghanaian Cinema in the Fourth Republic." *Ghana Studies* 4: 65–84.

———. 2002. "Christianity and the Ewe Nation: German Pietist Missionaries, Ewe Converts and the Politics of Culture." *Journal of Religion in Africa* 32 (2): 167–99.

———. 2003a. "Ghanaian Popular Cinema and the Magic in and of Film." In *Magic and Modernity: Interfaces of Revelation and Concealment,* edited by Birgit Meyer and Peter Pels, 200–222. Stanford: Stanford University Press.

———. 2003b. "Visions of Blood, Sex and Money: Fantasy Spaces in Popular Ghanaian Cinema." *Visual Anthropology* 16 (1): 15–41.

———. 2004. "'Praise the Lord': Popular Cinema and Pentecostalite Style in Ghana's New Public Sphere." *American Ethnologist* 31 (1): 92–110.

———. 2005. "Religious Remediations: Pentecostal Views in Ghanaian Video-Movies." *Postscripts* 1 (2/3): 155–81.

———. 2006a. "Impossible Representations: Pentecostalism, Vision and Video Technology in Ghana." In Meyer and Moors 2006, 290–312.

———. 2006b. "Religious Sensations: Why Media, Aesthetics, and Power Matter in the Study of Contemporary Religion." Inaugural lecture, Vrije Universiteit Amsterdam, 6 Oct.

———. 2007a. "Pentecostalism and Neo-liberal Capitalism: Faith, Prosperity and Vision in African Pentecostal-Charismatic Churches." *Journal for the Study of Religion* 20 (2): 5–28.

———. 2007b. "Sensuous Mediations: The City in Ghanaian Films—and Beyond." In *Wildness and Sensation: Anthropology of Sinister and Sensuous Realms,* edited by Rob van Ginkel and Alex Strating. Apeldoorn: Het Spinhuis, 254–74.

———. 2008. "Powerful Pictures: Popular Christian Aesthetics in Southern Ghana." *Journal of the American Academy of Religion* 76 (1): 82–110.

———. 2009a. "Comment on Ranger and Ter Haar and Ellis." *Africa* 79 (3): 413–15.

———. 2009b. "Introduction: From Imagined Communities to Aesthetic Formations: Religious Mediations, Sensational Forms and Styles of Binding." In Meyer 2009c, 1–28.

———, ed. 2009c. *Aesthetic Formations: Media, Religion, and the Senses.* Basingstoke: Palgrave Macmillan.

———. 2010a. "Aesthetics of Persuasion: Global Christianity and Pentecostalism's Sensational Forms." *South Atlantic Quarterly* 109 (4): 741–63.

———. 2010b. "'There Is a Spirit in That Image': Mass-Produced Jesus Pictures and Protestant-Pentecostal Animation in Ghana." *Comparative Studies in Society and History* 52 (1): 100–130.

———. 2011a. "Going and Making Public: Some Reflections on Pentecostalism as Public Religion in Ghana." In *Christianity and Public Culture in Africa,* edited by Harri Englund, 149–66. Athens: Ohio University Press.

———. 2011b. "Mediation and Immediacy: Sensational Forms, Semiotic Ideologies and the Question of the Medium." *Social Anthropology* 19 (1): 23–39.

———. 2011c. "Self-Contained: Glamorous Houses and Modes of Personhood in Ghanaian Video-Movies." In *Bodies of Belonging: Inhabiting Worlds in Rural West Africa,* edited by Ann Cassiman, 153–69. Antwerp: City Museum of Antwerp.

———. 2012. "Mediation and the Genesis of Presence: Towards a Material Approach to Religion." Inaugural lecture, Utrecht University, 19 Oct.

———. 2013. "Material Mediations and Religious Practices of World-Making." In *Religion across Media: From Early Antiquity to Late Modernity,* edited by Knut Lundby, 1–19. New York: Peter Lang.

———. Forthcoming. "How to Capture the Wow: R. R. Marett's Notion of Awe and the Study of Religion." *Journal of the Royal Anthropological Institute* 22 (1): March 2016.

Meyer, Birgit, and Annelies Moors, eds. 2006. *Religion, Media, and the Public Sphere.* Bloomington: Indiana University Press.

Meyer, Birgit, and Jojada Verrips. 2008. "Aesthetics." In *Key Words in Religion, Media, and Culture,* edited by David Morgan, 20–30. New York: Routledge.

Middleton-Mends, Kofi. 1995. "Video-Production: Which Direction?" Unpublished manuscript.

Mitchell, Jolyon. 2007. "From Morality Tales to Horror Movies: Towards an Understanding of the Popularity of West African Video Film." In *The Religion and Film Reader,* edited by Jolyon Mitchell and S. Brent Plate, 103–12. London: Routledge.

Mitchell, W. J. T. 2005. *What Do Pictures Want? The Lives and Loves of Images.* Chicago: University of Chicago Press.

———. 2008. "Four Fundamental Concepts of Image Science." In *Visual Literacy,* edited by James Elkins, 14–30. New York: Routledge.

Mittermaier, Amira. 2011. *Dreams That Matter: Egyptian Landscapes of the Imagination.* Berkeley: University of California Press.

Moore, Rachel. 2000. *Savage Theory: Cinema as Modern Magic.* Durham, NC: Duke University Press.

Morgan, David. 1998. *Visual Piety: A History and Theory of Popular Religious Images.* Berkeley: University of California Press.

———. 2005. *The Sacred Gaze: Religious Visual Culture in Theory and Practice.* Berkeley: University of California Press.

———. 2007. *The Lure of Images: A History of Religion and Visual Media in America.* New York: Routledge.

———. 2012. *The Embodied Eye: Religious Visual Culture and the Social Life of Feeling.* Berkeley: University of California Press.

Morris, Rosalind C. 2000. *In the Place of Origins: Modernity and Its Mediums in Northern Thailand.* Durham, NC: Duke University Press.

Morsch, Thomas. 2011. *Medienästhetik des Films: Verkörperte Wahrnehmung und ästhetische Erfahrung im Kino*. Paderborn: W. Fink.

Morton-Williams, P. 1953. *Cinema in Rural Nigeria: A Field Study of the Impact of Fundamental-Education Films on Rural Audiences in Nigeria*. Ibadan: West African Institute of Social and Economic Research.

Mullings, Leith. 1984. *Therapy, Ideology, and Social Change: Mental Healing in Urban Ghana*. Berkeley: University of California Press.

Murphy, David. 2000. "Africans Filming Africa: Questioning Theories of an Authentic African Cinema." *Journal of African Cultural Studies* 13 (2): 239–49.

National Commission on Culture. 2004. *The Cultural Policy of Ghana*. www.artsin africa.com/uploads/2011/04/Ghana.pdf.

National Media Commission. 1999. *National Media Policy*. Accra: Friedrich Ebert Stiftung.

Nkrumah, Kwame. 1964. *Consciencism: Philosophy and Ideology for Decolonization and Development with Particular Reference to the African Revolution*. London: Heinemann.

Oduro-Frimpong, Joseph. 2011. "Sakawa: On Occultic Rituals and Cyberfraud in Ghanaian Popular Cinema." Working Paper Presented to the Media Anthropology Network E-seminar, European Association of Social Anthropologists (EASA), 18 Jan.–1 Feb. www.media-anthropology.net/file/frimpong_rituals_cyberfraud.pdf.

———. 2012. "Popular Media, Politics and Everyday Life in Contemporary Ghana." PhD diss., Southern Illinois University.

Oha, Obododimma. 2000. "The Rhetoric of Nigerian Christian Videos: The War Paradigm of the Great Mistake." In *Nigerian Video Films*, edited by Jonathan Haynes, 192–99. Athens: Ohio University Center for International Studies.

Ong, Aiwa. 2011. *Worlding Cities: Asian Experiments or the Art of Being Global*. Oxford: Blackwell.

Okome, Onookome. 2002. "Writing the Anxious City: Images of Lagos in Nigerian Home Video Films." In Enwezor et al. 2002, 315–34.

———. 2007a. "Nollywood: Africa at the Movies." *Film International* 5 (4): 4–9.

———. 2007b. "Women, Religion and the Video Film in Nigeria: *Glamour Girls 1 & 2* and *End of the Wicked*." In *Theatre, Performance and New Media in Africa*, edited by Susan Arndt, Eckhard Breitinger, and Marek Spitczok von Brisinski, 161–85. Eckersdorf: Breitinger.

———. 2010. "Nollywood and Its Critics." In Şaul and Austen 2010, 26–43.

Onyinah, Opoku. 2002. *Akan Witchcraft and the Concept of Exorcism in the Church of Pentecost*. Birmingham: University of Birmingham.

Opoku, Kofi A., and Kathleen O'Brien Wicker. 2008. "Abidjan Mamiwater and Aba Yaba: Two Profiles of Mami/Maame Water Priesthood in Ghana." In Drewal 2008, 171–89.

Orsi, Robert A. 2005. *Between Heaven and Earth: The Religious Worlds People Make and the Scholars Who Study Them*. Princeton, NJ: Princeton University Press.

Palmeirim, Manuela. 2010. "Discourse on the Invisible: Senses as Metaphor among the Aruwund (Lunda)." *Journal of the Royal Anthropological Institute* 16 (3): 515–31.

Parker, John. 2000. *Making the Town: Ga State and Society in Early Colonial Accra.* Oxford: James Currey.

Parliament of the Republic of Ghana. 1961. *Cinematograph Act.* Date of Assent 17 August.

Parrinder, Edward G. 1950. "Theistic Beliefs of the Yoruba and Ewe Peoples of West Africa." In *African Ideas of God: A Symposium,* edited by Edwin W. Smith, 224–40. London: Edinburgh House Press.

Pedersen, Morten Axel. 2011. *Not Quite Shamans. Spirit Worlds and Political Lives in Northern Mongolia.* Ithaca, NY: Cornell University Press.

———. 2012. "Common Nonsense: A Review of Certain Recent Reviews of the Ontological Turn." *Anthropology of this Century* 5 (Oct.): http://aotcpress.com/articles/common_nonsense/.

Peek, Philip M. 1994. "The Sounds of Silence: Cross-World Communication and the Auditory Arts in African Societies." *American Ethnologist* 21: 474–94.

Pentcheva, Bissera V. 2006. "The Performative Icon." *Art Bulletin* 88 (4): 631–55.

Perneczky, Nikolaus. 2013. "Die Wiederverzauberung der Welt in Tunde Kelanis Dorffilmen." In *Spuren eines Dritten Kinos: Zu Ästhetik, Politik und Ökonomie des World Cinema,* edited by Lukas Foerster, Nikolaus Perneczky, Fabian Tietke, and Cecilia Valenti, 107–26. Bielefeld: Transcript.

Pfaff, Françoise, and Kwaw Ansah. 1995. "Conversation with Ghanaian Filmmaker Kwaw Ansah." *Research in African Literatures* 26 (3): 186–93.

Pinney, Christopher. 2004. *Photos of the Gods: The Printed Image and Political Struggle in India.* London: Reaktion.

Pinther, Kerstin. 2010. *Wege durch Accra: Stadtbilder, Praxen und Diskurse.* Köln: Rüdiger Köppe.

Pinther, Kerstin, Larissa Förster, Christian Hanussek, and Rautenstrauch-Joest-Museum. 2012. *Afropolis: City Media Art.* Auckland Park: Jacana.

Piot, Charles. 2010. *Nostalgia for the Future: West Africa after the Cold War.* Chicago: University of Chicago Press.

Plankensteiner, Barbara. 2007. "Benin: Kings and Rituals; Court Arts from Nigeria." *African Arts* 40 (4): 74–87.

———. 2011. "Dynasty and Divinity: Life Art in Ancient Nigeria." *African Arts* 44 (3): 84–86.

Plankensteiner, Barbara, and Nath Mayo Adediran. 2010. *African Lace: A History of Trade, Creativity and Fashion in Nigeria.* Ghent: Snoeck.

Plate, S. Brent. 2005. "Religious Cinematics: The Immediate Body in the Media of Film." *Postscripts* 1 (2/3): 257–73.

Pontzen, Benedikt. 2014. "Islam in the Zongo. An Ethnography of Islamic Conceptions, Practices, and Imaginaries among Muslims in Asante (Ghana)." PhD diss., Free University, Berlin.

Powdermaker, Hortense. 1962. *Copper Town: Changing Africa: The Human Situation on the Rhodesian Copperbelt*. New York: Harper and Row.

Prais, Jinny. 2014. "Representing an African City and Urban Elite: The Nightclubs, Dance Halls, and Red-Light District of Interwar Accra." In *The Art of Citizenship in African Cities: Infrastructures and Places of Belonging*, edited by Mamadou Diouf and Rosalind Fredericks, 187–207. New York: Palgrave.

Probst, Peter. 2011. *Osogbo and the Art of Heritage*. Bloomington: Indiana University Press.

Pype, Katrien. 2012. *The Making of the Pentecostal Melodrama: Religion, Media and Gender in Kinshasa*. New York: Berghahn.

Quason, Ato. 2010. "Signs of the Times: Discourse Ecologies and Street Life." *City and Society* 22 (1): 77–96.

———. 2014. *Oxford Street, Accra: City Life and the Itineraries of Transnationalism*. Durham, NC: Duke University Press.

Rancière, Jacques. 2006. *The Politics of Aesthetics: The Distribution of the Sensible*. London: Continuum.

———. 2009. *Dissensus: On Politics and Aesthetics*. London: Continuum.

Ranger, Terence O. 1983. "The Invention of Tradition in Colonial Africa." In *The Invention of Tradition*, edited by Eric J. Hobsbawm and Terence O. Ranger, 211–62. Cambridge: Cambridge University Press.

———. 1993. "The Invention of Tradition Revisited: The Case of Colonial Africa." In *Legitimacy and the State in Twentieth-Century Africa: Essays in Honour of A. H. M. Kirk-Greene*, edited by Terence Ranger and Olufemi Vaughan, 62–111. Houndmills: Macmillan.

———. 2007. "Scotland Yard in the Bush: Medicine Murders, Child Witches and the Construction of the Occult: A Literature Review." *Africa* 77 (2): 272–83.

Rappaport, Roy A. 1999. *Ritual and Religion in the Making of Humanity*. Cambridge: Cambridge University Press.

Rathbone, Richard. 2000. *Nkrumah and the Chiefs: The Politics of Chieftaincy in Ghana, 1951–60*. Athens: Ohio University Press.

Rattray, Robert S. 1927. *Religion and Art in Ashanti*. Oxford: Clarendon Press.

Reckwitz, Andreas. 2002. "The Status of the 'Material' in Theories of Culture: From 'Social Structure' to 'Artefacts.'" *Journal for the Theory of Social Behaviour* 32 (2): 195–217.

———. 2008. *Unscharfe Grenzen: Perspektiven der Kultursoziologie*. Bielefeld: Transcript.

———. 2012. "Affective Spaces: A Praxeological Outlook." *Rethinking History* 16 (2): 241–58.

Reinhartz, Adele. 2006. "History and Pseudo-history in the Jesus Film Genre." *Biblical Interpretation* 14 (1/2): 1–17.

Robbins, Joel. 2003. "What Is a Christian: Notes toward an Anthropology of Christianity." *Religion* 33 (3): 191–99.

———. 2007. "Continuity Thinking and the Problem of Christian Culture: Belief, Time, and the Anthropology of Christianity." *Current Anthropology* 48 (1): 5–38.

————. 2014. "The Anthropology of Christianity: Unity, Diversity, New Directions: An Introduction to Supplement 10." *Current Anthropology* 55 (S10): 157–71.

Robbins, Joel, and Matthew Engelke, eds. 2010. "Global Christianity, Global Critique." Special issue, *South Atlantic Quarterly* 109 (4).

Robbins, Rossell Hope. 1959. *The Encyclopedia of Witchcraft and Demonology.* New York: Crown.

Roberts, Allen F., Mary Nooter Roberts, Gassia Armenian, and Ousmane Guèye. 2003. *A Saint in the City: Sufi Arts of Urban Senegal.* Los Angeles: UCLA Fowler Museum of Cultural History.

Rodaway, Paul. 1994. *Sensuous Geographies: Body, Sense, and Place.* London: Routledge.

Rosenthal, Judy. 1998. *Possession, Ecstasy, and Law in Ewe Voodoo.* Charlottesville: University Press of Virginia.

Rouch, Jane. 1964. *Ghana.* Lausanne: Éditions rencontre.

Roy, Ananya, and Aihwa Ong. 2011. *Worlding Cities: Asian Experiments and the Art of Being Global.* Chichester: Wiley-Blackwell.

Sackey, Brigid M. 2003. "Apuskeleke: Youth Fashion Craze, Immorality or Female Harassment?" *Etnofoor* 16 (2): 57–69.

Sakyi, Kwamina. 1996. "The Problems and Achievements of the Ghana Film Industry Corporation and the Growth and Development of the Film Industry in Ghana." Master's thesis, University of Ghana.

Sánchez, Rafael. 2008. "Seized by the Spirit: The Mystical Foundation of Squatting among Pentecostals in Caracas (Venezuela) Today." *Public Culture* 20 (2): 267–305.

Sanders, Todd. 2003. "Reconsidering Witchcraft: Postcolonial Africa and Analytic (Un)Certainties." *American Anthropologist* 105 (2): 338–52.

Sarpong, Peter. 1996. *Libation.* Accra: Anansesem Publications.

Sassen, Saskia. 2002. *Global Networks, Linked Cities.* New York: Routledge.

Şaul, Mahir. 2010. "Art, Politics, and Commerce in Francophone African Cinema." In Şaul and Austen 2010, 133–59.

Şaul, Mahir, and Ralph A. Austen, eds. 2010. *Viewing African Cinema in the Twenty-First Century: Art Films and the Nollywood Video Revolution.* Athens: Ohio University Press.

Schmitt, Jean-Claude. 1998. *Ghosts in the Middle Ages: The Living and the Dead in Medieval Society.* Chicago: University of Chicago Press.

Schramm, Katharina. 2000. "The Politics of Dance: Changing Representations of the Nation in Ghana." *Afrika Spectrum* 35 (3): 339–58.

————. 2004a. "Senses of Authenticity: Chieftaincy and the Politics of Heritage in Ghana." *Etnofoor* 17 (1/2): 156–77.

————. 2004b. "Struggling over the Past: The Politics of Heritage and Homecoming in Ghana." PhD diss., Free University, Berlin.

————. 2010. *African Homecoming: Pan-African Ideology and Contested Heritage.* Walnut Creek, CA: Left Coast Press.

Schulz, Dorothea Elisabeth. 2012. *Muslims and New Media in West Africa: Pathways to God*. Bloomington: Indiana University Press.

Selasi, Taiye. 2005. "Bye-Bye Babar." *LIP, no. 5*, 3 March. http://thelip.robertsharp .co.uk/?p=76.

Senah, Kodjo. 2010. "Divided We Stand: Family Homes in Accra, Ghana." Paper presented at the University of Amsterdam, 5 March.

———. 2013. "Sacred Objects into State Symbols: The Material Culture of Chieftaincy in the Making of a National Political Heritage in Ghana." *Material Religion* 9 (3): 350–69.

Sereda, Stefan. 2010. "Curses, Nightmares, and Realities: Cautionary Pedagogy in FESPACO Films and Igbo Videos." In Şaul and Austen 2010, 194–208.

Shipley, Jesse Weaver. 2009a. "Aesthetic of the Entrepreneur: Afro-cosmopolitan Rap and Moral Circulation in Accra, Ghana." *Anthropological Quarterly* 82 (3): 631–68.

———. 2009b. "Comedians, Pastors, and the Miraculous Agency of Charisma in Ghana." *Cultural Anthropology* 24 (3): 523–52.

———. 2013. *Living the Hiplife: Celebrity and Entrepreneurship in Ghanaian Popular Music*. Durham, NC: Duke University Press.

Siegel, James T. 2006. *Naming the Witch*. Stanford: Stanford University Press.

Simmel, Georg. 1922. *Soziologie: Untersuchungen über die Formen der Vergesellschaftung*. München: Duncker und Humblot.

———. 1964. *The Sociology of Georg Simmel*. New York: Free Press.

Simone, AbdouMaliq. 2001. "On the Worlding of African Cities." *African Studies Review* 44 (2): 15–41.

———. 2004. *For the City Yet to Come: Changing African Life in Four Cities*. Durham, NC: Duke University Press.

Singer, Wolf. 2009. "Das Bild in uns: Vom Bild zur Wahrnehmung." In *Bildtheorien: Anthropologische und kulturelle Grundlagen des Visualistic Turn*, edited by Klaus Sachs-Hombach, 104–26. Frankfurt am Main: Suhrkamp.

Sobchack, Vivian C. 1992. *The Address of the Eye: A Phenomenology of Film Experience*. Princeton, NJ: Princeton University Press.

———. 2000. Introduction to *Meta Morphing: Visual Transformation and the Culture of Quick Change*, edited by Vivian Sobchack, xi–xxiii. Minneapolis: University of Minnesota Press.

———. 2004. *Carnal Thoughts: Embodiment and Moving Image Culture*. Berkeley: University of California Press.

———. 2008. "Embodying Transcendence: On the Literal, the Material, and the Cinematic Sublime." *Material Religion* 4 (2): 194–203.

Soja, Edward W. 2000. *Postmetropolis: Critical Studies of Cities and Regions*. Malden, MA: Blackwell.

Souriau, Étienne, and Henri Agel. 1953. *L'univers filmique*. Paris: Flammarion.

Spielmann, Yvonne. 2008. *Video: The Reflexive Medium*. Cambridge, MA: MIT Press.

Spitulnik, Debra. 2000. "Documenting Radio Culture as Lived Experience: Reception Studies and the Mobile Machine in Zambia." In *African Broadcast Cultures:*

Radio in Transition, edited by Richard Fardon and Graham Furniss, 144–63. Oxford: James Currey.

Spyer, Patricia. 2001. "The Cassowary Will (Not) Be Photographed: The 'Primitive,' the 'Japanese,' and the Elusive 'Sacred' (Aru, Southeast Moluccas)." In de Vries and Weber 2001, 304–20.

———. 2008. "Christ at Large: Iconography and Territoriality in Postwar Ambon." In *Religion: Beyond a Concept,* edited by Hent de Vries, 524–49. New York: Fordham University Press.

Spyer, Patricia, and Mary Margaret Steedly, eds. 2013. *Images That Move.* Santa Fe: School for Advanced Research Books.

Sreberny-Mohammadi, Annabelle, and Ali Mohammadi. 1994. *Small Media, Big Revolution: Communication, Culture, and the Iranian Revolution.* Minneapolis: University of Minnesota Press.

Steedly, Mary Margaret. 2013. "Transparency and Apparition: Media Ghosts of Post–New Order Indonesia." In Spyer and Steedly 2013, 257–94.

Steegstra, Marijke. 2006. "'White' Chiefs and Queens in Ghana: Personification of 'Development.'" In *Chieftaincy in Ghana: Culture, Governance and Development,* edited by Irene K. Odotei and A.K. Awedoba, 603–20. Accra: Sub-Saharan Publishers.

Stiebel, Lindy. 2001. *Imagining Africa: Landscape in H. Rider Haggard's African Romances.* Westport, CT: Greenwood Press.

Stoller, Paul. 1997. *Sensuous Scholarship.* Philadelphia: University of Pennsylvania Press.

Stolow, Jeremy. 2005. "Religion and/as Media." *Theory, Culture and Society* 22 (4): 119–45.

———. 2008. "Salvation by Electricity." In *Religion: Beyond a Concept,* edited by Hent de Vries, 668–86. New York: Fordham University Press.

———. 2012. "Introduction: Religion, Technology, and the Things in Between." In *Deus in Machina: Religion, Technology, and the Things in Between,* edited by Jeremy Stolow, 1–22. New York: Fordham University Press.

Stordalen, Terje. 2013. "Media of Ancient Hebrew Religion." In *Religion across Media: From Early Antiquity to Late Modernity,* edited by Knut Lundby, 20–36. New York: Peter Lang.

Strauss, Claudia. 2006. "The Imaginary." *Anthropological Theory* 6 (3): 322–44.

Sumiala-Seppänen, Johanna. 2008. "Circulation." In *Key Words in Religion, Media, and Culture,* edited by David Morgan, 44–55. New York: Routledge.

Svašek, Maruška. 2012. "Introduction: Affective Moves: Transit, Transition and Transformation." In *Moving Subjects, Moving Objects: Transnationalism, Cultural Production and Emotions,* edited by Maruška Svašek, 1–40. New York: Berghahn.

Taussig, Michael T. 1993. *Mimesis and Alterity: A Particular History of the Senses.* New York: Routledge.

———. 1999. *Defacement: Public Secrecy and the Labor of the Negative.* Stanford: Stanford University Press.

Taylor, Charles. 2004. *Modern Social Imaginaries*. Durham, NC: Duke University Press.

———. 2007. *A Secular Age*. Cambridge, MA: Belknap.

Thackway, Melissa. 2003. *Africa Shoots Back: Alternative Perspectives in Sub-Saharan Francophone African Film*. Bloomington: Indiana University Press.

Thalén, Oliver. 2011. "Ghanaian Entertainment Brokers: Urban Change, and 'Afro-Cosmopolitanism,' with Neo-liberal Reform." *Journal of African Media Studies* 3 (2): 227–40.

Thoden van Velzen, Bonno, and Wilhelmina van Wetering. 1989. "Demonologie en de betovering van het moderne leven." *Sociologische Gids* 36 (3–4): 155–86.

Tonah, Steve. 2007. *Ethnicity, Conflicts, and Consensus in Ghana*. Accra: Woeli Publication Services.

Tonda, Joseph. 2011. "Pentecôtisme et 'contentieux matériel' transnational en Afrique centrale: La magie du système capitaliste." *Social Compass* 58 (1): 42–60.

———. Forthcoming. *Éblouissements postcoloniaux*. Paris: Karthala.

Traut, Lucia, and Annette Wilke. 2015. "Einleitung." In *Religion—Imagination—Ästhetik: Vorstellungs- und Sinneswelten in Religion und Kultur,* edited by Lucia Traut and Annette Wilke, 17–70. Göttingen: Vandenhoeck and Ruprecht.

Tuakli-Wosornu, Taiye. 2007. "What Is an Afropolitan?" *Afro Beat,* 5 March. http://theafrobeat.blogspot.no/2007/03/what-is-afropolitan-by-taiye-tuakli .html.

Twum-Baah, Kwaku A. 2002. "Population Growth of Mega-Accra: Emerging Issues." In *Visions of the City: Accra in the 21st Century,* edited by Ralph Mills-Tettey and Korantema Adi-Dako, 31–38. Accra: Woeli Publication Services.

Uehlinger, Christoph. 2005. "'Medien' in der Lebenswelt des Antiken Palästina?" In *Medien im antiken Palästina: Materielle Kommunikation und Medialität als Thema der Palästinaarchäologie,* edited by Christian Frevel, 31–61. Tübingen: Mohr Siebeck.

Ukadike, Nwachukwu F. 1994. *Black African Cinema*. Berkeley: University of California Press.

———. 2003. "Video Booms and the Manifestations of 'First' Cinema in Anglophone Africa." In *Rethinking Third Cinema*, edited by Anthony R. Guneratne and Wimal Dissanayake, 127–43. New York: Routledge.

van den Bersselaar, Dmitri. 2007. The King of Drinks: Schnapps Gin from Modernity to Tradition. Leiden: Brill.

van de Port, Mattijs. 2006. "Visualizing the Sacred: Video Technology, 'Televisual' Style, and the Religious Imagination in Bahian Candomblé." *American Ethnologist* 33 (3): 444–61.

———. 2011. *Ecstatic Encounters: Bahian Candomblé and the Quest for the Unknown*. Amsterdam: Amsterdam University Press.

van der Veer, Peter. 2001. *Imperial Encounters: Religion and Modernity in India and Britain*. Princeton, NJ: Princeton University Press.

van Dijk, Rijk. 2001. "Contesting Silence: The Ban on Drumming and the Musical Politics of Pentecostalism in Ghana." *Ghana Studies* 4: 31–64.

Vasudevan, Ravi, ed. 2000. *Making Meaning in Indian Cinema.* Oxford: Oxford University Press.

Verrips, Jojada. 2001. "*The Golden Bough* and *Apocalypse Now:* An-Other Fantasy." *Postcolonial Studies* 4 (3): 335–48.

———. 2002. "'Haptic Screens' and Our 'Corporeal Eye.'" *Etnofoor* 15 (1/2): 21–46.

———. 2006. "Aisthesis and an-Aesthesia." *Ethnologia Europea* 35 (1/2): 27–33.

Verrips, Jojada, and Birgit Meyer. 2001. "Kwaku's Car: The Struggles and Stories of a Ghanaian Long-Distance Taxi Driver." In *Car Cultures,* edited by Daniel Miller, 153–84. Oxford: Berg.

Warner, Michael. 2002. *Publics and Counterpublics.* New York: Zone.

Weibel, Peter. 2011. "Religion as a Medium—the Media of Religion." In Groys and Weibel 2011, 30–43.

Wendl, Tobias. 1991. *Mami Wata: Oder ein Kult zwischen den Kulturen.* Münster: Lit.

———. 1999. "Le retour de l'homme-serpent: Films d'épouvante réalisés au Ghana." *Revue Noire,* no. 32, 48–51.

———. 2001. "Visions of Modernity in Ghana: Mami Wata Shrines, Photo Studios and Horror Films." *Visual Anthropology* 14 (3): 269–92.

———. 2007. "Wicked Villagers and the Mysteries of Reproduction: An Exploration of Horror Films from Ghana and Nigeria." *Postcolonial Text* 3 (2): 1–21.

Wilkens, Katharina. 2015. "Inkorporierte Imagination—Geistertänze und Exorzismus in Ostafrika." In *Religion—Imagination—Ästhetik: Vorstellungs- und Sinneswelten in Religion und Kultur,* edited by Lucia Traut and Annette Wilke, 107–30. Göttingen: Vandenhoeck and Ruprecht.

Wilks, Ivor. 1993. "The Golden Stool and the Elephant Tail: Wealth in Asante." In *Forests of Gold: Essays on the Akan and the Kingdom of Asante,* edited by Ivor Wilks, 127–68. Athens: Ohio University Press.

Wiredu, Kwasi. 2009. "An Oral Philosophy of Personhood: Comments on Philosophy and Orality." *Research in African Literatures* 40 (1): 8–18.

Woets, Rhoda. 2011. "'What Is This?' Framing Ghanaian Art from the Colonial Encounter to the Present." PhD diss., Vrije Universiteit, Amsterdam.

———. Forthcoming. "The Moving Lives of Jesus Pictures in Ghana: Art, Authenticity and Animation." In *Creativity in Transition,* edited by Maruška Svašek and Birgit Meyer. Oxford: Berghahn.

Wolfe, Ernie. 2000. *Extreme Canvas: Hand-Painted Movie Posters from Ghana.* New Orleans: Dilettante Press.

Wünsch, Michaela. 2011. "Mediale Techniken des Unheimlichen und der Angst." In *Phantasmata: Techniken des Unheimlichen,* edited by Martin Doll, Rupert Gaderer, Fabio Camiletti, and Jan Niklas Howe, 95–111. Vienna: Turia und Kant.

Yeboah, Ian E. A. 2000. "Structural Adjustment and Emerging Urban Form in Accra, Ghana." *Africa Today* 47 (2): 61–89.

FILMOGRAPHY

GHANA (CELLULOID AND VIDEO)

Abaddon (Paragon Pictures, 1996)
Abyssinia (Video City Ltd, 1985)
Accra Killings (Kama Films Production, 2000)
Amsterdam Diary (Danfo B. A. Productions, 2005)
Asɛm (Miracle Films, 2001)
Babina 1 and *2* (Aak-Kan Films 2000, 2003)
Baby Thief (GFIC, 1992)
Back to Kotoka (Movie Africa Productions, 2001)
The Beast Within (Astron Productions, 1993)
Beyonce: The President's Daughter (Venus Films, 2007)
Bitter Results (Aak-Kan Films, 1995)
Blood Money: The Vulture Men (OJ Productions, 1997)
Born Against (Kapital Screen Pictures, 1995)
The Boy Kumasenu (Gold Coast Film Unit, 1952)
Brenya 4 (Movie Africa Productions, 2007)
Bukom Lion (Paragon Pictures, 1994)
A Call at Midnight (Princess Films, 2011)
Candidates for Hell (Extra 'O' Film Producers, 1995)
Chronicles of Africa (Movie Africa Productions, n.d.)
Crossroads of People, Crossroads of Trade (Film Africa Limited, 1994)
Cult of Alata (World Wide Motion Pictures, 1991)
Dabi Dabi I and *II* (Miracle Films, 2002)
Dangerous Game (Aak-Kan Films, 1996)
Dark Sands (Gama Films, 1999)
Dede (GFIC, 1992)
Deliverance from the Powers of Darkness 1 and *2* (Sam Bea Productions, 1991)
Demona (Paragon Pictures, 1995)
Diabolo I–IV (World Wide Motion Pictures, 1991–95)

Dirty Secret (Venus Films, 2011)

The Dons of Sakawa (Venus Films, 2009)

Double Cross (H. M. Films, 1992)

Elmina (Emmanuel and John Apea Productions, 2010)

Expectations (Miracle Films, 2000)

Fatal Decision (H. M. Films, 1993)

Forbidden Fruit (Princess Films, 2003)

Ghost Tears (Movie Africa Productions and Hacky Films, 1992)

Gold Mask 1 and *2* (Blema Productions, 2009)

Guilty Pleasures (Venus Films, 2009)

Harvest at 17 (Film Africa Limited, 1992)

Heart of Man (Venus Films, 2010)

Heritage Africa (Film Africa Production, 1989)

Hot Fork (Movie Africa Productions, 2010)

Idikoko in Holland (Great Idikoko Ventures, 2005)

The Intruder (Jubal Productions, 1996)

Jennifer (Gama, 1999)

Jezebel I–IV (Movie Africa Productions, 2007–8)

Juju (Matthias Film, 1986)

Killing Me Softly (Astral Pictures, 1997)

Kiss Your Wife (Video Africanus, 1995)

Kukurantumi (Afromovies, 1983)

Kyeiwaa (Movie Africa Productions, 2007–12)

Living in Bondage (NEK Video Links, 1992)

Love and Sex I and *II* (Movie Africa Productions, 2010)

Love Brewed in an African Pot (Film Africa, 1980)

Mariska (Aak-Kan Films, 1999)

Mataa: Our Missing Children (Galaxy Productions, 1992)

Mataheko: The Danger Zone (Corporate Films, 2000)

Matters of the Heart (Great Idikoko Ventures, 1993)

Menace (Paragon Pictures, 1992)

A Mother's Revenge (Ananse System Productions, 1994)

Namisha (Aak-Kan Films, 1999)

Naomi (Harry Laud, 1995)

Nkrabea My Destiny (Amahilbee Productions, 1992)

No One Knows (Hacky Films, 1996)

No Time to Die (Afromovies, 2006)

Not Without (Hacky Films, 1996)

The Other Side of the Rich (GFIC, 1992)

Our Father (Movie Africa Productions, 1997)

Pastors Club (Miracle Films, 2009)

Princess Tyra 1–3 (Venus films, 2007–8),

Reward (World Wide Motion Pictures, 2000)

Ripples 1–3 (Princess Films, 2003)

Sacred Beads I and *II* (Aak-Kan Films, 2009)

Sakawa 419, I and *II* (Miracle Films, 2009)

Sakawa Boys (Mallam Issa Kawa) I, II, III (Movie Africa Productions, 2009)

Sakawa Girls (Blema Productions, 2009)

Sakawa (Big Joe Productions, 2009)

See You Amsterdam (Vista Far Reaching Visuals and H.M. Films, 2002)

Set on Edge (Gama, 1999)

Sexy Angel (Movie Africa Productions, 2010)

Shadows from the Past (Princess Films, 2000)

Spirit of Heritage I and *II* (Sarbah The Great Films, 2008)

A Stab in the Dark (Princess Films, 1999)

Step Dad (Movie Africa Productions and Hacky Films, 1993)

Stolen Bible (Secret Society) I and *II* (Idikoko Ventures 2001/2002)

Subcity (Movie Africa Productions, 2006)

Supi Supi: The Real Woman to Woman (Cobvision Productions, 1996)

The Suspect (Aak-Kan Films, 1998)

Tasheena (Aak-Kan Films, 2008)

The Turning Point (T. Print Productions, 2003)

Time (Miracle Films, D'Joh Mediacraft, and Igo Films, 2000)

Together Forever (Movie Africa Productions, 2002)

Tricky Twist (New Frontier, 1992)

Twisted Fate (Piro Films, 1993)

Unconditional Love (Movie Africa Productions, 1988)

Who Loves Me? (Venus Films, 2010)

Whose Fault? (Roses Productions, 1994)

Wicked Romance (Paragon Pictures, 2004)

The Witches of Africa (Ebkans Enterprise, 1992)

Women in Love I and *II* (Movie Africa Productions, 1996)

Zinabu I (World Wide Motion Pictures / Paragon Pictures, 1985)

Zinabu II (unclear)

Zinabu III (World Wide Motion Pictures, 1991)

Zinabu IV (Paragon Pictures, 1992)

Zinabu (World Wide Motion Pictures / Paragon Pictures, 2000)

NIGERIA

Allegation 2002 (Dang Movies Industries, 2002)

Blood Money (Ojiofor Ezeanyaeche Productions, 1997)

Church Bu$ine$$ (House of Macro Productions, 2003)

Karishika (Tony Jickson, 1996)

Living in Bondage (NEK Video Links, 1992)

An American Werewolf in London (UK/US: PolyGram Filmed Entertainment, 1981)
Deadly Voyage (UK/US: Union Pictures and Viva Films, 1996)
Ghanaian Video Tales (Germany: T. Wendl, 2005)
Jaguar (France: Les Films de la Pléiade, 1967)
Nosferatu: Eine Symphonie des Grauens (West Germany: Prana Film, 1922)
Rosemary's Baby (USA: William Castle Productions, 1968)
Sankofa (Ethiopia: Haile Gerima, 1993)
Snake in the Monkey's Shadow (Hong Kong: Goldig Films LTD, 1979)
Splash (USA: Touchstone Pictures, 1984)
This Is Nollywood (San Francisco: California Newsreel, 2007)
The Video Revolution in Ghana (USA: C. Garritano, 2000)
Welcome to Nollywood (New York: Cinema Guild, 2007)
What Lies Beneath (USA: Twentieth Century Fox Film Corporation, 2000)

INDEX

Abaddon (Paragon Pictures, 1996), 160, 314n5

Abbey, Augustine (alias "Idikoko"), xii, 31, 34, 112; as actor, 176; on moral message in movies, 136; as self-trained producer/director, 56

Abbeyquaye, Ernest, 46, 202, 204, 261

Abyssinia (Video City Ltd., 1985), 49–50

Accra, city of, 36, 94, 113, 301n1; Arts Centre, 264, 282; billboard advertisements in, 2, *2;* building boom in, 98–99, 100, 106, 308n10; cinema houses in, 42, 43, 46, 73, 302n13; Ga areas in, 43, 50, 82, 85, 88; global capitalism and, 93; history of, 85–86; Kanda neighborhood, 45, 81; Lagos compared to, 96; as modern city, 262; modernist architecture in, 87–88; new residential areas, 97–100; Oxford Street, 92, 98, 103, 308n8; population of Greater Accra, 89, 308n7; "Russia" neighborhood, 31, 32, 89; Teshie suburb, 28, 100, 153, 319n4; urban mobility in, 81–82; urban spaces of, 85–90. *See also* Opera Square (Accra)

Accra Killings (Kama Films Production, 2000), 95

acting clubs and schools, 72

Action Chapel International, 174

actors, 68, 225, 236; as born-again Christians, 325n8; confused by the public for roles played, 228–29, 324n5; in evil roles, 227–28; fear of spiritual forces on

film sets, 236–37. *See also* stars and stardom

Adinkra symbols, 258, 281

Adobe Premiere editing program, 67, 238, 330n16

advertising, 5, 125–26, *274;* billboard advertisements, *66;* in colonial-era films, 44; GBC (Ghana Broadcasting Corporation) and, 4; Ghanaian films advertised as Nigerian, 126; of Pentecostal-charismatic churches, 9; of special effects, 243–49, *245, 248;* still photographs from movies, 143, *144*

aesthetics, 18, 22, 40, 159; aesthetic formation, 15, 18, 299n10; new aesthetics of tradition, 278–286; of outrage, 152, 192; of persuasion, 312n15

affect, film and, 20, 299–300n17

afilmic, the, 246–47, 251

Afra (alias Bin Yahya [Big Daddy]), 67, 238

Africa in Picture Film festival, 34

Africa Magic (TV satellite channel), 74, 75, 125, 309n18

Africa Magic Plus (TV satellite channel), 75, 125, 309n18

African Americans, 255, 328n3, 329n10

African art films, 25, 48, 91, 150; alternative imagery of Africa in, 113; European audiences of, 294; "return to tradition" in, 93

African cinema, 23, 225, 255, 290, 292, 301n1; "African authenticity" claims and, 25–26, 286, 300n22; dominant

13; craving for new sensations, 3; dislike for "true life stories" about urban poor, 82–83, 306n1; "epic" films and, 275, 330n14; European/Western, 113, 220; expectations of, 290; feedback from, 7; global, 286; interactive participation of, 139–142, 151; international art film and African audiences, 25; lifestyles influenced by video films, 103–107; lived experience and, 118–122; moral teachings of movies and, 134–39, 150, 312n16; Nigerian films popular with, 70; producers' attitudes toward, 304n31; self and ethics of watching, 146–49; special effects and, 244–45, 248; watching films as communal experience, 142–46, *144;* yearning for entertainment, 43. *See also* spectators

audiovisualization, 21, 23, 27, 155, 191

Auerbach, Erich, 156

"auteur" films, 3

authenticity, 177, 260, 266, 286; "African cinema" and, 25–26; of traditional culture, 278

Babina 1 and *2* (Aak-Kan Films, 2000, 2003), 240, 244, *245,* 287

BabyThief (GFIC, 1992), 56, 266–68, 269, 270, 279

Back to Kotoka (Movie Africa Productions, 2001), 30, 305n41

Bannermann, Alex, 241

Barber, Karin, 6, 7, 312n14

Basel Mission, 257, 315n17

Basic Emotions paradigm, 300n17

Bayart, Jean-François, 27, 293

Bea, Sam, 56, 153–55, 170

Beast Within, The (Astron Productions, 1993), 128, 187

Behrend, Heike, 273, 316n18, 330n13

Belting, Hans, 17, 18, 299n12, 318n30, 327n20

Benjamin, Walter, 18, 90, 273, 299n13

Bentus, Lord (alias Ato Blinx), 228–29, 237, 272, 324n4

Betacam, 60, 238, 302–303n1, 305n38

Beyonce: The President's Daughter (Venus Films, 2007), 73, 102

Bible, 156, 157, 179, 187, 320n8; Jezebel in 1 and 2 Kings, 322n22; King David in, 280; Revelation of John, 156–57; translated into "native" languages, 257

Big Star Studio, 67, 238

Bitter Results (Aak-Kan Films, 1995), 32

Blier, Suzanne Preston, 232, 326n14

blockbusters, 5, 72, 73, 229

"blood money," 7, 24, 205, 268

Blood Money: The Vulture Men (OJ Productions, 1997), 96

"blue" movies. *See* pornographic movies

Bollywood, 25, 26, 27, 73, 75. *See also* Indian (Hindi) films

Bonsam, Kwaku, 180–81, 264, 265, 321n17

Born Against (Kapital Screen Pictures, 1995), 180

Boy Kumasenu, The (Gold Coast Film Unit, 1952), 43, 307n4

Bremen Mission, 257, 315n17

Brenya 4 (Movie Africa Productions, 2007), *210, 211,* 327n21

bricolage, 53, 225, 232, 294

British imperialism, 162–64, 314n10

British Ministry for Information, 42

Broad and the Narrow Way, The (lithograph), 317n26

Brooks, Peter, 221

Bukom Lion (Paragon Pictures, 1994), 314n5

Bunyan, John, 160

Call at Midnight, A (Princess Films, 2011), 310n6

Candidates for Hell (Extra 'O' Film Producers, 1995), 180

Cape Coast, former slave castle in, 255, 328n3

capitalism, 93, 193; narratives about occult forces and, 194; neoliberal, 2, 8; Pentecostalism and, 9

Captan Cinema Company, 42, 46, 302n11

Carroll, Noël, 219–220, 322n24

cassette tapes, 65, 67, 116, 305n37

Castoriadis, Cornelius, 14, 298n7

Catholics/Catholicism, 186, 187, 258, 297n4, 318nn29–30, 326n13

Celestial Church of Christ, 31, 331n19

celluloid film, 12, 25, 53, 297n2; in colonial
Ghana (1920s–1957), 41–44; decline of,
55; degeneration of, 50; downfall of, 79;
garbage heap of reels/films, 61, *62,*
305n35; hope for revival of, 60; in inde-
pendent Ghana to mid-1980s, 44–49;
"mentality of celluloid," 63; shortcom-
ings of, 77; video as substitute for, 29, 35,
40, 57
censorship, 32, 41, 57; in colonial era, 42;
moral of story in video films and,
130–34; sharia in northern Nigeria
and, 311n10; transition from celluloid
to video and, 78
censorship board/office, 3, 36, 55, 92,
306n48; audience as moral public and,
118; chief as member of, 270; classifica-
tion system of, 130; foreign movies and,
48, 303n21; Gama's problems with, 61;
"influx" of Nigerian movies and, 70;
moral education vision of, 48; in North
Industrial Area, 81; number of movies
registered with, 309–10n1; preview
sessions of, 130, 311n9; state discourse on
film-as-education and, 62, 133–34;
Zinabu I and, 315n15
Chaplin, Charlie, 43, 302n8
chiefs/chieftaincy, 254, 256, 264–66; Akan,
258; chiefs' responses to video film
representations, 270–73; colonialism
and, 329n10; in epic films, 275; as "liv-
ing" tradition, 284; as obstacle to
"development," 266–68; power and,
268–270
Chinese films, 46
Christianity, 1, 19, 29, 58, 126, 150; African
Independent Churches, 170, 331n19;
Africanization of, 258; anthropology of,
9, 297–98n5; born-again, 172; Christian
movies, 10, 30; conversion to, 51, 231,
293; depiction of time before, 275; early
cinema in Europe and, 313n4; early
evangelism in Ghana, 168; ethics of
watching and, 146–49; failure of films
critical of, 64, 276; as "light" against
"powers of darkness," 192; logic of fight
between God and Satan, 136; Pietist,
169; sermons, 134; traditional religion

and, 21, 264–65; video films and,
171–182, 191
Chronicles of Africa (Movie Africa Produc-
tions, n.d.), 64
Church Bu$ine$$ (Nigeria: House of Macro
Productions, 2003), 216
Church of Pentecost, 133, 146, 213, 229
Cinarc, 226
"cinema of attraction," 242
cinemas/cinema houses, 42, 43, 137; dress
codes in, 46; "low-class," 78; managers
of, 126; pastoral disapproval of, 147; as
places of Pentecostal worship, 47;
screening sequence of movies in, 54. See
also video centers; *specific cinemas*
Cinematographic Act (1961), 302n10,
303n22
Cinematographic Palace (Accra), 41
city, the, 35–36; behind façade of beauty
and progress, 94–97; immorality of, 44;
occult practices in, 83–84; as potential
realm of immorality, 94–95; "real life
stories" of urban poor, 82–83; "sensuous
geography" of, 148; as space of moder-
nity, 266; urban mobility, 81–82; urban
space, 85–90; video movies as mediation
of, 90–94. *See also* Accra, city of
"civilization," 43, 44, 83, 257, 259
Codjoe, Veronica, 54
Cofie, Eddie, 174–75, 176, 188, 189, 228,
316n22
"colo" (old-fashioned things), 64, 103
Colonial Films Committee, 41
Colonial Film Unit (CFU), 42–43, 44
colonialism, 53, 77, 219, 256, 260; chief-
taincy and, 264; depiction of time
before, 274–75; ideological discourses
of, 83; "indirect rule" and, 163–64, 257,
259, 329n10; missionaries and, 257
color, 50, 55, 77, 142
Comaroff, John L. and Jean, 194
comedy, 29, 31, 71, 125, 126
computers, 16, 198; computer-designed
posters, 55, 75; editing of video films
with, 71–72, *72,* 238–39, *239,* 241, 248;
special effects designed with, 241, 247,
248, 250. *See also* Internet
concert parties, 6, 49, 87, 134, 312n13

Diawara, Manthia, 26, 301n1

digital editing, 67, 209, 238–39, 241, 242, 246. *See also* editing

Dirty Secret (Venus Films, 2011), 73, 306n48

distribution, xii, 46, 54, 110; posters advertising films, 54, 304n28; private distributors, 52

divination, 19, 170, 184, 189

documentaries, 43, 45, 113, 272

Dons of Sakawa, The (Venus Films, 2009), 323n3

Dontoh, David, 305n35

Double Cross (H. M. Films, 1992), 30

"Draft of the National Film and Video Policy," 62, 63, 64

dreams, 200, 207, 321n14

drugs, plots involving, 68, 145, 269

Dugbartey Nanor, Ezekiel, 226, 227, 237, 261

Dunia Cinema (Accra), 125, 302n13

dzemāwɔn (god), 315n17

Economic Recovery Program, 89

ECOWAS (Economy Community of West African States), 70

editing, 71–72, *72*, 223, 237–243, *239, 240,* 246. *See also* digital editing

education, state discourse on film as, 8, 35, 46, 80, 296; censorship board and, 62, 133–34; in colonial era, 41, 44; foreign movies seen as negative influence, 48; Gama employees as supporters of, 60; GFIC productions and, 56; media liberalization and, 91; private video filmmakers and, 58; removed from actual viewing practices, 47; spiritual realm seen as "superstition," 150; vision of ideal spectator and, 118

Edwards, Pascaline, 231

Elmina (Emmanuel and John Apea Productions, 2010), 331n4

Elmina, former slave castle in, 255, 328n3

Elsas, Mandy, 295, 304n28

Encyclopedia of Witchcraft and Demonology, The (Robbins), 207, 321n15

endings of films, proper and moral, 176, 218, 229; audience preferences and,

300n21, 327n21; "triumph of good over evil," 130, 135. *See also* morality/ethics

English language, 41, 130, 142; Big English, 128, 141; correct English, 161, 312n18; as lingua franca in southern Ghana, 141; subtitles in, 71, 141, 178, 179, 275

Eni, Emmanuel, 153, 322n23

entertainment, 3, 9, 76; military regime and, 49; Pentecostal ideas/imagery transferred into, 10; Pentecostalism merged with, 22; Pentecostal-lite, 173; women and family entertainment, 127

entrepreneurs, cultural, 1, 5, 256

epic genre, 37, 82, 254, 264, 293; aesthetics of traditional culture in, 278–284, 285; depiction of time before Christianity, 275–76; emergence of, 274, 330n14; as "history" or "old-time" films, 273–74, 282; set in precolonial era, 274–75

ethnic festivals, 256

evil. *See* good and evil, dualism of

Ewe people/language, 169, 204, 308n15, 315n16, 321n17, 326n14; *gbɔgbɔ* (spirit), 110, 169, 315n16; mission churches and, 257, 328n4; *trɔwo* (gods), 315n17; *vɔdu* (god), 315n17; *vodun* and Mami Water cult among, 211

exhibition, 45, 46, 52–53, 54

exorcism, 185, 326n12. *See also* deliverance

Expectations (Miracle Films, 2000), 187, 229, 230

extraversion, 27, 195, 213, 293

ɛyɛ sunsum asem (Akan: "spiritual matter"), 315n16

Fabian, Johannes, 6, 318n2

family, 7, 14, 56, 142

family, extended, 6, 94, 110, 111, 112, 118

family, nuclear, 111, 128, 146; celebrated by Christians in contemporary Ghana, 108, 168; "self-contained" house and, 99, 101, 109

fantasy, 13, 114, 147, 198, 321n14

fashion, 283–84, 285, 287

Fatal Decision (H. M. Films, 1993), 101, 116, 172, 174–75

Feather Edge editing program, 241

Ferguson, James, 89, 113, 115

Ghana Cinematographic Exhibitions Board of Control, 303n22
Ghana Film Award ceremonies, 236, 262
Ghana Films Cinema, 176
Ghana Films Theatre, 54, 125, 139
Ghana Film Unit, 44
Ghanaian Video Tales (Wendl, 2005), 207
"ghost films," 243
ghosts, 23, 37, 57, 60, 319n4, 320n9; elusive iconographies of, 293; figuration of, 217; video films featuring, 199–204
Ghost Tears (Movie Africa Productions and Hacky Films, 1992), 111, 116, 202, 203, 319n5, 320n10; special effects in, 238; synopsis, 200–201
Gilbert, Michelle, 269
Gillespie, Marie, 310n2
Ginsburg, Faye, 297n3
Gintersdorfer, Monika, 294
glamour films, 73, 125, 141
Global Contemporary, The (exhibition), 295
Globe Cinema (Accra), 45, 52, 161
Glover, Ablade, 327n1
God, Christian, 145, 160, 171, 230, 326n13; audiovisual perspective of, 190; as character played by actor in movies, 153; conflict with indigenous deities, 58, 315n17; dream as sign from, 179; dualistic struggle with Satan/the devil, xi, 10, 21, 23, 68, 136, 137, 203, 290; "eye of God" (omnivision of God), 183, 184, 185, 190, 317nn25–26; film-as-revelation and, 172, 186; iconoclastic opposition to representation of, 185; as invisible transcendent entity, 169, 315n17; invoked at end of epic movies, 282–83, 285; Jesus as human Son of, 155; miracles and power of, 174; occult forces overcome by, 176; revelation in the Bible and, 313n2; Sacred Heart of Jesus motif and, 188; special effects representing hand of God, 138; spiritual war with the demonic, 187; visions of, 167, 328n5
gods/goddesses, 231, 272, 289, 315n17, 317n28; Christian denigration of, 257; craftsmanship of sculptures and, 232; "culture of power" and, 270; existence or nonexistence of, 194; family gods,

110; Mami Water as, 214, 268; the occult and, 193; Pentecostal demonization of, 23; revelation and, 156; river, 237, 327n21; triumph of Christian God over, 58; Zulu, 163
Goethe, Johann Wolfgang, 291
Gold Coast (colonial Ghana), 41–44, 85, 256, 301n1
Gold Coast Film Unit, 43, 45, 302n9
Gold Mask 1 and *2* (Blema Productions, 2009), 329n9
good and evil, dualism of, 137, 170, 186, 192; "naming" the occult and, 217; psychological conflicts depicted in terms of, 221; witchcraft and, 207
Graham, Billy, 207
Green-Simms, Lindsey, 196, 222, 242
"Guide to Film Censorship" (Information Services Dep't.), 131, 134, 136
Guilty Pleasures (Venus Films, 2009), 73
Gunning, Tom, 200, 242
Gyimah, Allen, 49–50, 303n20

Hackman, Steve Asare, 30
Hacky Films (video shop), 65, 116
Hagan, George Panyin, 252–53, 255, 256, 327n1
Hagenbeck, Carl, 210, 322n18
Haggard, H. Rider, 36, 161–64, 198–99, 314n8, 314n10
Hama, Lambert, 32, 61
Hamilton, Caroline, 163–64
Hanegraaff, Wouter, 318n1
Harvest at 17 (Film Africa Limited, 1992), 303n24, 324n6
Hausa people/language, 3, 300n20
Haynes, Jonathan, 27, 300n20
Head of Christ (Sallman painting), 188
Heart of Man (Venus Films, 2010), 73
Heritage Africa (Film Africa Limited, 1989), 53, 263–64, 292, 304n30, 310n1
Hermann, Adrian, 300n19
hermeneutics, 19
Herzfeld, Michael, 89
Hesse, Rev. Dr. Chris, 55
"high-class" movies/cinemas, 67, 73, 75, 101, 141
Hirschkind, Charles, 18, 147

and, 197; of the invisible, 198; lived experience and, 195; religion as, 158, 184, 224, 243

megachurches, 9–10, 88

Meizongo, Hajia Hawa, 29, 54

melodrama, 57, 126, 221, 222, 226, 270

memory, 201, 231, 299n12

Menace (Paragon Pictures, 1992), 314n5

Mensah, Hammond (alias H. M.), xii, 30–31, 34, 69; on colonial-era film, 43; at GFIC premises, *56;* as Muslim who creates Christian movies, 172; on Palladium Cinema, 301n2; at Royal Tropical Institute in Amsterdam, 292

Mensah, Rose Attaa, 236, 327n17

Merleau-Ponty, Maurice, 18, 119, 121, 310n3

mermaids, 57, 128, 217, 325n8. *See also* Mami Water

Michel, Majid, 73

Middleton-Mends, Kofi, 32, 47, 135–36, 261

mimesis, 224, 228, 235

Miracle Films, 65, 67, 68, 69, 72–73, 277

"miracle films," 243

missions/missionaries, 169–170, 220, 232, 275, 315n17, 328n4; "native" culture/language and, 257; as strong presence in southern Ghana, 264

modernity, 44, 83, 84, 97, 189; exemplified by film, 45; expectations of, 89; fashion styles and, 287; film as signifier of, 45; "International Style" architecture in Accra, 87–88, 91; Mami Water iconographies and, 212; tradition in coexistence with, 256; Western, 260, 309n19

Mohammed, Gado, 55, 63

montage, 182–83, 238

morality/ethics, 35, 77, 122, 130, 286, 319n5; chieftaincy and, 267; cinema seen as immoral, 146–47; city as immoral place, 44, 94, 96; conveyed in entertaining manner, 152; delivered in cinematic experience, 139; depictions of sexuality and, 108; ethics of watching, 118, 146–49, 151, 218; imported movies accused of immorality, 48; "occult economies" and, 193; revelation format and, 291; of spectators, 136; transgression required by, 137–38, 147, 182; virtue taught in

storytelling, 134; wealth and, 7, 212. *See also* endings of films, proper and moral

Morgan, David, 22, 157, 188, 317–18n29

morphing techniques, 241–42

Morton-Williams, P., 302n8

Mother's Revenge, A (Ananse System, 1994), 202–203, 264

Mullings, Leith, 205

mumɔn (Ga: "spirit"), 169, 315n16

Murnau, F. W., 200

music, 6, 62, 91, 124, 161; curfews under Rawlings regime and, 49; European/Western classical music used in films, 140, 166, 202, 312n17; "hiplife," 124

Muslims, 30, 281, 297n4, 302n13; Christian movies produced by, 172; Islamic "ethics of listening," 147; Mallams, 133, 178; Muslim Council, 130

NAFTI (National Film and Television Institute), 32, 47, 54, 57, 123, 175, 303n20; Cantonments premises of, 81; criticism of occult-themed films and, 63; cultural heritage and, 253; editors trained at, 238; establishment of, 48; film-as-education discourse and, 132; marginalization of self-trained filmmakers and, 64; Sankofaism and, 260–61, 330n15

Namisha (Aak-Kan Films, 1999), 240

Nankani, Kishore, editing studio of, 229, 241

Nankani family, 42, 46, 67, 302n11

Naomi (Harry Laud, 1995), 111

narratives, 111, 163, 176, 196; about witchcraft, 206, 212; moral lessons and, 152; the occult and, 193, 194, 195; scientific materialism and, 161–62; "spiritual eye" and, 184; trans-figuration and, xii; trans-figuration of, 155, 196

National Commission on Children, 130

National Commission on Culture (NCC), 130, 252, 253, 262, 303n24

National Democratic Congress (NDC), 197n1

National Media Commission, 63

National Media Policy, of Ghana Parliament, 63, 64

174–75, 240, 316n22; fake, 11, 97, 216; female, 173; "fetish" priests as foil to, 133; flamboyant appearance of, 331n19; juju and, 265; Mami Water and, 215–16; miracles performed by, 243, 316n21; "Ɔsɔfo" TV show and, 136; represented in movie posters, 244, *245;* Sacred Heart of Jesus motif and, 188; support for actors playing occult roles, 228, 326n12; video/cinema/TV disapproved by, 147, 173, 174

Pastors Club (Miracle Films, 2009), 178–182, *180, 181,* 184, 186, 191, 216

Peek, Philip M., 317n27, 319–320n7

Pentecostal-charismatic churches, xii, 10, 58, 81, 172, 291; actors involved in, 226; Africanization from below and, 170; cinema halls as places of worship, 47; in conflict with state politics of tradition and identity, 258, 328n5; diversity of, 21; entertainment and, 174; global version of Christianity, 115; "Hallelujah movies" produced by, 171; imaginaries and, 16, 153; "mass movement" and, 175–76; popularity of, 57, 180; Prosperity Gospel, 177, 206; public role of, 9; teachings on sex in marriage, 108, *108;* witchcraft as topic in, 205

Pentecostalism, 2, 8–13, 158; African gods demonized by, 23; "crusades," 9; entertainment merged with, 22; flamboyant lifestyle associated with, 99–100; negative stance toward tradition, 279, 291; pastors as actors, 175–182, *180, 181;* Pentecostals/Charismatics as percentage of Ghanaian population, 297n4; Prosperity Gospel, 177, 206; public omnipresence of, 11, 32, 35, 125, 158; transgression (the devil) needed by, 136–37; wealth and well-being associated with, 110

People's National Defense Council (PNDC), 197n1

perception, 15, 19, 119, 157, 246, 299n13, 310n3; imagination and, 13; mediation and, 121–22, 310n4; self-anesthetization as ethics of watching and, 148; senses as organs of, 22

personhood, 6, 7, 20, 24, 114, 115; African notions of, 309n15; alternative notions of, 23; Christian/Pentecostal views of, 101; moral notions of gendered personhood, 218; "naming" the occult and, 216; occult forces and, 194; self-contained house and, 109–12; urban modernity and, 84

phenomenology, 119, 120, 121, 150

Philosophy of Horror, The (Carroll), 219–220

Pietism, 169

Pilgrim's Progress (Bunyan), 160

Pinther, Kerstin, 109, 301nn1–2

Piot, Charles, 2

piracy, video, 39, 40, 51, 79, 305nn42–43

Plaza Cinema (Accra), 42, 46, 47

Plissart, Marie-Françoise, 309n19

police, representation of, 61, 68

popular culture, 6, 34, 64, 135

pornographic movies, 7, 30, 51, 303n21, 306n49

postcolonial studies, 25

posters, 54, 55, 126, 218, 249, 304n28; collections of, 295; production of, 81; special effects advertised by, 244, *245, 248*

prayer, 22, 186, 199, 233, 250; collective, 227; as protection against witchcraft, 207, 321n12

Princess Films, 67, 311n6

Princess Tyra (Venus Films, 2008), 102, *102,* 283–84, *283*

privatization, xii, 5, 78, 92, 253, 255

profilmic, the, 246–47, 251

"progress," 45, 83, 91, 309n19; ambivalence about, 97; consumerism and, 92; Pentecostal-charismatic route to, 90; as Western-influenced notion, 257; Western theological ideas of, 113

Protestantism, 232, 257, 258, 326n13

public space, 5, 124

public sphere, 1, 12, 78, 259, 289; opened up to alternative voices, 59, 80; "pentecostalized," 11; privatized and commercialized, 3, 4; strong presence of Pentecostalism in, 128

Pure fire Miracles Ministries, 149
Pype, Katrien, 198, 226, 228, 236, 325n8

Quarshie, Veronica, 310–11n6
Quartey, Richard, 29, 30, 51, 160–61, 176, 314n6; as born-again Christian, 164, 167; Haggard novel *She* and, 164; Paragon Pictures movies of, 314n5; on the spiritual and the physical, 170, 171; synopsis of *Zinabu* and, 164–68; on witchcraft, 207
Quashigah, Linda, 31
Quason, Ato, 9, 92, 307n3, 308n8

radio, 4, 59, 95, 174, 249
Rancière, Jacques, 1, 5, 19, 122, 299n9
Ranger, Terence, 192
Rawlings, J. J., 49, 50, 55, 297n1, 303n19; Sankofa policy continued by, 255, 263; traditional religion and regime of, 265
reception studies, 310n2
Regal Cinema (Accra), 42, 46
Regional and National House of Chiefs, 266
religion, 113, 115, 174; anthropology of, 194; film and, 157–160; horror discordant with, 220; as "medium of absence," 21; "pagan," 232, 257
religious real, 22, 300n19
representation, 133, 173, 247, 291, 294, 325n10; audiovisual, 10, 23, 119, 197, 207, 232, 235; of chieftaincy, 270, 271; cinematic, 293; critiques of, 300n17; of family relations, 26; figurative, 197; imagination/imaginaries and, 13, 15; mediation and, 150; of occult forces and practices, 12, 197, 224; politics of, 91, 92, 128, 129; resistance to, 190, 210, 250; revelation and, 171, 190, 192, 222; selection and, 113; self-representation, 27; of the spiritual, 177, 223, 237; state-driven, 7; textual, 157; of tradition, 24, 37, 254, 258, 276, 281; uncanny and, 219; of urban space, 84, 85, 90, 92, 106. *See also* cultural representation; invisible, representation of the
revelation, 19, 21, 169, 170, 182, 254, 291; aesthetics of outrage and, 192; art horror

and, 220; as format for movies, 172, 186; gaze and, 183, 185, 190, 191, 220–21; Jesus pictures and, 187; Pentecostal sensory practices and, 190; pictorial figuration and, 191; public performance of, 198; as requirement for seeing the occult, 248; Revelation of John, 156–57; special effects and, 240; as strategy of exposure, 232; surrealist project and, 296; witch-craft movies and, 209
Reward (World Wide Motion Pictures, 2000), 82
Rex Cinema (Accra), xi, 39, 42, 45, 47, 126, *126;* as respectable venue, 125; as second-ranked cinema, 54
Ribeiro, Thomas, 61, 304n29
Ripples 1–3 (Princess Films, 2003), 311n6
rituals, 125, 235, 271, 317n27; chieftaincy and, 272; decline of, 265; Hollywood fictions, 166; libations and, 110, 199; as movie theme craved by audiences, 71; in Nigerian movies, 231; objects associated with, 111, 169–170, 280; "outdoorings," 99; as performance, 236, 326n13; ritual murder, 23, 84, 331n4; urban occult societies and, 83–84
Road to Kukurantumi, The (Ampah, 1983), 302n15
Robbins, Joel, 297–98n5, 323n2
Robbins, Rossell Hope, 207, 321n15
Rosemary's Baby (USA: William Castle Productions, 1968), 160
Rouch, Jane, 46
Rouch, Jean, 46, 87, 103
Roxy Cinema (Accra), 28, 42, 47, 125, 142
Royal Cinema (Accra), 42, 47, 125
Royal Tropical Institute (Amsterdam), 34, 292, 307n2
rumors, xi, 7, 155, 218, 249, 319n3; about fake pastors, 180; about satanic wealth, 289; mediations of the occult and, 195; popular imaginaries and, 59; trans-figuration and, 156

Sacred Beads I and *II* (Aak-Kan Films, 2009), 231, 280–81, *282*
Sacred Heart of Jesus motif, 187, 188, 293, 318n29

senses *(continued)*
 sible to, 21, 138, 185; synesthesia versus centrality of vision, 119, 139, 178; technology of audiovisualization and, 191

sermons, 134, 155, 179, 190, 218, 249; about satanic wealth, 289; mediations of the occult and, 195; trans-figuration and, 156; on witchcraft, 207, 321n12

Set on Edge (Gama, 1999), 61

Seventh Day Adventists, 229, 230

Sex Machine (Great Idikoko Ventures, unfinished), 31

sexuality, 7, 57, 212, 267; censorship of sex scenes, 132; criticism of films with sex scenes, 74; ethics of watching and, 149; excessive depiction of, 291; illicit, 108; lesbian, 128, 147, 213; marital bedroom in movies, 107–108; "naming" the occult and, 217; in Nigerian movies, 68, 69; popularity as movie theme, 71

Sexy Angel (Movie Africa Productions, 2010), 73

Shadows from the Past (Princess Films, 2000), 310n6

She (Haggard novel, 1887), 161–64, 167, 198–99, 219, 314nn7–10

Shepstone, Theophilus, 163–64, 314n10

shrines, on film, 232, 233, *234*, 250, 281, *282*

Sidiku Buari, 116

Siegel, James, 216

Silverbird Cinema (Accra), 73

Silverline Productions, 29

Simmel, Georg, 106, 272

Simone, AbdouMaliq, 95, 114

Sinare, Kalsoume, 244, 287

Sistem Televisyen Malaysia Berhard. *See* Gama Media Systems Ltd.

slave trade, 85, 255, 328n3

Smith, Bob, xi, 228

Snake in the Monkey's Shadow (Hong Kong: Goldig Gilms LTD, 1979), 50

snakes/snake charmers, 109, 175, 277, 316n22, 327n21; "bad death" by snake-bite, 199; demons associated with, 153; Diabolo (snake-man), *ii*, xi, 95, 135, 228; Indian snake charmer and Mami Water, 210–11, 322nn18–19; special effects and,

177; witches' ability to transform into, 206, 208

soap series, televised, 10, 53

Sobchack, Vivian, 119, 120–21, 150, 158, 310n4

Soja, Edward, 307n3

Sorcerer's Apprentice (Goethe), 291

sound, 72, 139–142, 151, 235, 320n9

Souriau, Etienne, 246

South Africa, 25, 163–64, 314n10

speaking in tongues, 167, 177

special effects, 20, 67, 125, 185, 229, 323n25; advertising of, 243–49, *245, 248;* animation of the occult and, 250; digital technology and, 330n16; divine power represented through, 186; editing and, 237–243, *239, 240;* regarded as un-African, 261; spiritual realm conjured by, 138; in witchcraft movies, 208, 209

spectators, 26, 27, 134, 159; actors confused for roles played, 228, 229; attitudes toward video movies, 117; female, 126–27; female spectators and consumer lifestyle, 104; ideal spectator, 77, 118, 127; seduction of, 1; Western, 291. *See also* audiences

speech, Christian attitude toward, 185–86, 317n27

Spirit of Discernment, 170, 184, 189, 317n26. *See also* Pentecostalism

Spirit of Heritage (Sarbah The Great Films, 2008), 282–83

spirits, xii, 22, 155, 157, 217, 236, 323n2; acceptability of depictions of, 49; actors playing role of, 227–28; anthropologists and, 194; camera as device to render spirits visible, 167; Christian campaign against, 257; conflict of good and evil spirits, 170; deliverance from evil spirits, 9, 110; earth spirits, 240; enlivened by human acts, 251; fake pastors and, 179; fear of, 259; filmmaking process and, 226, 227, 231–34, 237, 249; forest spirits, 23; *gbɔgbɔ* (spirit in Ewe language), 110, 169, 315n16; God against evil spirits, 153; hidden presence of, xi, 171, 183; of home villages, 111; logic of revelation and, 156; movies exposing hidden acts

mobile medium and, 65, 79; Western imagination of Africa and, 113

video film critics, 57, 84

video film production, xii, 46, 54, 61, 70; female producers and, 29, 54; producers and, 5, 28–32, 56–58, 65–67, 71–73, 80

video film sets, 81, 230, 236; in Enugu, Nigeria, 295; in rural villages, 330n14; as space between illusion and reality, 227

video films (video movies), 19, 84, 150; African cinema and, 24–28; Christianity and, 171–182; color technology as factor in rise of, 55; definition of, 297n2; emotional effect on audiences, 117, 128; at film festival in Amsterdam, 292; for home consumption, 59–67, 66; imaginaries and, 16; oral culture and, 137, 140, 141, 165; as part of popular culture, 34; Pentecostal Christianity and, 8–13; pioneers of video film industry, 29; popularity of, 52, 53, 56; privatization of industry, 92; public role of, 5; quantity of, 2; religion and, 157–160; social transformations and, 6; state cinema (mid-1980s to 1996) and, 49–59; surrealist affinity with, 225, 296; video technology, 40, 45, 50–51, 79; as "visual texts," 12; watching experience and, 139–149, 140, 144

violence, 7, 68, 69, 106, 172; censorship of, 131, 132; excessive depiction of, 291; fighting scenes, 47, 125, 131, 141, 143

Vista Foundation, 31, 34

visual culture, 15, 17

visualizations, 271–72, 273, 330n13

vɔdu (god), 315n17

Volta Region, xi, 39

voodoo (vodun), 166, 178, 209, 232; Mami Water cult and, 211; reappropriation of Hollywood imagery, 232, 293, 325n10

Vries, Hent de, 243

weddings, videos of, 49

Welcome to Nollywood (New York: Cinema Guild, 2007), 306n50

Wendl, Tobias, 93, , 207, 311n8

West Africa Pictures Limited, 42, 45

What Lies Beneath (USA: Twentieth Century Fox Film Corporation, 2000), 320n9

Who Loves Me? (Venus Films, 2010), 102, 103

Whose Fault? (Roses Productions, 1994), 116

Wicked Romance (Paragon Pictures, 2004), 314n5

Witches of Africa, The (Ebkans Enterprise, 1992), 183, 188, 208, 209

witches/witchcraft, 23, 24, 29, 37, 57, 188; as "African electronics," 205, 327n17; animal bodies inhabited by, 206, 321n13; conversion to Christianity and, 51; criticism of depictions of, 60, 63; "dark side of kinship" and, 212; elusive iconographies of, 293; European, 207, 321n15; films about, 204–10, 208, 210; folktales about, 175; modernity of, 192, 204–205; moviemaking and, 230; "naming the witch," 216–17; "negative image of Ghana" associated with, 262; ɔbayifoɔ, 321n13, 321n17; popularity of movies about, 71; regarded as un-African, 261; as "superstition," 258; as topic in Pentecostal churches, 205, 321n12; traditional religion associated with, 265

Wolfe, Ernie, 295

women, 104–105, 281; character of bad woman in films, 128; Christian mother and wife, 168–69; Christian woman as ideal spectator, 127–28; female pastors, 173; as majority of spectators, 126–27; with occult powers, 32; priestesses of African religions, 168

Women in Love I and II (Movie Africa Productions, 1996), 30, 109, 128, 213

"Work of Art in the Age of Mechanical Reproduction, The" (Benjamin), 273

World Bank, 307n5

World Council of Churches, 258

World Miracle Church International, 174

World War II, 42, 86

World Wide Motion Pictures, 29, 52

Yaro, Moro, 56

Yawson, Price (alias "Waakye"), 112

Yoruba people/language, 300n20
Yoruba theater, 5–6, 312n14

Zinabu [remake of Zinabu I] (Worldwide
 Motion Pictures, 2000), 315n13
Zinabu I (Worldwide Motion Pictures/
 Paragon Pictures, 1985), xii, 1, 29, 116,
 160–61, 304n30, 315n13; dramatic
 speech act in, 185; as famous title, 116;
 figuration of the spiritual, 171; genesis
 of, 36; Haggard novel She as inspiration
 for, 161–64; special effects in, 238;

synopsis of, 164–69; witchcraft theme
 of, 51
Zinabu II (studio and date unclear), 162,
 304n30, 315n13
Zinabu III (Worldwide Motion Pictures,
 1991), 207, 208, 304n30, 315n13, 321n16,
 326n12
Zinabu IV (Paragon Pictures, 1992),
 304n30, 314n5, 315n13
Zinabu IV (Worldwide Motion Pictures,
 1992), 304n30, 315n13
Zulu kingdom, 163–64, 314n10

DATE DUE			
9/26/18			

Moore Reading Room
KU Religious Studies Department
1300 Oread Avenue
109 Smith Hall
Lawrence, Kansas